W9-BXG-270

ANTHONY BOURDAIN
REMEMBERED

ANTHONY BOURDAIN
REMEMBERED

An Imprint of HarperCollins*Publishers*

JESSAMINE COUNTY PUBLIC LIBRARY
600 South Main Street
Nicholasville, KY 40356

ANTHONY BOURDAIN REMEMBERED. Copyright © 2019 by CNN. All rights reserved. Printed in the United States of America. No part of this book may be used or reproduced in any manner whatsoever without written permission except in the case of brief quotations embodied in critical articles and reviews. For information, address HarperCollins Publishers, 195 Broadway, New York, NY 10007.

HarperCollins books may be purchased for educational, business, or sales promotional use. For information, please email the Special Markets Department at SPsales@harpercollins.com.

Previously published in 2018 by CNN.
Ecco hardcover published in 2019.

Image credits: see page 208.

Library of Congress Cataloging-in-Publication Data has been applied for.

ISBN 978-0-06-295658-3

19 20 21 22 23 LSC 10 9 8 7 6 5 4 3 2 1

IF I'M AN ADVOCATE
FOR ANYTHING, IT'S TO
MOVE. AS FAR AS YOU
CAN, AS MUCH AS YOU
CAN. ACROSS THE OCEAN,
OR SIMPLY ACROSS
THE RIVER. WALK IN
SOMEONE ELSE'S SHOES
OR AT LEAST EAT THEIR
FOOD. IT'S A PLUS FOR
EVERYBODY.

ANTHONY BOURDAIN

FOREWORD

When we met Tony for the first time in 2012 to discuss developing and hosting our first CNN Original Series, he explained that he did not consider himself a journalist. But it was clear that like the best journalists, he was driven by deep curiosity and respect for the people and places whose stories he told. The show he and ZPZ created showed us what thoughtful dialogue looks like—with other people, cultures, and ideas. Tony's words and voice always drew us into the scene and into those conversations.

Parts Unknown worked for CNN because it complemented our global coverage. The series added a dimension of humanity that is sometimes missing from our stories as we move rapidly from one to another. Tony's work was refreshing and sometimes controversial, but we knew that viewers embraced his honesty.

When Tony died, we saw the outpouring of emotion and immediately set up a space on our CNN digital site for his fans to come together . . . to grieve, to celebrate Tony, to reminisce. Thousands of people of all ages, from all over the world, weighed in. His appeal crossed every boundary. It was a revelation for us to witness such a deep connection between an enormously diverse audience and one individual. We built out

a social media destination for fans to share their memories, but what followed was an outpouring of love that was almost overwhelming. There were waves of emotion. Thousands of notes, comments, and messages of support. It was beyond what we anticipated.

The tributes spoke to his legacy: That the world is much smaller than we imagine, people are a lot more alike than they are different, there is less to fear about the world than we think. One post stood out to me in particular, from a team of travel writers who had been inspired by Tony and were following that dream. Tony was their guidepost, and they are now following along the paths he created and making some new ones of their own. It was the passing of a torch.

Social media is a powerful means of expression, but it is a fleeting one. It evaporates before you can grasp it. We wanted to capture these messages, so representative of Tony's influence and impact, and save the best of it in one place. We wanted a book that could be revisited over time and appreciated slowly, like a long, enjoyable meal with a close friend.

This is that book. Included are many social posts from fans who changed their worldviews or even their lives because of Tony, as well as comments from chefs, journalists, filmmakers, musicians, and writers he inspired. It is something permanent to hold in our hands that allows us to go back and be reminded of what Tony meant, and still means, to the people who were in his life and outside of it, close to his world and in parts unknown.

Amy Entelis, Executive Vice President for Talent and Content Development, CNN Worldwide

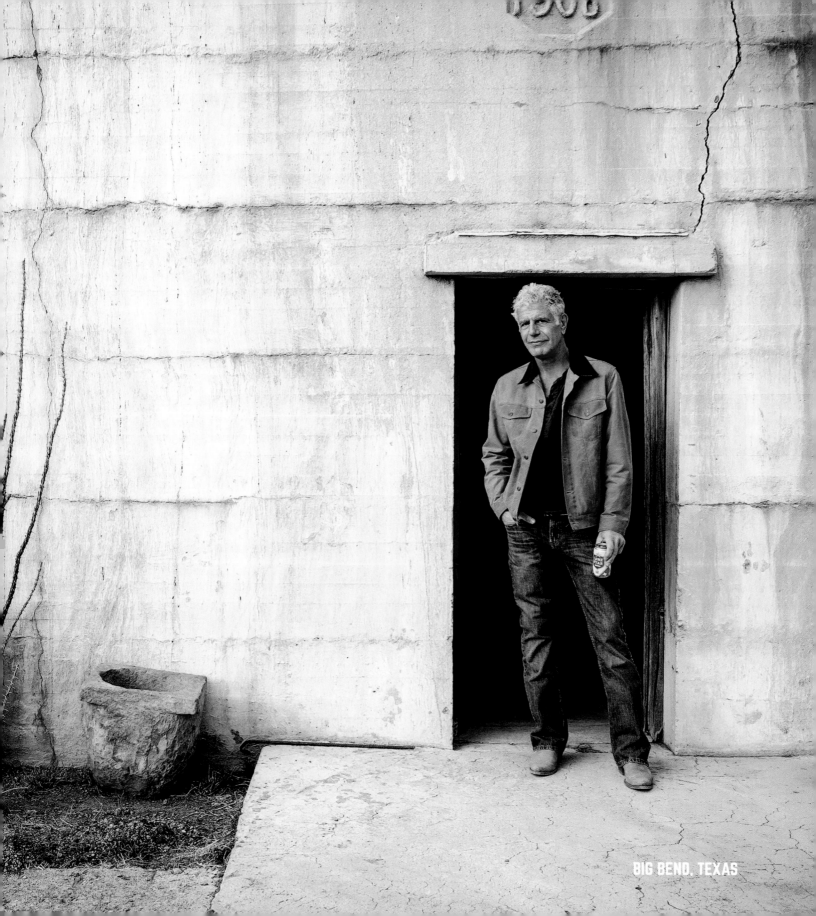

BIG BEND, TEXAS

I went to Quality Meats for dinner in 2015 and met this amazing human being. Living in NYC, I often saw celebrities and chose never to interact with them—but not this man. I saw him at the host's table with his family as they were departing and I was about to be seated. I quickly offered him a handshake, and he graciously reciprocated. I never do this, but I could not resist asking him for a recommendation on what to eat that night. He replied in his casual, off-the-cuff manner to start with the bacon appetizer. Followed by the ribeye steak, medium rare; do not use any of the sauces that they will bring out to the table because they only hide the true flavor. He then asked his daughter what she ordered for dessert, and she replied, "the burnt marshmallow ice cream." He said that he has had it before and the ice cream is wonderful and to trust her opinion on the current day's version.

One thing to note is that I typically do not eat pork, but when the most prolific foodie-storyteller suggests it, I had to approach it as if we were in a foreign country ordering a dish that I had seen on *Parts Unknown*. I ordered the meal exactly as he recommended and had a brief insight into the gastronomic feasts that satiated his soul. I will never forget that experience.

Bobby K.

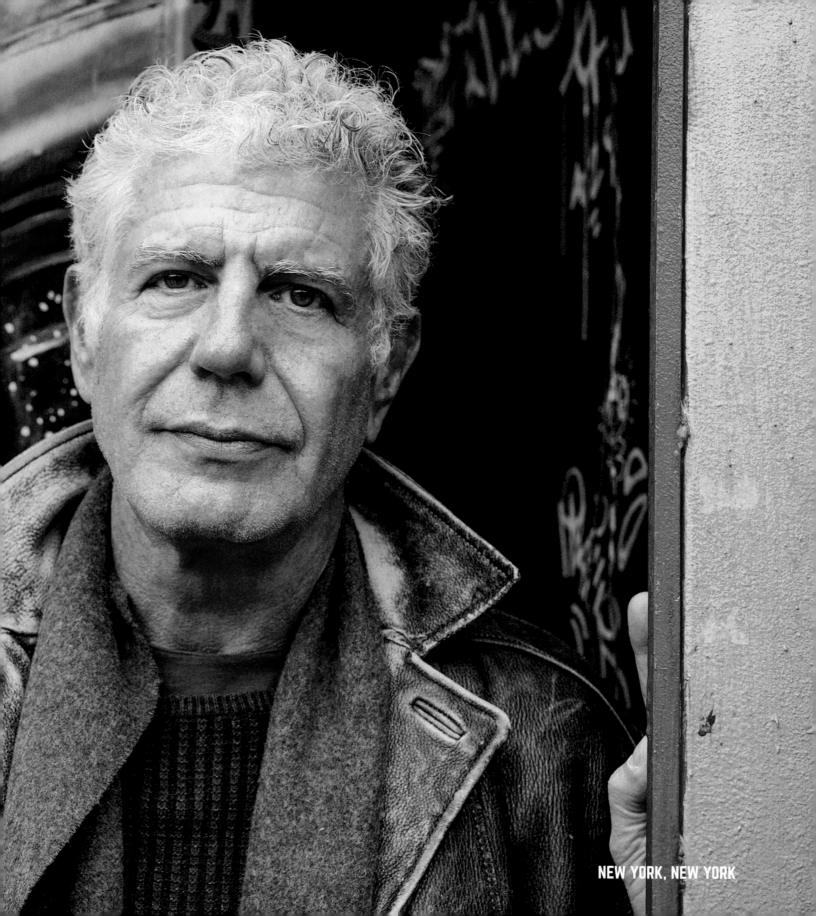

NEW YORK, NEW YORK

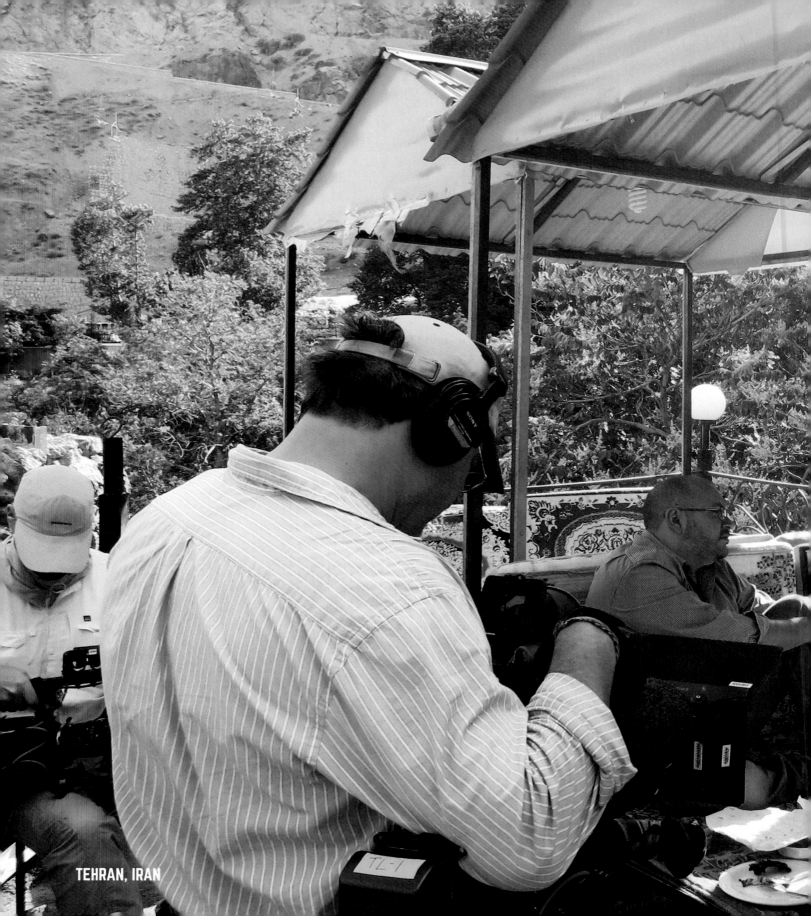

TEHRAN, IRAN

The Iran episode of *Parts Unknown* did more than any foreign television production ever has to show my homeland in all its complexities—for better and for worse. He gave a voice to my country in a way no American production had before.

I now see that Tony's wanderlust had more to do with people than with food. He and his crew were never just after a few quick shots of a place or its most iconic dishes. They were there to tell our stories, to highlight our similarities and differences.

The legacy of Tony's many travels will be the hundreds of hours of film showing that all human beings share common dreams and aspirations. At this time in history, that's what the people of Iran—and so many other places around the world—need most.

I'm forever grateful to Tony and *Parts Unknown* for their quest to humanize us all.

Yeganeh Salehi, writer

ANTHONY BOURDAIN NEVER WANTED TO BE CALLED A JOURNALIST, BUT THAT'S EXACTLY WHAT HE BECAME. IN FACT, HE'LL END UP BEING REMEMBERED AS ONE OF THE MOST INFLUENTIAL TELEVISION CORRESPONDENTS EVER.

JASON REZAIAN, JOURNALIST

I STARTED LEARNING TO COOK BECAUSE OF TONY. I STARTED LEARNING TO SEE THE WORLD OUTSIDE THE LENS OF A SMALL TOWN IN WEST VIRGINIA BECAUSE OF TONY.

Brady H.

His episode on South Korea was the first thing I watched after learning that I was being moved there for my dad's work. It gave me confidence that I would be fine when I moved there (I was in high school) and that it would truly be an adventure like his.

His willingness to adventure into Korea and try the food and meet the people was the exact way myself and my family decided to approach our move there. Thank you, Anthony!

Colleen

He didn't come here wanting to change people's minds, but to truly listen to us and allow us to tell our story.

Amy S.

ST. PETERSBURG, RUSSIA

Anthony showed me how truly connected we all are. Food, family, ritual—in every culture we all share this instinctive desire to break bread. I loved his humor and frank, open, passionate storytelling.

Amy G.

HIS INFLUENCE WAS, AND IS, STAGGERING.

Edward Lee, chef and author

I read his book *Kitchen Confidential* shortly after college, after working as a grill man in a Mississippi kitchen with enough drama and substance abuse to feel like a pre-K version of a Bourdainian milieu. Because of that, I felt a special kinship with the author. But it was in his second career, on television, that Bourdain came to be more than a foul-mouthed raconteur with a string of unhygienic anecdotes about the food-service industry.

He became a guide and champion of travel and experiencing the wider world, with shows that combined cuisine, history, culture, politics, and everyday life around the world.

Michael S.

After reading *Kitchen Confidential*, watching his shows, he taught me that anyone can go from the battlegrounds of the food industry to being anything you want. Meet anyone you want. Explore the world any way you want.

Oliver K.

NEW YORK, NEW YORK

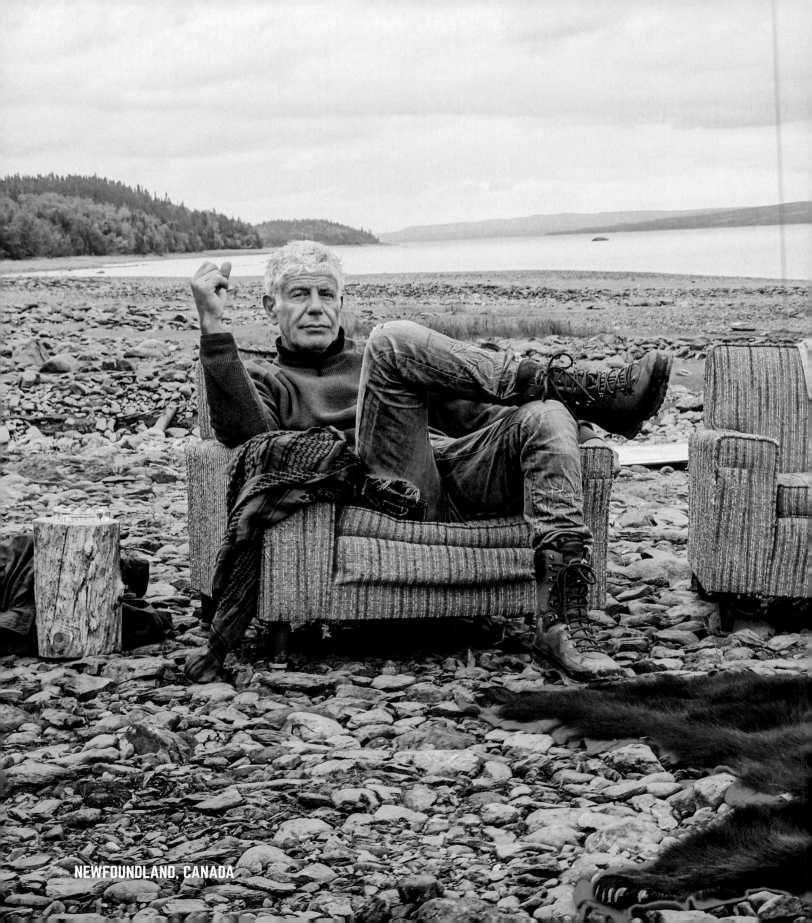

NEWFOUNDLAND, CANADA

TONY BOURDAIN WAS
THE REVOLUTIONARY
OF THE FOOD UNIVERSE.
HE LITERALLY CHANGED
THE LANDSCAPE.

JONATHAN WAXMAN, CHEF AND AUTHOR

MANILA, PHILIPPINES

HE BROUGHT US ALL TO THE TABLE WITH SO MANY CULTURES AND CUISINES. WE LEARNED ABOUT HUMANNESS FROM ANTHONY, THANK YOU.

Mary Rita S.

Due to you, I started my culinary career at fourteen, and I have been in this business ever since and I'm twenty-four now. You gave me a purpose in my life and helped me figure out what I wanted to do with it. You inspired me, you guided me, and I was encouraged by you to want to try so many things and I've only done a fair few. I can only hope I can be half as intelligent and wonderful as you were and for my life to be as filled with wonder as yours was.

Hunter L.

I'll remember Tony as the strange-looking guy on television who ate anything you put in front of him. I'll remember him as a caring person who taught us that being different is OK. He would travel the world and break bread not only with those who shared his beliefs but those who could not have been further from where Anthony stood. He immersed himself in their traditions and ideas, and allowed himself to be open and understanding. He taught us to listen, rather than speak. He taught us to break bread, not friendships or ideas. There were no religious rifts or racial biases with Tony and the people he met. It was always Just Tony—eating a pork sandwich, having a drink, and sharing stories. He showed us that we are more similar than we are different.

Rick V.

I WAS A LINE COOK WHEN *KITCHEN CONFIDENTIAL* CAME OUT. HE TOLD THE WORLD THAT I WAS A WARRIOR. BUT HE CONVINCED ME, AND US IN THE KITCHENS EVERYWHERE, THAT WE WERE MORE THAN OUTCASTS AND MISFITS. HE MADE US HEROES TO OURSELVES.

JOHN B.

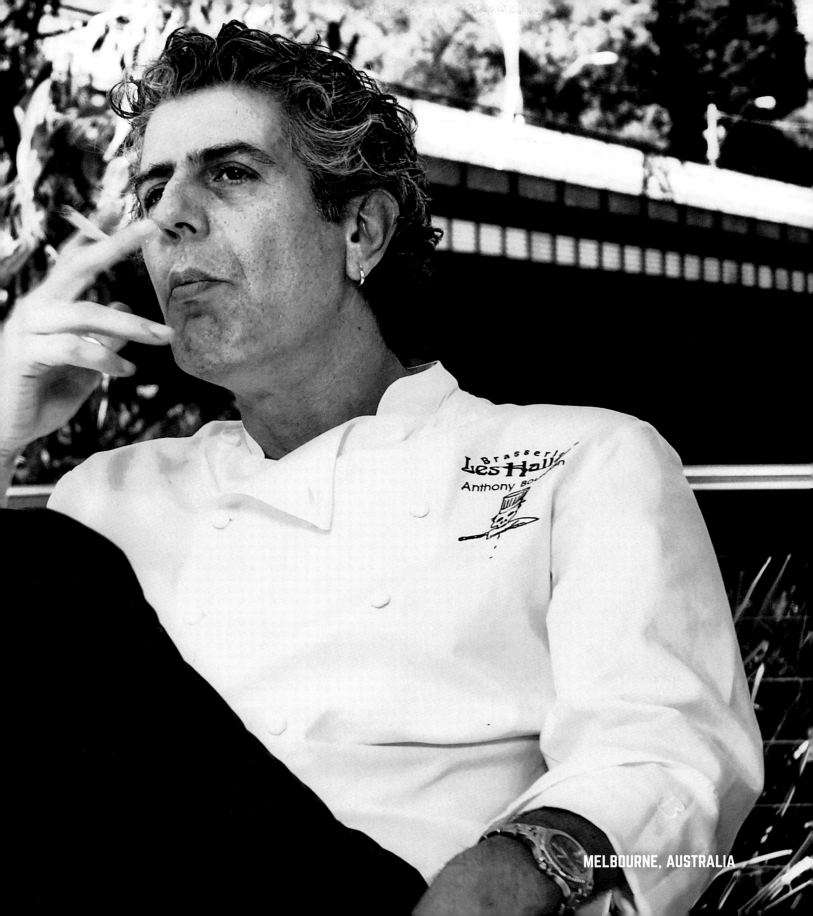

MELBOURNE, AUSTRALIA

EVERYBODY WHO HAD DREAMS OF TRAVELING WITH TONY . . . IT'S EXACTLY AS COOL AS YOU THINK IT IS.

W. Kamau Bell, comedian

Through his stories, his wit, and his travels, he inspired me to perpetually step out of my comfort zone in order to live a life truly worth living. A raw, flawed, and beautiful man, Tony's legacy will continue to guide me to be a better husband, a better father, a better ally, and a better man. I can only hope to make a fraction of an impact on the world that he did.

Matt N.

I had the pleasure of meeting Anthony outside the Christchurch Convention Centre when I was merely a kitchen hand. He was outside, smoking a cigarette. We looked at each other and had a casual chat as you do. . . . He was interested in what I did and said I should become a cook—fourteen years later, here I am. So lucky to have met you, brother!!

Chris B.

Anthony gave every guy in America who's trapped in a dead-end job hope that life gives us second chances.

S. J.

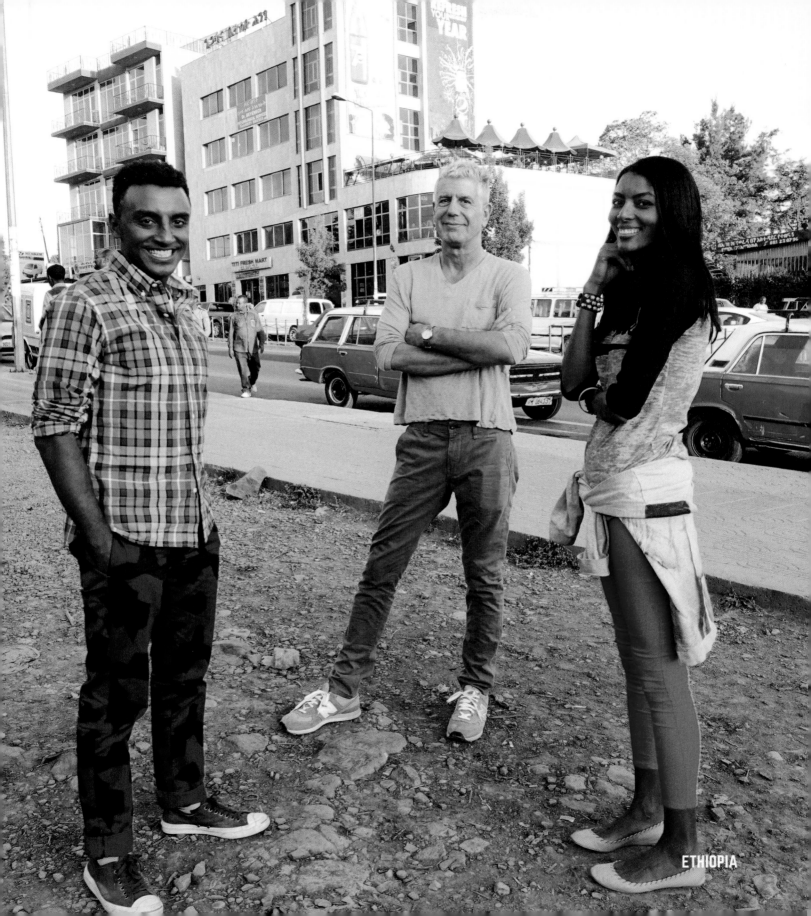

ETHIOPIA

ANTHONY WAS MY BEST FRIEND.
HE WAS AN EXCEPTIONAL HUMAN
BEING, SO INSPIRING AND
GENEROUS. ONE OF THE GREAT
STORYTELLERS OF OUR TIME
WHO CONNECTED WITH SO MANY
AROUND THE WORLD ON A LEVEL
RARELY SEEN. HE BROUGHT US ALL
ON SOME INCREDIBLE JOURNEYS.

ERIC RIPERT, CHEF AND AUTHOR

NEW YORK, NEW YORK

Back in 2005 I was training to be a sous chef, and I would drive ninety minutes each way during the northeast Ohio winter, then work eleven- to twelve-hour days. I bought the *Kitchen Confidential* audio CDs and listened on my drive every day for three months. I must have listened to that book nine or ten times during that time. I will always think of that book as my coach during that crazy time. He's a rock star.

Brian

I was in culinary school and about to enter an industry that, even as Anthony put it, chews up and spits out the weak. His book *Kitchen Confidential* just hit the shelves. He unknowingly helped prepare me for the reality of the commercial kitchen and all the pain, sweat, heartache, joy, excitement, and passion that it brings.

I brought his books with me as I traveled Europe, working and learning as a chef, and saw everyday reminders of him in almost every kitchen I worked in. It continues to this day.

He will continue to be seen and present, in my mind, in every kitchen I will find myself in.

Jeff B.

TO ME YOU WERE THE GONZO OF THE CULINARY ARTS.

Matt R.

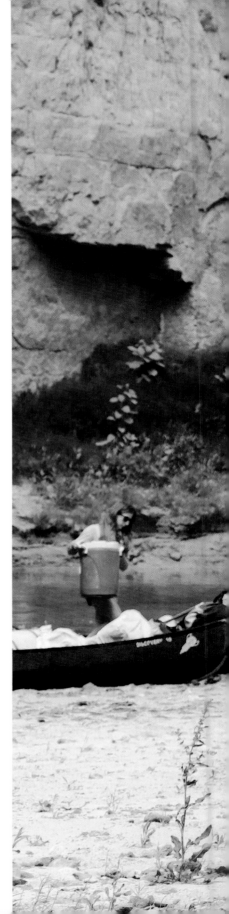

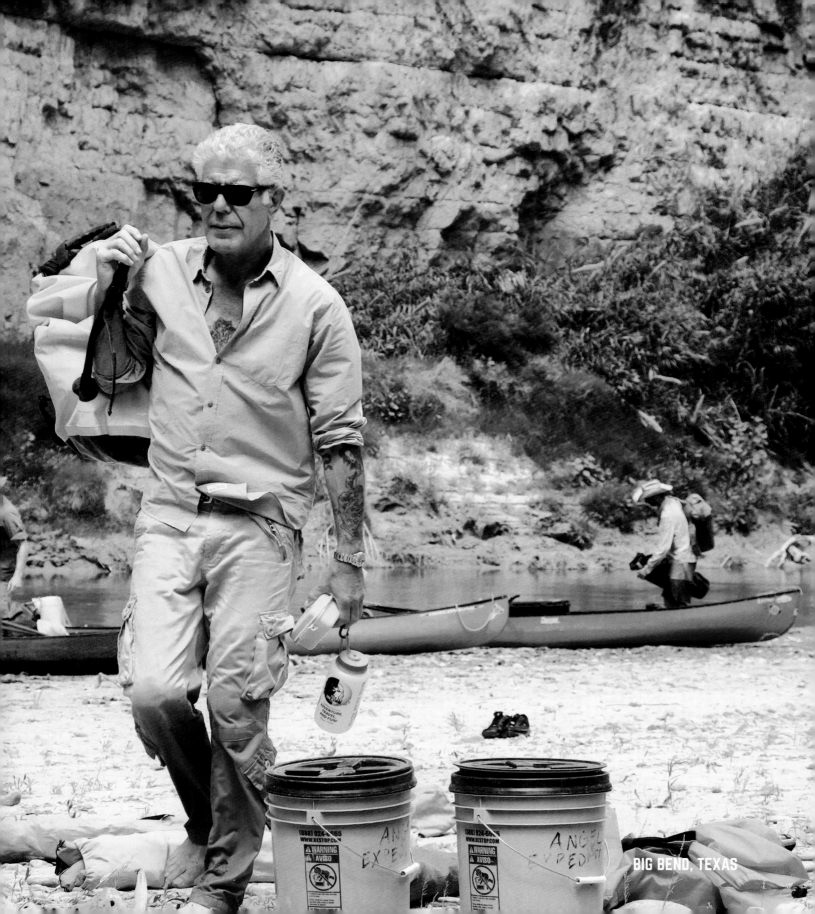

BIG BEND, TEXAS

I DIDN'T KNOW ANTHONY BOURDAIN BUT FELT A SPECIAL KINSHIP AND NOW AN ACUTE LOSS. HE EXCELLED AT STORYTELLING AND FINDING THE VERY BEST ONES IN EVERY MORSEL OF LIFE. I'LL MISS HIM.

KEN BURNS, FILMMAKER

QUEENS, NEW YORK

VASHON ISLAND, WASHINGTON

Traveling the world as a camera operator, I could relate to many of the situations Tony and his crew were putting themselves in. But the way they took on the challenges and embraced them, continuously outdoing themselves to always tell such amazing stories, inspired me most. Constantly pushing the boundaries of nonfiction television. It inspired me to strive to always want to be "more like Bourdain" in my work.

Ryan M.

HE HAS MADE ME A BETTER PERSON—GENTLER, MORE ACCEPTING, AND A THOUGHTFUL LISTENER.

Anne

My mother had passed away, and one night I was watching him. Feeling lost and alone, I decided I was buying a plane ticket to Asia, one-way, packing a backpack, and going off the grid. I was going to eat with locals, and see the parts of Asia that I thought would only be a dream. I was going to find peace in losing my best friend and mother through travel and food. I would like to think if he would have ever known my story, he would have been proud of a fifty-year-old single woman leaving the East Coast (US) and finding my way to new friends and an open mind to try anything even if I did not know what I was eating or even where I was going on a seven-week trip.

Nita

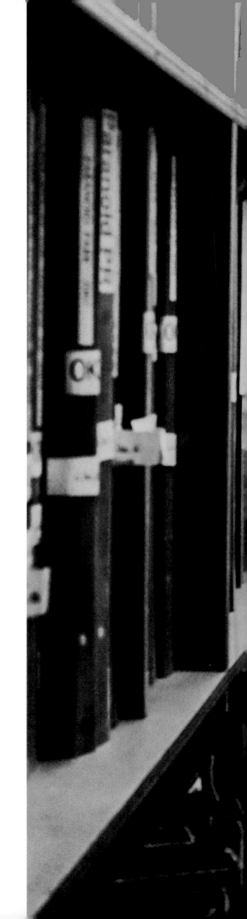

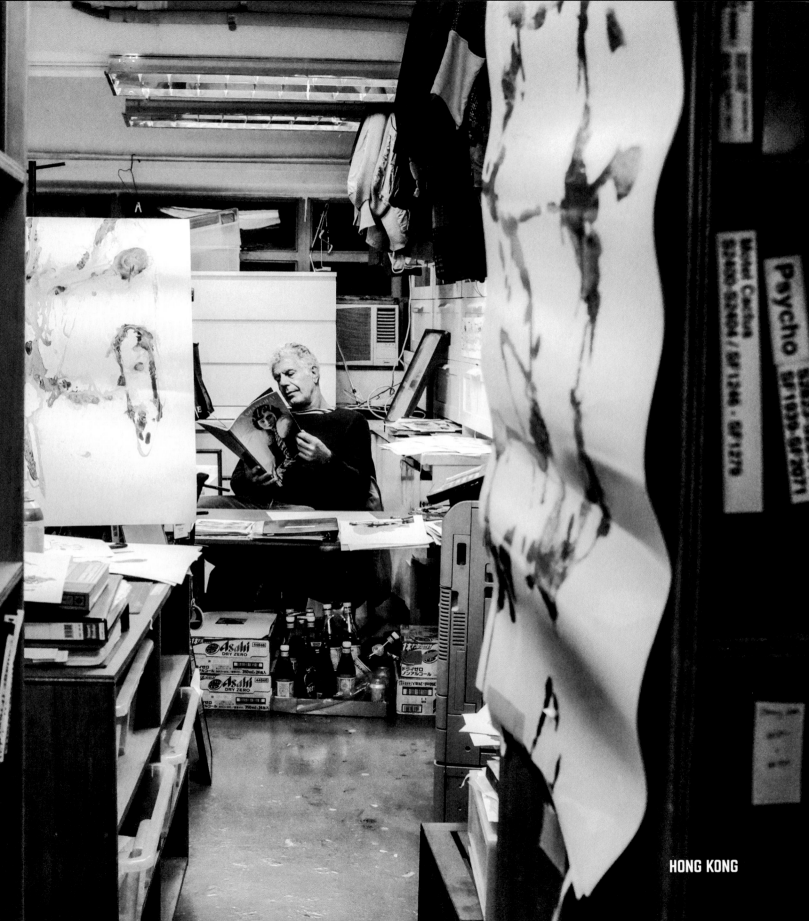

HONG KONG

IT'S EASY TO LOVE TONY. YOU CAN SEE IT. HE'S THE MOST CARING PERSON I'VE EVER MET. THAT'S WHY I'M HAPPY AND PROUD TO CALL HIM A FRIEND.

JOSÉ ANDRÉS, CHEF

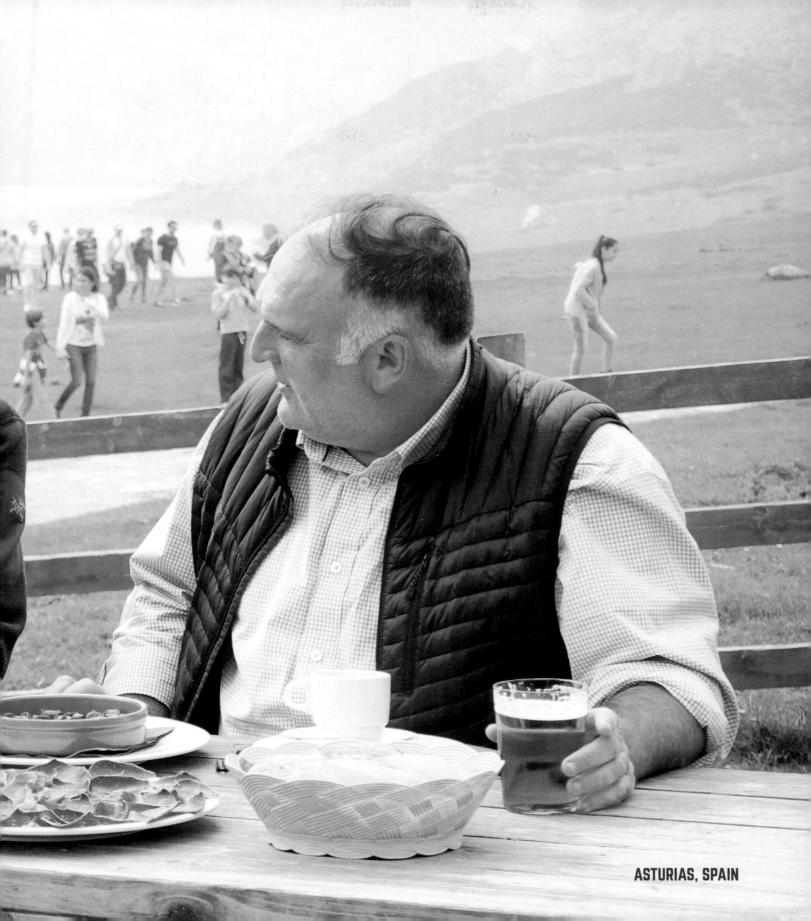

ASTURIAS, SPAIN

THE TIME I SPENT WITH THIS
GENTLEMAN, THE CONVERSATION
ABOUT LIFE THROUGH FOOD, WAS
UNFORGETTABLE. ANTHONY HAD
A UNIQUE WAY OF CONNECTING
LIFE THROUGH FOOD, WHICH
WAS EXTRAORDINARY.

LUTHER "LUKE" CAMPBELL, MUSICIAN,
RECORD EXECUTIVE, AND ACTOR

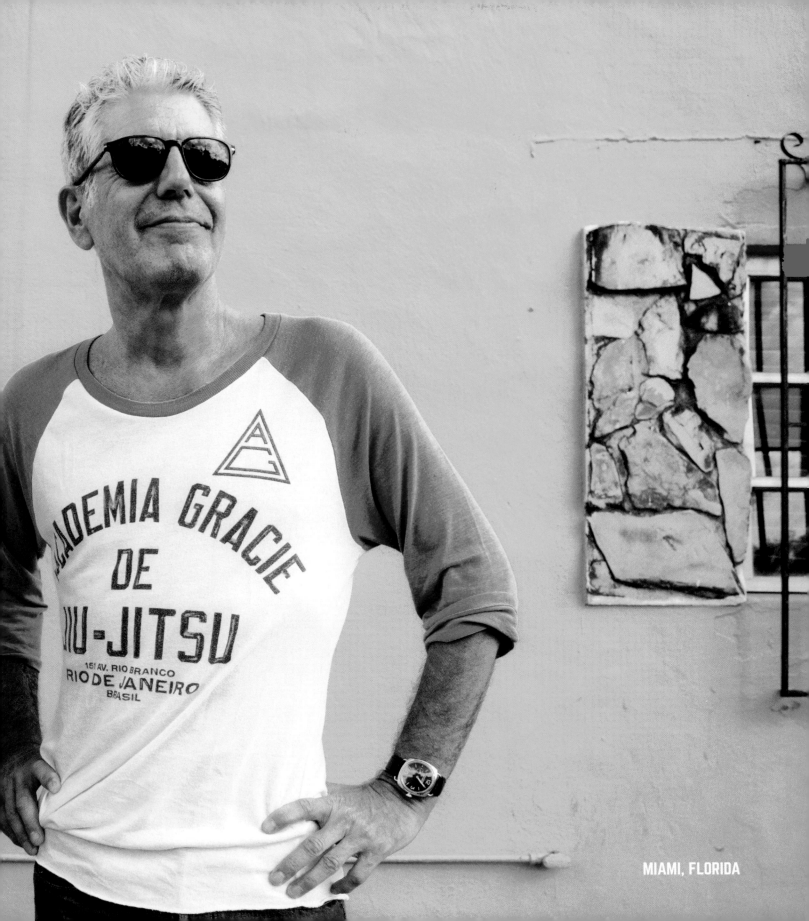

MIAMI, FLORIDA

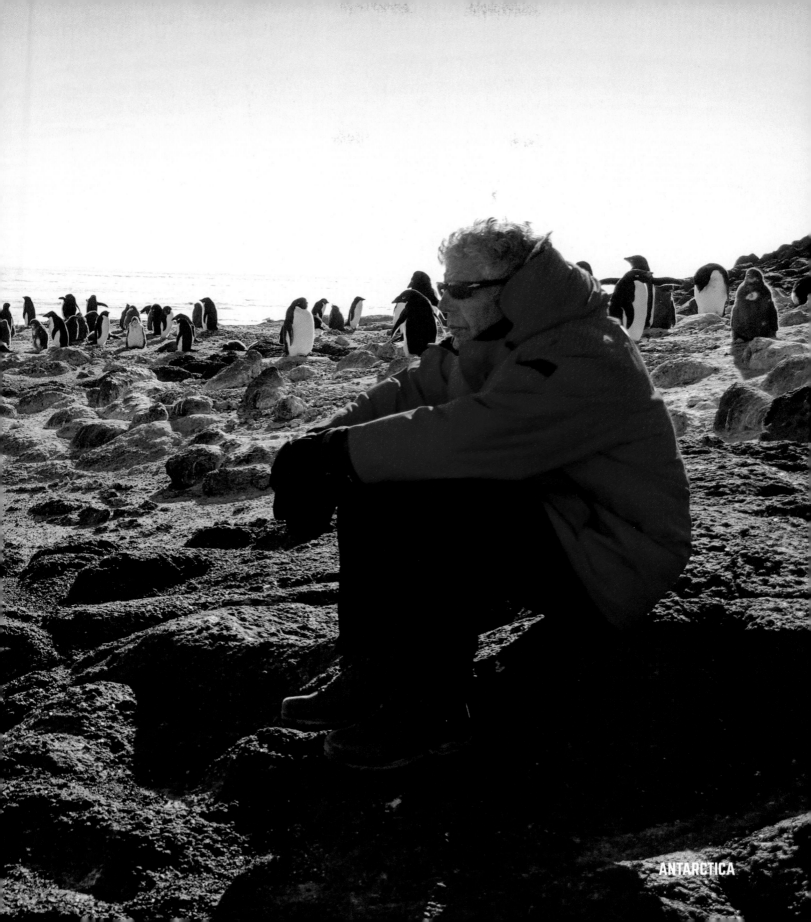

ANTARCTICA

I feel so thankful to him for introducing me to a world I never knew, the world of food and especially food around the world. It was through Anthony that I learned about who the sushi master Jiro Ono was, and that recommendation (seeing the Jiro doc and making a pilgrimage to Tokyo by any means necessary) singlehandedly changed the course of my professional and creative life.

Anthony also believed, and talked often about, how all forms of creativity were connected: how chefs and drummers and comedians and actors and directors and painters all drew on the same well of thoughts and emotions. That feeling stuck with me. Watching him take trips to faraway lands to get a taste of heaven (and, just as often, to show how life on earth can be hell for people under the thumb of cruel governments or oppressive poverty) was the equivalent of my many trips to obscure record shops continents away. Lastly, I'll miss our endless banter about the merits (or lack thereof) of yacht rock. Anthony came on *Fallon* often, and every time, he liked to warn me that his walk-on music better have "some umph to it." He wanted power and attitude. I'd agree with him, and then I'd play another Billy Joel song, which infuriated him. A few years back, to thank him for writing the foreword to my book, I started the ultimate troll project, though I never got to give it to him. We had an "argument" over Herb Alpert's "Route 101": I made the case that the song's good-feeling/good-time vibe couldn't be denied, and he made the case that he denied it, and the more heated the argument got, the more we laughed. I told him imma make him the mother of smooth-pop playlists and then he would see the light. I'm finishing that playlist, and when I do, I'll name it after him, just so I can imagine that laugh of his.

Questlove, musician, producer, and actor

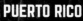
PUERTO RICO

Like so many others who watched his shows over the years, I can't help but think of Anthony Bourdain as a friend whom I never was fortunate enough to meet. His desire to explore the world, and to learn about the people he encountered, served to make social curiosity "cool." Even this admittedly antisocial introvert has been inspired to engage in conversations with fellow travelers and locals wherever I meet them. Now, when I travel, I am less of an observer and more of a participant, and better for it.

By inviting us all to journey with him, teasing us with glimpses of exotic locales, foods, events, and lifestyles, he slyly showed us that we are all more alike than different. He reminded us that, however diverse in ideology, circumstance, or religion we might be, there is room at the table for everyone, and that civil conversation and common ground can be better cultivated when breaking bread together, especially with a good bottle of wine.

Joli M.

I discovered Anthony Bourdain by accident and since then I have never missed an episode. My husband and I have a disabled son, so we will never get to travel the world, but with his show we got to see all these beautiful countries through his eyes. He has inspired us to be more open-minded.

Elizabeth and Hicham H.

THANK YOU FOR SHOWING US THE WORLD—UNBORDERED/UNBOUNDED AND AS IT SHOULD BE.

Roven E.

Anthony Bourdain traveled to Colombia (more than once) when people were still afraid to go there. He told our stories with respect, honesty, and kindness. He made me feel like Colombians mattered. I had fought the stereotypes of who we are in the US for so long. He showed the beauty and the pain we had gone through. Gracefully. He was my living room friend. An advocate. I am devastated by the loss of his voice.

Isabel M.

I wanted to hang out with him . . . especially loved his friendships.

Shirley

MY DREAM WAS TO BE THAT THIRD PERSON AT THE TABLE IN HANOI HAVING A BEER WITH BOURDAIN AND OBAMA.

Javier S.

Anthony Bourdain had a way of bringing my family together. Regardless of our politics or opinions, we had a love for this guy in common. We could gather around the TV, lean in, and be swept away. He reminded us of places we'd loved and showed us places we'd love to go. I thought we were just watching TV, but over the years his thoughtfulness and intention taught me that it's a privilege to sit at someone's table—and that's a pretty important lesson.

Kimberly H.

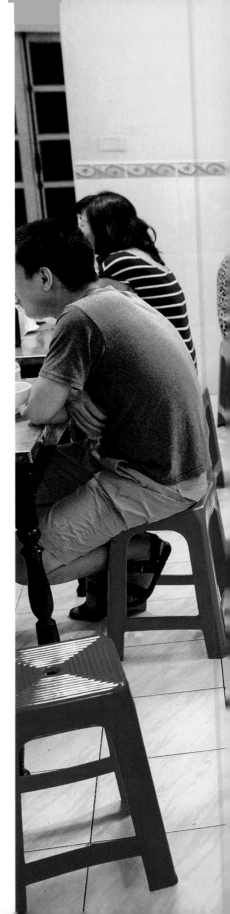

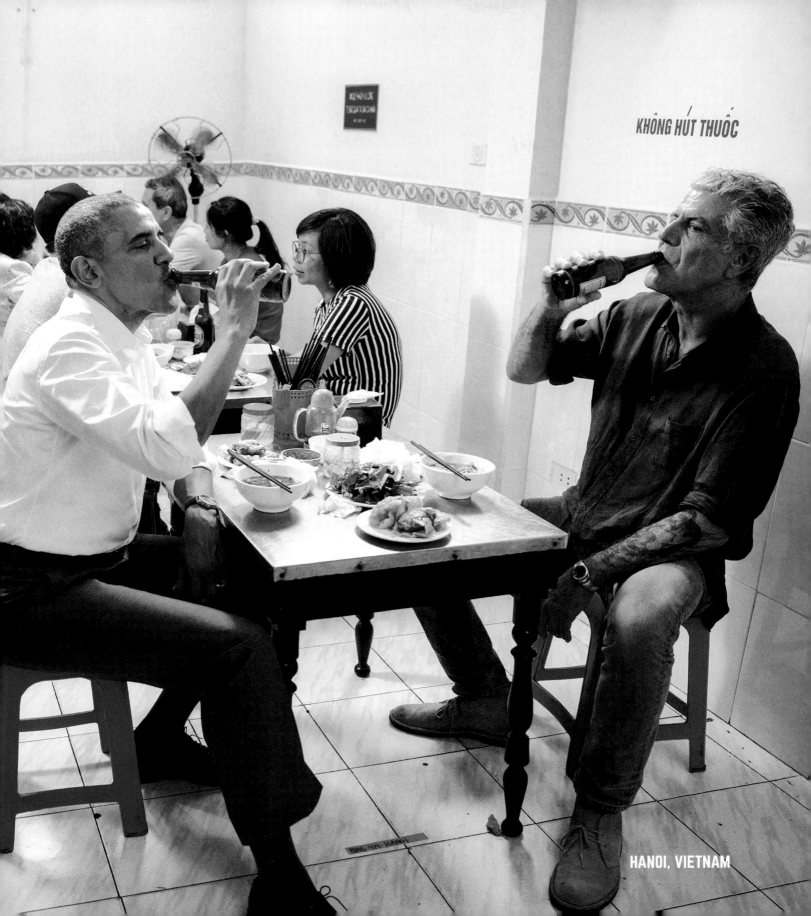

KHÔNG HÚT THUỐC

HANOI, VIETNAM

HE WAS AUTHENTIC WELL
BEFORE IT BECAME A
BRAND STRATEGY.
 HIS PERSONAL ARC OF
REDEMPTION AND CAREER
EVOLUTION WAS INSPIRING.
AS A FAN, I JUST ENJOYED
WATCHING THAT GROWTH.
 HE JUST GAVE ALL OF US,
WHO MAY HAVE FELT LIKE
JUST A SIMPLE GOOD-FOR-
NOTHING COOK, HOPE.
 HE WILL BE MISSED, AND
IS IRREPLACEABLE.

RICHARD BLAIS, CHEF AND AUTHOR

PORT OF SPAIN, TRINIDAD

IN A TIME OF FEAR AND SCAPEGOATING OF THE "OTHER," ANTHONY BOURDAIN STOOD FIRMLY AS A VOICE AGAINST THE GENERALIZATION OF OTHER PEOPLE OR COUNTRIES. HECK, HE WAS PROBABLY ONE OF THE BEST CULTURAL AMBASSADORS OF THE MODERN ERA.

Edwin O.

It's hard to put into words the impact Anthony Bourdain had on my life. My family wasn't able to travel much growing up, but Anthony was there to open my eyes to the magic of adventure, food, and the unknown. He was my idol, my first crush, my direct line to the rest of the world from my living room. So many of my own adventures have stemmed directly from emulating Anthony's openness, warmth, and inquisitiveness. I can't imagine a world without him in it, and I can't thank him enough for being my TV friend in times when I had no one else.

Abby R.

WEST BANK, MIDDLE EAST

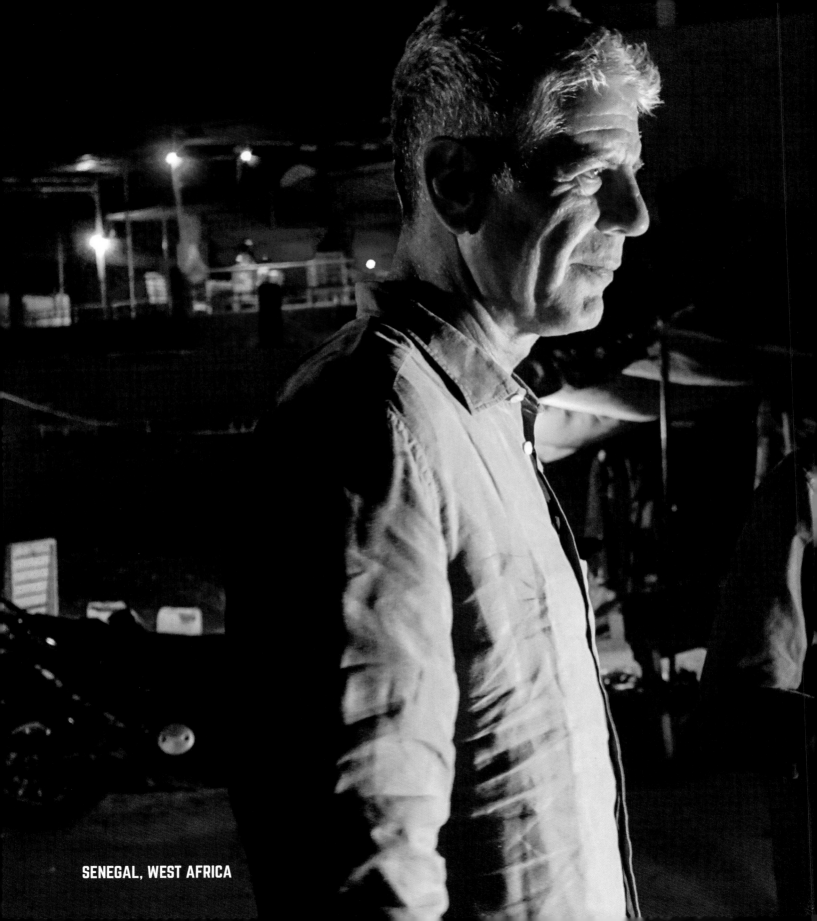

SENEGAL, WEST AFRICA

I ALWAYS LOVED MY COUNTRY, BUT I THINK TONY WAS ABLE TO SEE A BEAUTY THAT WE CAN'T SEE. HE WAS SHOWING THE BEAUTY IN THINGS THAT WE DON'T PARTICULARLY FIND BEAUTIFUL.

PIERRE THIAM, CHEF

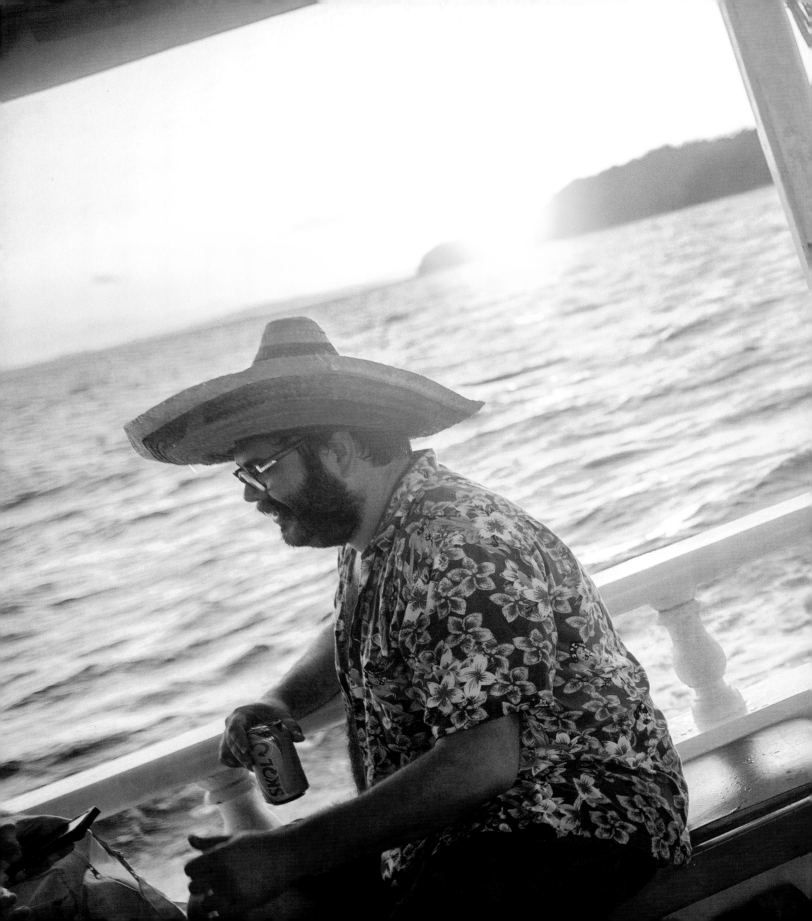

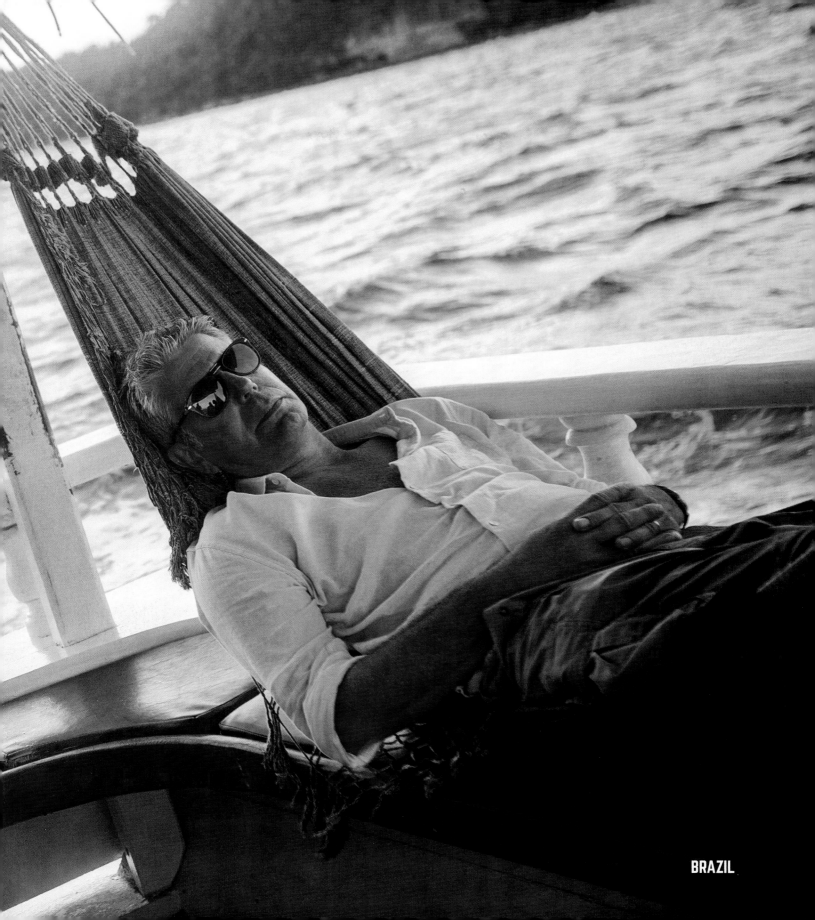

BRAZIL

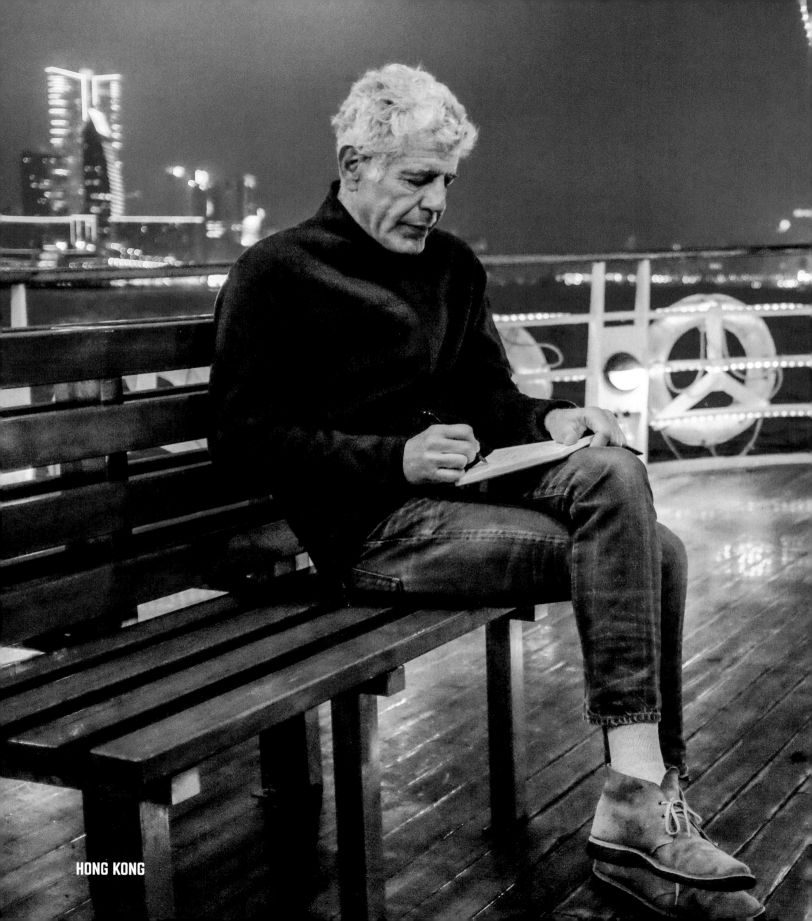

HONG KONG

HIS RAW WIT, FRANKNESS, AND SENSE FOR ADVENTURE INSPIRED ME TO STOP CENSORING MYSELF AND START EXPRESSING MYSELF.

Rosa T.

In 2008 I was a young cadet at the US Air Force Academy. I was rarely allowed to leave the Academy grounds. Anthony's shows became a way for me to travel the world without leaving my dorm room.

Later, as an Air Force officer, I was stationed in remote places and had few opportunities to get out of my little isolated world. Anthony's shows continually became my escape.

Because of this man, no matter how small or isolated my world could get, I always felt like I could escape with a friend to some remote culture and breathe for at least an hour or two.

Cole S.

Tony literally changed the way I travel. The destinations I now choose, the people I meet, the food I eat. He changed the way I live. He was my mentor even though we never met.

Monica

CROW AGENCY, MONTANA

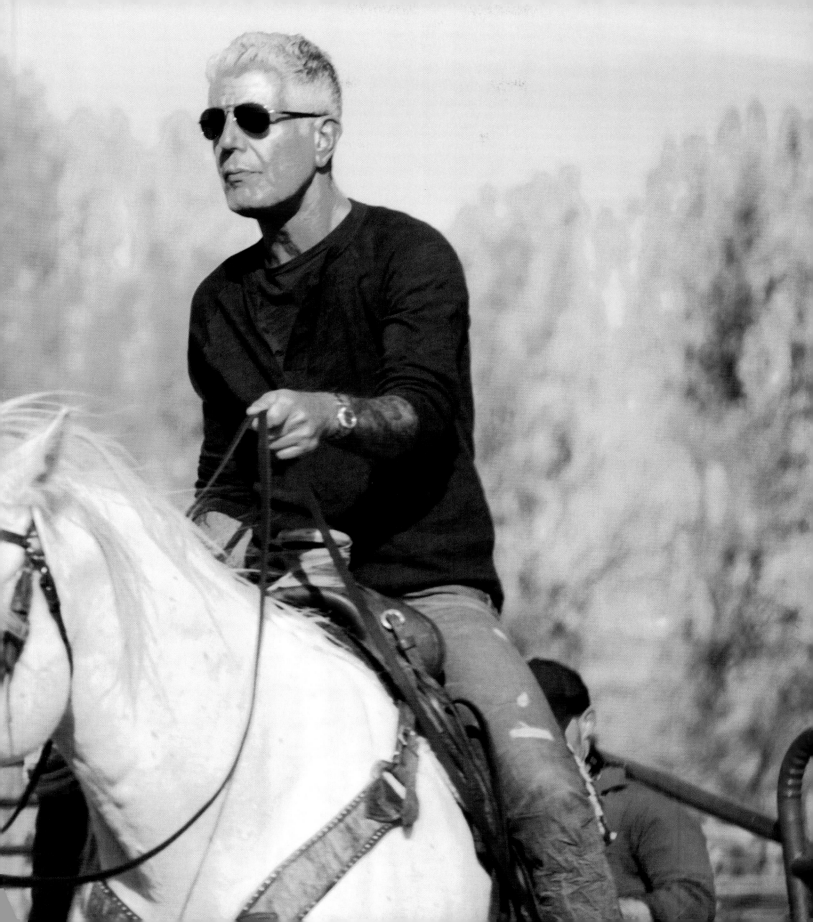

I loved the passion Tony had when traveling and exploring different cuisines of the world. Recently, Tony visited Little Armenia in Hollywood, California, and there was a tutorial about making basturma. I grew up in an Armenian family— and my mother hated basturma, and my father loved it. For the first time in my life, I got to see how basturma was made, and the love and labor that goes into it, through Tony's eyes. I remembered my father, who is now deceased, and understood. Tony helped open up a space in my heart.

Ella W.

TONY SAW RIGHT THROUGH THE SHEEN AND LANDED ON THE HEART.

Phoebe P.

I retire on June 30. And I plan to get out of my comfort zone— and go walk in someone else's shoes or at least eat their food. I'm not afraid for my walkabouts to be seen as foolish, nor am I afraid they'll lead me to a dead end now and again. But I'm determined to gain new insights into the culture of others. I have Anthony Bourdain to thank for my inspiration.

Lee K.

... TYPICAL JERSEY CAT ... MAKIN' IT LOOK EASY, WHEN IT'S ACTUALLY HARD.

Hakim B.

ATLANTIC CITY, NEW JERSEY

Before Anthony Bourdain came to us with *Kitchen Confidential*, we chefs were society's leftovers, swimming against the tide of college degrees and white-collar jobs: chopping onions, roasting meats, peeling spuds, and scraping floors covered with the hot ash of our tempers mixed in with the day's scraps. Bourdain broke with the Code, revealing our lives as something out of a Kerouac novel.

He was the Bruce Chatwin of food, a wizard of booze, a kitchen iconoclast, one of the most beautifully troubled motherf***ers there ever was. We loved him dearly for being courageously vulnerable and outspokenly bold. . . .

Tony was able to find the unique nuances of a place and its people, with an insatiable thirst and visceral intuition for extracting stories. He truly was the psychic alchemist of storytelling.

Alessandro Porcelli, founder of Cook It Raw

BIG BEND, TEXAS

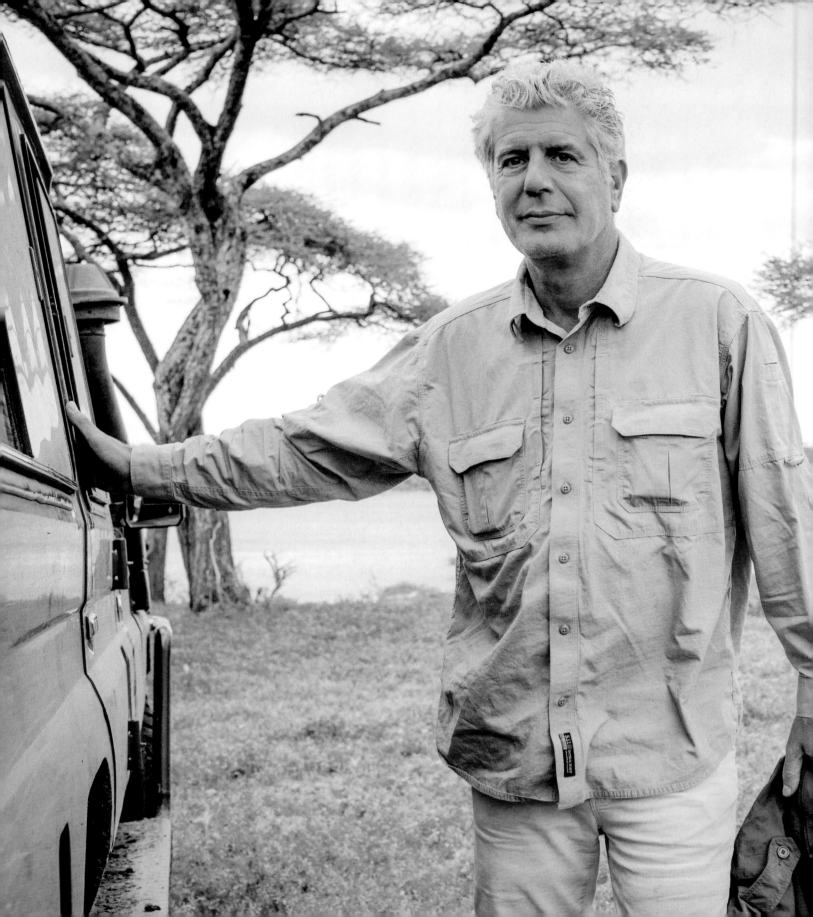

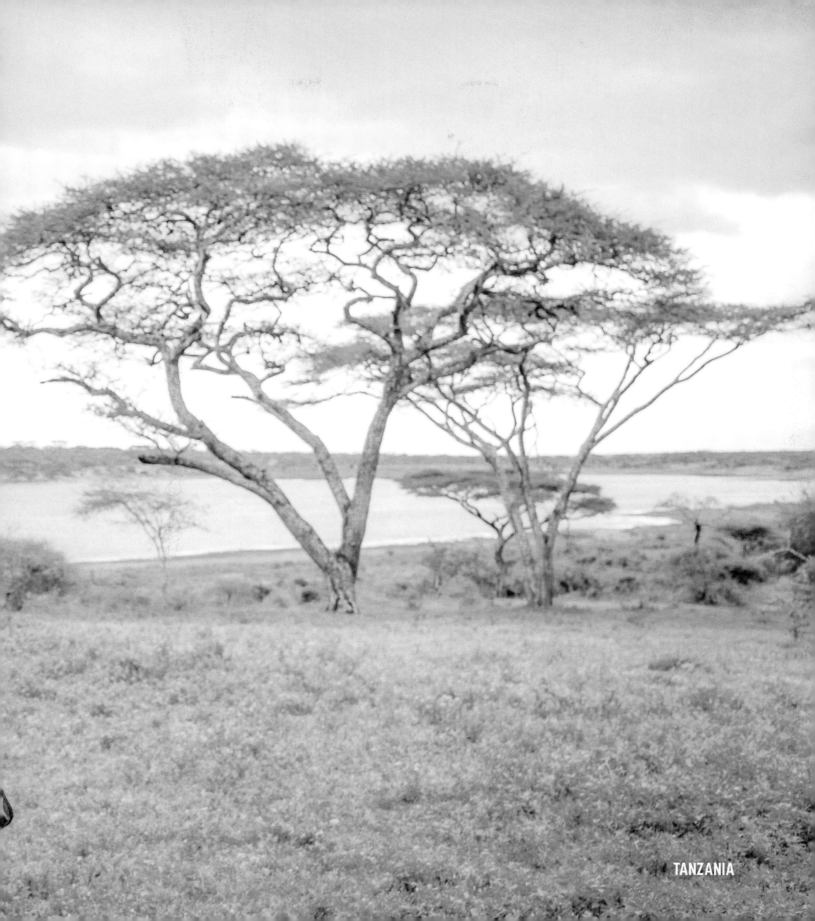

TANZANIA

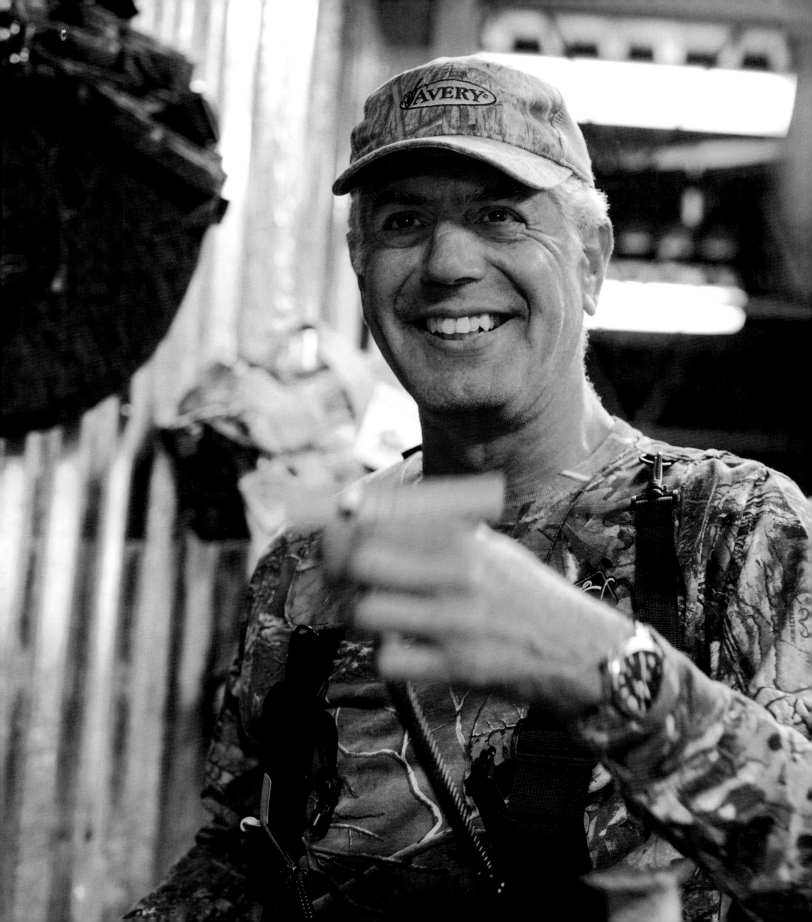

TONY, AS I WILL
REMEMBER
HIM. ALWAYS
QUICK WITH
A WITTICISM,
ALWAYS QUICK
WITH A BIT OF
WISDOM.

ANDY RICKER, CHEF AND AUTHOR

SOUTH CAROLINA

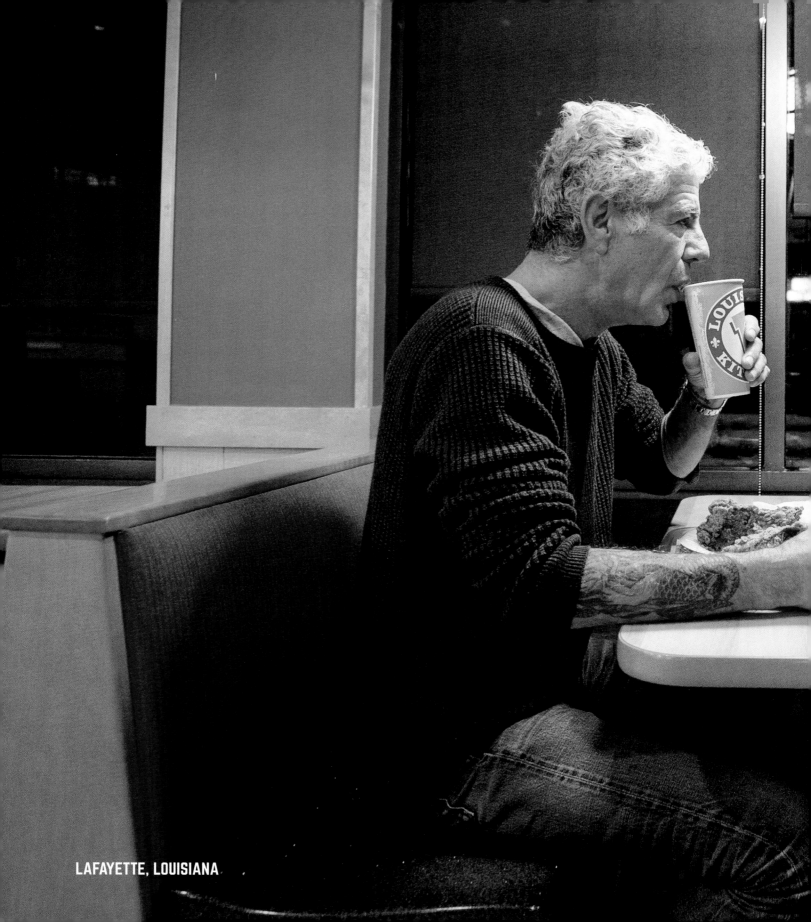

LAFAYETTE, LOUISIANA

HE REALLY BROKE THE MOLD,
PUSHED THE CULINARY
CONVERSATION, AND WAS THE
MOST BRILLIANT WRITER. . . .
HE LEAVES CHEFS AND FANS
AROUND THE WORLD WITH A
MASSIVE FOODIE HOLE THAT
SIMPLY CAN'T BE FILLED.

JAMIE OLIVER, CHEF AND AUTHOR

THE MOST APPEALING PART OF HIS SHOWS FOR ME WAS NOT THE FOOD, IT WAS HIS NARRATIVE, HIS ABILITY TO CONNECT WITH PEOPLE FROM ALL WALKS OF LIFE. WHETHER HE WAS EATING WITH OBAMA OR WITH REGULAR PATRONS OF A FOOD TRUCK IN PLACES I NEVER KNEW EXISTED, HE WAS ABLE TO MAKE US DREAM OF A MORE HUMANE, SENSITIVE WORLD WHERE EVERYONE WAS SPECIAL AND WAS TREATED WITH DIGNITY AND RESPECT.

Olivo S.

He taught me to get off the eaten, beaten path and venture out of my comfort zone. He taught me it will be OK.

Kathleen

I grew up in India in a middle-class family where vacation meant summer holidays at the grandparents'. Therefore, traveling and the joys associated never came naturally to me. Until I discovered Tony. His thought-provoking commentary, his free-flowing persona, his zeal to explore, and unbridled curiosity made me the man I'm now. He made a difference to my life.

Anonymous

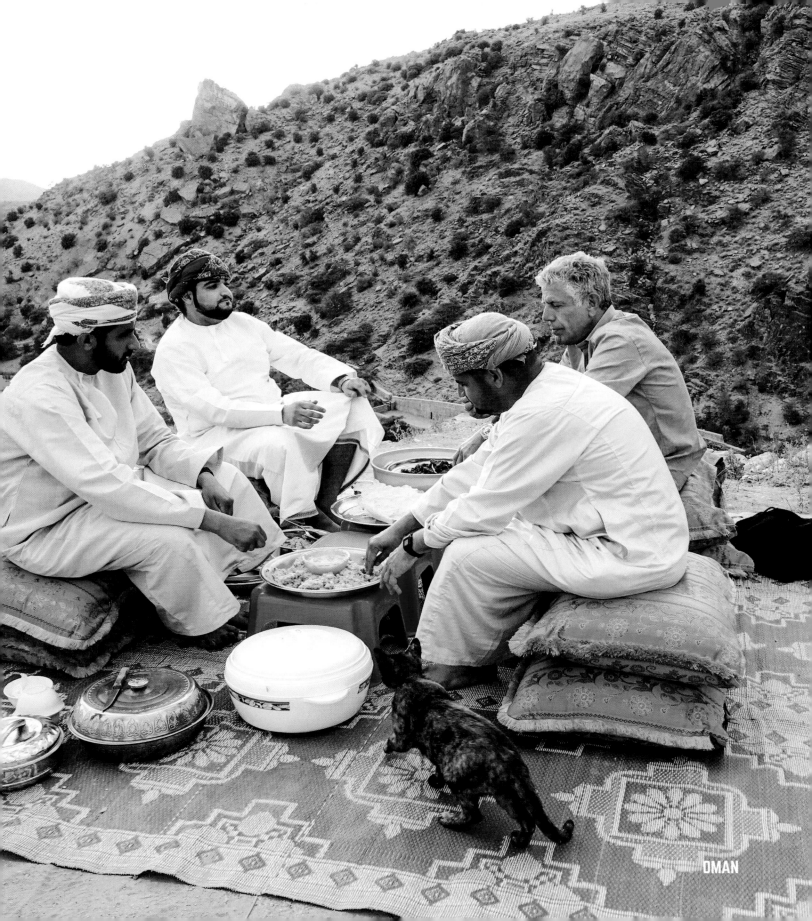

OMAN

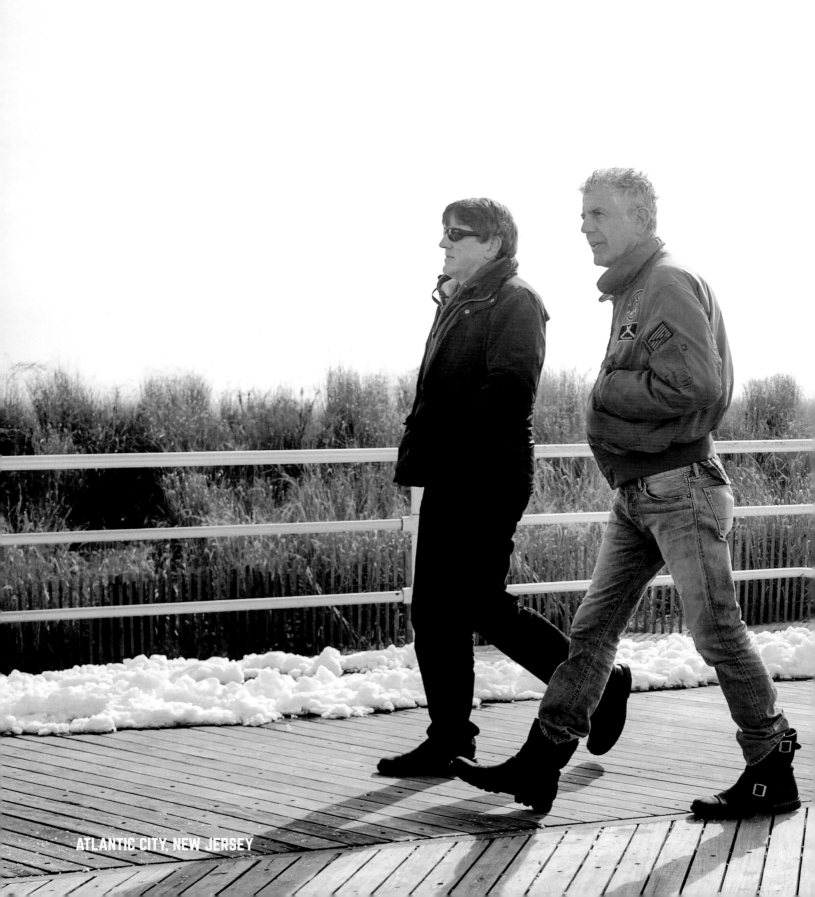

ATLANTIC CITY, NEW JERSEY

BOURDAIN FOUND BEAUTY IN PLACES THE REST OF THE WORLD SAW AS THE MOST SCREWED UP.

BOURDAIN NAILED JERSEY AS I KNEW HE WOULD. AND SO NEW JERSEYANS EXPERIENCED SOMETHING PEOPLE IN KENYA, CHINA, SINGAPORE, AND THE SCORES OF OTHER PLACES BOURDAIN VISITED HAVE: THE RELIEF AND JOY OF SEEING YOUR SACRED STORY TOLD RIGHT.

BRIAN DONOHUE, WRITER

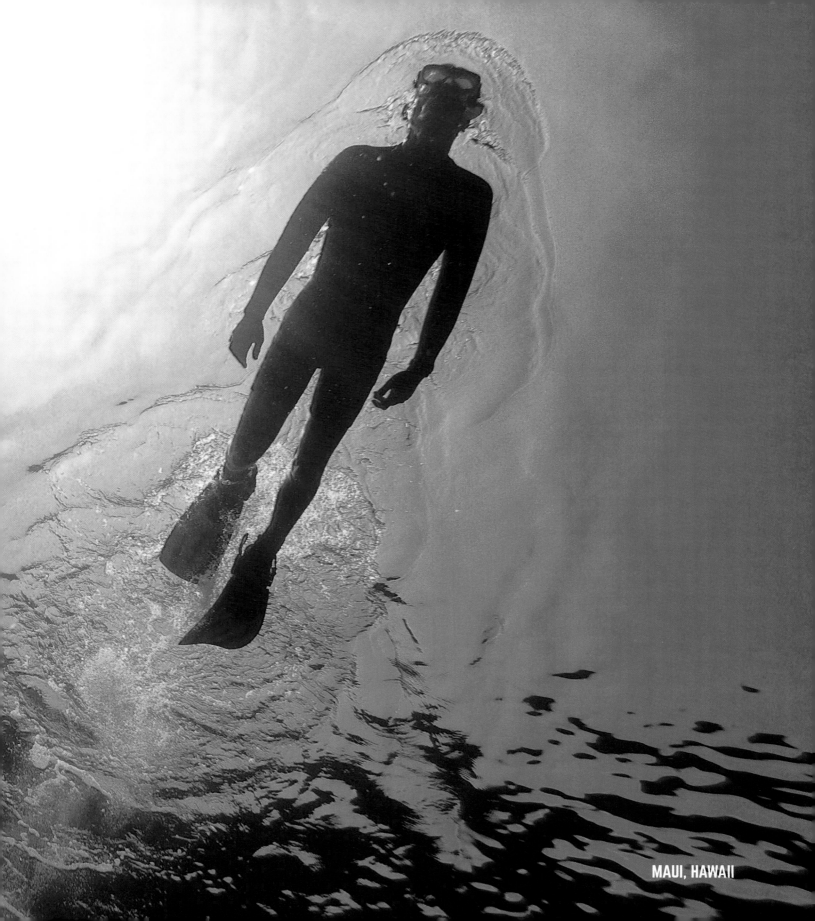

MAUI, HAWAII

I once made Anthony Bourdain a Negroni when he was a guest on a Food Network show I worked on. I had researched that it was his favorite drink, so I wanted to make sure that I had all of the right fixings. I didn't know what I was doing. I had never made anything fancier than a gin and tonic, and I was, admittedly, out of my element. I made the drink for him in the green room at Cinevillage before the show. I handed it to him nervously. He sipped slowly and told me it was the best he had ever had. I swear his eyes twinkled when he told me. Or maybe it was my eyes that did the twinkling. Imagine me making Anthony Bourdain the best Negroni he ever had. He treated everyone with the same gentle affection. No big chef ego. No celebrity status. No BS. He told people to call him Tony. He smoked with the kitchen crew between live commercial breaks, before and after the show. He took photos with us on set. He signed books. He told stories. He laughed. A truly awesome experience that I will never forget. Thanks, Tony.

Lucie G.

THANK YOU, ANTHONY BOURDAIN, FOR NOT LETTING US OFF THE HOOK, FOR REMINDING US THAT THE FRUSTRATION, THE INCONVENIENCE, AND THE RESPONSIBILITY WE HAVE FOR BEING BETTER PEOPLE IS WORTH BEARING THE BURDEN.

Gus G.

The greatest storyteller, who showed us how to love the planet, culture, and people by using food as the international language.

Nirmala N.

BAHIA, BRAZIL

TODAY THE WORLD LOST A GIANT FORCE OF NATURE . . . A BRILLIANT CHEF WHO KNEW HOW TO SPEAK THE LANGUAGE OF COOKS AND AN UNPARALLELED FOOD/TRAVEL/ CULTURE STORYTELLER BUT MOST IMPORTANTLY A DEAR FRIEND.

DANIEL BOULUD, CHEF AND AUTHOR

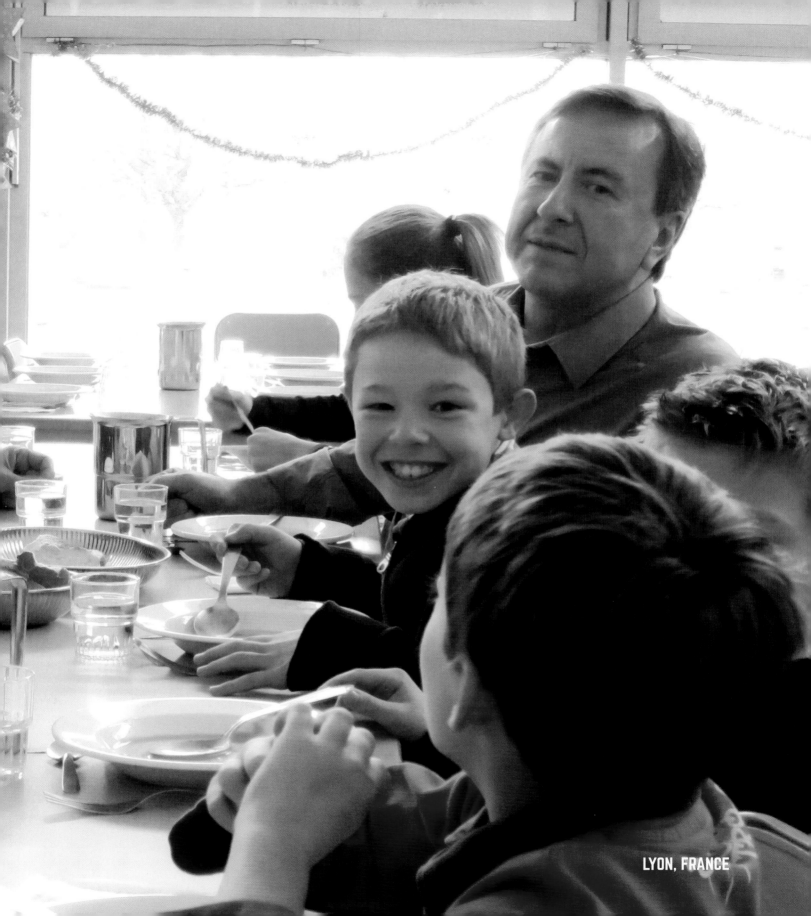

LYON, FRANCE

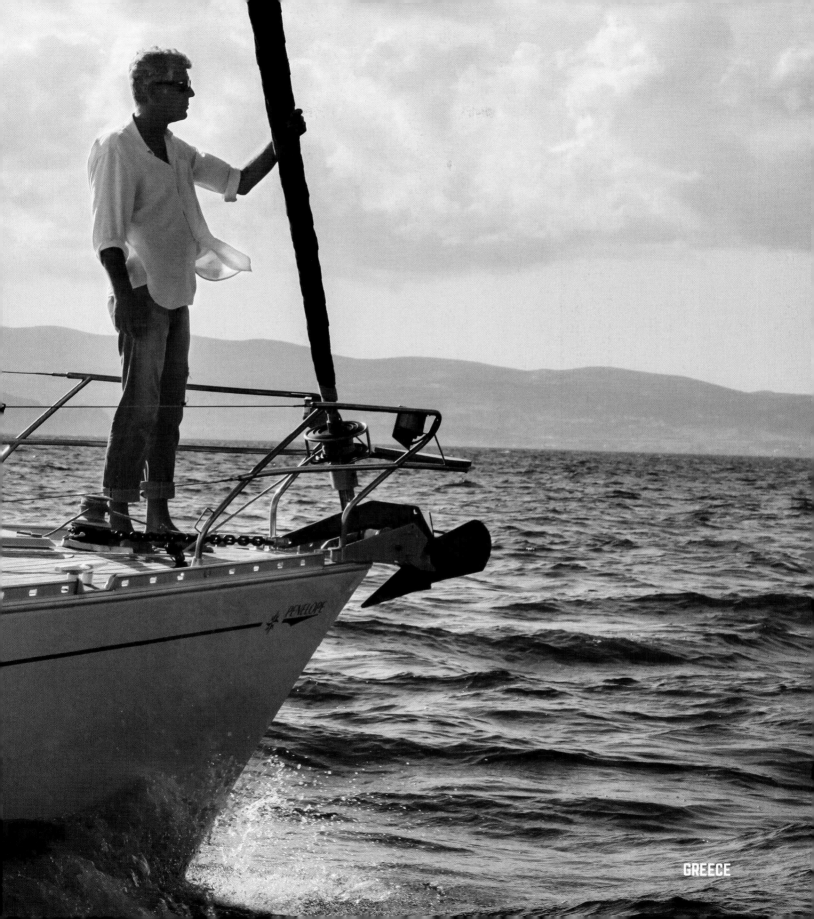

GREECE

86 CHEF BOURDAIN. WE WILL CLEAN UP YOUR STATION. HEAD FOR YOUR AFTER-SHIFT DRINK. YOU DESERVE IT.

ROBERT R.

BERLIN, GERMANY

SRI LANKA

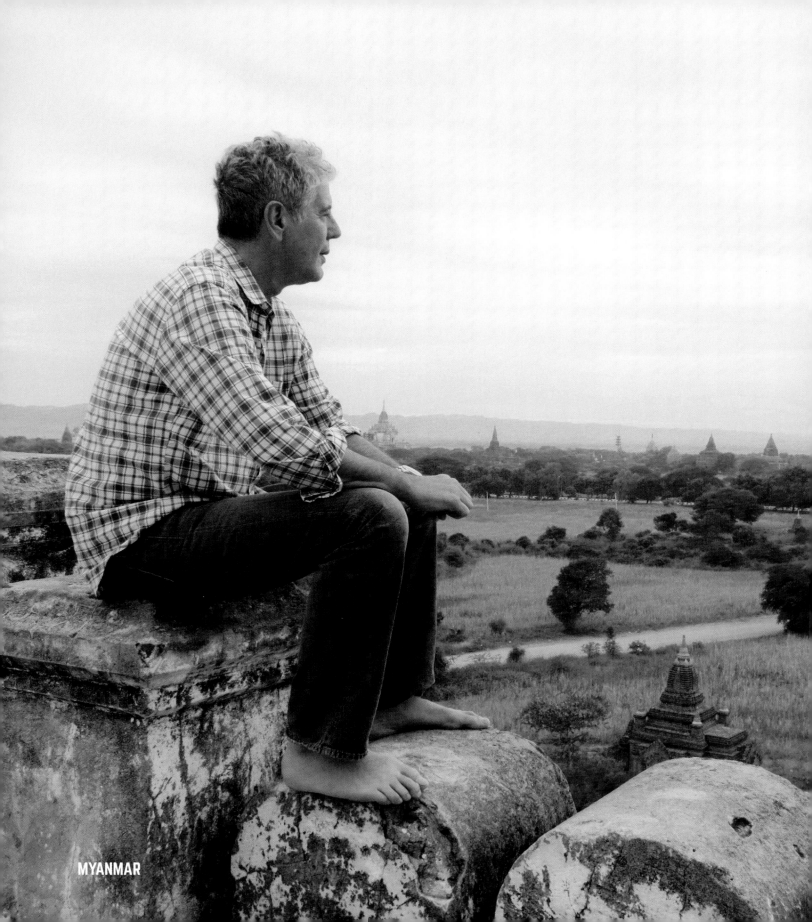

MYANMAR

I'll remember him as a really tall, funny guy who inspired me to clean up my act and take my job a lot more and a lot less seriously at the same time. Meeting him and working at Les Halles were two of the things that helped me process losing my father. He was an incredibly gracious guy. Specifically took a job at Tony's old place just to meet him because he was such an inspirational figure to me.

Eleuterio V.

I WAS BORN IN BURMA BUT GREW UP IN NYC, AND HIS FIRST CNN EPISODE WAS ABOUT BURMA (MYANMAR). IT WAS SUCH AN HONOR. I RESPECT THE MAN AND HIS WORK—NOT ONLY FOR ALL HIS TALENTS BUT HIS ATTITUDE TOWARD THE MARGINALIZED POPULATIONS. HE WAS RESPECTFUL AND AN HONORABLE MAN.

Bryan

ARMENIA

LAFAYETTE, LOUISIANA

Will miss his funny laugh and sense of humor plus all the food and places he traveled, he made me feel more adventurous in my own life.

Cyn H.

After reading *Kitchen Confidential* during a very pivotal and reflective time in my life, I was moved to try my first oyster. Not long thereafter I found myself vacationing solo for the first time—to three new countries, no less! In each place, I made sure to try or do something he did. But also, in the spirit of Tony, I made sure to venture off the beaten path and have meaningful conversation with locals. What a wonderful adventure.

Amy M.

HE WAS SUCH A NATURAL POET, EASILY GOING FROM PROFOUND TO PROFANE, SOMETIMES IN A SINGLE THOUGHT.

Tracy O.

I regularly showed the Iran and Nigeria episodes of *Parts Unknown* in my high school comparative politics course. In Iran, he celebrated the beauty of ancient traditions that exists alongside religious fundamentalism and the oppression of journalists. In Nigeria, he painted a complicated portrait of cosmopolitanism and emerging economic power with extreme poverty and government corruption. Yes, he loved to sample the world's food and drinks, but he used food and cooking and eating to explain some of the most basic sources of joy and meaning and pride that people can get out of life. Through these shows, he challenged Westerners (especially Americans) to question our perceptions and judgments of other cultures, to acknowledge history, and to embrace our common humanity.

Tiffany W.

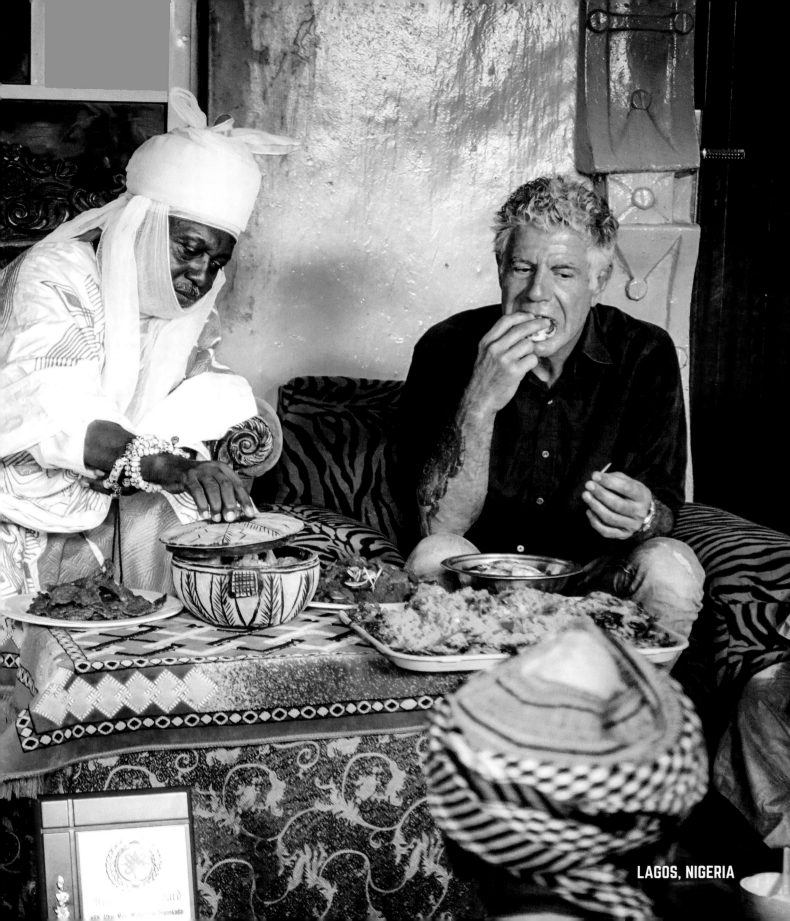

LAGOS, NIGERIA

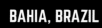
BAHIA, BRAZIL

HE WAS WILLING TO LISTEN—SOMETHING HE, AS A LOQUACIOUS MAN, PERHAPS DOESN'T GET ENOUGH CREDIT FOR, ALTHOUGH IT'S ALL OVER HIS TELEVISION WORK—AND HAD AN INCREDIBLE SKILL FOR LISTENING AND HEARING WHAT'S REALLY BEING SAID.

HE'S IRREPLACEABLE AS A VISIONARY WHO FOREVER TRANSFORMED OUR RELATIONSHIP TO FOOD AND RESTAURANT CULTURE.

JEN AGG, AUTHOR

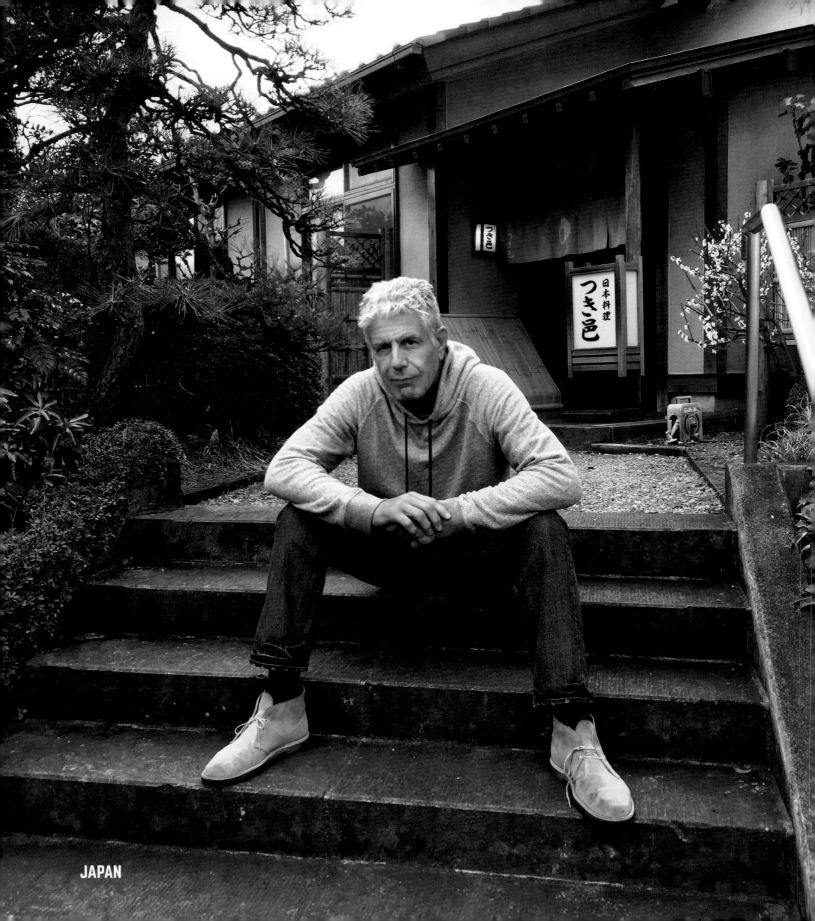

JAPAN

Literally my travel guide and inspiration in life. Even sitting in my office, I would have episodes of *No Reservations* playing on YouTube to give me a feeling of knowing—maybe not this week, but soon—I'd be in some jungle somewhere, or a rain forest, or buying street food in Jamaica for two dollars, or eating tapas in a mom-and-pop place in Barcelona, that was the best meal I would have all day. All inspired by your unassuming way of travel. Offend no one, appreciate the simplest things, and absorb it all.

Michel C.

FOR YEARS I WATCHED BOURDAIN'S SHOWS IN AWE, INSPIRED BY HIS STORYTELLING AND DESTINATIONS. I FINALLY MADE THE DECISION LAST YEAR TO QUIT MY JOB, TRAVEL THE SILK ROAD, SHARE STORIES, AND WRITE A COOKBOOK—ALL WITH THE PURPOSE OF BRINGING PEOPLE CLOSER TOGETHER AS BOURDAIN DID.

Daphne W.

He inspired me to climb to the Pizzarium Bonci in Rome, to go bonkers at the robot museum in Tokyo, and just last week to taste if Montreal truly had the best bagels at St-Viateur. He motivated me to get up, get out, and travel to soak in new cultures.

Rebecca N.

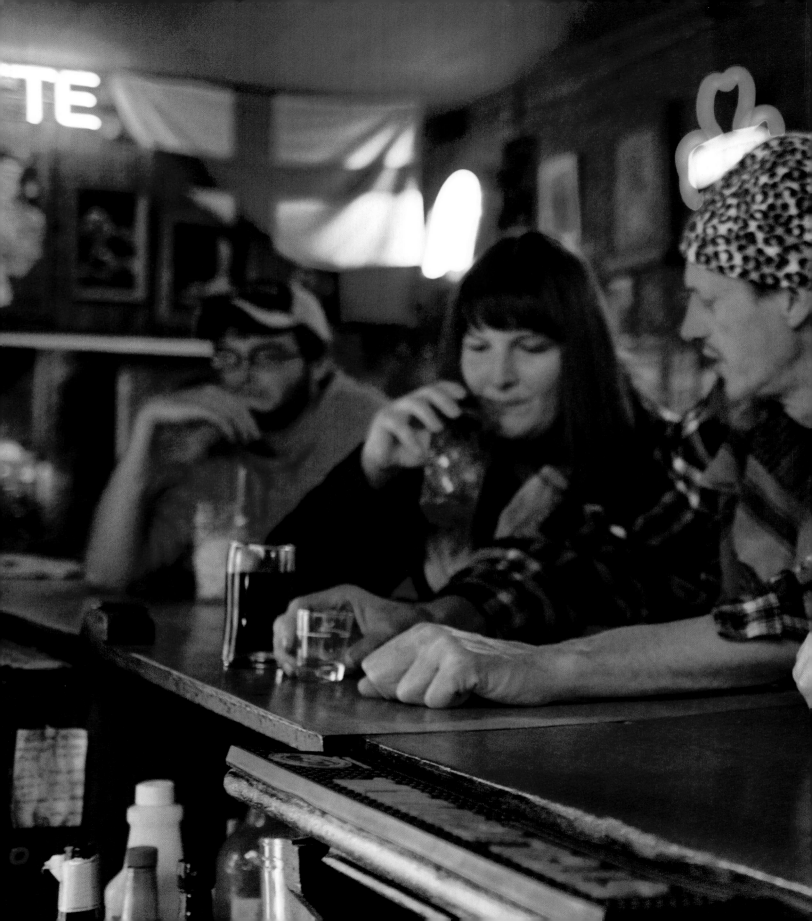

BUTTE, MONTANA

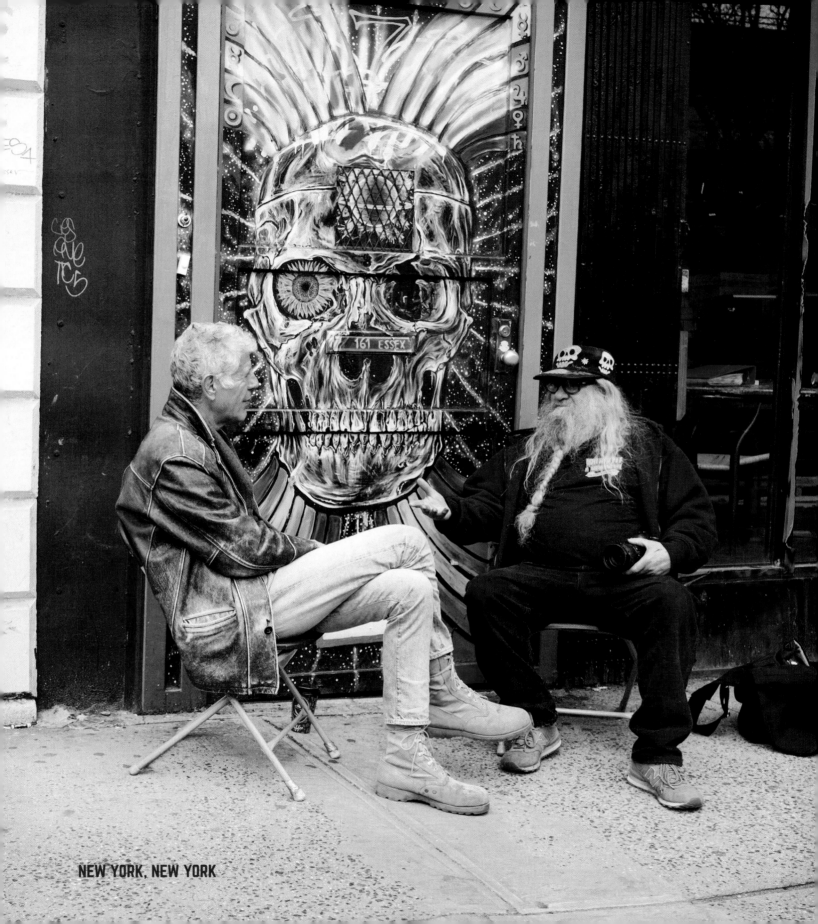

NEW YORK, NEW YORK

Tony was a formative person to me. He wasn't just my hero, he felt like a part of my family. He helped structure my worldview as a young man: not to be afraid of different foods, different people, and different places. He directly inspired me to travel frequently in my early twenties. Heck, Tony taught me to cook. I learned how to make stocks and roast garlic from *Kitchen Confidential*. I learned how to hold a chef's knife and dice onions from *No Reservations*.

Andrew

HE WAS PERFECTLY IMPERFECT. THAT IS WHAT PEOPLE LOVED ABOUT HIM.

Kathleen M.

Live life to the fullest, that's what he's shown us.

I was a moving-truck driver until he published an essay of mine in his book *Medium Raw* eight years ago. I started a career in the restaurant industry and now am the general manager of Café Sebastienne at the Kemper Museum of Contemporary Art in Kansas City. I've staged at Eleven Madison Park in New York and Noma in Copenhagen.

He has influenced me to speak with a voice and travel.

Mickey P.

In using Anthony Bourdain's shows to help prep our students for international travel, we felt like we knew him just a little bit. His insight and perspective will be missed.

Jamilah R.

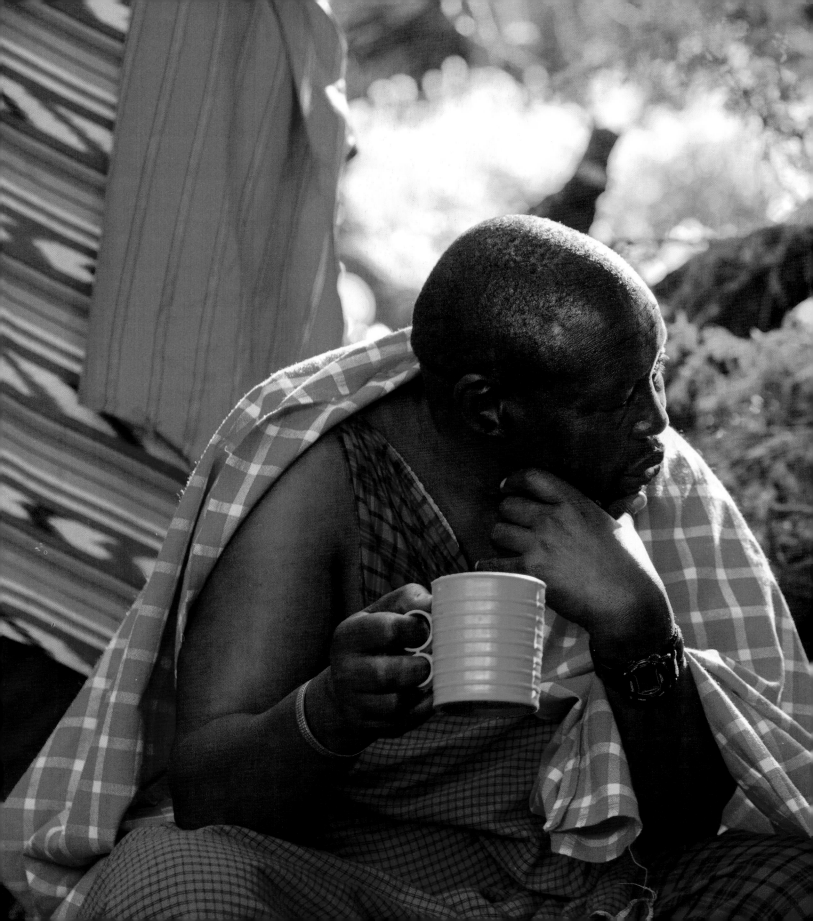

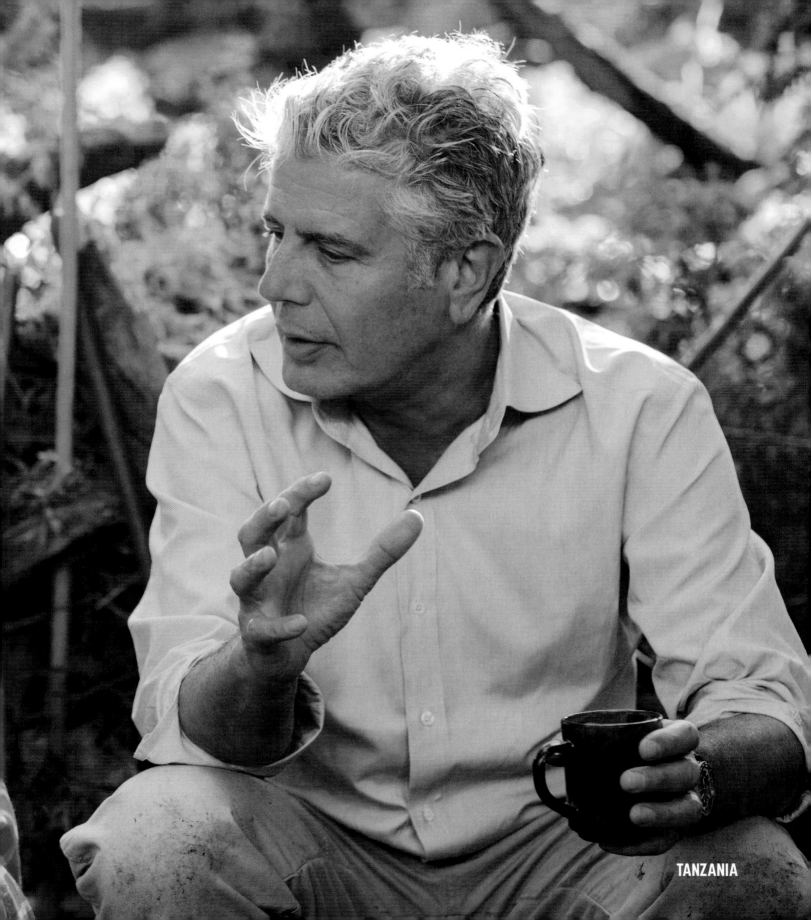

TANZANIA

HIS PASSION FOR COOKING, WRITING, AND HIS HUNGER FOR ADVENTURE WERE INSPIRING. WE WILL ALWAYS HAVE LYON AND THOSE DAYS OF EATING LIKE KINGS TOGETHER . . . HIS PASSIONATE CHARACTER AND TRUE HONESTY WILL BE MISSED ACROSS THE INDUSTRY AND THE WORLD.

DANIEL BOULUD, CHEF AND AUTHOR

LYON, FRANCE

What would the world of travel and food reporting look like without the humanity he brought to it? Would I have had the confidence to apply for this job? Would this job even exist?

What I loved most is the gusto. Mr. Bourdain's taste buds and legendarily steely stomach might have objected to a few of the delicacies he guzzled down on camera for our vicarious entertainment, and education, but he was, above all, a tireless ambassador for testing your comfort zone, for being all in.

He was even a fan of durian, the tropical fruit so pungent it's banned from hotels in Thailand. "Your breath will smell as if you'd been French-kissing your dead grandmother," he said. From him, that was a ringing endorsement. It was also the first time I had heard of durian. I've still never had the guts to try it.

Mr. Bourdain, for many of us viewers and admirers, didn't just bring us to street carts in Cambodia and inside home kitchens in Mexico; he made them tactile and Technicolor. He was the friend on the road trip who jumps into the dark, dank pond first, and then ropes you in: "This is terrible! Get over here!" . . .

Jada Yuan, travel writer, *The New York Times*

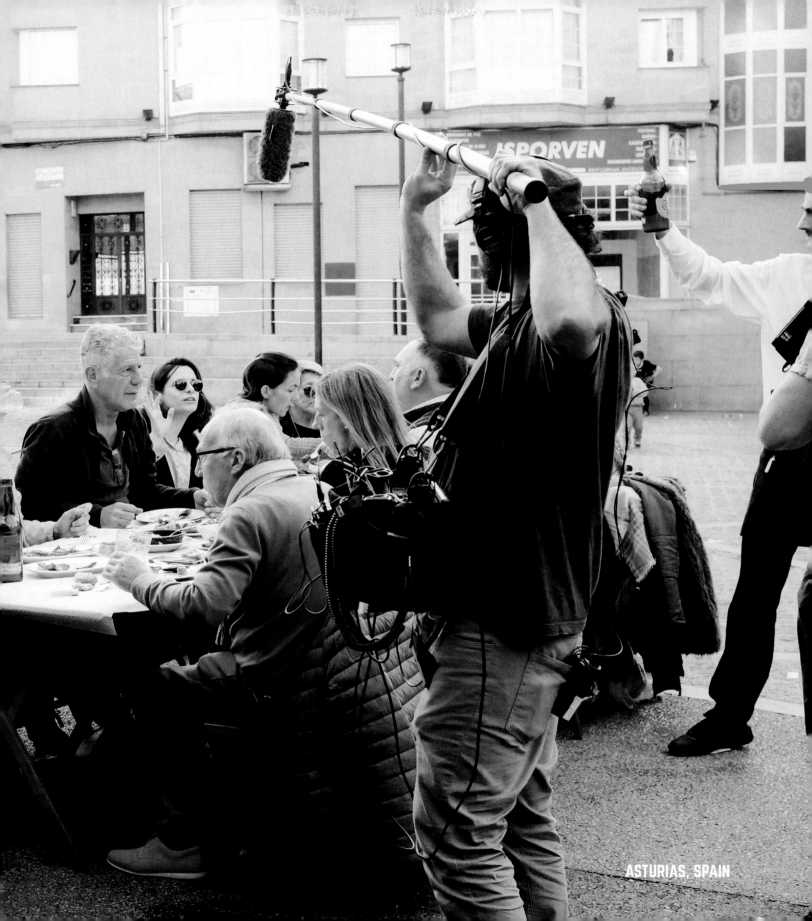

ASTURIAS, SPAIN

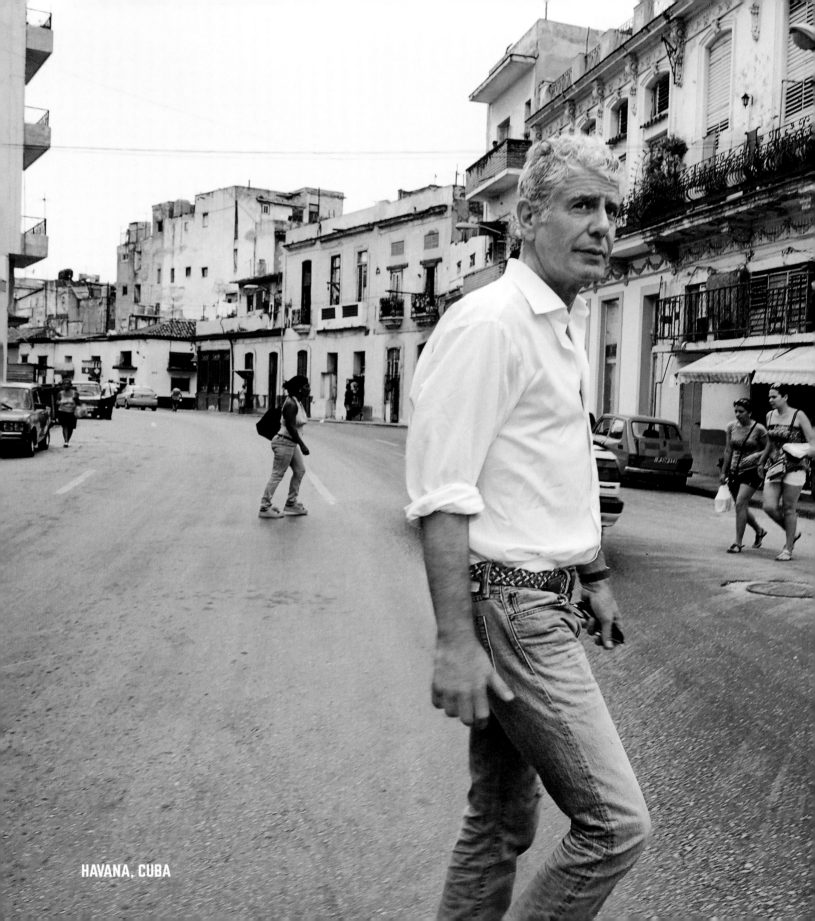

HAVANA, CUBA

GENERALLY HE INSPIRED ME TO GO BEYOND MY NORMAL DISHES AND SHOW MY LOVE WITH COOKING. COOK FREE OR DIE.

Juha M.

He was the first chef to show me it's equally as good to eat a two-dollar Cuban sandwich from a lunch truck with one slim napkin as it is to eat at a five-star restaurant from a menu you cannot pronounce. If the wine doesn't "match," it's all OK . . . and if you don't care for wine, get what you want. Experimenting with your own palate is everything.

Julie M.

I grew up in a Greek diner family and was sometimes made to feel like I was unimportant or that I didn't have anything worthwhile to contribute. The work was hard, and you smelled at the end of a hard day's work. But Anthony Bourdain validated me and my family's hard work and made me feel like I had something special. I was better able to understand the contribution we made to our community and how important that really is.

Angela H.

When I read *Kitchen Confidential*, I was just learning how to live on my own. I did not know how to cook anything except pasta, and was intimidated by what at the time seemed like such a confusing world of measurements, herbs, and different meat cuts. But despite being an expert in that world, he spoke to me through the pages as a real person. He wrote that the simplest way to prepare fish was often the best. Now, years later, preparing food for people I love and breaking bread together with them at my own table is a true joy in my life. I owe much of that to him.

Katie F.

Thank you for showing my country, Portugal, to the world. You make every country look so singular and the world so small.

Anabela G.

ANTHONY BOURDAIN TAUGHT ME AND MY TWENTY-TWO-YEAR-OLD DAUGHTER TO NOT BE AFRAID OF THE UNKNOWN. EMBRACE ALL PEOPLE AND CULTURES AND EXPERIENCES. HE TAUGHT US ALL THE TRUE MEANING OF "YOU WILL NEVER KNOW WHAT YOU LIKE UNTIL YOU TRY IT."

Sheila W.

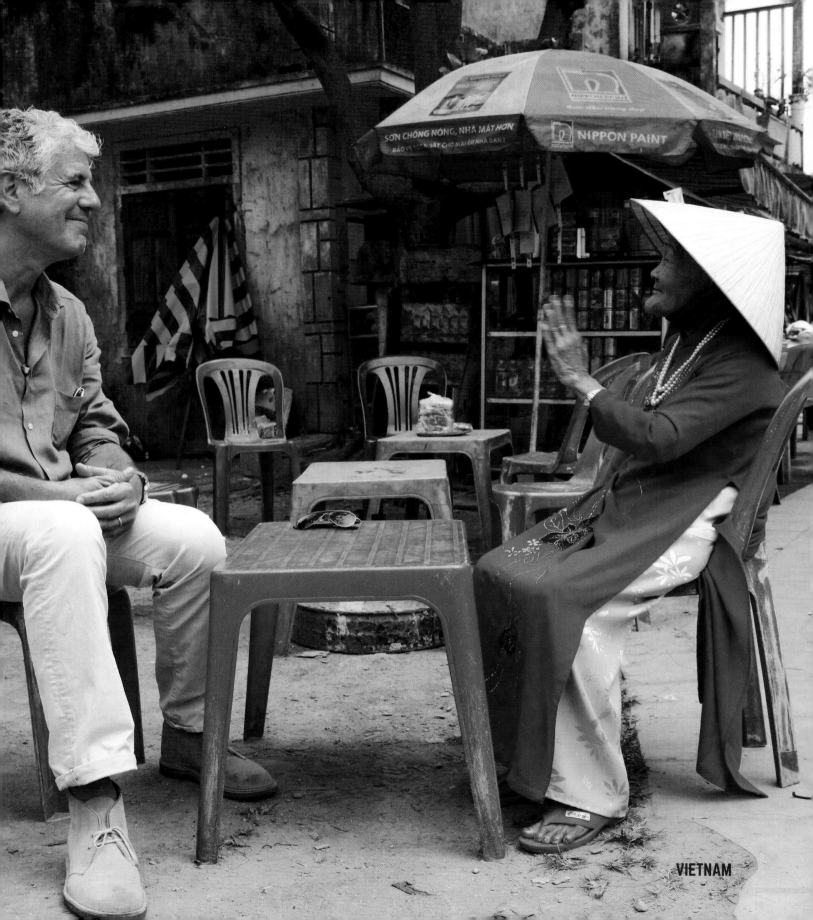

VIETNAM

MARSEILLE, FRANCE

"OH TONY"—JUST HEARING ERIC SAY THAT, YOU KNEW TONY WAS UP TO NO GOOD AND ERIC WAS IN TROUBLE. I LOVED SEEING THEM TOGETHER.

KELLEY R.

BERLIN, GERMANY

EVERYTHING HE SAID WAS ON POINT. NO FLUFF.

JASON WANG, CHEF

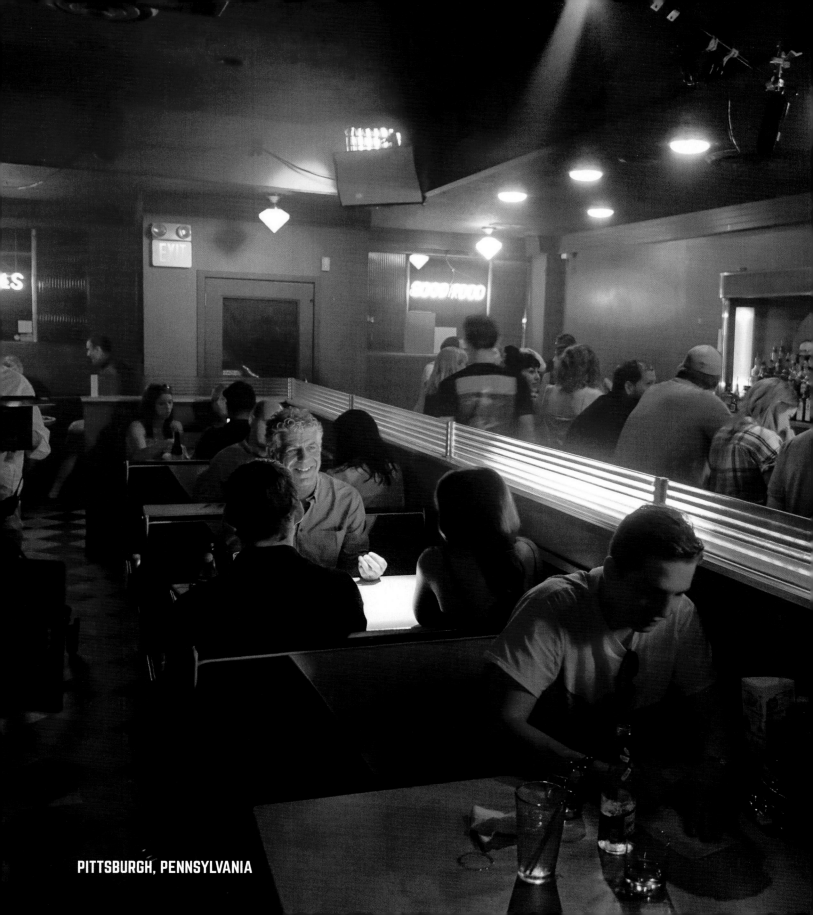

PITTSBURGH, PENNSYLVANIA

To Tony Bourdain. . . . You were the original pirate. You took kitchens from "Unknown" and "Confidential" to the inspiration of generations of young "Glorified Dishwashers." We cut together. We burned together. We screamed together. I was in kitchens for twenty-nine years, and you were one of the main reasons I pushed through and ground it out for all of those long days.

James T.

The Pittsburgh episode perfectly captured what the Steel City is all about: heritage, family, and of course, food. When Anthony came to my city and then shared it with the world, it made me proud—proud to be from this city, proud to be a citizen of this country and ultimately the world. I travel with bigger eyes and ears now.

I travel with a hunger for experience and culture in a way that it never occurred to me would be possible. Thank you, Anthony Bourdain.

Brooke P.

He inspired me to travel to places I never thought I would.

Maribel L.

BRONX, NEW YORK

WHAT OTHER NEW YORKER TALKS ABOUT CHICAGO THE WAY BOURDAIN DID? HE CURATED SO MANY AMAZING STORIES ABOUT OUR ARTISTS, OUR COOKS, AND REGULAR BIG-HEARTED FOLKS WHO ARE KEEPING OUR CITY STRONG AND EVOLVING. WE ARE NOT DEEP-DISH PIZZA. TO BORROW A LINE FROM BOURDAIN, "WE'RE A BIG, BRASH, MUSCULAR, BROAD-SHOULDERED MOTHERF**N' CITY."**

Maria A.

I never even knew I wanted to travel the world until I started watching Anthony Bourdain. He taught me things I never knew I wanted to learn. No one in my lifetime has made more of an effort to show us why we should not be afraid of people who are not like us.

Brian W.

ASTURIAS, SPAIN

Tony was able to see what we are not able to see. He could give importance to things that many of us took for granted. And that's the beauty of Tony—with just a stroke of a phrase he could make you think about something in ways you never thought possible.

In the end, I saw that it was not so much me showing him the region where I was born, which is an important part of myself. At the end of the day, he was showing it to me, and that's beautiful.

José Andrés, chef

BOURDAIN WAS A REBEL AND
A MISFIT, AND HE USED HIS
WRITING, HIS TV SHOWS, AND HIS
PLATFORM TO DEFEND EQUALITY
FOR ALL, AND HE DID IT WITH A
SENSE OF HUMOR THAT SPLIT THE
WORLD WIDE OPEN AND MADE
EVEN HIS FIERCEST CRITICS
LAUGH . . . HE WROTE, "MALE,
FEMALE, GAY, STRAIGHT, LEGAL,
ILLEGAL, COUNTRY OF ORIGIN—
WHO CARES? YOU CAN EITHER
COOK AN OMELET OR YOU CAN'T."

ALICE DRIVER, JOURNALIST

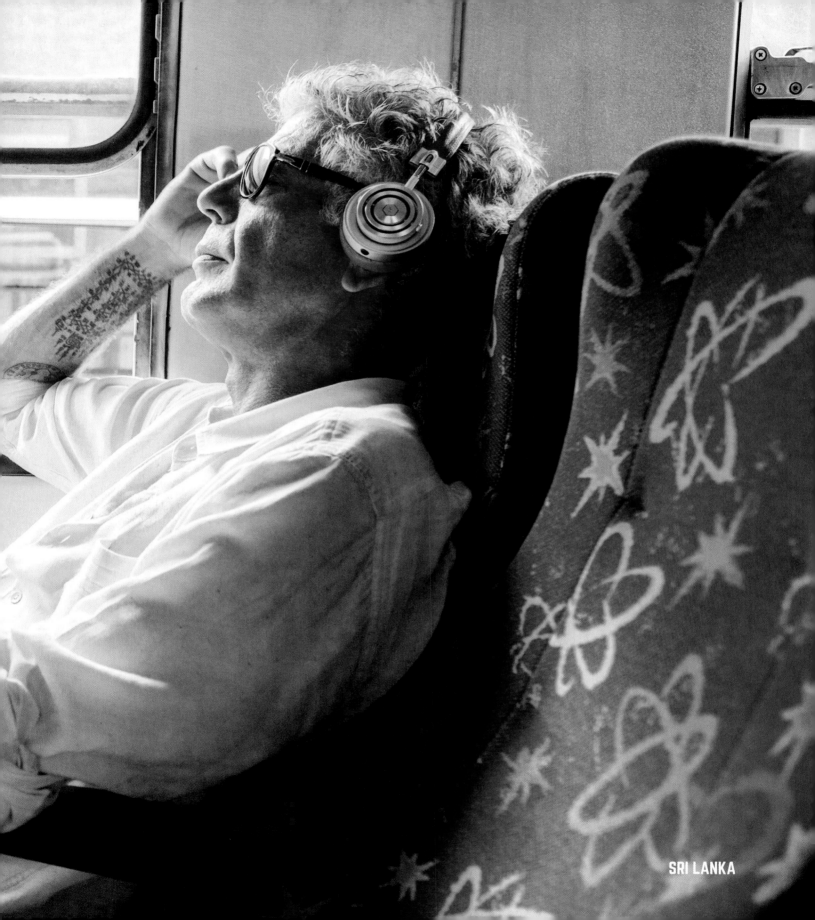

SRI LANKA

DILIJAN, ARMENIA

He didn't buy hypocrisy or think that we should do things because they're politically convenient. You saw it on every episode: He would go to a country and talk about the colonial days in postcolonial countries or who the ruling junta was. He'd give you that in the first fifteen, twenty seconds of each episode.

Food is part of culture, and culture is part of people's history and identity and what they've gone through. He understood that, and I loved that about him.

Serj Tankian, activist and musician

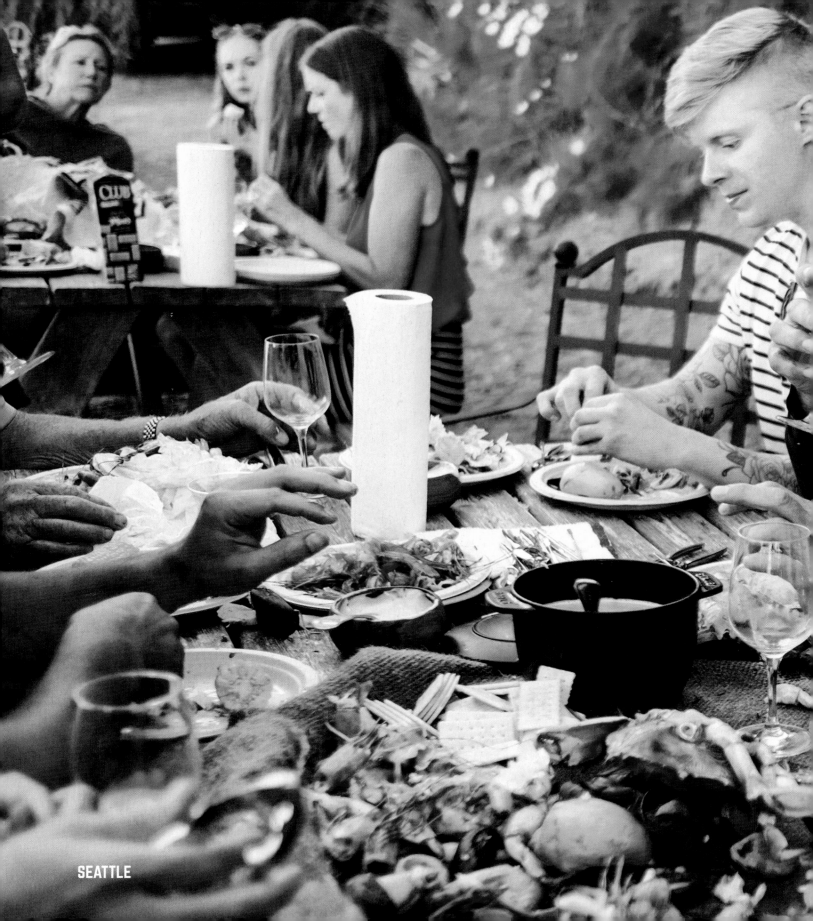

SEATTLE

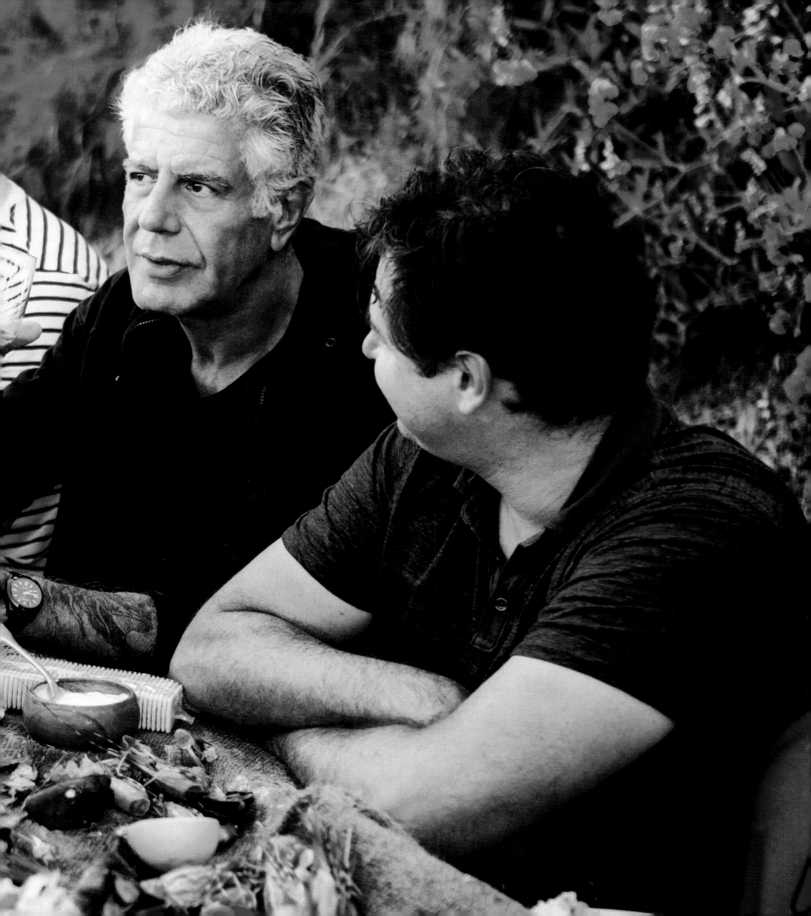

For years I was sick and on dialysis, I couldn't really travel far or long, but I felt connected to the places he went and learned more about the people who live there, what they value, what they enjoy most out of life . . . really living life, not just what they ate.

Chris R.

My husband and I had a wish/bucket list based off of places he visited on his show. I know we will probably never make it to all the places, but it was nice to dream. He had an amazing ability to interact and create conversation between strangers and anyone he met.

Emily C.

SEEING TONY REALLY GET WHAT QUÉBEC IS AND WHO THE QUÉBÉCOIS PEOPLE ARE GOT ME HOOKED ON *PARTS UNKNOWN*. IF HE WAS ABLE TO EXPLAIN WHO WE ARE AND WHAT THIS PLACE IS, SURELY HE COULD DO THE SAME ABOUT OTHER PEOPLE. I KNEW I COULD TRUST HIM.

Marc-André B.

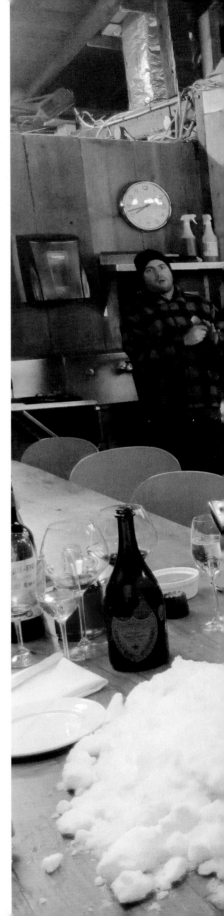

MONTREAL, CANADA

TRIPE. I DIDN'T ENJOY IT, BUT TONY WAS 100 PERCENT THE REASON I TRIED IT.

Amy P.

A voice like Anthony's standing by those who are weak, those who are mistreated, those who are misunderstood, was more than just a celebrity getting to know a new country or culture—it made us feel someone was willing to fight in our name and was standing side by side with us. Anthony will never be forgotten here as long as there is a Mexico and as long as there is an America.

Antonio A.

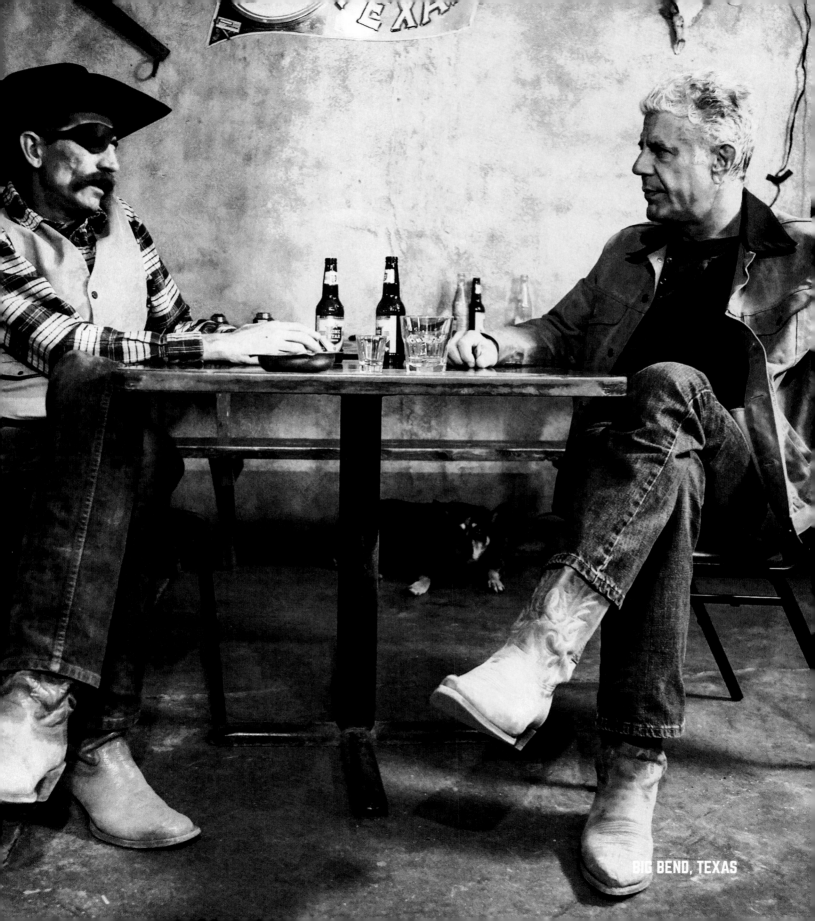

BIG BEND, TEXAS

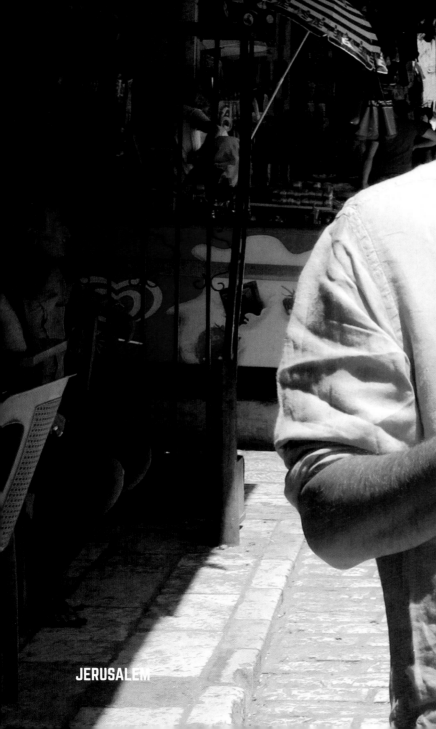
JERUSALEM

In 2013 I spent two days with Anthony Bourdain, showing him around Jerusalem. The conversations were brilliant and the meals delicious. I quickly realized that I was talking to a man with an incredibly intuitive understanding of very complicated situations. He took nothing as a given. Everything was questioned, discussed, debated. He understood how important it is to get to know individuals, instead of simply taking the official line we're always given.

Jerusalem gets its fair share of visitors. They listen to the same stories, get the same narrative. For Tony, this was never enough. When the show came out, covering Israel, and the West Bank, and Gaza, you could immediately tell that this was no ordinary visitor. He visits Gaza, meets Jewish settlers in the West Bank, turns over every stone, and ends up telling a complex and very human story. This was his strength, and it shows how brilliant Tony was as a storyteller.

Yotam Ottolenghi, chef and author

THERE WERE FEW GREATER ADVOCATES FOR THE UNSUNG BACK-OF-HOUSE WORKERS THAN ANTHONY BOURDAIN. YES, HE COUNTED THE WORLD'S MOST PROMINENT CHEFS AMONG HIS CLOSEST COMPANIONS. BUT HIS TREMENDOUS EMPATHY AND ADVOCACY WAS FOR THE LINE COOKS, PORTERS, AND DISHWASHERS WHOSE NAMES WOULD NEVER BE KNOWN OR FACES SEEN BY THE DINING PUBLIC YET WITHOUT WHOSE GRUELING LABOR RESTAURANTS WOULD GRIND TO A HALT.

KAT KINSMAN, WRITER

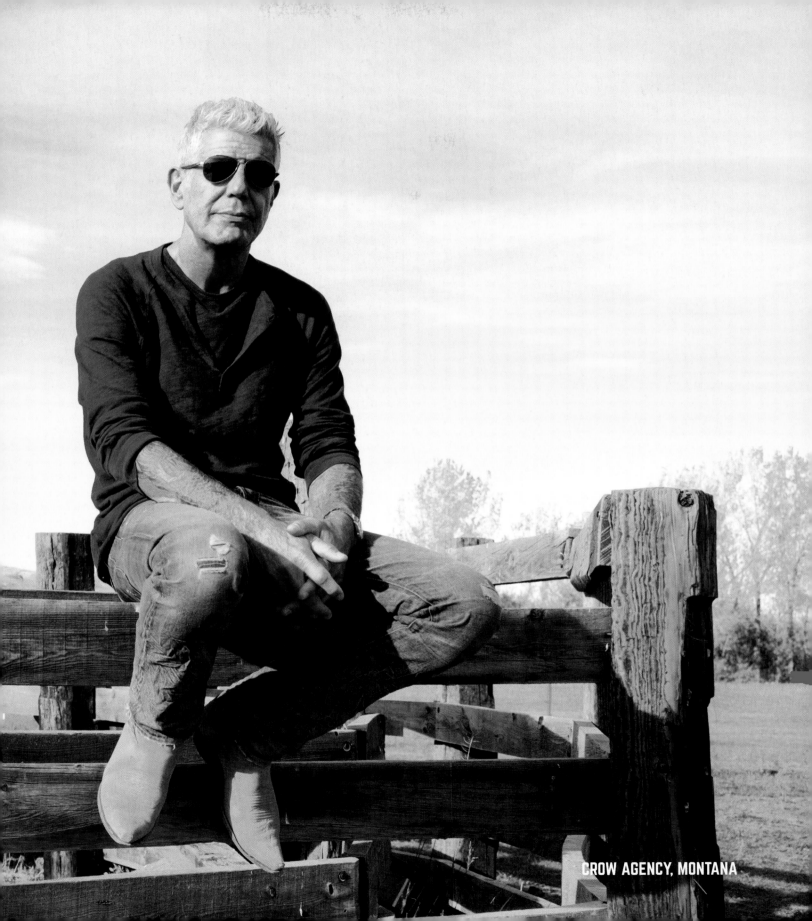

CROW AGENCY, MONTANA

When Anthony did his story on Vietnam, he brought the human factor into it. A couple of my best friends that are Vietnam combat veterans: they were in the heart of it. I never cared for that country because of what lingers on with my friends—it never goes away. I have to say, he changed my thinking, he brought the human factor into it. Made me realize we're all people in the end, we're all the same. Nobody is better than anybody else.

Mark B.

A PROFOUNDLY OBSERVANT, EMPATHETIC, AND CURIOUS HUMAN WHO MADE NO APOLOGIES OR EXCUSES.

KIM H.

He made you look at the "REAL YOU" and be that person every day. He stressed "Get to the point, otherwise what's the use?"

Timothy S.

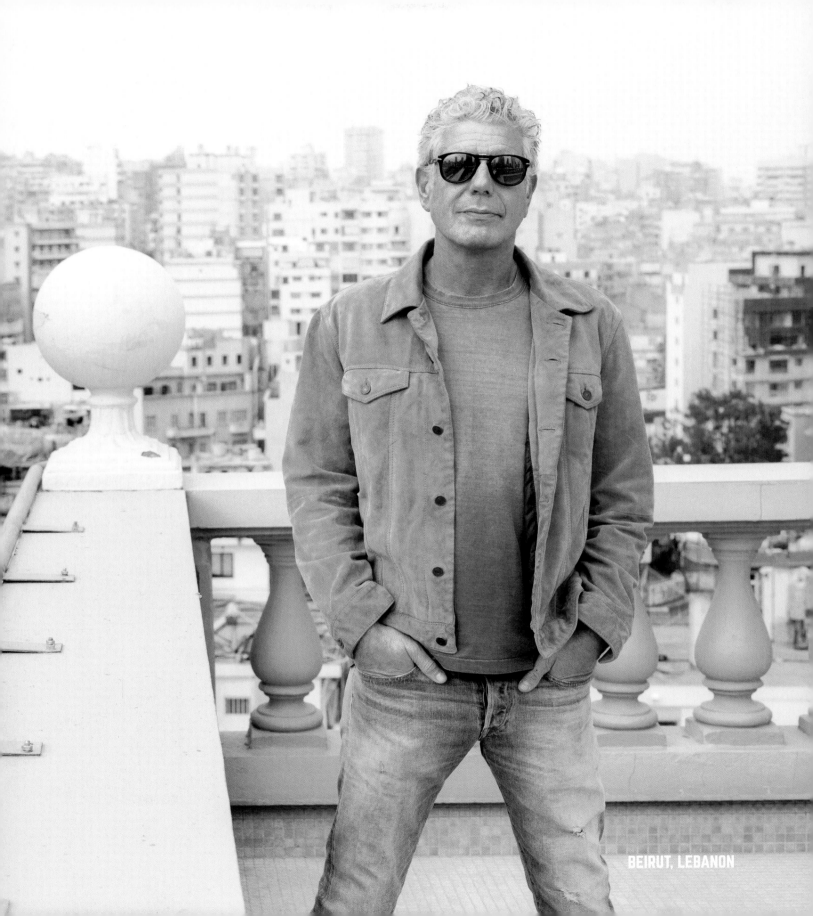

BEIRUT, LEBANON

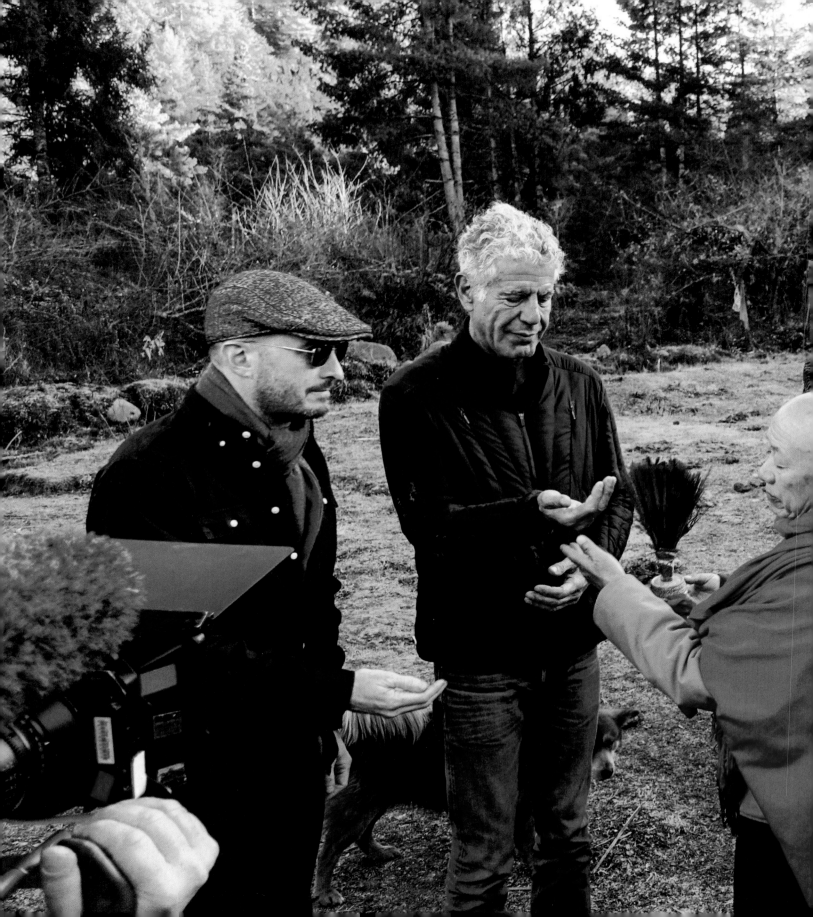

Bhutan was where I really got to know Tony.

There, I became aware of his utter lack of vanity. He never adjusted his hair or gave a damn about makeup or a lighting setup.

He was always dressed perfectly for whatever we were doing—never flashy, never understated. He just showed up, and he worked. I have rarely witnessed talent on his scale be so willingly present and real.

Tony was just himself: humble, confident, authentic, mischievous, kind. . . .

He was really alive, fully energized, fully engaged, very curious, and completely connected to this moment in time. The news in the world was crushing, but Tony was determined. He had rolled up his sleeves and was ready for the ugly fight. . . .

Hard truths spinning in the smoke of incense in one of the most perfect spots nature has to offer. Isn't that what we expect from Tony?

Darren Aronofsky, filmmaker

BHUTAN

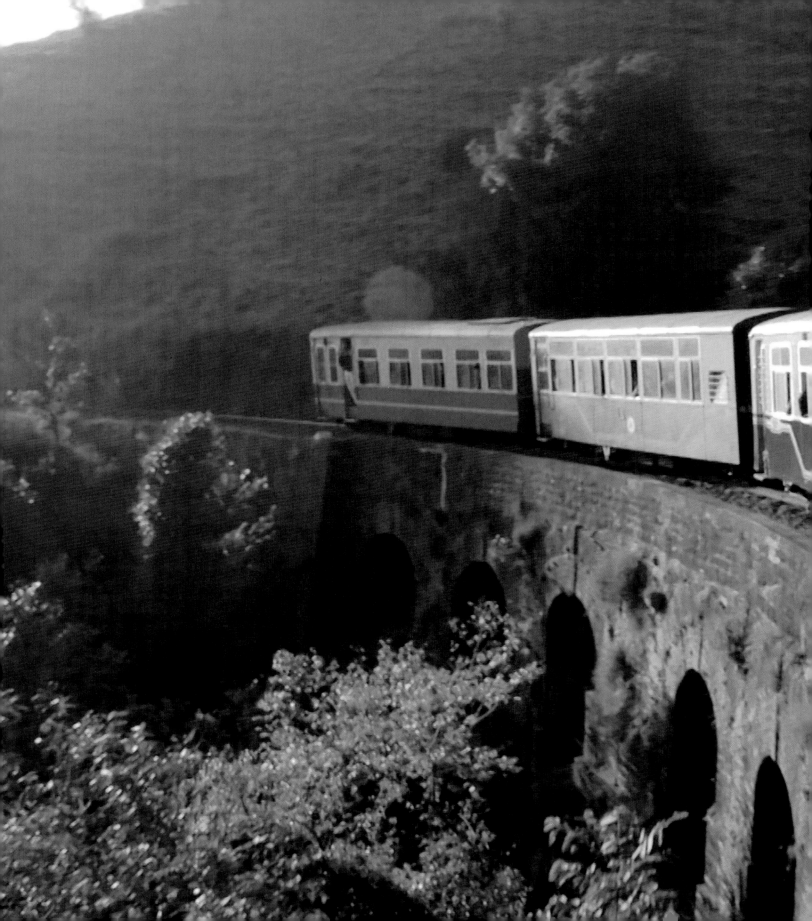

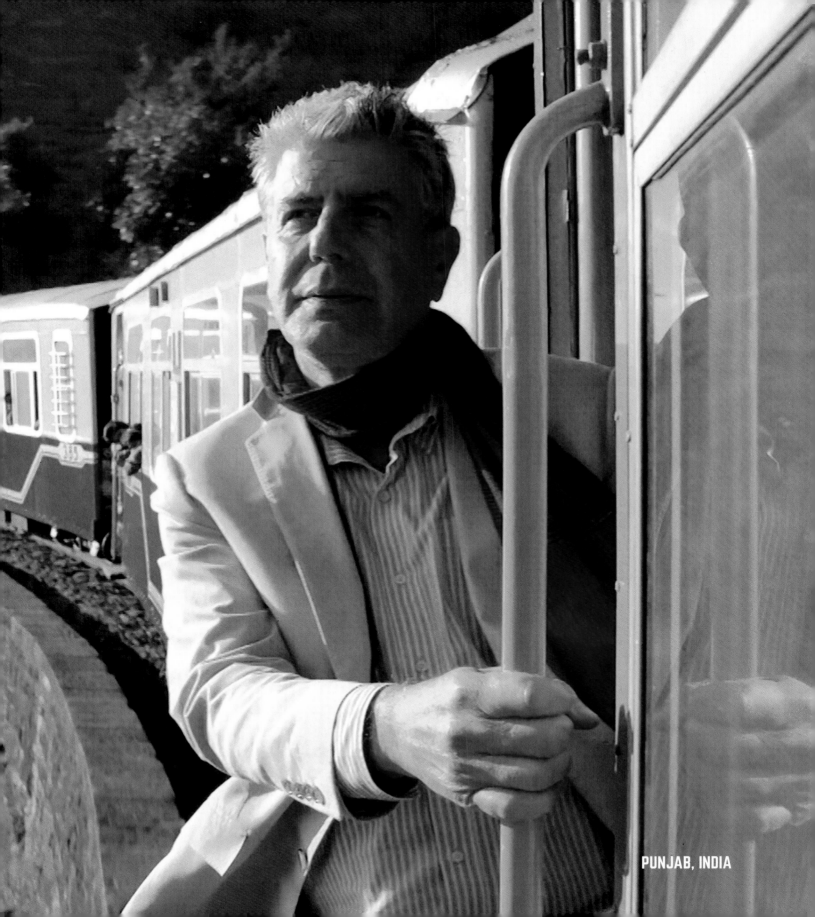

PUNJAB, INDIA

For the millions who watched his television series *No Reservations* and *Parts Unknown*, he redefined not just the travel show, but the whole point of travel itself.

If you were paying attention, he offered a wonderfully inquisitive, quietly humble, and profoundly empathetic way to move through the world. . . .

What we saw, over and over again, was empathy and humanity. Nearly everywhere, people take great pride in the food they make, and nearly everywhere, feeding others is a way of showing affection, love, devotion, and hospitality. And Bourdain wasn't mostly eating the fanciest, highest-end food prepared by professionally trained chefs. He ate what was good—food prepared in a street-side stall, or in a plastic-chair hole-in-the-wall—or in a home kitchen.

Food was a tool through which to learn a little bit more about the values, history, and priorities of the person feeding you. Food was a tool through which to understand a place, to broaden your own understanding of the world, and maybe to break open the door to a new chamber within yourself.

Jill Filipovic, writer

VIETNAM

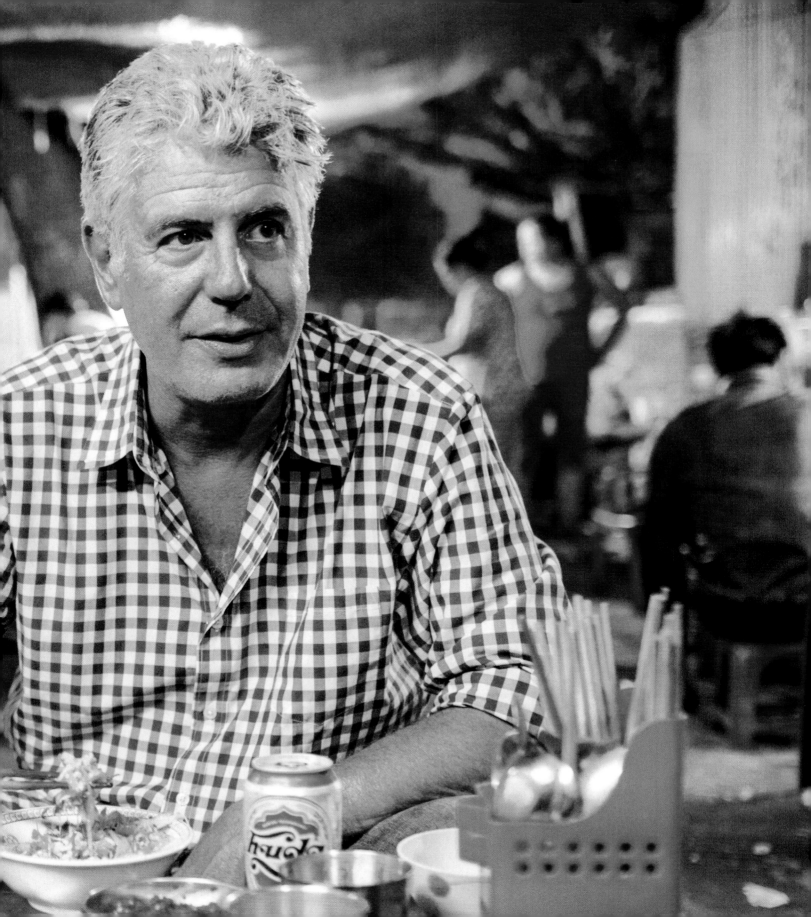

WAS A CARING, DEMOCRATIC
WHO EXTOLLED AND
YED EQUALLY THE SIMPLE
ET COOKING OF MEXICO AND
HREE-STAR COOKING OF
EST FRENCH RESTAURANT.

NEW YORK, NEW YORK

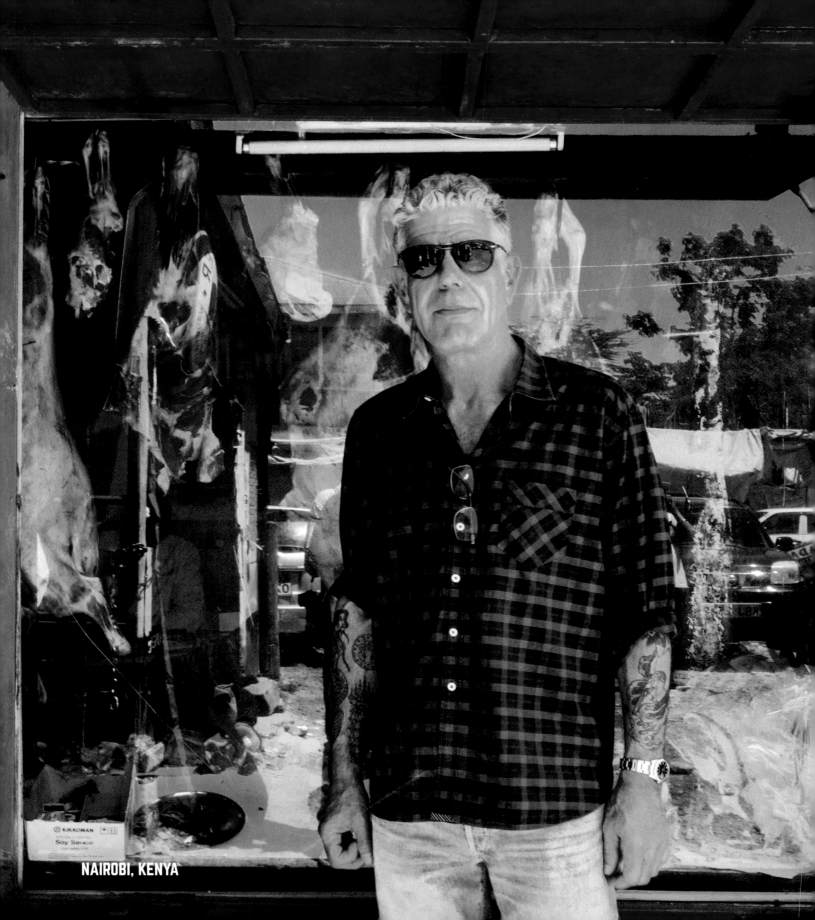

NAIROBI, KENYA

I wish there were a way to personally thank him for really opening our eyes and putting us in other people's shoes. I've gone through my own junk, and seeing him experience all the world had to offer gave me motivation to want to live for those moments for myself.

Rikuza

ANTHONY WAS THE PERSON WE ALL WISH WE'D MEET ONE DAY AND CLAIM AS A FRIEND. SINCE MOST OF US NEVER DID, HIS SHOWS WERE THE NEXT BEST THING. THE PATIENT EAR, THE SHARP WIT, THE KEEN EYE, THE KIND HEART . . . MOST IMPORTANTLY, THE GENUINE SOUL.

Dmitry S.

He was and always will be a true pillar of our humanity, bringing us all closer to understanding that borders need not exist among us, collapsing that vastness between us and knitting us together through an understanding of one another's cultures, idioms, and traditions.

Jesse R.

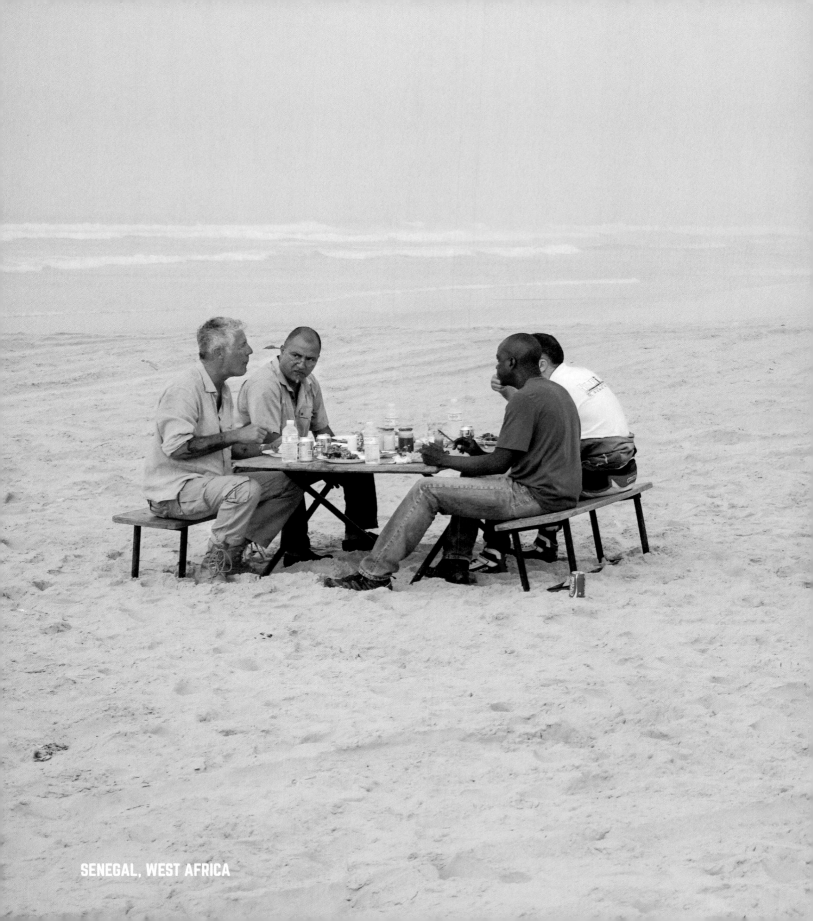

SENEGAL, WEST AFRICA

ANTHONY BOURDAIN SHOWED US WHAT IT WAS LIKE TO BE HUMAN . . . TO SHARE CULTURE, TRADITION, LOVE, AND THE JOY OF FRIENDS AND FAMILY. HE GAVE US ALL INSIGHT INTO FORGOTTEN PLACES, SHINING HIS LIGHT IN A DARKENING WORLD. HIS LIGHT WILL BE GREATLY MISSED.

MEGAN N.

AB left a legacy that is more powerful than most rock stars and politicians. He was more of a statesman than those we elect. He brought humanity, showing us this crazy world. He laughed at America, showing us it is far worse elsewhere, yet he showed us the beauty of others.

Marie W.

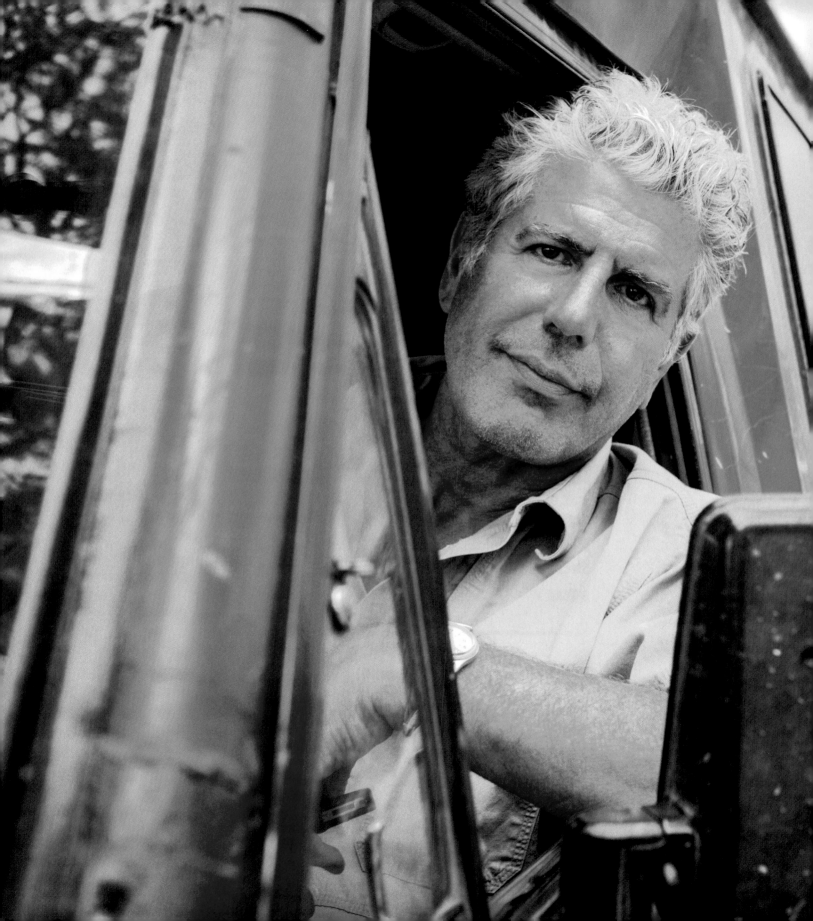

TANZANIA, AFRICA

I'VE BEEN A FAN FOR A LONG TIME. ON A RECENT TRIP TO LISBON, MY WIFE SAYS, "I'M GOING TO PRETEND TO BE ANTHONY BOURDAIN" WHEN TRYING A CERTAIN PORTUGUESE SAUSAGE FOR THE FIRST TIME. THANK YOU FOR THE FOOD COURAGE.

Ernesto Q.

Pho. Would never have tried it but for his emotive description. Fortunately I got to thank him for introducing me to one of my favorite foods.

John G.

For an overworked lawyer out in the Canadian prairies, you provided a welcome escape by bringing an insightful lens to our big wide world. You leave a legacy behind: be brave, be curious, be kind, and most importantly, have fun.

Joe G.

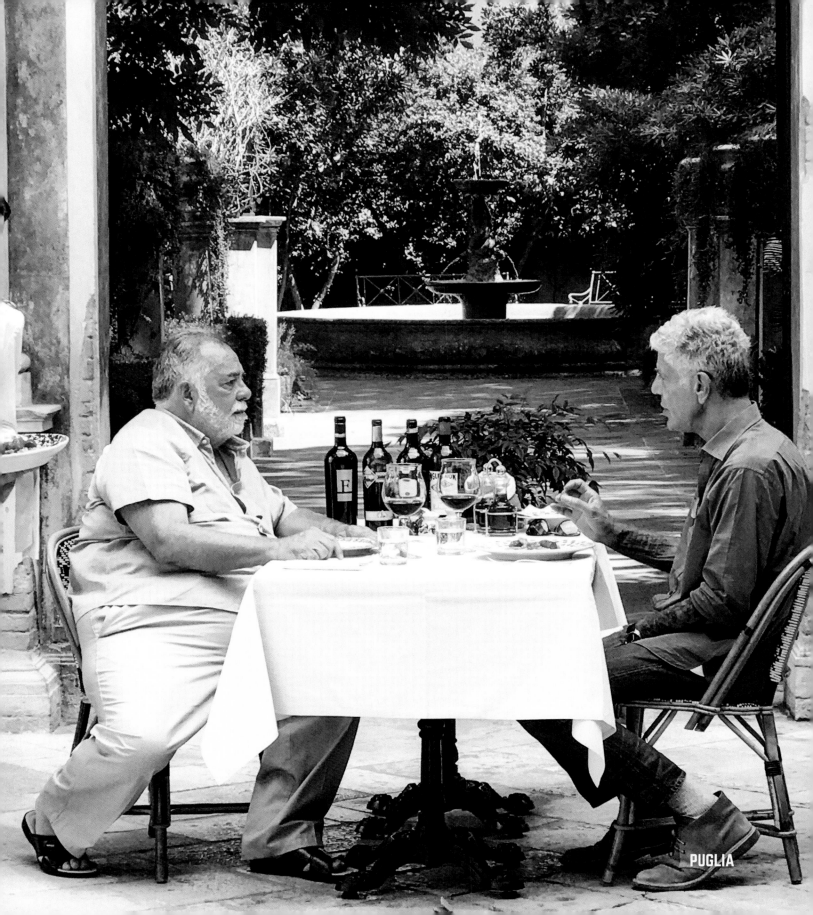

PUGLIA

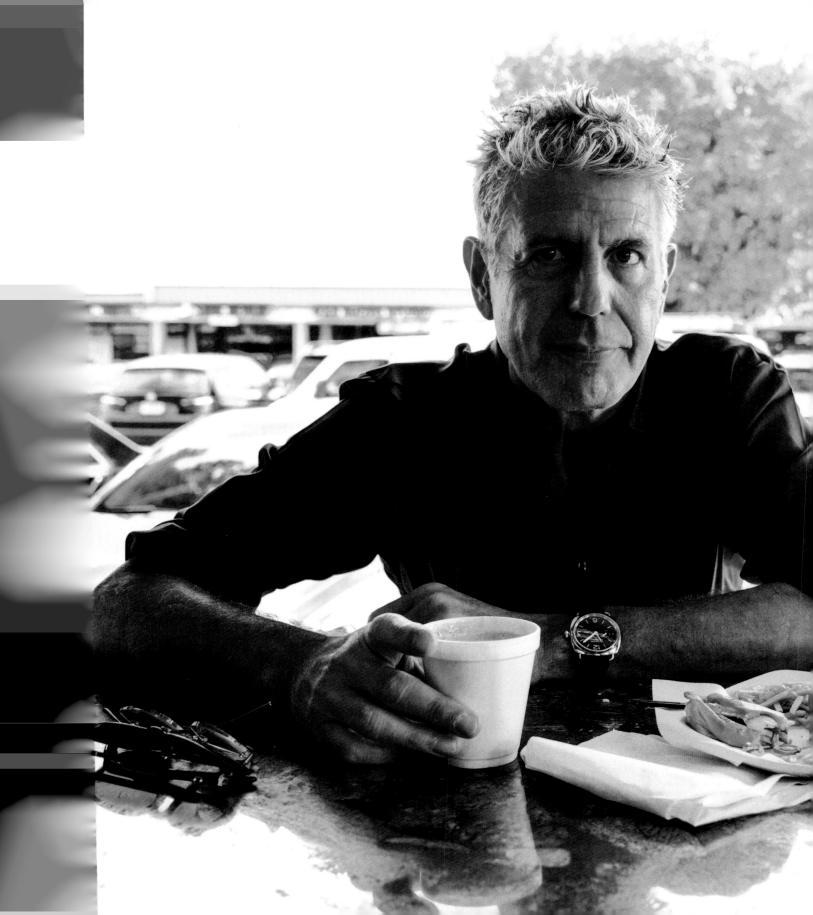

Few people understood the power of food as well as our dear friend, chef, author, and compatriot, Tony Bourdain. When he traveled, he took us further and deeper than we expected. He told us stories, explained history, made us laugh, and told truths that others have not been bold enough to tell. Never pretentious, he listened to others and intertwined politics, food, and social justice. His voice was strong, clear, and individual and will be dearly missed! We thank you, Tony.

Rollie Wesen, cofounder and executive director of the Jacques Pépin Foundation

———————

Anthony Bourdain seemed to have such a love and a zeal for life. Mr. Bourdain brought the world into our homes. His experiences became our experiences.

Diane W.

MIAMI

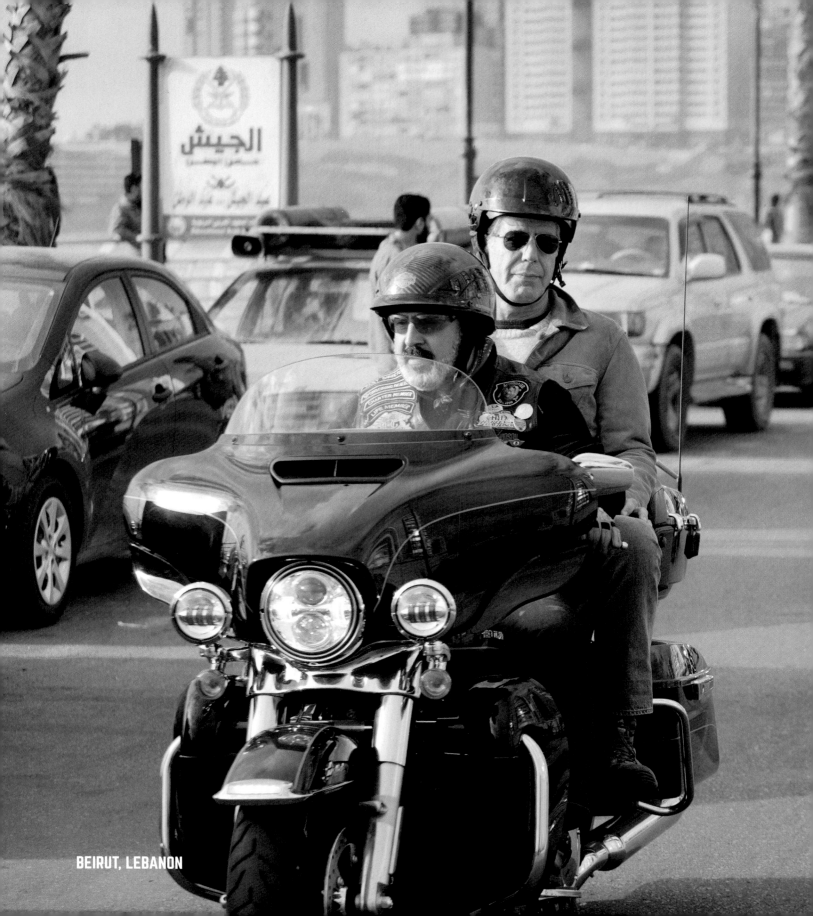

BEIRUT, LEBANON

Anthony Bourdain was universally adored for his writing, his wit and swagger, his bitter intelligence, his sarcasm, and his refreshingly honest vision of the world. It was as nuanced and tender as it was grim and sardonic. Tony gave us a world that we didn't know we needed. He gave us stories of people we didn't know we loved. He gave us the meat and the juice and never spared us the gristle, the cartilage and blood. He gave us his time and energy and thoughtfulness. He gave us a humanity we sometimes didn't deserve.

When I was a virtual nobody, he helped me—with books, with TV, with advice, with a food documentary, which, to this day, is the work I am most proud of. He was a complex person, and the public will remember him in many varied ways. I will remember him as a kind man who wanted to help bring others into the light. A young chef, a struggling business, a food hawker, a musician, an activist, or even a homeless person—Tony's broad vision of humanity included them all. . . .

In a distant future, when we look back at this era, at all its chatter and noise, we will dust off the infinite clutter of nonsense, and we will truly see Anthony Bourdain for what he was: a muse who showed us the best of what humankind can be.

Edward Lee, chef and author

He introduced my family to the world of traveling and food, so much that my daughter left grad school a year after giving me his book for Christmas. She is now running a Michelin two-star restaurant in NYC.

Ron W.

WHAT BOURDAIN DID BEST WASN'T NECESSARILY EXTRAORDINARY—AT LEAST IT SHOULDN'T HAVE BEEN. HIS GESTURES OF COMPASSION, OPEN-MINDEDNESS, AND FAIRNESS LIFTED SPIRITS, PUT OPPORTUNITIES WITHIN REACH, AND SAVED LIVES. BUT THEY WERE MERELY SIMPLE ACTS, OF WHICH EACH AND EVERY ONE OF US IS CAPABLE.

MIKE COSTELLO, FARMER, GUEST ON *PARTS UNKNOWN*

When anyone ever asked me what I would like to do in life other than my real career, I would answer "be Anthony Bourdain." I loved his storytelling, his personality, his nonconventional way of looking at things.

Dorothy P.

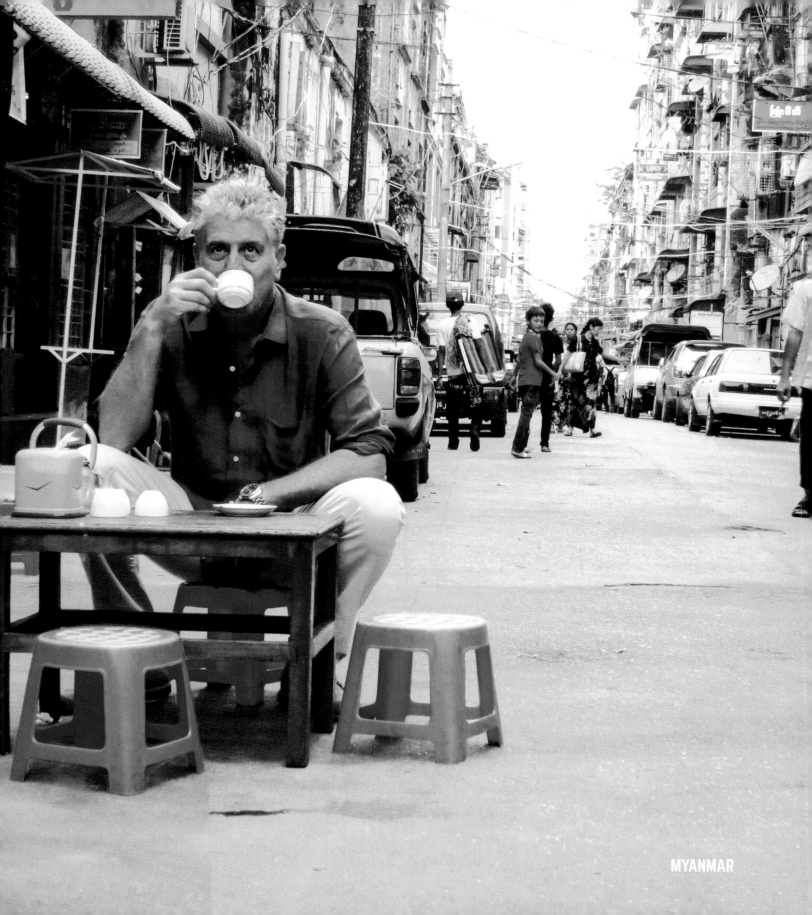

MYANMAR

There are few people in the world that understand the human condition better than Anthony Bourdain. He was a master of the spoken and written word, and his ability to cross cultural boundaries and celebrate our shared humanity was second to none. He was a global citizen who showed us both the dark and beautiful aspects of society.

Tammy G.

The first time I saw a clip of Anthony Bourdain, I thought he was a brash, loud American. He was, but after watching and reading more of him, I became completely hooked and fell in love with his work. The guy was a rock star of all things food, culture, and travel, and inspired many good times and adventures for me and I'm sure many others.

David M.

His authenticity is what we all fell in love with.

Patrick O.

THANK YOU FOR SO MUCH. FOR LETTING US TAG ALONG ON YOUR AMAZING ADVENTURES. FOR YOUR RESPECT FOR EVERY PLACE AND CULTURE THAT YOU EXPERIENCED. AND MOST OF ALL . . . FOR BEING AN ADVOCATE FOR THE HUMAN RACE.

Trace E.

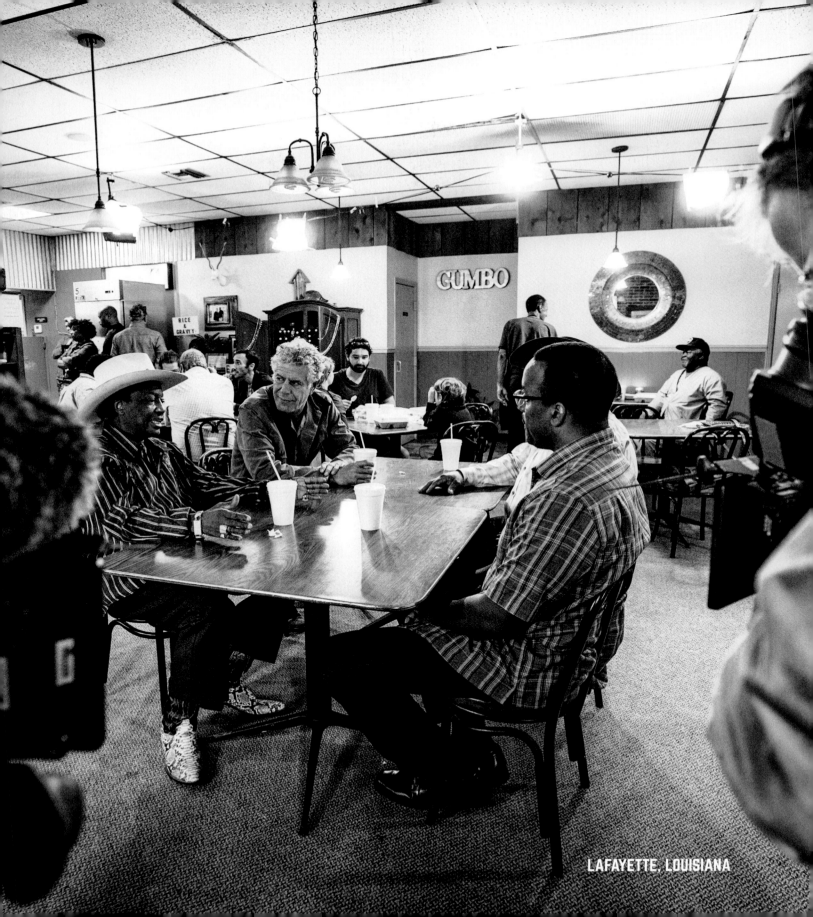

LAFAYETTE, LOUISIANA

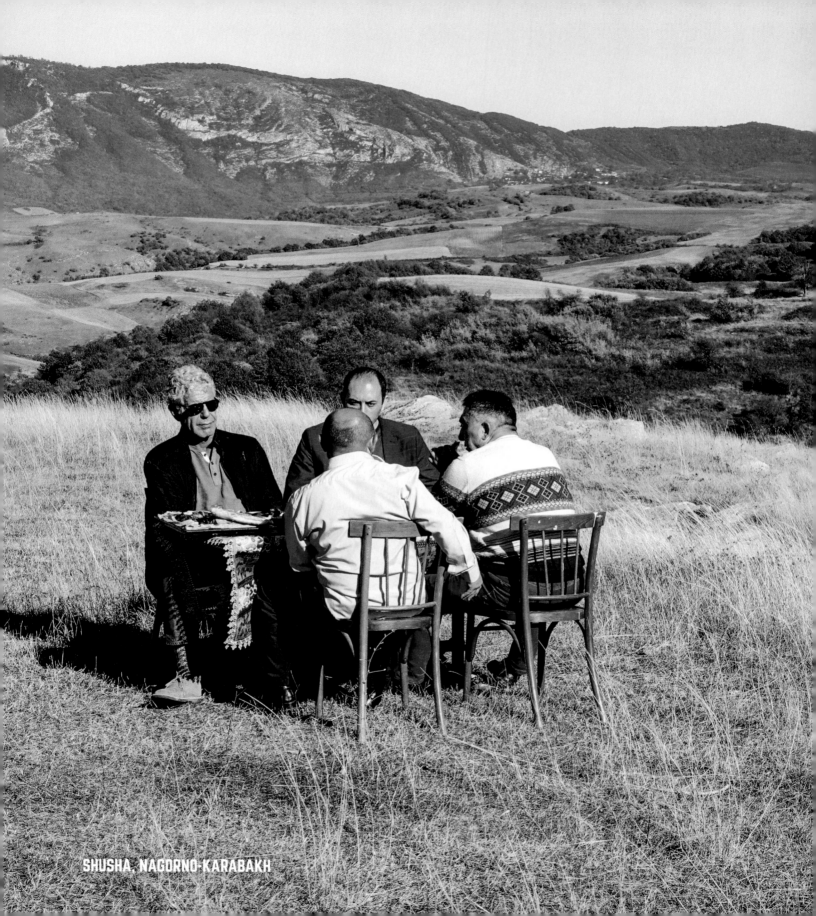

SHUSHA, NAGORNO-KARABAKH

For my generation especially, he allowed us to live vicariously through his adventures and experiences. . . . He opened up corners of the world some would never imagine they could experience.

As a first-generation Iranian American Jew—his episodes in Iran and Israel hit home. I got a glimpse into a land and people (Iran) that I'm not sure I'll ever have the joy of experiencing in person.

Rebecca D.

THE ARMENIA EPISODE WASN'T JUST INTERESTING, BEAUTIFUL, AND INSIGHTFUL, BUT IT WAS SUPREMELY MEANINGFUL FOR THE COUNTRY AND THE PEOPLE. MANY, LIKE ME, ARE REFUGEES OF THE NAGORNO-KARABAKH CONFLICT HE DESCRIBED, SO HIS COVERAGE IS VERY IMPACTFUL. HIS MERE VISIT TO THESE CONTESTED LANDS PUT HIM ON A BLACKLIST, AND WE COMMEND HIS COURAGE.

Armen O.

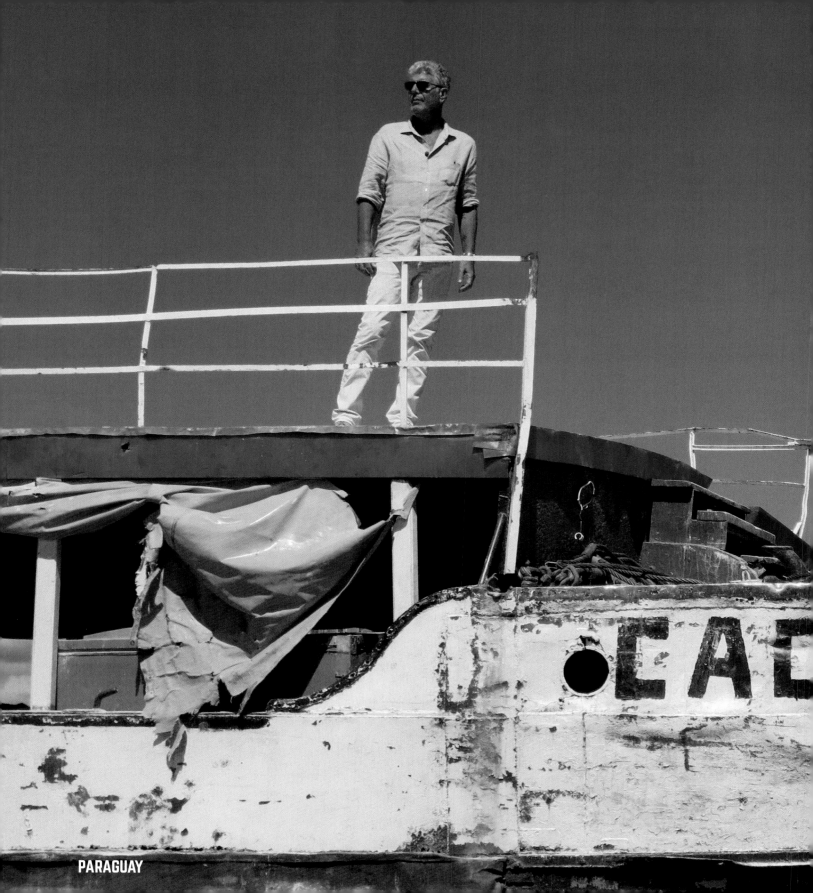

PARAGUAY

People who appeared on Bourdain's shows opened up to him, giving him their life stories because he actually handled them with care, rather than rushing to commodification. He found beauty in the sad, and the poignant, and even in the mundane, every day. Watching his shows, you got the feeling that his on-camera partners meant as much to him, if not more, than his audience.

It's a testament to the last two decades of Bourdain's work that so many people in the days after his death credited him for showing them the world through their screens. And, given that, it's an even bigger testament that so many, in this age of increasing accountability for cultural appropriation, called him one of the only celebrities that they trusted to showcase their heritage.

"Food is culture" is a platitude you hear from pretty much everyone with a sauté pan and a camera these days, but Bourdain showed us what that really meant. Nobody in the world worked harder to use food as an equalizer and as a tool to make people see the humanity in each other.

From the Philippines, to Cambodia, to Burma, to Ethiopia, to the Ozarks, to Detroit, to Haiti after all of the other American cameras had long gone, he reached out to various communities with his willingness to treat them like people and not set pieces, and to give them an opportunity to tell their stories in their own ways.

His singular focus on highlighting those most often ignored is the source of Bourdain's greatest legacy: a generation of cooks, writers, and creators of all stripes that feel powerful in their own voices. After years of being ignored, countless communities across the country and around the world understand what it feels like to be seen and heard and are unwilling to move backward.

Eric Atienza, writer

BEFORE WE TRAVEL, WE ALWAYS SAY, "WHERE WOULD TONY GO? WHO WOULD HE BREAK BREAD WITH?"

Wendy C.

Before I was able to see so many places and people around the world with my own eyes, I saw them through his. I think I watched every episode of *A Cook's Tour* and *No Reservations*—following along as Tony explored the world through the lens of food. I could never get enough. Eventually that following along became following in his footsteps. I set off to explore the world—to see, smell, and taste it all firsthand. What started as six months around Asia has now been nearly six years of travel.

These days, I hardly ever watch his shows. I still love them, but I don't need to watch Tony. I internalized him a long time ago. A voice in my head that encourages me to get out of my comfort zone, go a little farther off the beaten path, and try something new and different. I think of Tony like a friend. I thought that we might meet one day, maybe even work on something together. I suppose that was his charm. His ability to make you feel like an old friend, sitting there at the table with him, even when you were thousands of miles apart. Judging by all the reactions I see in the wake of his death, I guess I must not be the only one who felt that sense of closeness from afar.

Neville M.

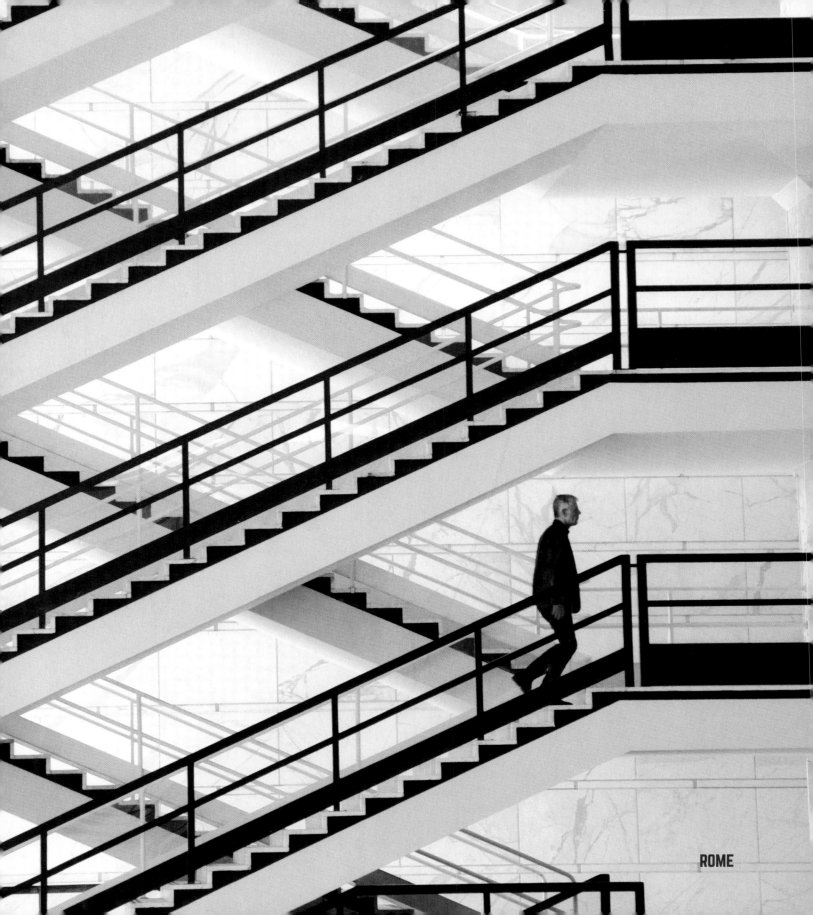

ROME

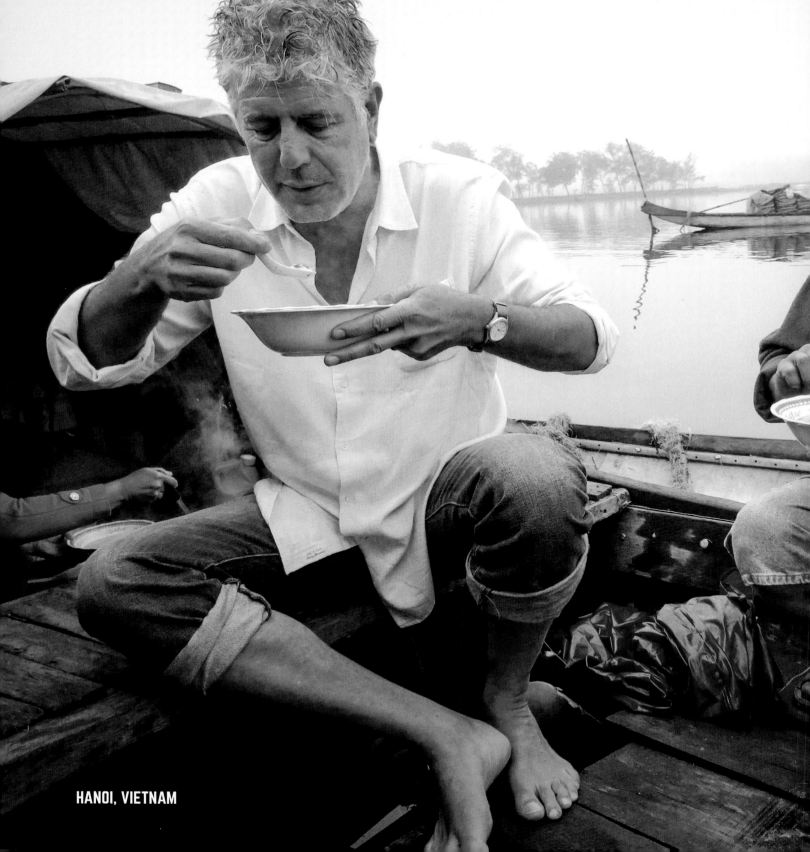

HANOI, VIETNAM

When I was traveling in North Carolina, exploring the Great Smoky Mountains, I convinced my bf to stop at this rural, rustic diner, a hole-in-the-wall, and try livermush for the first time because I knew it's something Anthony Bourdain would do . . .

Maria K.

MY IDEA OF HEAVEN IS SLURPING A BOWL OF PHO WITH TONY IN SOME VIETNAMESE HOLE-IN-THE-WALL RESTAURANT.

Terri H.

We tracked down Com Hen in Hue, Vietnam, in an alley-like street, and sat on the little plastic stools to try the delicious dish only found there. It was our favorite meal in Vietnam. I would have never known, if not for him.

Dawn M.

With his many trips to Vietnam, he inspired me and my six-year-old to try pho. Now it is a weekly dish in our house. Thank you for opening both our eyes and taste buds to amazing places and dishes.

Meghan H.

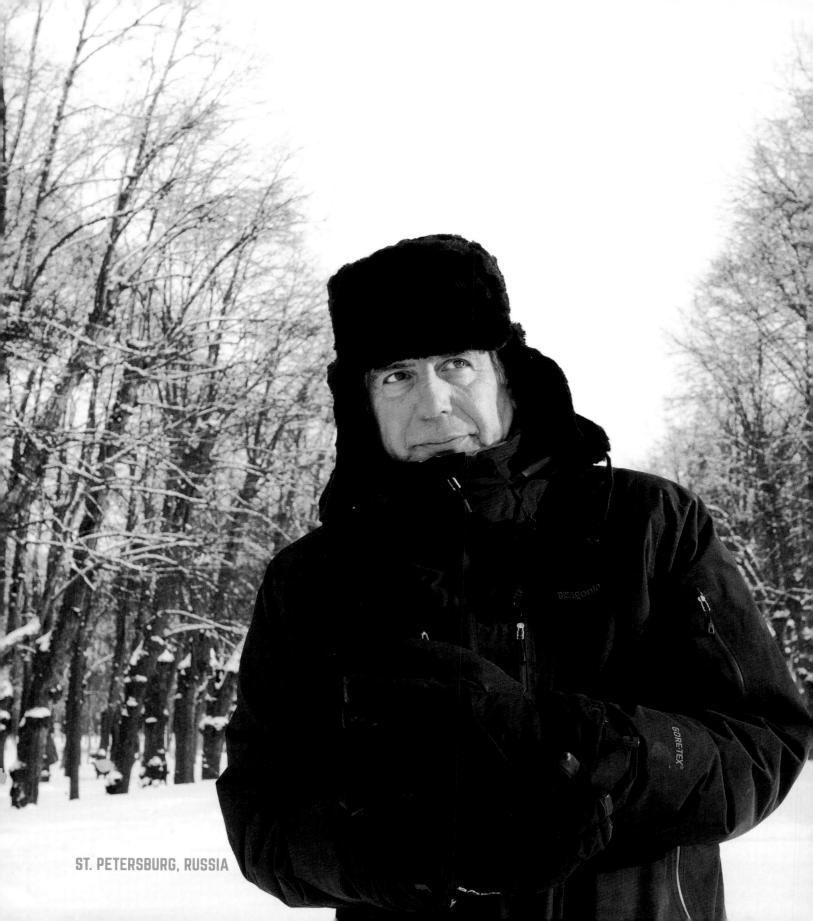

ST. PETERSBURG, RUSSIA

HE OPENED MY HEART AND MIND TO PLACES I KNOW I'LL NEVER SEE. EXPOSED US ALL TO FOOD, CULTURE, POLITICS—WITH SUCH ACERBIC WIT AND HUMOR. EMBRACED THE DIVERSITY OF THIS CRAZY WORLD. I HEAR HIM SAYING, "MAN, THAT'S GOOD" WHILE SLURPING NOODLES.

Charlotte S.

There were episodes, of *Parts Unknown* especially, that were some of the most beautiful things I've ever seen on film. His shows and some of his writings had an honest sincerity and sentimentality that somehow never crossed into the platitudinous.

Adam Z.

"LOW PLASTIC STOOL, CHEAP BUT DELICIOUS NOODLES, COLD HANOI BEER." THIS IS HOW I'LL REMEMBER TONY. HE TAUGHT US ABOUT FOOD— BUT MORE IMPORTANTLY, ABOUT ITS ABILITY TO BRING US TOGETHER. TO MAKE US A LITTLE LESS AFRAID OF THE UNKNOWN. WE'LL MISS HIM.

FORMER PRESIDENT BARACK OBAMA

HANOI, VIETNAM

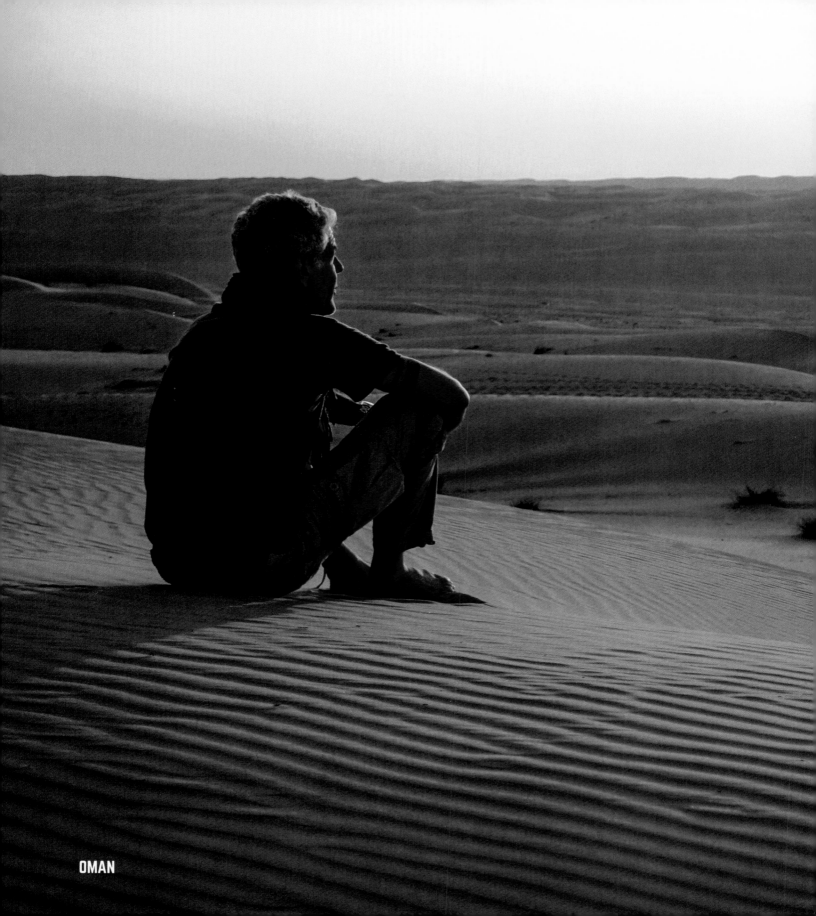

OMAN

For many of us, he was not just another writer or personality to admire. He was literally who we wanted to *be*. . . .

[As] a traveler and writer, I owe him a lot. I probably owe him more than I realize. Bourdain didn't invent food and travel journalism, but he made it so exciting. He was like the one high school history teacher you had that made you feel like learning was actually fun. His voice was raw, and it was unique. And he took that voice, hooked it up to an old amplifier he'd jury-rigged with twine and electrical tape, and blasted his message to every corner of the world.

The message was uncomplicated: Go to the place. Eat the thing. Talk to the person. Mr. Bourdain made you want to spend weeks in places you never would have thought to visit, and devour plates of food you may never have before dared to try. He made the unapproachable look appealing; the daunting look downright attractive. The first season of his CNN show, *Parts Unknown*, went to places like Myanmar, Libya, and the Congo. By challenging the idea of what a travel show could be and where it could go, he accomplished more than just good TV; he helped give a voice to places and people that were absent or underrepresented in media. And that made the world a more understanding, more curious, and kinder place.

Mr. Bourdain knew better than anyone that travel and food were the two things that could hope to heal a fractured world. I always appreciated his honesty; he managed to be hopeful without sugarcoating reality. He understood there was both great beauty and great ugliness in the world and dared to present both to us. . . .

Lucas Peterson, travel writer, *The New York Times*

TONY. THANK YOU FOR TRAVELING ALL OVER THE WORLD. SHOWING US NEW THINGS, INTRODUCING COUNTLESS AMERICANS, WHO OTHERWISE WOULD NOT HAVE SUCH ACCESS, TO THE CRAZY PLANET WE CALL HOME. YOU 1000 PERCENT MADE THE WORLD A BETTER PLACE.

NAOMI POMEROY, CHEF AND AUTHOR

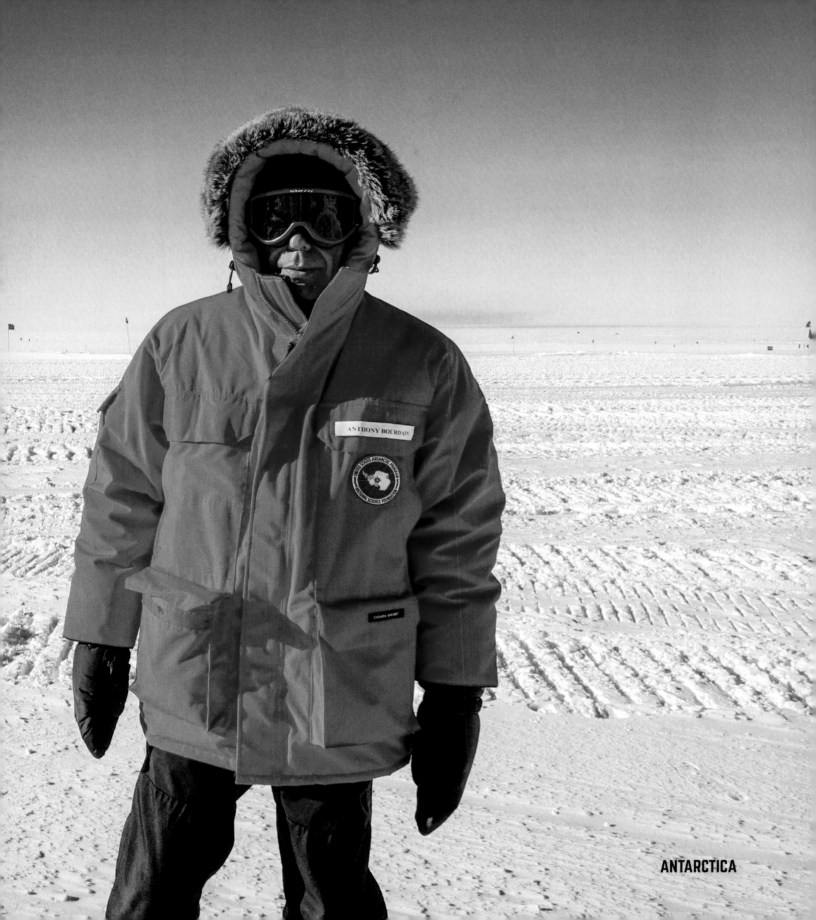

ANTARCTICA

HE ALLOWED ME A SNEAK PEEK INTO KITCHENS AROUND THE WORLD. SAVED ME A SEAT AT THE CHEF'S TABLE AND ELBOW ROOM NEXT TO HIS FAVORITE CHEFS. I SAW SIGHTS AROUND THE WORLD AND MET PEOPLE FROM VARIOUS WALKS OF LIFE BECAUSE HE WAS WILLING TO SHARE HIS EXPERIENCES.

Karen K.

He spoke with the people he met, not at them, and often over a meal. No matter where he found himself in the world, he knew that he was a guest and carried himself with the type of respect toward others such an understanding brings. He was the opposite of the archetypal American tourist abroad, choosing to listen and learn as a way to experience other people's cultures.

Kristen O.

We liked him because we enjoyed imagining our life could have been like his, because chefs all thought in his writing style! It was plain, and honest. He was the Bukowski or Henry Miller of food. He was a regular guy, just like the rest of us cooks. He was our voice.

Skip G.

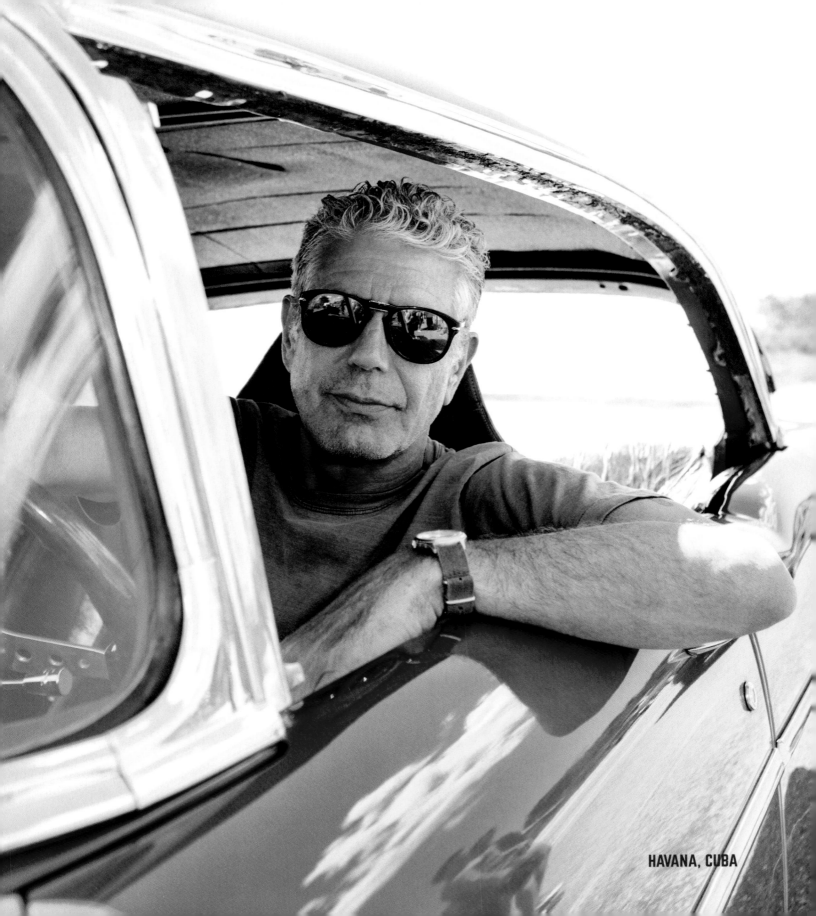

HAVANA, CUBA

MR. BOURDAIN, THANK YOU FOR COMING TO OUR STATE. MANY OF US LOVED YOU BEFORE THAT EPISODE. NOW YOU ARE REVERED BY MOST OF SOUTHERN WEST VIRGINIA. OUR CHAMPION.

Terri H.

Thank you for taking a full-time working mom of two young children in the suburbs to places on earth she likely will never make it to. I was transported for an hour each week to explore fascinating cultures, stories, and food. You sparked honest dialogue that often made me sit back and think that maybe people across the globe have more in common than we think.

Emmeline K.

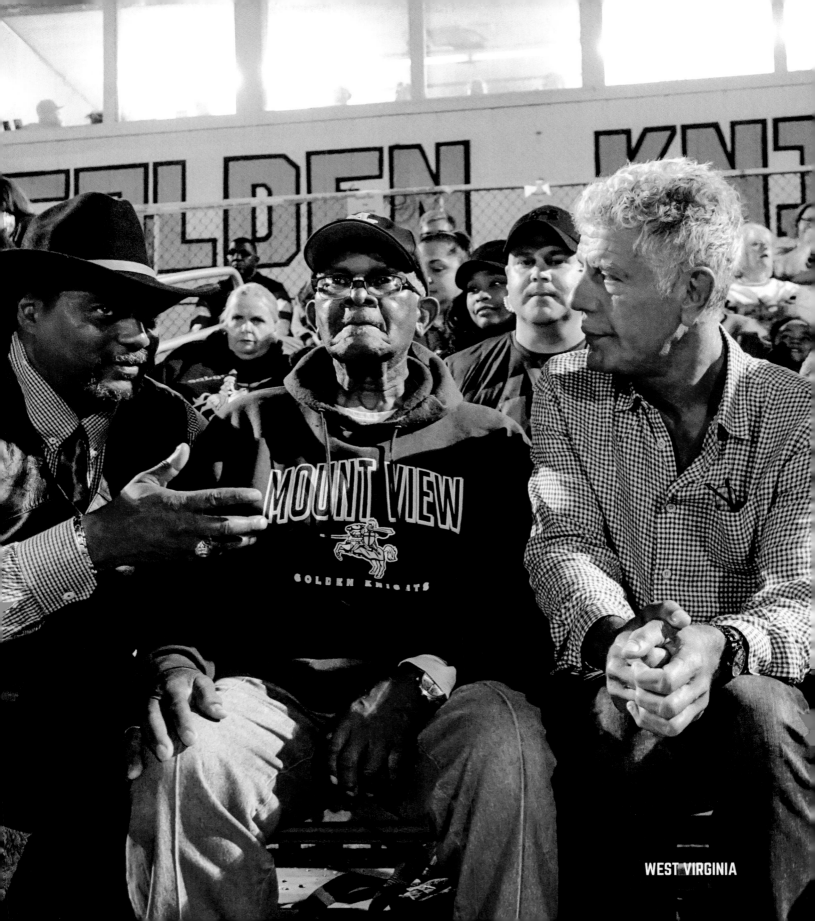

WEST VIRGINIA

The thing about Tony was that he wasn't the kind of traveler who centered things around what he knew. He didn't say, "Let me show you what's really happening here." He said, "Watch me go through this experience and maybe we'll both learn something together. . . ."

I was—and still am—in awe of him. It is one thing to be an experienced and gracious world traveler. It is another thing to be a writer who can seemingly easily, humorously, and profoundly sum up the human experience. And it is a completely different thing to make great television. Tony did all these things. Oh yeah, he was a great cook, too. . . .

He was far more than just the host of a popular TV show. He was a singular force in the universe for good and for good times.

W. Kamau Bell, comedian

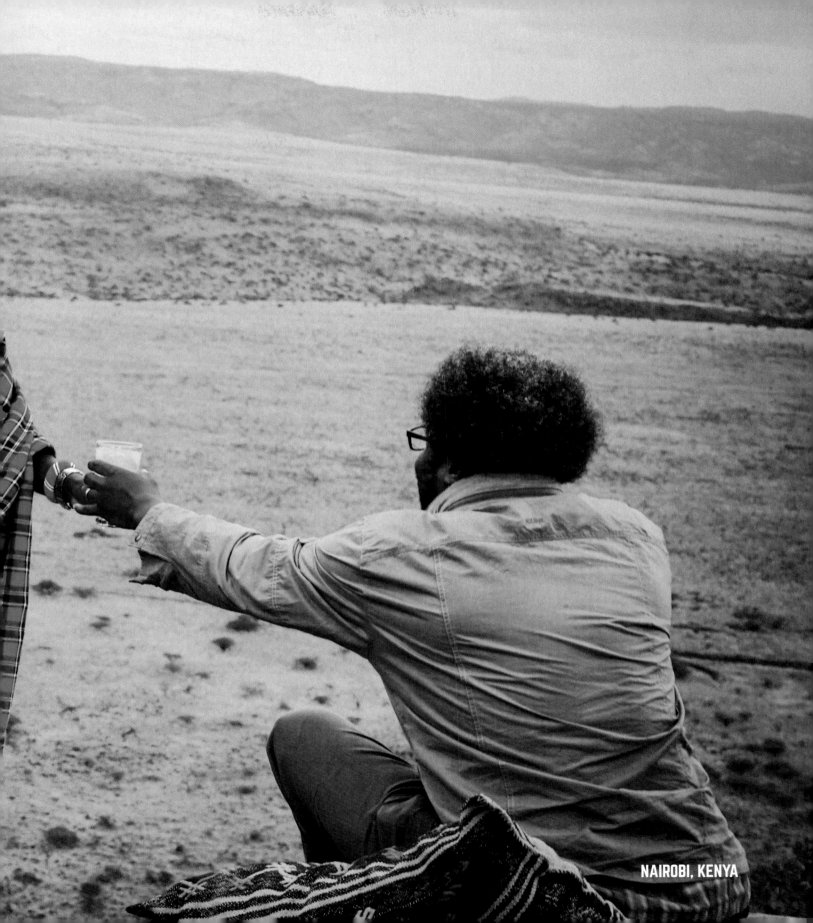

NAIROBI, KENYA

ARMENIA

Last year, I left my job to care for my father, who was dying. Some nights when I wasn't totally exhausted, I'd watch old episodes of *No Reservations* and *Parts Unknown*. His love of people and place, his honest storytelling, searching for answers, but leaving us with questions, provided me such great comfort during a really sh*tty period. I was watching his Zanzibar episode late one night and turned to my sister, saying, "When Dad dies, I am going there." And I did because of him. I channeled his sense of adventure and curiosity. I even met Abed Karame (Anthony interviewed him) randomly and drank beer with him. Anthony reminded us that the universe was small and we should get out and explore, and get lost, ask questions, and share a meal with a stranger.

Jodi A.

FRENCH ALPS

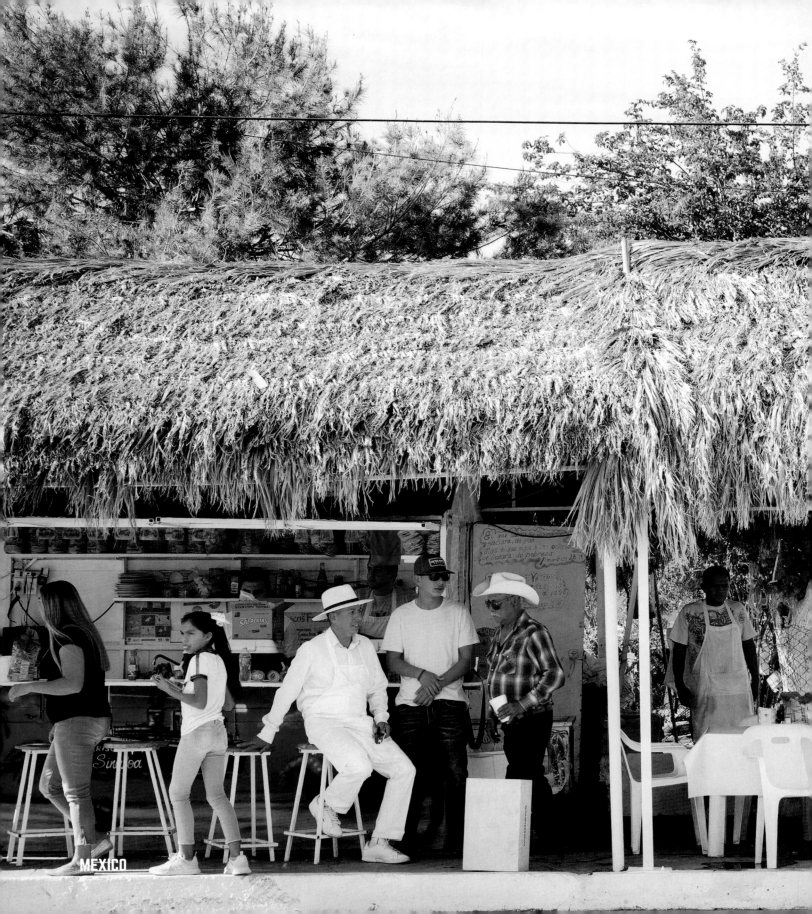

MEXICO

REMEMBERING ALL THE TALKS ABOUT MEXICO AND WHERE YOUR COOKS AT LES HALLES WERE FROM. SMART, WITTY, THOUGHTFUL, AND ON A CONSTANT MISSION TO DISCOVER AND SHARE. I'LL MISS YOU, BROTHER.

Aarón Sánchez, chef and author

BERLIN, GERMANY

TONY'S RESTLESS SPIRIT WILL ROAM THE EARTH IN SEARCH OF JUSTICE, TRUTH, AND A GREAT BOWL OF NOODLES.

TOM COLICCHIO, CHEF AND AUTHOR

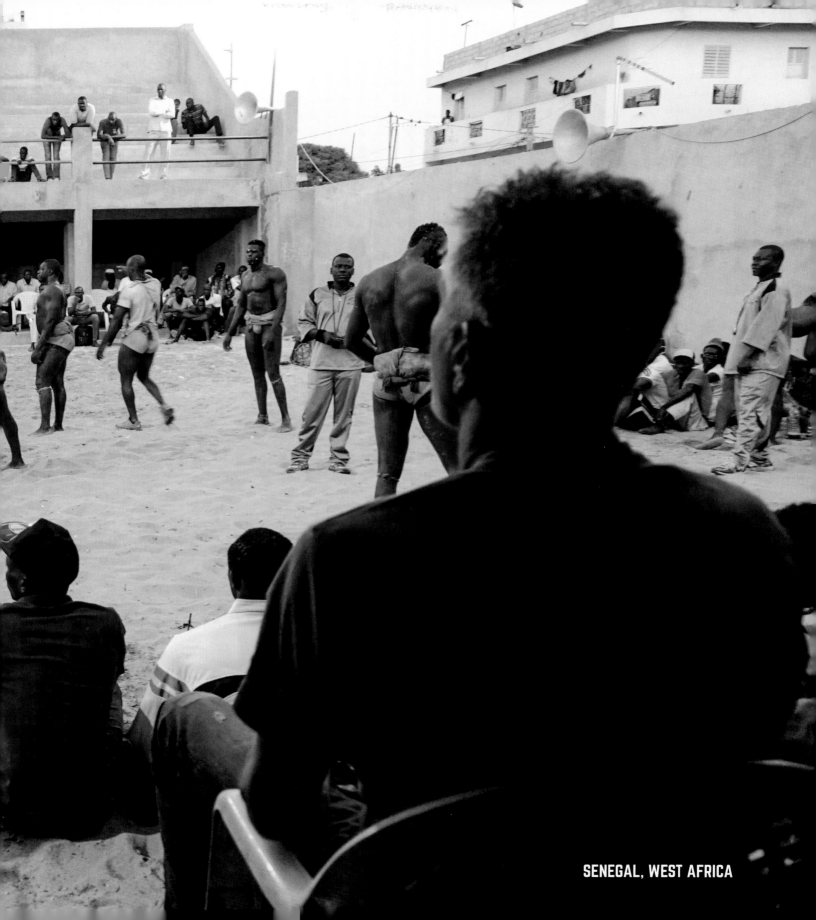

SENEGAL, WEST AFRICA

EVERY COOK AND DISHWASHER IN THE WORLD HAS LOST A FRIEND.

Michael T.

He was as cool as the other side of the pillow.

Bakari S.

I CALL THIS THE ANTHONY BOURDAIN EFFECT: IT'S ONLY 7:45 A.M., AND IN THE MIDDLE OF WATCHING THE SHOW, I GOT UP AND STARTED COOKING. OF COURSE I ONLY HAVE SPANISH CHEESE AND SOME WHITE BEANS— GARBANZO BEANS—IN A CAN, MEXICAN CHORIZO, AND BEER. YES, BEER AT 8:32. IT'S READY!

Jesus S.

NEW YORK, NEW YORK

MANILA, PHILIPPINES

Bourdain was my hero, a constant presence in my mind who ignited a hunger to constantly seek something more and to recognize that human similarities far outweigh the differences. His passion for this world and enjoying everything good it has to offer was infectious.

Amanda R.

I WATCHED A CLIP OF *PARTS UNKNOWN* IN AN AIRPORT LOBBY MONTHS AGO. IT WAS RIGHT AFTER I HAD APPLIED AND GOTTEN INTO CULINARY SCHOOL, BUT I WAS STARTING TO DOUBT MYSELF. I WAS WORRIED COOKING DIDN'T MEAN ANYTHING, AND I DIDN'T WANT TO DO SOMETHING I DIDN'T REALLY LOVE. WATCHING ANTHONY BOURDAIN EAT A MEAL IN THE HOME OF A FAMILY IN ANOTHER COUNTRY MADE ME REALIZE JUST HOW BEAUTIFUL FOOD CAN BE. HE UNITED CULTURES THROUGH FOOD AND MADE ME REALIZE CULINARY SCHOOL WAS WHERE I'M MEANT TO BE.

Ryan F.

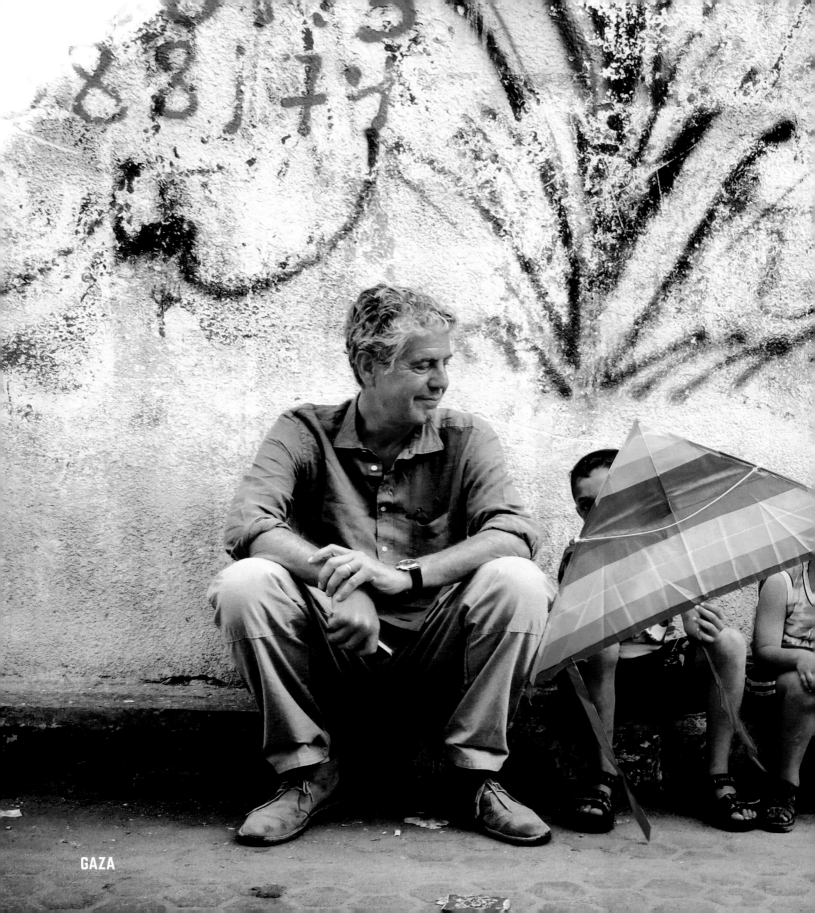

GAZA

FOREVER WITH ME, TONY. . . . YOU BELIEVED IN ME, WHERE I CAME FROM, AND YOU WANTED THE WORLD TO KNOW ME. YOU TOLD ME I WAS THE LAST OF MY KIND, BUT YOU TRULY ARE THE LAST OF YOUR KIND AND TOUCHED ME AND MY FAMILY SO DEEPLY. I AM FOREVER INDEBTED TO THIS PASSIONATE, GREAT MAN. TRULY HEARTBROKEN TODAY. THE WORLD IS A BETTER PLACE FOR YOU BEING IN IT.

LUDO LEFEBVRE, CHEF AND AUTHOR

THE WORLD IS NOW A MORE BORING,
LESS SARCASTIC PLACE WITHOUT
THE BRILLIANCE OF HIS SARDONIC
MONOLOGUES AND COMMENTARIES.
WITHOUT BOURDAIN, SUNDAY NIGHTS
MIGHT AS WELL NOT EXIST.

DUTCH W.

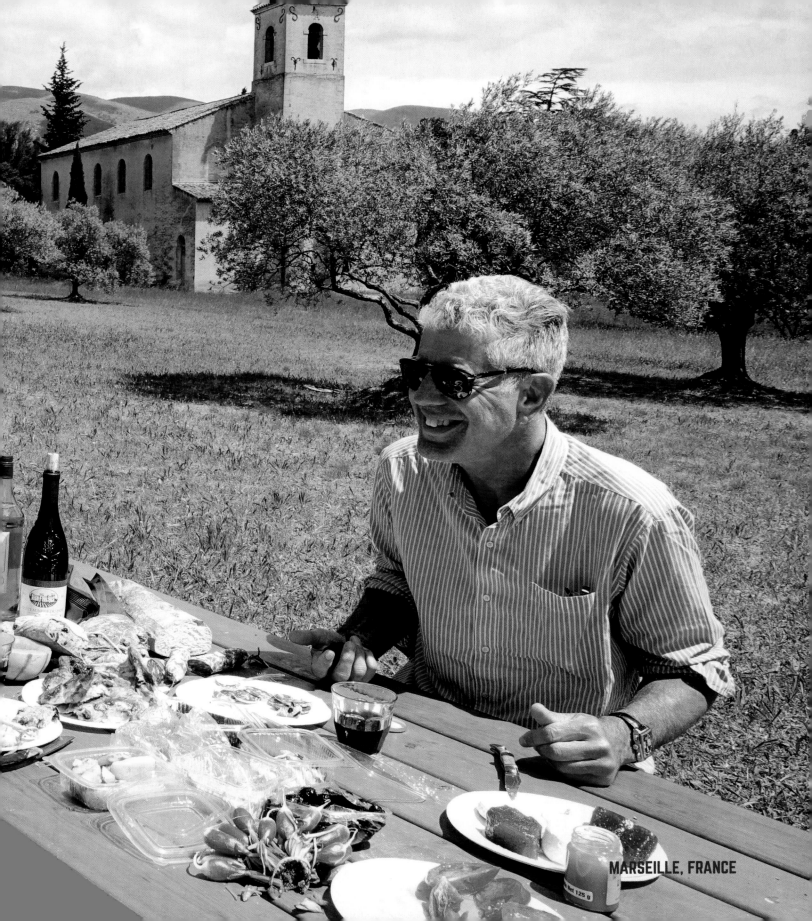

MARSEILLE, FRANCE

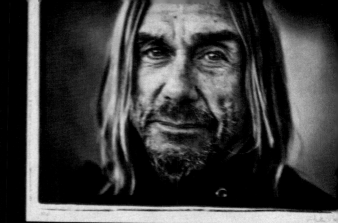

NEW YORK, NEW YORK

I LOVED THE GUY, AND HE WAS A LIGHT OF KINDNESS AND GOOD VIBES IN MY LIFE.

IGGY POP, MUSICIAN

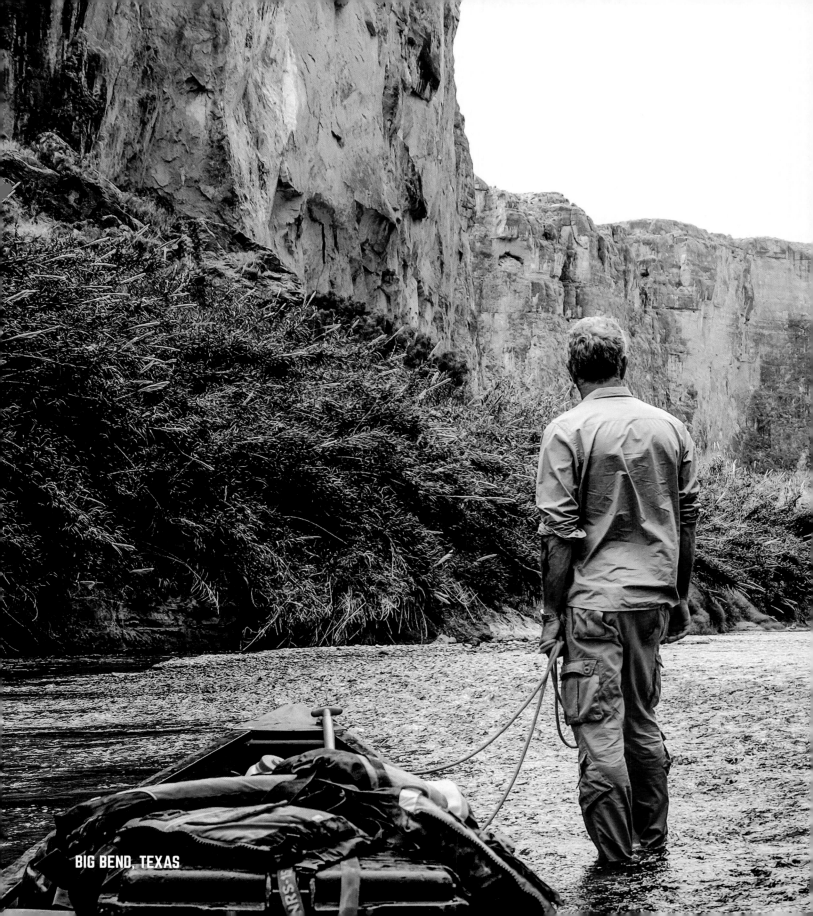

BIG BEND, TEXAS

THANKS FOR SHOWING US THAT THE UNKNOWN IS SOMETHING ALWAYS WORTH EXPLORING.

DIANA F.

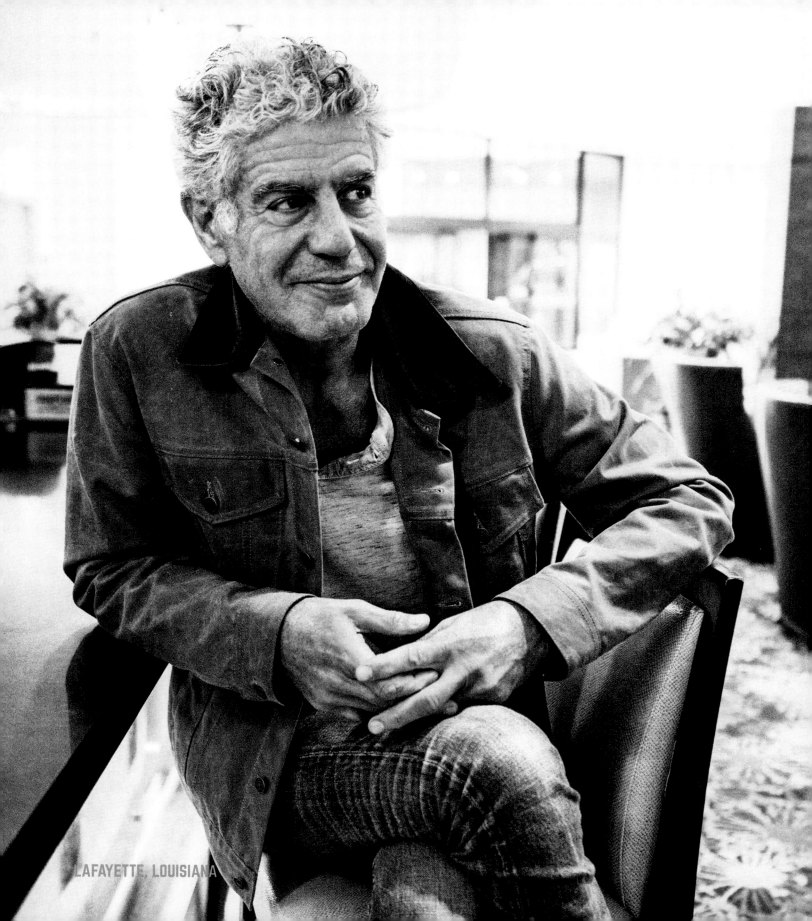

LAFAYETTE, LOUISIANA

TRAVEL ISN'T OFTEN PRETTY. IT ISN'T OFTEN COMFORTABLE. SOMETIMES IT HURTS, IT EVEN BREAKS YOUR HEART. BUT THAT'S OKAY. THE JOURNEY CHANGES YOU; IT SHOULD CHANGE YOU. IT LEAVES MARKS ON YOUR MEMORY, ON YOUR BODY. YOU TAKE SOMETHING WITH YOU. HOPEFULLY, YOU LEAVE SOMETHING GOOD BEHIND.

ANTHONY BOURDAIN

Thank you to Carolyn Disbrow and Katie Isaacson for the good taste, dedication, and hard work that made this book possible.

PHOTO CREDITS

CNN staff: 12–13, 18–19, 20, 25, 35, 36–37, 38–39, 44, 51, 52–53, 56, 61, 71, 72–73, 74–75, 78–79, 80–81, 93, 96, 104–105, 106–107, 112–113, 120–121, 132–133, 138–139, 140–141, 148–149, 153, 164–165, 167, 172–173, 174–175, 181, 182–183, 184, 186–187, 192–193, 195, 196, 198–199, 200–201

David Scott Holloway: Cover, 10–11, 15, 17, 30–31, 32–33, 48–49, 58–59, 64–65, 66–67, 68–69, 82–83, 84–85, 90, 98–99, 100, 102–103, 108, 111, 114–115, 118, 122–123, 126–127, 134–135, 137, 142–143, 146, 150–151, 154–155, 156–157, 161, 168, 170, 179, 190–191, 202, 206

Josh Ferrell: 40–41, 42–43, 86, 88–89, 116, 124–125, 129, 159, 162, 176–177

Jessica Lutz: 9, 29, 62–63, 131, 188–189, 204–205

Mario Tomo: 54–55, 77, 94–95

ALL ABOVE: © Cable News Network. A WarnerMedia Company. All Rights Reserved.

Mike Coppola/Getty Images for Turner: 26–27
Christina Simons/Alamy Stock Photo: 22–23
Pete Souza/Official White House Photo: 47
Tom Hopkins: 144–145

TEXT CREDITS

Pages 106, 175: Excerpts from "How Anthony Bourdain Inspired Two World Travelers for The Times," by Jada Yuan and Lucas Peterson. Copyright © *The New York Times*, June 11, 2018.

Edited and produced for CNN by Amy Entelis, Carolyn Disbrow, and Katie Isaacson with Girl Friday Productions. Editorial by Emilie Sandoz-Voyer, Micah Schmidt, and Kristin Mehus-Roe. Design by Rachel Marek and Paul Barrett.

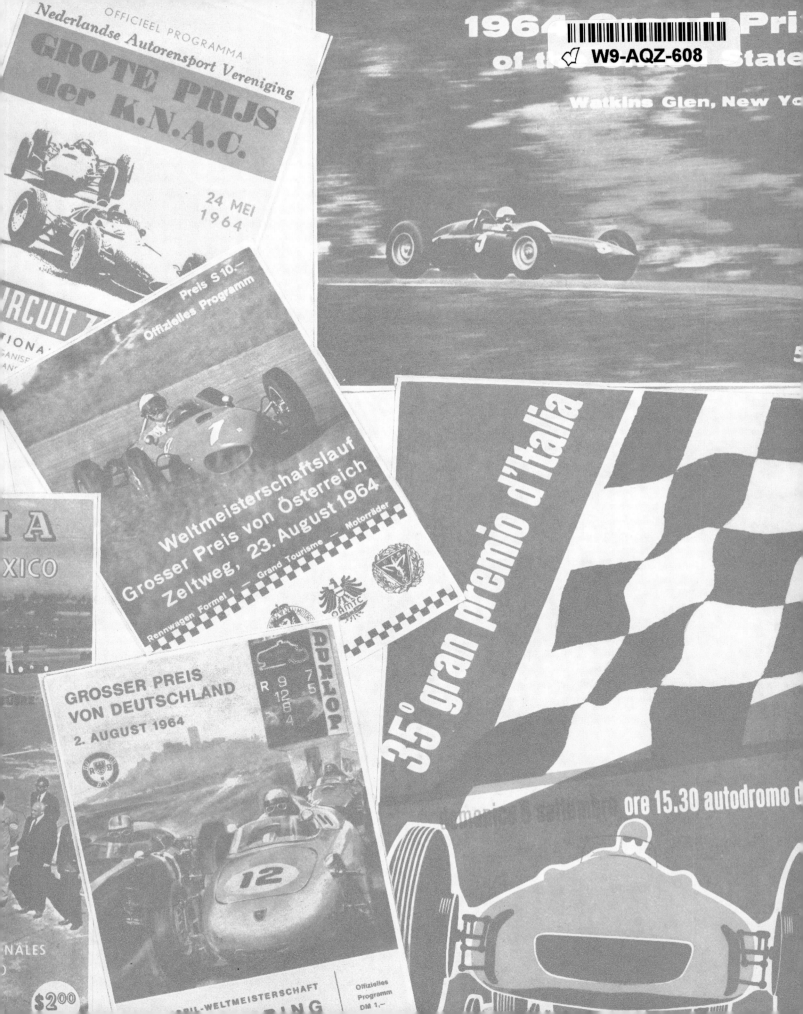

W9-AQZ-608

OFFICIEEL PROGRAMMA

Nederlandse Autorensport Vereniging

GROTE PRIJS der K.N.A.C.

24 MEI 1964

1964 Grand Prix of the United States

Watkins Glen, New York

Preis S 10,—

Offizielles Programm

Weltmeisterschaftslauf
Grosser Preis von Österreich
Zeltweg, 23. August 1964

Rennwagen Formel 1 — Grand Tourisme — Motorräder

35° gran premio d'Italia

ore 15.30 autodromo d

GROSSER PREIS
VON DEUTSCHLAND
2. AUGUST 1964

DUNLOP

R 9 7 5
12 8 4

MEXICO

IA

NALES

$2.00

SIL-WELTMEISTERSCHAFT
RING

Offizielles Programm
DM 1,—

GRAND PRIX
World Championship

Some previous books by Louis T. Stanley:

Grand Prix World Championship 1963
Grand Prix World Championship 1962
Grand Prix World Championship 1961
Grand Prix World Championship 1960
Grand Prix World Championship 1959

People, Places and Pleasures
The Cambridge Year
Journey Through Cornwall
The Old Inns of London
Life in Cambridge
Germany After the War
The University City of Cambridge
The Beauty of Woman
The London Season
Collecting Staffordshire Pottery

The Book of Golf
Swing to Better Golf
The Golfer's Bedside Book
Master Golfers in Action
This is Golf
Green Fairways
Fresh Fairways
This is Putting
Fontana Golf Book
The Woman Golfer
The Golfing Year, 1951
The Golfing Year, 1952
How to be a Better Woman Golfer
The Faulkner Method
Golf As I Play It
Golf As I See It

Lawn Tennis
Los Campeones de Tenis en Accion
Style Analysis
Rugby Football

Sports Review, 1951
Sports Review, 1952

GRAND PRIX

The 1964 World Championship

Text and Photographs by
Louis T. Stanley

Foreword by
John Surtees

Doubleday & Company Inc. · Garden City, New York

Doubleday edition 1965
Copyright © Louis T. Stanley 1965
Library of Congress Catalog Card Number 62-5391.
Printed in Great Britain

Contents

Foreword by John Surtees
1964 World Champion

The camera-laden figure of Louis Stanley is to be seen at every race track and he is unique in being involved at almost every level in the management of one of the most efficient and competent racing organisations in the world.

There is no doubt that he has also become one of the most controversial figures in the field of Grand Prix writing, due to his fearlessly outspoken comments on race-course personalities. These comments and lines, scathing and critical as well as complimentary and friendly, have been levied on drivers, pressmen, organisers and managers alike.

During the early days of my relatively short period in motor-racing, I had at times doubted the sincerity of some of his statements. But now having had the pleasure of talking to him on a wide variety of subjects—for he is most entertaining and well informed on the broadest possible canvas—I have nothing but the highest regard for him. To have the courage to speak his mind without concern for the popularity (or the reverse) that it brings, is a quality enjoyed by very few.

This book brings the atmosphere, and almost the distinct smell, of the motor-racing circus and, by his enquiring way Louis Stanley has captured the real story of the game.

Motor-racing is not merely the drivers but is so much more the people who go to make up a team and who are only too often indistinct figures in the background. He has brought them to their rightful place by the clear and incisive use of his camera and his pen.

What is left unsaid is admirably supported by the naturalness of his photography.

All this, I believe, adds up to produce a book which, whether one agrees with the written or pictorial comments or not, makes thorough good reading and a valued addition to the enthusiast's library.

To my Wife

Introduction

1964 was an interesting season with fluctuating fortunes. The excitement was sustained to the last few seconds of the final Grand Prix in Mexico. There was nothing one-sided about the results. Grand Prix races, with the exception of Bandini's Austrian success, were shared by the top four drivers. Graham Hill won Monaco and U.S.A.; Dan Gurney—French and Mexican; Surtees—German and Italian; Clark—Dutch, Belgian, and British. It looks neat and tidy with honours evenly distributed. At least that is how the records will suggest to posterity. They can give no indication of the excitement and drama of Spa-Francorchamps, when Gurney, the decisive, clear-cut leader dropped out a few minutes from the end; how Graham Hill broke down on the last lap with the race in his pocket; and McLaren had to coast down to the finishing-line, only to see victory snatched away by inches as Clark took the chequered flag. Statistics can give no hint of the tension at Monaco when Graham Hill began the last lap in the lead, but with no oil pressure. On that occasion his luck held and the B.R.M. won for the second successive year. Good fortune was not present at Monza. His B.R.M. never left the line. It was left to Surtees to blaze the trail in close company with Gurney, Clark and McLaren. This particular Grand Prix produced some of the keenest wheel-to-wheel duels of the season. It extended throughout the field. The standard of driving was high, there were no dubious tactics. Every man seemed inspired—from the leaders to the backmarkers. A highly appreciative and excitable Italian crowd got full value for their money, plus a Ferrari victory and a Milanese in third place. In moments such as these the antics of a highly partisan following add to the colour of the scene. By comparison Holland was dull. Clark drove a flawless race, but he led from start to finish and was never seriously threatened. That was not his fate at Rouen. The Lotus broke down and Gurney went on to win, poetic justice after being robbed in Belgium of deserved victory. The British Grand Prix found a new home at Brands Hatch. It was a refreshing change, an excellent circuit and organ-ised with imagination. The race carried the dual, though somewhat meaningless title of European Grand Prix, and produced an unyielding struggle between Graham Hill and Clark. Lap after lap the B.R.M. was in striking distance of the Lotus. On this occasion Hill's strategy did not pay dividends. He left his challenge too late, instead of taking the lead early on. Austria produced a mixed bag. The circuit was so rough and uneven that mechanical failure robbed the field of all the favourites. Retirement rate was exceptionally high, including a nasty spill that burnt out Phil Hill's Cooper, happily without harm to the American. Bandini emerged the victor in this battle of the toughest machinery. Germany saw a repeat win for Surtees. This was his best race of the season. Nürburgring is an exacting examination of skill and stamina. He has both as was demonstrated in brilliant fashion. Successive wins in this hard race is no mean achievement. Watkins Glen saw another repeat performance. This time it was Graham Hill, who gained the verdict after a typical concentrated exhibition of faultless driving. Mexico produced a dramatic finish that was almost unbelievable. Three men could have won the title. Of these Graham Hill was the first to be eliminated through a shunt by Bandini (of which more later). Clark was then lined up for victory and the World Championship. His lead looked unassailable until the last lap. Unknown to the pits, his Lotus was losing oil pressure. Just as he began the final lap, he threw both arms in the air, a gesture of anguish. The Championship was barely two minutes away, but it could have been twelve months for he knew the Lotus would not finish. His fears were justified. Gurney won the Grand Prix of Mexico. Bandini slowed down and allowed Surtees to move into 2nd place, which was suffici-ent to give him the 1964 World Championship.

Critics have said that Surtees was lucky. No doubt he was. The same could be said about Clark at Spa. Any man who wins the World Championship must enlist good fortune on his side. The "breaks" supply that extra-plus which makes all the difference between winning and

losing. In Surtees' case it played a very small part. At the beginning of the season the Maranello cars were disappointing. The fault was due to Ferrari's policy of putting Grand Prix development requirements low down on his list of priorities. At Rouen any serious thought of winning the title would have been laughable. Surtees was thoroughly fed-up and had some plain speaking about the unsatisfactory state of affairs. His words appeared to have an effect. The Ferrari looked more competitive at Brands Hatch. In Germany it became a winner, again in Austria, again at Monza. The tide had turned in a big way. Surtees began to drive with even greater determination. He worked hard for success, and richly was it deserved. His three rivals were disappointed. Clark drove in the immaculate fashion we expect; Hill, poker-faced and grim, wrung every ounce of power from the B.R.M.; Gurney personified unruffled confidence. Either of the first two could have won. The third deserved to win. Elsewhere I have given the world ranking of drivers for 1964. It is a task that permits endless permutations. A weakness of the World Championship table is that of necessity it can give no credit to a driver who does not finish in the first six places. The complete domination shown by Gurney throughout the Grand Prix at Spa counts for nothing. Mechanical failure a few minutes from the end of a long, gruelling race wipes out the value of a magnificent performance. The French journal *l'Equipe* published their table of the best drivers of 1964. In it Gurney is listed No. 10 behind Bonnier, Ginther, Arundell, Bandini, McLaren, Brabham, Surtees, Clark and Graham Hill. I do not know the Frenchman who worked out this order of merit, but it would suggest that he was not present at any of the 1964 Grands Prix. To place Gurney at 10, one place above Vaccarella, is ludicrous. Provided the Brabham–Climax can be clear of mechanical troubles, the Californian would be a good bet for the 1965 World Championship.

Much will depend, of course, on the development work put in by Ferrari. If the pattern is the same as in 1964, the odds are against Surtees retaining his title, but having won the Constructors' Championship, Enzo Ferrari may follow a more progressive Formula One programme. If he does, then Surtees is going to be a difficult man to beat. Coventry-Climax had a lot of trouble with accessories failing. Even so, there are signs that the Coventry-Climax V-8s are very near the limit of their potential development. The same might be said of B.R.M., though every team has something up its sleeve for a new season. A little weight off here, modifications, fractional increases in power, improved road-holding—in fact, all the familiar jargon, full of promise that so often evaporates as soon as the cars are on the grid. Potentially the most dangerous is undoubtedly the combination of Clark and the Lotus–Climax. If the car holds together, there is always the possibility of that lightning start, a first lap lead that is never relinquished until the chequered flag drops. Most interesting of all will be the performance of the Honda. After a hesitant start, the car improved immensely. The fuel-injected V-12 engine and gearbox looked promising. Doubtless during the off-season months attention will turn to road-holding, braking and over-heating problems.

Cure these and the title might easily take a trip East, though to do so a first-class driver will need to be recruited.

1964 saw the death of Earl Howe at the age of 80. His racing career had become almost a legend in his lifetime. An outstanding figure in the sport, he was virtually the last of the old-type amateur drivers. He has been succeeded as President of the British Racing Drivers' Club by the Hon. Gerald Lascelles, an admirable choice with considerable knowledge and boundless enthusiasm. Among the items of general interest, a long-drawn-out legal argument over the Monza crash of 1961 was finally concluded when Jim Clark was notified by the office of the State Public Prosecutor in Italy that he had been completely vindicated. The ruling stated that "pure mischance caused the accident". There had been rumours that Clark would not be able to drive in the Italian Grand Prix for fear of arrest. At Monte Carlo, Joakim Bonnier, President of the Grand Prix Drivers Association, presented the organisers of the Monaco Grand Prix with the Association's annual Trophy for the best organised Grand Prix of 1963. This particular award had been introduced in recognition of the work put in by the organisers and as an incentive for even greater efficiency it was decided on a basis of points award to the maximum of ten for eight headings: 1. Safety arrangements for drivers and spectators; 2. Standard of flag marshalling; 3. Accuracy of timekeeping; 4. Ambulance, fire-fighting and medical services; 5. Condition of circuit; 6. Adequacy of practice periods; 7. Ease of entry and exit to pits and paddocks; 8. General attitude of organisers. Each G.P.D.A. member gave his marks after each World Championship Grand Prix. Apparently the results were closer than might have been anticipated: 1. Grand Prix of Monaco—56·90; 2. Grand Prix of U.S.A.—56·80; 3. Grand Prix of Holland—56·66; 4. Grand Prix of Mexico—56·10; 5. Grand Prix of Italy—53·38; 6. Grand Prix of Belgium—53·00; 7. Grand Prix of France—50·75; 8. Grand Prix of Great Britain—50·32; 9. Grand Prix of South Africa—50·27; 10. Grand Prix of Germany—49·50. I am sure that considerable thought was given to such ranking, in the same way that someone puzzled out the drivers' list in *l'Equipe*. Judged by the same standards but with a different outlook my list would vary from No. 5 downwards. Anyhow for 1964 I would name the Grand Prix of the United States as being the best organised in every detail, with the exception of one marshalling blemish. Even with that black mark, they should be clear winners. 1964 almost saw a racing landmark removed. The Continental Correspondent of *Motor Sport* is Denis Jenkinson, who was navigator to Stirling Moss on the 1955 Mille Miglia. Jenkinson is a well-known figure at all the Formula One events, easily picked out by somewhat shapeless clothes and a healthy, bushy beard. He bet Sydney Allard that an Allard Dragon Dragster couldn't beat a 12-sec. quarter mile. If it did, his beard was the penalty. John Hulme clocked 11.92 sec. with the machine. Allard relented, but Jenkinson had to beat this time at the British Drag Racing Association's practice day. To his credit the little journalist registered the necessary speed. His beard was saved.

It was disappointing because many people are curious to know what he looks like without the fungus.

Now for minor irritations, peas under the mattress, that ought to be removed if Grand Prix racing is to be healthy. The sport has a small and incomparable *élite*. That is its strength, but at the same time a source of embarrassment. The worst of getting to know people thoroughly is that it makes criticism more difficult. Also, the very fact of knowing them intimately makes us see personal failings rather more sharply than perhaps we have a right to see—someone who, after all, must be judged by his driving and not by his private life. On the other hand, not so very long ago I was continually reading about the personal reminiscences of some motor-racing figure . . . what at school he learned from his mates, and what in later life he taught his women. I appreciate that in the case of world figures like Cellini, Rousseau, Wagner and Pepys these details may have interest. But motor-racing figures are not of this size and I have enough Victorian fastidiousness to believe that unless a man is of such stature, his sex experiences should be kept to himself. Such biographical insights become as boring as Frank Harris in a crash helmet.

In the past I have welcomed the part played by the Grand Prix Drivers Association. It is now five years since it was founded on the occasion of the 18th Grand Prix of Monaco. Many of its deliberations have been worthwhile. It seeks, among other things, to improve circuit safety and create closer co-operation with the C.S.I. All this has been done, but there is still room for improvement in its work. A general criticism is its tendency to be unbusinesslike with too few doing too much of the talking. That, at least, is what I have been told by some of its members. Maybe it is true. If so, the remedy is in their own hands. I do know that the Association hesitates before taking one of its own members to task. That was told to me by its President. I can understand the hesitation. Such a possibility presents several delicate problems. On the other hand, a toothless debating society is not much good. Every sport needs discipline and occasionally disciplinary action. It is merely an academic question as to who wields the stick. In domestic matters I would prefer the Association to control its own members rather than have outside organisations enforcing law and order. I content myself by airing an irritation that occurs every season and upsets many people quite unnecessarily. At the conclusion of the Grands Prix of Holland, France, Belgium, Austria, and sometimes Germany, the promoters go to a great deal of trouble and expense to provide entertainment with a lavish buffet or dinner at which the prize-presenation takes place. Trophies and cheques are handed over by local dignitaries. Speeches are made. Organisers do everything in their power to extend the warmest hospitality to drivers and team personnel. Invitations beforehand give the time and place. Year after year the drivers are guilty of shocking bad manners by arriving late without warning or apology. Naturally the proceedings cannot be held up. Catering requirements mean that food is ruined if kept waiting, so speeches are made, compliments are paid, and trophies are given to the Mayor for presentation only to find that none of the principals are present. Twice in 1964 they turned up in a bunch after their names had been called. Again no apologies, the incident being treated like a joke. Boorish behaviour is inexcusable. If it is impossible to be present at the stated time, then the G.P.D.A. President ought to be informed so he can tell the organising hosts. I might add that until the prize-ceremony is over, the drivers are contracted to appear. In that sense they are paid performers. The obligations of starting-money do not end when the chequered flag drops. Apart from anything else, let each driver imagine his own reactions if he invited some people to a party and they turned up half-way through the meal without any explanation or apology. His own reaction is exactly the same that other people have of him. At the same time it is a reflection on those who represent motor-racing.

Still on the subject of food, race organisers in England could well pay more attention to hygiene. Anyone seeking refreshment in this country will invariably find table-tops bespattered with spilt tea, dirty plates, dirty cups, dirty saucers, no teaspoons, inadequate seating, and probably warm beer dispensed by surly, glaring female teetotallers. There is no excuse for this kind of service. Spectators pay enough for the privilege of watching races that at times leave one unmoved to the point of paralysis. Their ticket ought to ensure clean refreshment tents, clean crockery and toilets that don't stink. Inviting foreign visitors to have a sandwich and a drink is tantamount to a snack in a swill-trough. The stumbling-block is the reluctance of English race organisers to recognise basic obligations.

An important section of the Grand Prix scene is the journalistic group who describe the races in print. On the whole a high standard of accuracy is maintained as readers of Geoffrey Charles in *The Times*, Dennis Holmes of the *Daily Mail*, Basil Cardew of *Daily Express*, Maxwell Boyd of *Sunday Times*, Peter Garnier of *Autocar*, Philip Turner of *Motor*, and Denis Jenkinson of *Motor Sport* would agree. But there are exceptions. It is the primary business of a journalist to be readable. He owes that to his editor, to the buyers of the paper or journal, and, above all, to the sport. Motor-racing is not helped by chunks of basic slang. No journalist has a right to his place of privilege (and to his salary) if he has become bored with the sport in question. Weariness is unforgivable. Those whom motor-racing has turned queasy should quit. I have one such fellow in mind, the motoring correspondent of a well-known paper who not only boasts that he cannot stand motor-racing or any of the people associated with it, but admits that he knows nothing about the sport. His reports confirm that ignorance, whilst his presence on the circuit, or worse still, in a dining-room, is sufficiently unpleasant to recall Sinclair Lewis' violent outburst against a similar type when he said, "what other job is there where an unqualified, ignorant, talentless son-of-a-bitch is allowed to tear your work to pieces—and be paid for it". Such an individual does no credit to his profession.

In 1965 I would like to see qualifying requirements abolished in World Championship races. At present the backmarkers are called upon to drive beyond their limits

and maybe skill to get on the grid. At Nürburgring, Carel de Beaufort tried to get his ageing Porsche round in impossible times in an attempt to qualify and in so doing lost his life. A fairer and safer solution would be for the organisers to invite the number required for their starting-grid, plus a short list of reserves in case of default.

I would like to see the anomalous position tidied-up of non-finishing finishers. It is patently absurd that a car abandoned on a circuit through mechanical failure should be classified as a finisher entitled to championship points. The remedy is simple. If a car fails to cross the finishing-line it should be out of the race and not entitled to any points.

I would like to see the new dummy-grid system of starting to be regularised. At the moment the signal for engines to be started-up is given far too early. It is pointless going to the expense of preparing a car for a Championship race only to see hopes disappear in smoke through some fool of an official causing engines to boil before moving forward to the true grid. Zandvoort and Monza both had ridiculously long delays.

I would like to see improvements in official timekeeping. Accuracy is essential, but there is reason to question many of the times recorded. I would like to see marshals acting more promptly when a car is leaving trails of oil on a circuit. It seems to be nobody's job to do anything on such occasions. I would like to see a revision in the award of Championship points. The winner of a Grand Prix ought to receive 10 not 9, which might prevent a situation arriving in which a driver with a collection of 2nd places would get the title in spite of a rival winning maybe three Grands Prix. I would like to know why the British national press thought so little of a British driver and conceivably a British car winning the World Championship that only one motoring correspondent (*Sun*) was sent to Mexico. There is plenty of talk about Great Britain failing to shine in international sport, but little sign of practical support. I would like to think that we have seen the last of Aintree from a Grand Prix point of view, and that goes for Mrs. Mirabel Topham, whose heart seems to bleed for the unhoused thousands of Liverpool. I do not know George Harriman, chairman of B.M.C., but he seems to be singularly ill-informed if this remark made at a Motor Show luncheon in Grosvenor House is an indication of his outlook . . . "In our opinion, pure motor-racing does not help to improve the breed of a car . . ."!

One final topic. The Mexican Grand Prix produced one of the most controversial races the World Championship has known. It centred round the action of Lorenzo Bandini, whose shunt involving Graham Hill conceivably cost B.R.M. the title. That incident is described in detail elsewhere. As far as B.R.M. are concerned, the matter is closed. An error of judgment occurred. Explanations and apologies were forthcoming and accepted. Some months later the G.P.D.A. attempted to revive the whole business. No doubt intentions were good, but it was foolish to stir-up trouble after such a long interval. If the Association of Drivers wished to hold an enquiry, it ought to have been done within hours of it happening. Moreover, as it was for them a domestic affair, it would have been

politic to have avoided publicity. Views expressed in private with knowledge and authority could only have done good. In a lethal sport like motor-racing, a man's actions during a race are of concern to his fellow-drivers. If a man is at fault, he should be reproved, but I do not think the G.P.D.A. is the body to do so publicly. That responsibility should rest on broader, more impartial shoulders.

If the Bandini incident has done nothing else, it brought to light the urgent need for an international disciplinary committee that has the power to deal with such matters. Every major sport has such a controlling body. The Jockey Club offers a useful analogy. If during a race a jockey is accused of an offence affecting the chances of another entrant, or an objection is lodged, or the stewards raise a query about running form, the result of the race is withheld until the jockey concerned is questioned, evidence heard, and the verdict given on the spot. Similar machinery should exist for motor-racing, particularly during World Championship events. It may be said that such machinery already exists with the C.S.I. With due respect to that venerable body, their methods of tackling such a problem are hopeless. The President of the C.S.I.—Maurice Baumgartner—was present in Mexico at the time of the Bandini incident, but nothing was done, no enquiry was held, no evidence was checked.

A disciplinary committee of three members ought to be present at every Grand Prix. If infringements occur, and the driver accused is found guilty of dangerous driving, penalties should be imposed on the spot. Points should be cancelled and a substantial fine imposed. If the offence is particularly serious, perhaps causing another car to crash and maybe injuring a driver, he should be suspended. If a car crashes through mechanical failure and it is later found that the constructor or owner allowed the machine to be raced with a part weakened through an attempt to shed weight, permission to race should be withheld. These but touch the fringe of instances that frequently occur. At present the drivers escape unpenalised. Had such punitive measures been in force, I can think of at least two lives that might have been saved during the past few years.

It is possible that the reader may not know the structure of the international body that controls the sport. He is forgiven. At times many people wonder if such an official group exists. The parent is the Fédération International de l'Automobile. The Commission Sportive Internationale is a subsidiary committee of the F.I.A. One criticism is that the delegates are elderly men out of touch with current trends and unrepresentative of the racing world. Like most censure, it is true in part. The F.I.A. has about seventy countries affiliated to it, but only twelve have seats in the C.S.I. Five are permanently reserved for the key countries—Britain, America, Italy, Germany and France. The remaining seven are allocated among the other countries. All the delegates of the C.S.I. have an equal vote. That in itself is a contentious issue. The reason can be seen by listing the countries represented: Belgium, France, Germany, Holland, Italy, Mexico, Monaco, Portugal, Sweden, Switzerland and the United States of America. This means that delegates

representing countries that neither build racing cars nor organise Grandes Epreuves are allowed to exercise voting rights on issues beyond their interest or experience. To be controlled by a body of men so composed is unsatisfactory. The F.I.A. and C.S.I. are important in that they represent a useful cross-section of international opinion and goodwill, but the structure is cumbersome. I would like to think that left to their leisured deliberations, they do no harm. Unfortunately it is not so. As an effective working unit, the C.S.I. is notoriously inefficient and seemingly incurable. Time and again their edicts are divorced from reality. Their handling of the Formula 2 question in 1964 was typical. Assurances had been given that motor-racing formulae would be given a life of at least three years. Unexpectedly the C.S.I. announced the intention of abolishing the existing Formula 2 for 1,000 c.c. machines and substituting a 1,600 c.c. formula based on production power-units. That meant the life of the existing formula was chopped to two years as the 1,600 c.c. scheme was to operate from January 1966. This casual announcement paid no attention to broken promises, nor was there any concern about the thousands of pounds that firms would waste because of their decision. There was total disregard for the case of the constructors. In such an atmosphere it is impossible to plan and budget ahead when vital regulations are changed without warning or foresight. The C.S.I. members do not stake huge sums of money on the sport they seek to control. They are not designers, constructors, technicians, mechanics, workpeople or drivers. They do not depend on the sport for their livelihood like all these categories. They are merely faceless, anonymous delegates who sit on their bottoms at meetings convened in the capitals of Europe and scrape around for often meaningless and valueless scraps of legislation. I have left until last the *bonne bouche* of 1964 that swallows up the rest. On the evening of the first training session for the vital Mexican Grand Prix, when the title was within the grasp of Graham Hill, Clark and Surtees, the President of the C.S.I.—Maurice Baumgartner—announced that officially Clark was only entitled to 2 points at Monaco—not 3. That laconic statement meant that Clark was eliminated from the title hunt. Immediately protests were made. How could it be possible that such a mistake could be made at the *first* Grand Prix and the fact be withheld until the *last* Grand Prix, roughly six months later? Why had the C.S.I. just realised the discrepancy? Why wait until the end of the first practice? and so on. To cut a long story short, telephone calls to Paris clarified the situation and the worthy President had to eat his words. Someone remarked it was a pity they didn't choke him.

Such pearls of wisdom originating from these C.S.I. deliberations remind me of one of Beatrice Lillie's unrealised ambitions . . . to put on a sketch showing a heavily panelled hall, complete with sweeping staircase and elaborate tapestries. The actress, in black velvet, reclines on a chaise-longue. A bell tolls. Rising, pale as death, she takes a lamp and goes up the stairs. At the top, she parts the heavy drapery and peers into the night. Then, slowly shaking her head . . . "P—ing down as usual," she murmurs, and disappears out of sight. An appropriate description of C.S.I. attempts to control Grand Prix racing. Rarely has so little been achieved by so many.

Grand Prix of Monaco

100 LAPS HOT AND SUNNY 194 MILES

The first round of the World Championship took us to the Riviera setting of Monte Carlo, the most colourful race in the calendar. It has everything for driver and spectator. There is always tension and incident, for though it is the slowest race, the speeds achieved on the narrow twisting streets are extremely fast. Since the race was inaugurated some 36 years ago, no Grand Prix driver has been killed, which says a great deal for the experienced skill of the 16 men who do battle on this trickiest of circuits. There had been four earlier non-Championship Grands Prix, useful warming-up clashes that gave some indication of the machinery available. Results suggested that the Championship was going to be close with evenly-matched cars. The four races had produced

Opposite: Louis Chiron, an active link with the Golden Age of motor-racing, drove against such men as Varzi, Caracciola, Fangio, Villoresi and Farina. His personal race record makes brave reading. As a lad he worked in the Hôtel de Paris in Monte Carlo. Today, aged 66, Chiron presides as Race Director for the Grand Prix of Monaco.

Right: Another veteran racing driver, debonair Baron de Graffenried (centre) has a technical point explained by one of the most promising of younger drivers, Joseph Siffert of Switzerland. Alongside the massive cars driven by de Graffenried, current racing machinery looks minute, although the potential power is far greater.

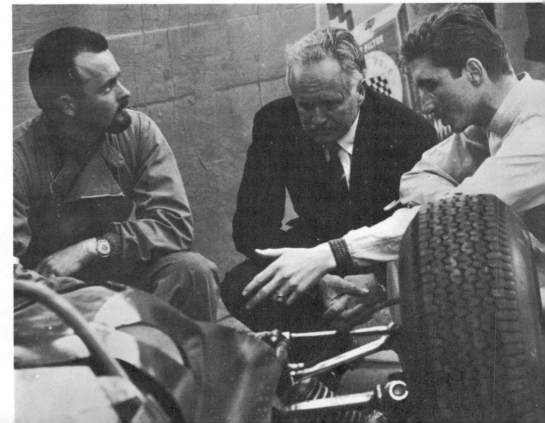

An attempt to reintroduce Dundreary Whiskers, or Monaco's counter to the Beatles.

Raymond Mays (right) reminisces with de Graffenried.

Italian concentration by Ugolini (left) and Romolo Tavoni (right) former Ferrari team manager.

Not much escapes the eye of Dick Jeffrey of Dunlop's (left).

Innes Ireland—battered and bruised, but willing.

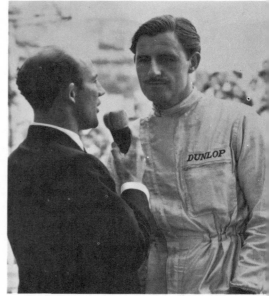

Stirling Moss interviews Graham Hill.

Tim Parnell ponders a tricky one.

The beard and the hat—journalists Denis Jenkinson and Henry Manney on duty.

Mary Anne Innes-Ker examines Richard Attwood through tinted glasses with Raymond Mays in attendance.

J. H. van Haaren (right) *presiding genius of the Dutch Grand Prix, is a frequent onlooker at the Monaco race. Tall, dignified and grave, his views on Grand Prix racing are informative and expert. During the war he played a distinguished part in the Dutch Resistance Movement. Is excellent company, sometimes delightfully indiscreet, but always fair in his observations.*

Richie Ginther, diminutive racing driver, decides to put Darwin's theory to the test.

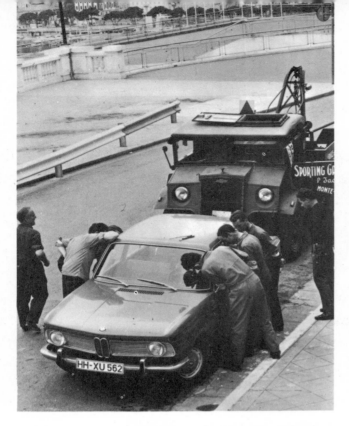

The usual hold-up before the race starts. Somebody parks his car in the middle of the track.

four makes of car as winners. Surtees had won the Syracuse Grand Prix in the new V–8 Ferrari; Clark had taken Goodwood with the Lotus–Climax; Brabham came first in the Aintree 200 and Silverstone International Trophy, though the latter only by half a car length from Graham Hill's B.R.M. Innes Ireland had been successful in the curtain-raiser at Snetterton. Crashes had interrupted several build programmes. Graham Hill was lucky to escape death at Snetterton when the brand-new B.R.M. water-skied in torrential rain and was virtually written off. Team Lotus saw their new Type 33 chassis wrecked at Aintree, fortunately without injury to Clark. Ginther had not been so lucky. Not only did he smash his B.R.M. at Aintree, but he finished in Walton Hospital with broken bones and bruises. Ireland also wrote-off a car at Silverstone. Rob Walker's new Brabham–B.R.M.V–8 had been burnt-out during the International Trophy. Accidents such as these upset plans with the result that tried and familiar machinery appeared for the Monaco Grand Prix.

A week earlier rumours had circulated that no British cars would be on the grid through an argument about the hoary question of qualifying for starting-places. Jacques Taffe, Commissaire Général attended a meeting of constructors and team managers in the B.R.M. marquee at Silverstone. Agreement was reached amicably. Everyone accepted the qualifying clause provided it was scrapped in 1965. Twenty-three cars entered, but non-appearance and one shunt reduced the disappointments to three, Amon, Revson and Collomb.

The previous season's lap record is usually the target when practice begins. The time was 1 min. 34·5 sec. set up by Surtees in the V–6 Ferrari, whilst Clark had clocked a testing lap of 1 min. 34·0 sec. With the exception of Gurney and Clark, who were on their way back from Indianapolis, almost everyone went out. The pace was set by Brabham, Surtees and Graham Hill. In the end Surtees had fastest time with 1 min. 35 sec., Brabham fractionally slower on 1 min. 35·1 sec., with Graham Hill 1 min. 35·3 sec. Just before the training period ended, Ireland came into the chicane with a locked rear wheel. The Lotus hit a post and finished up a horrible mess. Ireland was fortunate to escape with bruises. It

The first major international event to be held for the new Formula 3, was won in decisive fashion by Jackie Stewart. There were several incidents, such as Jean-Pierre Jaussaud (45) hitting the steel barrier, and Arthur Mallock (67) heading for the Hôtel de Paris entrance.

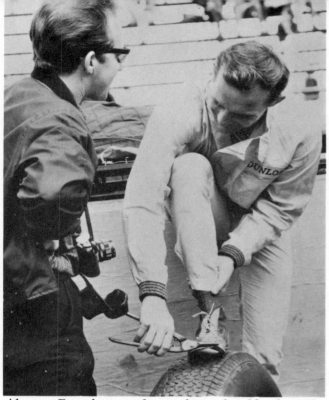

Above: *Enough to make a chiropodist blanch. Mike Hailwood tries a self-pedicure.*

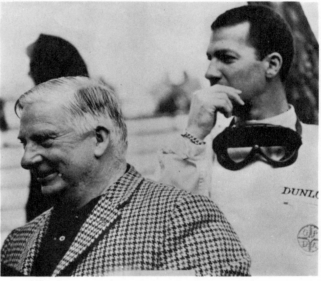

was not his week, for a few days earlier his car had been wrecked at Silverstone, whilst only twenty-four hours before he had been involved in a head-on collision in a private car at Nice airport. As he was driving the wrong way round an island, there was hardly cause for surprise, but it was a nasty experience. In the pits, he told me he had so many bumps and bruises he didn't know which one ached the most. Clark reached the pits just too late to register a time, an irritating postscript to an abortive trip to America. He had gone all the way to Indianapolis only to find the car was not ready, but he made up for lost time before breakfast the next day. First out, he quickly had times in the 1 min. 34 sec. range, finally settling for 1 min. 34 sec., Brabham came within 0·1 sec., whilst Graham Hill had 1 min. 34·8 sec. Surtees had gearbox trouble and was out in the spare V–6 car. It was good to see Phil Hill in a comparatively trouble-free car. Monte Carlo is usually to his liking. This time he clocked 1 min. 36·7 sec. Bandini and Arundell were both impressive. McLaren had an alarming experience as practice was ending. The right-hand steering arm of his Cooper broke,

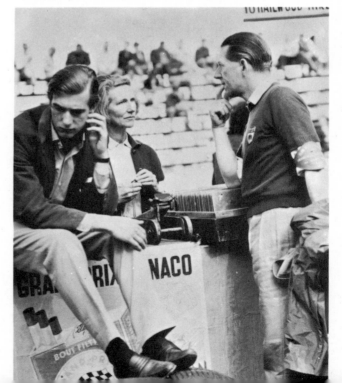

Chris Amon, Joakim Bonnier and Rob Walker share a rash of nail-biting.

Above: *Royal reaction to excitement. Prince Rainier bites his lower lip, Princess Grace is more vocal.*

the car hit the kerb, damaged the front suspension and meant that the New Zealander would be in a 1963 Cooper for the race. As an insurance against a repetition of the mishap, Cooper's mechanics fixed a steel jacket on the cast steering arms of Phil Hill's car. There was overtime in Chapman's camp as Arundell's car was being switched to 13-in. wheels, whilst Parnell's men had plenty to do making Hailwood's Lotus raceworthy after its crash against a wall. Excitement during the final practice session centred on the qualifying group. Only 16 cars could be lined up. Nineteen entries were still circulating. Collomb tried hard, but could not improve on 1 min. 41·4 sec. Anderson did surprisingly well with 1 min. 38 sec. Siffert claimed last place with 1 min. 38·7 sec. Revson and Amon joined Collomb in the pits. Pole position went

An innovation was a display by drum majorettes who looked far smarter than the American Navy band that perambulated in the pit area.

to Clark with Brabham next to him on the front row. Graham Hill and Surtees shared 2nd berth with equal times of 1 min. 34·5 sec.

Race day had all the Monégasque ingredients that make this Grand Prix unique. The hills become ant-heaps of spectators looking down on the twisting course. The harbour looked gay, the Mediterranean almost equalled the blue of its postcards. One grandstand might have been an annexe of the U.S. aircraft-carrier *Enterprise* for it was manned by a solid mass of sailors. An air of gaiety was infused by the appearance of a flurry of majorettes, pleasant little wenches who looked like Girl Guides in fancy dress. We were also regaled by the U.S. Navy Band, who marched as if they had been trudging for days. The circuit was opened by Prince Rainier and Princess Grace completing a lap in a 2·6-litre Alfa Romeo Spyder, and everything was set for this waiting grid:

The split-second before the flag drops. Few starters can time this nerve-racking signal so accurately as Louis Chiron. 1964 was no exception. The count-down was clear and incisive. The field shrieked up the hill without incident or accident.

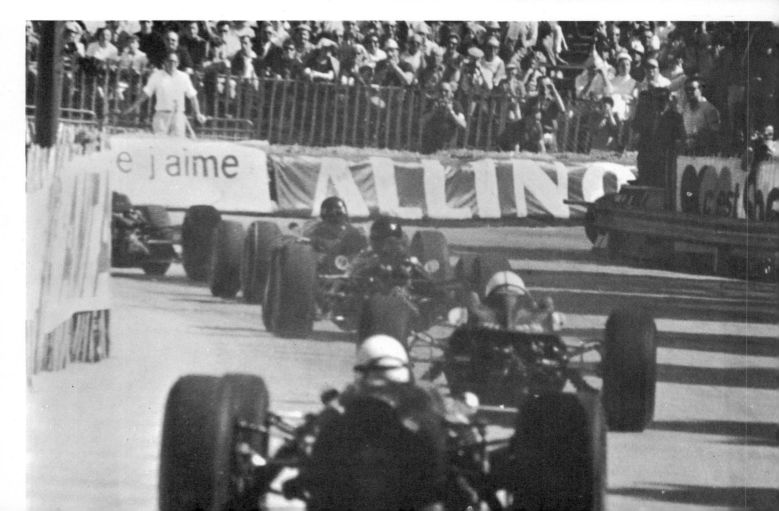

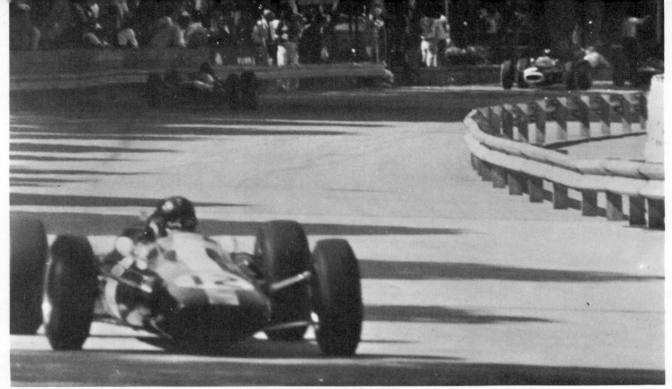

Jim Clark drove magnificently in spite of the handicap of a broken anti-roll bar.

12
J. Clark
(Lotus–Climax)
1 min. 34·0 sec.

5
J. Brabham
(Brabham–Climax)
1 min. 34·1 sec.

8
G. Hill
(B.R.M.)
1 min. 34·5 sec.

21
J. Surtees
(Ferrari)
1 min. 34·5 sec.

6
D. Gurney
(Brabham–Climax)
1 min. 34·7 sec.

11
P. Arundell
(Lotus–Climax)
1 min. 35·5 sec.

20
L. Bandini
(Ferrari)
1 min. 35·5 sec.

7
R. Ginther
(B.R.M.)
1 min. 35·9 sec.

9
P. Hill
(Cooper–Climax)
1 min. 35·9 sec.

10
B. McLaren
(Cooper–Climax)
1 min. 36·6 sec.

19
J. Bonnier
(Cooper–Climax)
1 min. 37·4 sec.

16
R. Anderson
(Brabham–Climax)
1 min. 38·0 sec.

4
M. Trintignant
(B.R.M.)
1 min. 38·1 sec.

15
T. Taylor
(B.R.P.–B.R.M.)
1 min. 38·1 sec.

18
M. Hailwood
(Lotus–B.R.M.)
1 min. 38·5 sec.

24
J. Siffert
(Lotus–B.R.M.)
1 min. 38·7 sec.

The cars moved up from the dummy-grid. Louis Chiron semaphored the remaining seconds, dropped the flag smartly and the entire field was away to a clean start. When the cars came out of the tunnel Clark was leading by some 200 yards, but came into the chicane too fast, hit the straw bales, swung across the road, and only by split-second reaction and brilliant driving saved himself from crashing, and a possible pile-up in the bunched cars. These were Brabham, Graham Hill and Gurney, with Surtees and Ginther immediately behind. None of these could make any impression on the Lotus. By lap 9 the gap had widened to 9 seconds, a margin that represented terrific driving, but all was not well with Clark's car. As he passed, something trailing produced a cloud of sparks, the mountings of the rear anti-roll bar had parted from the chassis. If they broke off it could have been unpleasant for the drivers behind and possibly spectators. The stewards were about to give him the black flag when Chapman decided to call the car in. Ironically during that lap most of the trouble had broken off without damage to anyone. Only one tubular link was left to be removed. When he rejoined the race Gurney and Graham Hill had gone ahead. It was then lap 37. By that time the race pattern had changed considerably. Surtees had gearbox trouble and packed up. Trevor Taylor retired with a punctured petrol tank. McLaren went out with an oil leak. Brabham's fuel-injection went wrong after a terrific performance for thirty laps. Trintignant was in considerable pain through burnt feet. Behind Clark an intense struggle was developing between Bandini and Phil Hill with Ginther just ahead. Arundell came next, then Bonnier was just in front of Anderson and Hailwood, with Siffert trailing at the rear.

In spite of having to adapt his tactics to the different handling characteristics of his car, Clark drove with such determination that a new record was set up on lap 49 of 1 min. 34·0 sec. Graham Hill retaliated on lap 53 with an inspired 1 min. 33·9 sec., which took the B.R.M. past Gurney in the down-hill section. Further back Bandini had forced his way past Phil Hill. Pressure was put on Gurney by Clark, but the American is too experienced to get flustered. Unfortunately the gearbox could not stand the strain. Lap 62 saw the Brabham coasting into

Phil Hill (9) drove well, but retired when the rear suspension of his Cooper-Climax collapsed. He was then lying 4th. John Surtees (21) was plagued with gear-box troubles in the practice sessions. It was this complaint that caused his Ferrari V–8 to retire. Joakim Bonnier (19) circulated consistently round the twisting course. Mechanical troubles accounted for several cars. In the end the Swedish driver crossed the line in 5th place. Both Richie Ginther (4) and Peter Arundell (11) drove with rare determination to finish 2nd and 3rd.

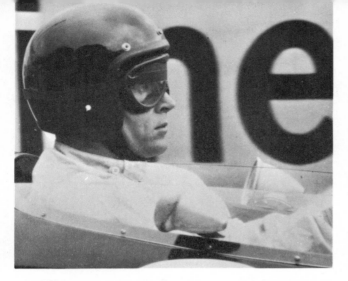

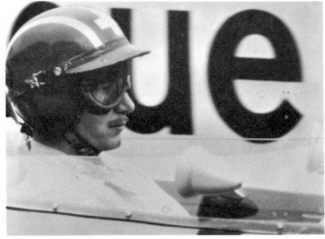

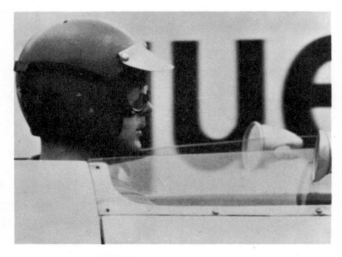

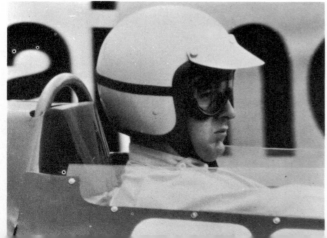

the pits. That left only two cars on the same lap with the B.R.M. leading by 6 seconds. Ginther, in spite of a clutchless B.R.M., held on to 3rd place. Bandini retired. Phil Hill moved into the 4th berth until lap 70 when his race ended with broken rear suspension. That left Arundell, Bonnier, Hailwood and Anderson behind the first three cars.

At lap 80 Hill's B.R.M. was 14 seconds ahead of Clark, who was blowing oil smoke. Ten laps later the two B.R.M.'s went past. Clark had gone. He came into the pits with no oil pressure. Chapman sent him out again in 4th place. Arundell was 3rd, but he too had similar trouble. Graham Hill now led by three laps, but unbeknown to the others, only good fortune enabled him to finish that final lap. His oil pressure was at zero. In the pits we thought that it could well be Ginther who took the chequered flag. The tunnel was watched with mesmerised anxiety. The helmet was unmistakeable. Hill had done it. Every yard to the finish seemed a mile. Ginther came second, with Arundell third. Clark's engine gave up the ghost half-way up the hill on the 96th lap. On his walk back to the pits the crowds gave him a well-earned ovation, but full credit went to B.R.M. For the second year running the Bourne cars had taken 1st and 2nd places. Reliability had paid rich dividends. Hill's drive had been magnificent. The performance was one of his finest wins. Equally commendable was Ginther's 2nd place. There were grave doubts whether the little American would be fit to drive at all, because he was still suffering from the after-effects of the Aintree crash. Cracked ribs were strapped, apart from unhealed cuts and bruises. At the finish he was exhausted, whilst the palms of his hands were raw and blistered. Ginther may be small, but they don't make them tougher. Only six cars actually finished, but under current rules, the following were classified:

Results

1. Graham Hill (B.R.M.) 2 hr. 41 min. 19·5 sec. 72·64 m.p.h. (race record).
2. Richie Ginther (B.R.M.) 99 laps.
3. Peter Arundell (Lotus–Climax) 97 laps.
4. Jim Clark (Lotus–Climax) 96 laps.
5. Joakim Bonnier (Cooper–Climax) 96 laps.
6. Mike Hailwood (Lotus–B.R.M.) 96 laps.

It is always fascinating to study a man's reaction to strain and stress. These studies of Dan Gurney, Joseph Siffert, Peter Revson and Lorenzo Bandini were taken as their cars were approaching the famous Hairpin Bend, where over-doing it can result in a crash or pile-up.

Above: *Whilst the race was in progress, sound tracks were taken along the course.*

7. Bob Anderson (Brabham–B.R.M.) 86 laps.
8. Joseph Siffert (Lotus–B.R.M.) 78 laps.
9. Phil Hill (Cooper–Climax) 70 laps.

Fastest lap: G. Hill, 1 min. 33·9 sec. 74·92 m.p.h. (circuit record).

World Championship

1. Graham Hill	9 points
2. Richie Ginther	6 points
3. Peter Arundell	4 points
4. Jim Clark	3 points
5. Joakim Bonnier	2 points
6. Mike Hailwood	1 point

Constructors' Championship

1. B.R.M.	9 points
2. Lotus–Climax	4 points
3. Cooper–Climax	2 points
4. Lotus–B.R.M.	1 point

Four more studies at the same hairpin. Richie Ginther, Jack Brabham and Bob Anderson are the personification of grim concentration. Brabham's mouth is firmly set. In contrast, Bruce McLaren looks calm and relaxed. Very rarely does he get rattled or ragged. Under severe pressure he remains the same quiet, methodical driver, capable of winning the World Championship with the minimum of showmanship.

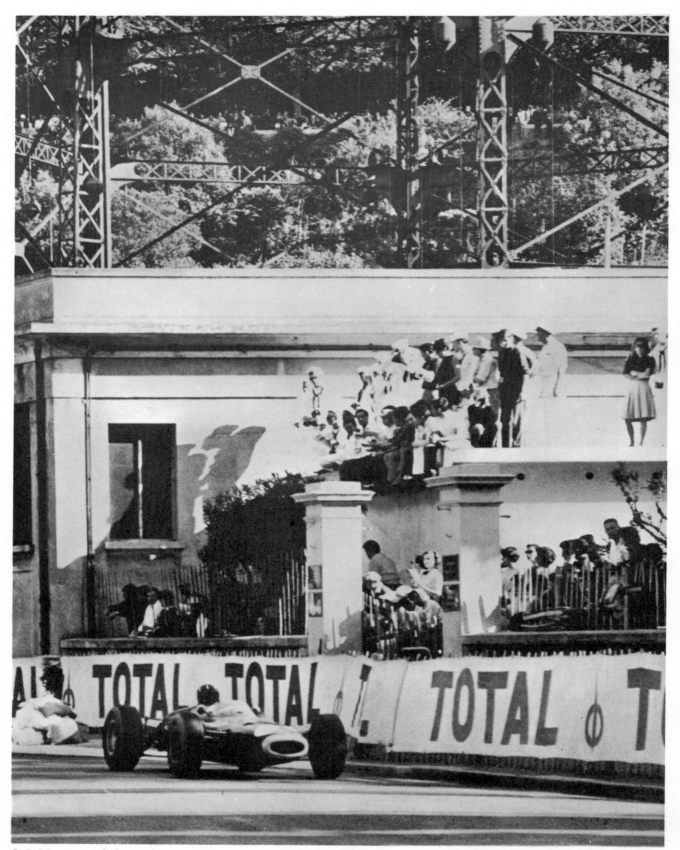

B.R.M. repeated their one, two 1963 victory with Graham Hill taking the chequered flag and Ginther finishing 2nd.

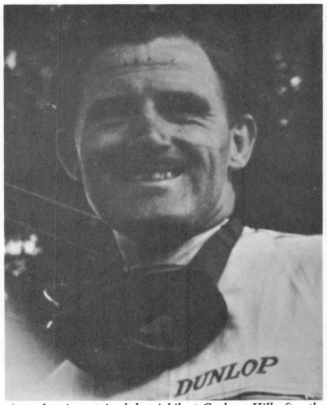

A tired, grime-stained, but jubilant Graham Hill after the presentation by Princess Grace.

Racing over and the crowd invades the pit area. In a matter of hours Monte Carlo returns to normal.

Victory dinner at the Hôtel de Paris with Tony Rudd, Raymond Mays, Richie Ginther, Jean and Louis Stanley.

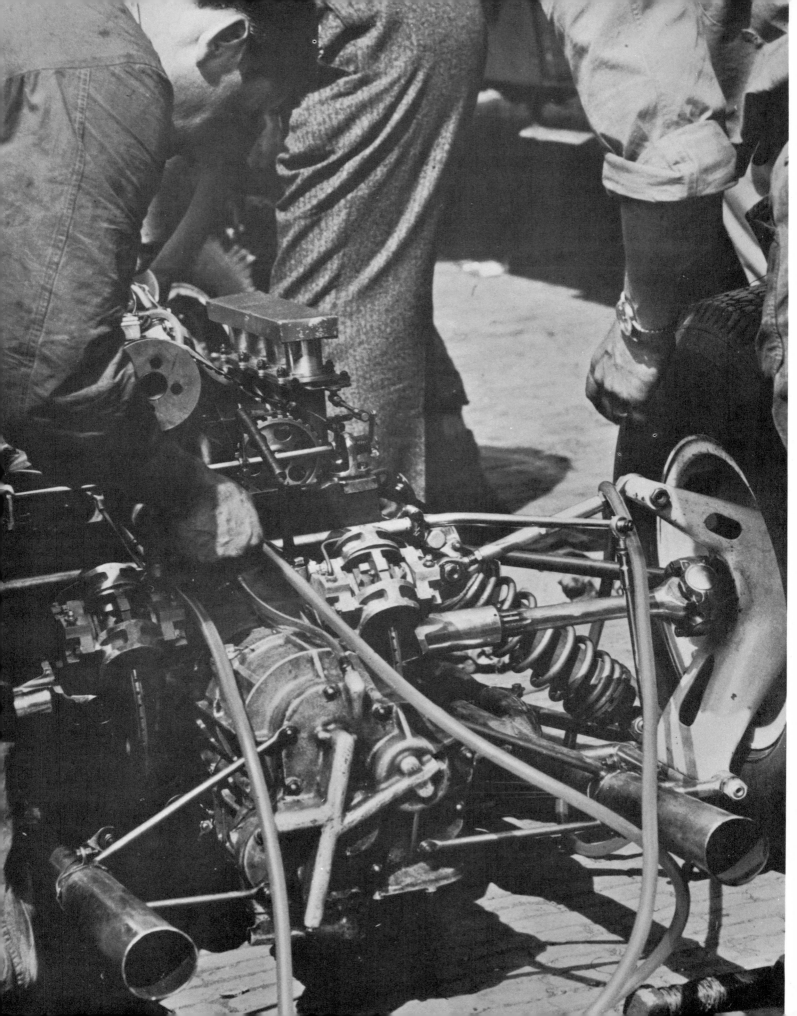

Grand Prix of Holland

| 80 LAPS | VERY HOT | 208 MILES |

There were no qualifying headaches at Zandvoort. The entry was by invitation. The grid was limited to 18 cars. B.R.P. was not represented which meant that Innes Ireland and Trevor Taylor were without a drive. Ferrari sent V–8's for Surtees and Bandini, with a V–6 as a spare. Lotus, Brabham and B.R.M. had the cars used at Monaco. Parnell had Lotus 25's for Hailwood and Amon. Cooper fielded 1964 Coopers for McLaren and Phil Hill. Siffert and Bonnier were in Brabham–B.R.M.'s Centro Sud were B.R.M. Anderson was in a new Brabham–Climax. de Beaufort relied on the old 4-cylinder Porsche.

The lap record was 1 min. 33·7 sec. set up in the 1963 race by Clark. That target was beaten in the first practice session by Gurney who clocked 1 min. 32·8 sec., later cut to 1 min. 31·2 sec., with Clark on 1 min. 31·6 sec.

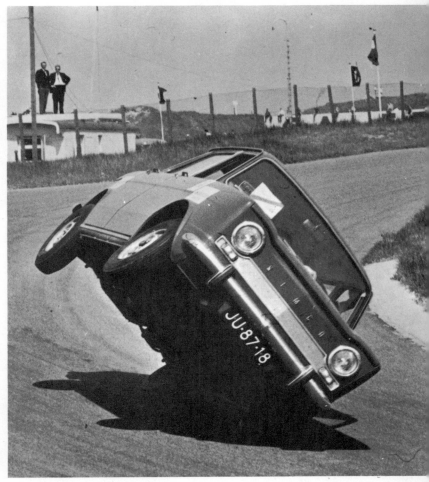

Opposite: Meticulous race preparation is essential if success is to follow, sometimes made difficult at Zandvoort by blown sand.

Right: An exhibition of Simca motoring on two wheels preceded the Championship race.

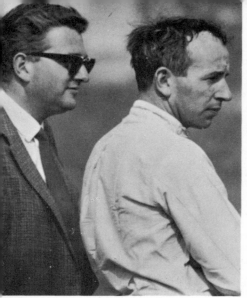
Surtees watches his rivals practice at Hunze Rug.

There are moments when Graham Hill does not personify light-heartedness.

Peter Garnier (Autocar) gives Tony Rudd the facts.

Dragoni and Bandini apply Ferrari pressure on Peter Arundell.

Carel de Beaufort takes a Heineken trip.

Insouciant journalist, Bernard Cahier, plus Mexican belt, and inevitable cameras.

Maxwell Boyd (Sunday Times) carries enough cameras to satisfy any editor.

Giancarlo Baghetti appreciates the finer points of racing.

Joakim Bonnier is still the only bearded driver in the Championship.

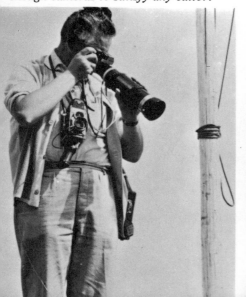

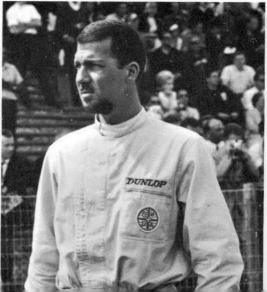

At least such was the official announcement, though pit timekeepers maintained that a mistake had been made. Clark should have been credited with the fastest lap. Brabham had been motoring hard to get a useful time. Light drizzle towards the end of the first session did not help, and the Australian settled for 1 min. 33·8 sec. Immediately after lunch he left for Indianapolis via New York. The trip was caused through the Indianapolis car not being ready for practice a few days earlier. Actually he had been pipped by 5 seconds. That meant returning to England and Holland to get a time for a Grand Prix, back to America, arriving at 10.0 a.m. on the Saturday morning. Fifteen minutes' concentrated driving produced an average of over 152 m.p.h. which ensured his Brabham–Offenhauser qualifying, then the long journey back to Holland, arriving just in time for the race. His few practice laps had given him a 3rd-row berth.

The second practice session produced plenty of activity, particularly in the pits for several cars were in trouble. Both Coopers were handling badly. Baghetti found his Centro Sud B.R.M. jammed in first gear. Bonnier's throttle was stuck open. Hailwood came to rest with a broken crown-wheel and pinion. Surtees was held up with an oil leak. Only Gurney, Clark and Graham Hill seemed happy. All three were grouped together in the 1 min. 31 sec. groove, times that were not improved during the final training period. Surtees was still having trouble, a leaking radiator being the cause. Siffert made an appearance in his new Brabham, but was dogged with teething complaints. The best time he clocked was 1 min. 44 sec. Bandini went out in the new V–8 Ferrari, but came in with a sticking throttle. Maggs had a narrow escape. He took a left-hander too fast, came across the tracks, clouted a post, broke the light alloy hub, rolled down the banking, and finished upside-down, trapped in the cockpit until released by spectators. Before the car turned over, it ploughed through a wire fence, one stout strand grazing the top of Maggs' helmet. A foot lower and he would have been decapitated. The danger of these stout wire-stranded fences ought to be appreciated by the authorities. On safety measures the Dutch officials are particularly helpful, but this is one they seem to have missed. Chris Amon was the fastest independent, with 1 min. 35·9 sec., a curious feature being that he had the identical best time at the end of each practice.

Race day was warm and sunny. Crowds streamed in their thousands to the circuit. Roads from Amsterdam were blocked solid. The sand dunes were black with spectators. On a fine day they make ideal natural grandstands, but in the rain they offer no protection at all. Hailwood's car had a new crown wheel and pinion fitted. Surtees was in the new V–8 Ferrari. Bandini had the older of the V–8's. Maggs was a non-starter. The drivers circulated round the track in Sprites, then 17 Grand Prix cars completed a warming-up lap to take this grid formation:

Ginther decides to have a change of view.

Climbing the Ferrari transporter can be a revealing exercise.

Guess who? The grid number gives the identity.

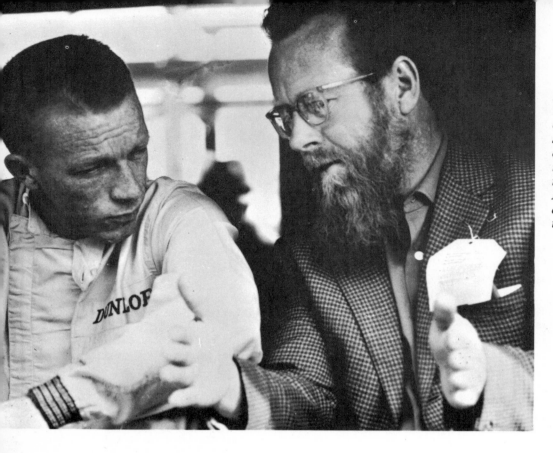

Richie Ginther listens attentively as Denis Jenkinson (Motor Sport) describes the one that got away. In more serious vein there are not many items of motor-racing interest that escape the attention of this ubiquitous journalist, whose monthly reports of Grand Prix racing, items and personalities are model examples of accuracy and technical detail.

6	18	16
G. Hill	J. Clark	D. Gurney
(B.R.M.)	(Lotus–Climax)	(Brabham–Climax)
1 min. 31·4 sec.	1 min. 31·3 sec.	1 min. 31·2 sec.

	24		2	
	B. McLaren		J. Surtees	
	(Cooper–Climax)		(Ferrari)	
	1 min. 33·3 sec.		1 min. 32·8 sec.	

8	14	20
R. Ginther	J. Brabham	P. Arundell
(B.R.M.)	(Brabham–Climax)	(Lotus–Climax)
1 min. 34·0 sec.	1 min. 33·8 sec.	1 min. 33·5 sec.

	4		22	
	L. Bandini		P. Hill	
	(Ferrari)		(Cooper–Climax)	
	1 min. 35·0 sec.		1 min. 34·8 sec.	

10	26	34
C. Amon	J. Bonnier	R. Anderson
(Lotus–B.R.M.)	(Brabham–B.R.M.)	(Brabham–Climax)
1 min. 35·9 sec.	1 min. 35·4 sec.	1 min. 35·4 sec.

		12
*A. Maggs		M. Hailwood
(B.R.M.)		(Lotus–B.R.M.)
1 min. 37·0 sec.		1 min. 36·1 sec.

36	28	32
J. Siffert	G. de Beaufort	G. Baghetti
(Brabham–B.R.M.)	(Porsche)	(B.R.M.)
1 min. 44·0 sec.	1 min. 39·9 sec.	1 min. 38·0 sec.

*Non-starter due to crash in practice session.

Tony Maggs had a narrow escape when his Centro Sud B.R.M. spun, struck a post, lost a rear wheel, ploughed through the sand, collected part of a wire fence, the single strand slicing across the driver's helmet. The car then rolled down a bank, trapping Maggs upside-down in the cockpit. A Dutchman came to the rescue. His first remark deserves to be recorded. Stooping, he peered into the upturned cockpit, saw the inverted driver, and asked, "What do you want?" I cannot repeat Maggs' answer. Maggs is shown here just after being released. Tony Rudd, B.R.M. Chief Engineer, and Graham Hill visit the scene of the incident, and examine the extent of the damage that made it a non-starter in the race.

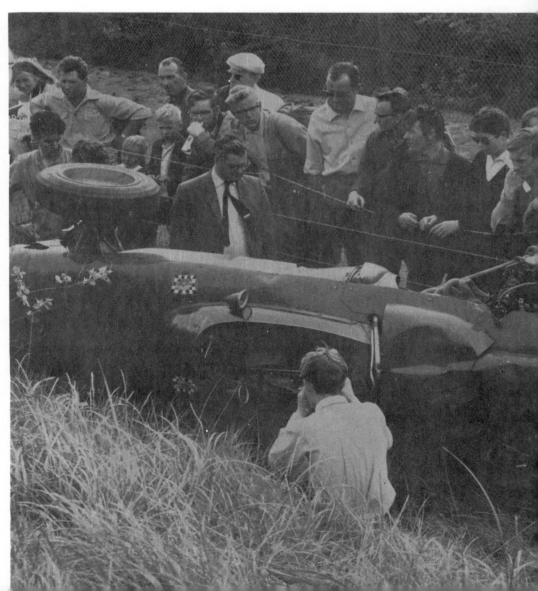

The dummy-grid system was used. Engines were started far too soon. It was four minutes before the cars moved forward to the grid proper. By that time temperature gauges were nearing the danger mark. Fortunately all was well. President van Haaren dropped the flag and 17 cars rocketed away in a cloud of rubber smoke. The three front-row cars reached the first corner almost in line formation. Someone had to give way. Gurney on the inside braked, Clark and Hill shot into the corner first, with the Lotus fractionally in front. From that moment Clark was never headed or threatened. In that sense it was a one-car race. He built up a lead that finally gave him victory by a margin of 53·6 seconds. He had the satisfaction of lapping every car. A lap of 1 min. 32·8 sec. was a new circuit record. His race average of 98·02 m.p.h. was likewise a fresh record which he could have bettered had the pace not been deliberately slowed down in the closing stages. From start to finish it was a classic example of immaculate driving. In that mood both driver and car make an almost unbeatable combination.

The fact that it was a runaway Lotus triumph does not mean the race was dull. There was plenty of excitement in the tussle behind. Gurney and Graham Hill had a terrific wheel-to-wheel struggle, with Surtees joining in with gusto. By lap 10 the Ferrari had overtaken the Brabham. At that time Clark was 4 seconds ahead of Hill. Two laps later the Lotus had broken the circuit record, and the gap widened. Hill still held second place, but the B.R.M. did not sound quite right, whilst Gurney also seemed in trouble. Lap 22 saw the American pull into the pits. He had broken one of the spokes of the steering wheel. As there was no spare, his race was over. Hill's B.R.M. was misfiring badly and Surtees went past into 2nd place. Every time the Bourne car came to Hunzerug the trouble was more pronounced. Fuel vaporization in the fuel pump caused the engine to cut. Hill was

President van Haaren drops the flag and Gurney momentarily leads Clark, an advantage that only lasted seconds.

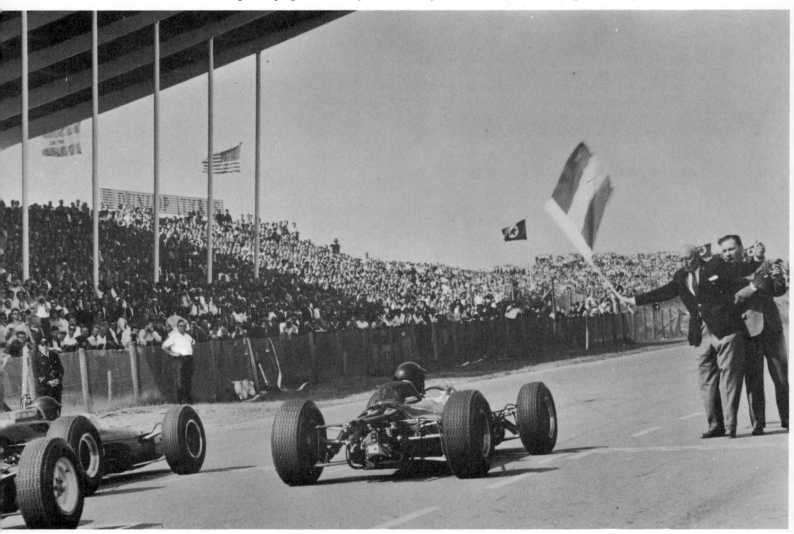

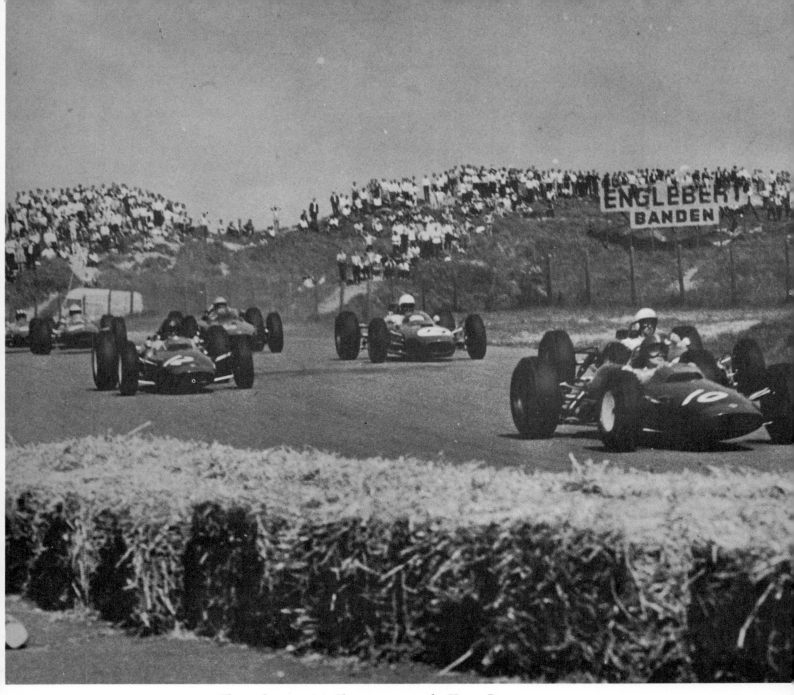

The pack comes into Tarzan curve to the Hunze Rug.

jerked forward, until the vapour bubble passed, fuel came in and the engine cut back again at full throttle, the violent action throwing Hill's head backwards. That would happen several times going up the slope. It was like driving in a rodeo. Precious time was lost every lap. Arundell, who had been circulating in lonely isolation in 4th place, responded to pit signs and began to apply pressure.

About this time Ginther's B.R.M. was affected the same way, only his engine cut out completely and he came to a halt on the circuit. As soon as the pump cooled, the car started sweetly and re-entered the fray without a splutter, but it only lasted a lap. He came into

the pits. Water was poured over the pump and effected a cure that could only be temporary. Lap 40 saw Clark some 30 seconds ahead of Surtees, who held about the same advantage over Graham Hill. Arundell and Brabham were now having a private race. The Australian looked as if he was going to overtake when a broken distributor rotor put him out of the race. Seven laps later Arundell passed Graham Hill. Two laps later and Clark lapped the B.R.M. Lap 50 saw Hill in the pits. Water was poured over the pump and pretty well swamped the cockpit. The trick worked. Hill shot away in a resuscitated car, though in one sense it somewhat damped his ardour. As he accelerated the water shot up his legs

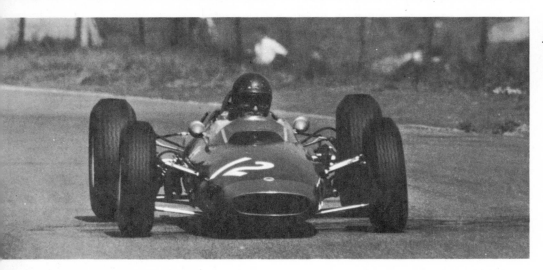

Joakim Bonnier drove a steady race, but was unable to recapture the flair that gave him and B.R.M. the first-ever Grand Prix victory a few seasons ago.

Mike Hailwood gave a spirited performance in the Parnell Lotus–B.R.M. before retiring with a broken crown wheel and pinion, but was credited with 12th place.

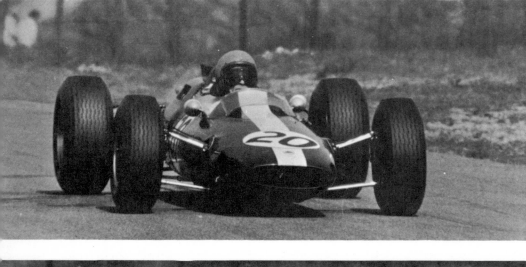

Peter Arundell continued his run of consistent driving that had already produced eight points in his first team Formula One season.

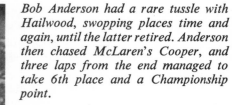

Bob Anderson had a rare tussle with Hailwood, swopping places time and again, until the latter retired. Anderson then chased McLaren's Cooper, and three laps from the end managed to take 6th place and a Championship point.

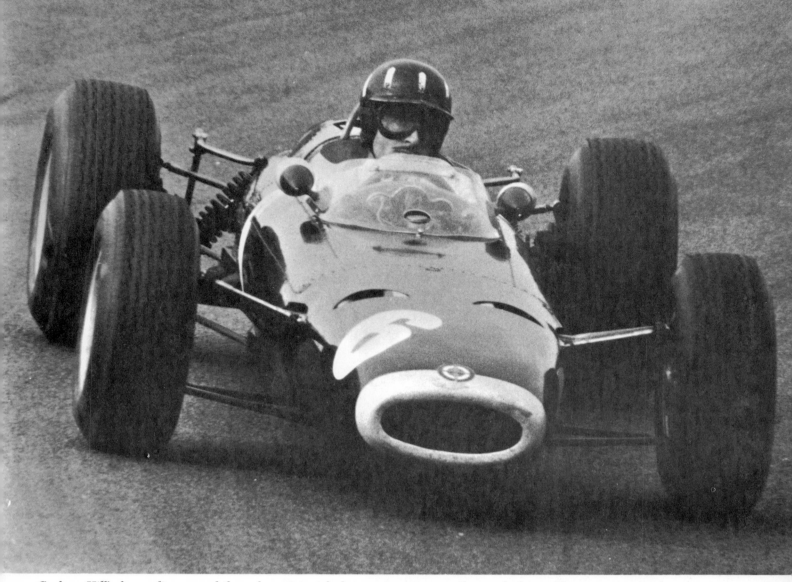

Graham Hill's hopes disappeared through persistent fuel starvation, temporarily cured when cold water was poured over the pump.

like a shower-bath at speed. It was then lap 55 and he had dropped back to 6th place. Clark was 45 seconds ahead of Surtees. The B.R.M. was now trouble-free. Four laps was enough to catch Amon. McLaren was the next and it looked as if Arundell might be overtaken. Realising the danger Arundell increased his speed, at one stage almost losing control, but managed to keep on the track. Fortunately for him the fuel vaporization trouble began again and Hill settled for 4th place. Ginther's car was similarly plagued and came into the pits for cooling. In that order the remaining laps were ticked off. Clark an undisputed winner, Surtees an unspectacular 2nd, Arundell a promising 3rd, Graham Hill a lucky 4th.

Of the other cars, de Beaufort went out on lap 10 with piston trouble. Bandini's Ferrari never sounded right. At the outset he was in danger of claiming last place when the engine picked up and performed reasonably, but on lap 26 the Ferrari packed up for good. Hailwood had a spirited fight with Anderson, swopping places time and again. Unfortunately, just as both were about to challenge McLaren, Hailwood dropped out with a broken crown wheel and pinion. Anderson applied pressure on the Cooper and with four laps to go succeeded in taking 6th place from McLaren, whose car was proving difficult to handle. It was a good race for Anderson and he thoroughly deserved the Championship point. Amon drove with confidence. He gave one of the finest performances of his career, showing rare judgment for a boy of his age. It was a tonic to see his enthusiasm afterwards.

The Dutch Grand Prix had been an interesting contest. It lacked the excitement of cut-and-thrust for leading place, but rewarded spectators with a typical Clark win, tactics that take the Lotus out in front from the

37

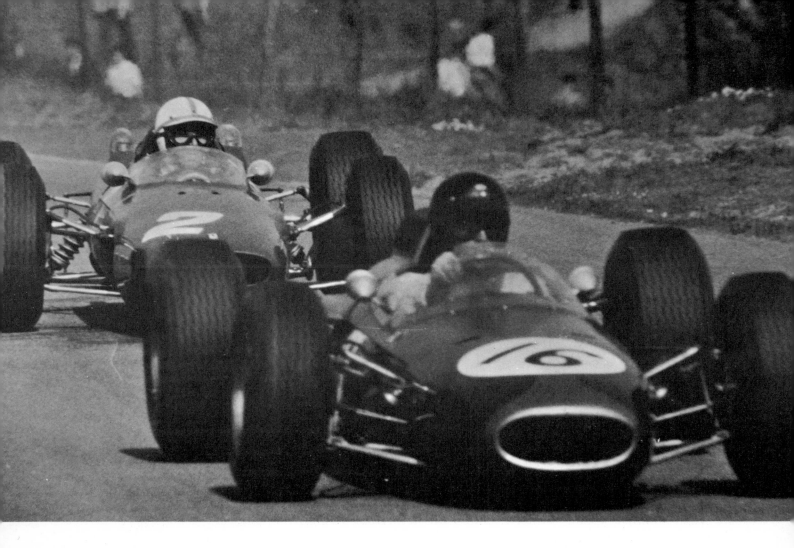

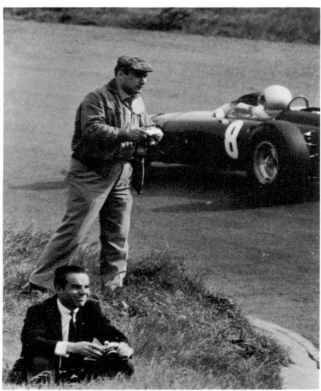

Above: *Gurney (16) and Surtees had a fierce duel. The American held the advantage until lap 10 when the Ferrari went past on the inside of Tarzan. Eventually Gurney broke his steering wheel and retired. Surtees claimed an invaluable 2nd place.*

Left: *Cahier takes life easily as Ginther passes.*

start and wear the opposition down by the sheer brilliance of driving and ability to get extra power. The race also underlined the unpredictability of Grand Prix car behaviour. In Monte Carlo the B.R.M.'s were the personification of reliability. Temperatures were higher in Monaco, yet there was no hint of vapour locking. The Lucas pressure pump for the injection system worked without a trace of trouble. Moreover lap speeds are much lower at Monaco. It was also wretched luck that Gurney should break a steering wheel when he looked certain to collect useful points. Monte Carlo gave B.R.M. the honours for consistency. At Zandvoort that distinction went to Lotus.

Results

1. Jim Clark (Lotus–Climax) 2 hr. 7 min. 35·4 sec. 98·02 m.p.h. (race record).
2. John Surtees (Ferrari) 2 hr. 8 min. 29 sec.
3. Peter Arundell (Lotus–Climax) 79 laps.
4. Graham Hill (B.R.M.) 79 laps.
5. Chris Amon (Lotus–B.R.M.) 79 laps.
6. Bob Anderson (Brabham–Climax) 78 laps.
7. Bruce McLaren (Cooper–Climax) 78 laps.
8. Phil Hill (Cooper–Climax) 76 laps.
9. Joakim Bonnier (Brabham–B.R.M.) 76 laps.
10. Giancarlo Baghetti (B.R.M.) 74 laps.
11. Richie Ginther (B.R.M.) 64 laps.
12. Mike Hailwood (Lotus–B.R.M.) 57 laps.
13. Joseph Siffert (Brabham–B.R.M.) 55 laps.

Fastest Lap: Clark, 1 min. 32·8 sec. 101·07 m.p.h. (circuit record).

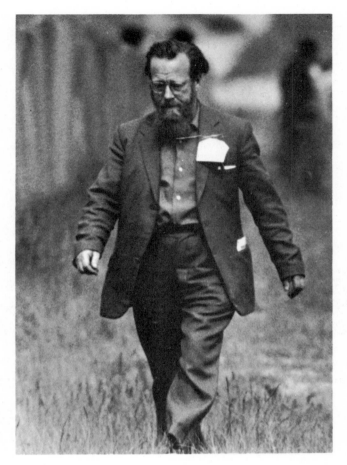

Right: *A preoccupied Jenkinson makes his way home.*

Overheating fuel and vapour locking affected Ginther's B.R.M. Here he is challenged by Jack Brabham, who progressed through the field to within striking distance of the leaders, only to retire with fractured fuel pump drive.

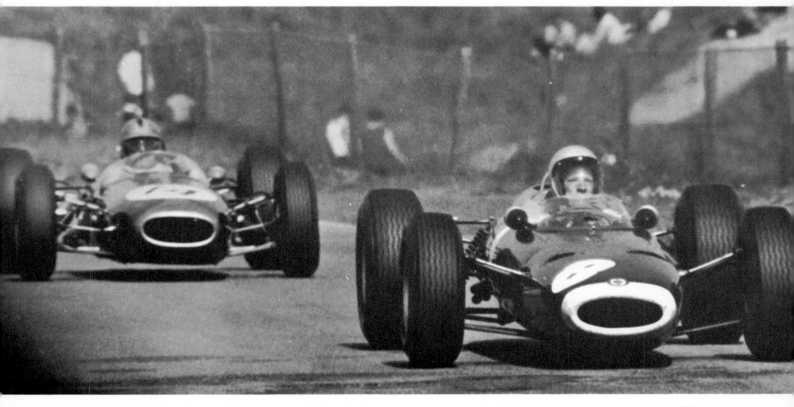

The moment that every driver dreams about . . . the split-second before the chequered flag drops. This time there was no doubt about the winner. It proved not so much a race, more a procession.

World Championship		Constructors' Championship	
1. Graham Hill	12 points	1. Lotus–Climax	13 points
Jim Clark	12 points	2. B.R.M.	12 points
3. Peter Arundell	8 points	3. Ferrari	6 points
4. Richie Ginther	6 points	4. Lotus–B.R.M.	3 points
John Surtees	6 points	5. Cooper–Climax	2 points
6. Joakim Bonnier	2 points	6. Brabham–Climax	1 point
Chris Amon	2 points		
8. Mike Hailwood	1 point		
Bob Anderson	1 point		

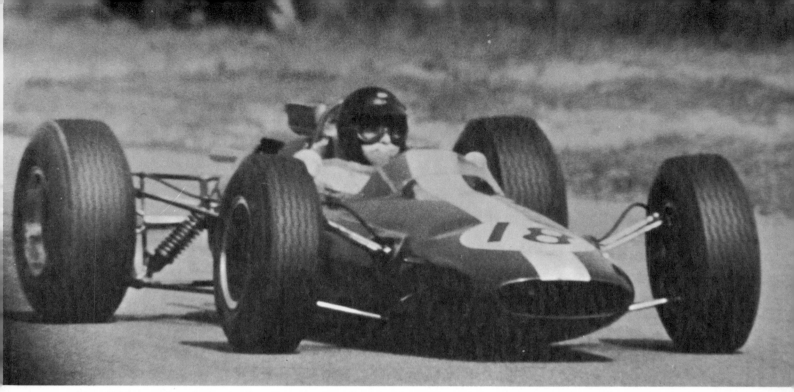

Jim Clark, worthy winner, leading from start to finish, with a new record speed of 98 m.p.h., plus a new absolute lap record.

The Dutch have a disconcerting habit of keeping passive spectators under control with mounted police.

Tension at the start as the cars stream up the hill to the pine forests of the Belgian Ardennes.

Grand Prix of Belgium

32 LAPS	OVERCAST	280·32 MILES

Spa invariably produces a thrilling race, but no one could have anticipated such a sensational finish. The drama of the closing minutes made it one of the most exciting Grands Prix ever seen in the World Championship.

But that is anticipating. Instead, let me turn to the eve of practice with feverish last-minute preparations. The claim that Spa-Francorchamps is the finest of all road circuits is more than justified. It is also the most dangerous. One slip can be fatal. This is no place for inexperience. Even veterans have respect for its insistent demands. Concentration must never flag. There is no section where a driver can relax. It is always a relief when

Paul Frere, the Belgian driver, talks to Phil Hill, former World Champion, (right) *before the race.*

An engrossing letter for Joseph Siffert.

Dennis Holmes (Daily Mail) *caught off guard but at least respectable.*

The curves of local fashions were somewhat eye-catching.

Marianne Bonnier preparing the lap charts.

B.R.M. mechanic "Sheriff" Perkins has a young Belgian apprentice.

John Crosthwaite, one of the project engineers from Bourne.

Last-minute modifications to the Rob Walker car.

One can defies the Parnell team.

Rob Walker listens to the Bonnier version.

Somehow Innes Ireland managed to collect a multi-coloured black eye.

the cars emerge out of the Ardennes forest for the last time and the chequered flag drops without a crash or injury marring the day. Before the training session began we learnt that once more the anticipated Honda entry had been scratched. Maurice Trintignant also withdrew, preferring to enter for the Mont Ventoux hill-climb. Mike Hailwood was another absentee. He had just won the Senior T.T. in the Isle of Man, but was far from well with a throat infection. His car was taken by the American, Peter Revson. Centro Sud drivers, Maggs and Baghetti, were in the pits, but their cars were missing. The transporter had apparently broken down on the way from Modena. The entry consisted of B.R.M., Lotus, Ferrari, Cooper and Brabham. These works cars, plus Ireland (B.R.P.) and Bonnier (Rob Walker), were assured grid positions. The remainder: Taylor (B.R.P.), Siffert and Anderson (Brabhams), Baghetti and Maggs (Cen-

Near-nudity at Spa, but no suggestion of under-nourishment, though by comparison Ken Gregory is rather on the scraggy side.

Contrast of contours . . . bonny Wally Hasson and pencil-line Richie Ginther.

tro Sud), Amon and Revson (Parnell) plus Pilette (Scirocco) had to scrap for starting-money. Regarding machinery, Ferrari still waited for their 12-cylinder car. Lotus had rebuilt the 1964 Type 33 that crashed at Aintree. B.R.M. had a brand new car with a slim-look frontal area, streamlined and lighter. Coopers produced their 1964 cars with steering arms strengthened.

First practice began with everyone scratching round to beat four minutes, when an inspired Gurney upset plans with remarkably fast laps. 3 min. 55 sec., was improved to 3 min. 52 sec., and finally 3 min. 50·9 sec., a time that broke Brabham's outright lap record of 3 min. 51·9 sec. made in a 2½-litre Cooper. Gurney's average was 136·599 m.p.h. Theorists were disturbed that in a monocoque-age, the American had blazed the trail in the out-dated space-frame Brabham. At the end of the session Surtees was the next fastest, but still 4·3 seconds slower. B.R.M.'s managed to break the 4-minute mark with Hill on 3 min. 57·2 sec., and Ginther 3 min. 57·3 sec. Clark managed 3 min. 57·5 sec., McLaren 3 min. 58·8 sec. and Bandini 3 min. 59·2 sec. The Gurney-target looked hopeless, but there was no shortage of effort on the final practice. Graham Hill has never tried harder. In the end he clocked 3 min. 52·7 sec., which ensured 2nd place on the grid. Whilst he was getting that time Arundell managed a useful tow for 3 min. 52·8 sec. Jack Brabham decided to quicken the pace and claimed a front-row position with 3 min. 52·8 sec. Apparently tiring of just sitting on the pit counter, Gurney had a few laps and managed 3 min. 51·7 sec., the fastest time of the day. Bonnier was trying hard when his brakes failed coming to La Source. He spun and crashed heavily against the wall. For a moment it looked horrible, but though the Cooper was badly damaged, the Swede was unhurt. A few minutes later Trevor Taylor had the same trouble at the identical place. This time he came hurtling down the track sideways and managed to stop just short of the wall. Phil Hill had his quota of excitement at the pits. An ignition fault set the Cooper on fire, but the flames were extinguished before too much damage was done. The Ferraris were far from happy. Revson, on the other hand, was thoroughly enjoying himself and finished fastest of the independents.

That night a storm of tropical intensity circled round Spa. Torrential rain recalled memories of the previous season when the race resembled a speed-boat contest. Fortunately it cleared by morning, and though the clouds looked menacing, the local weather forecast was emphatic that rain would not fall. The prophecy was a bit groggy as the cars appeared on the track. A light shower sent Lotus mechanics scurrying for rain tyres; then Graham Hill's B.R.M. had electrical trouble which was cured; and Trevor Taylor had a puncture and quick wheel-change. A last-minute argument over starting-money resulted in only 18 cars lining-up for this grid:

Reading-time in the B.R.P. pit.

Lecture-time in the B.R.M. camp. Graham Hill appears somewhat disinterested in Tony Rudd's slide-rule calculations.

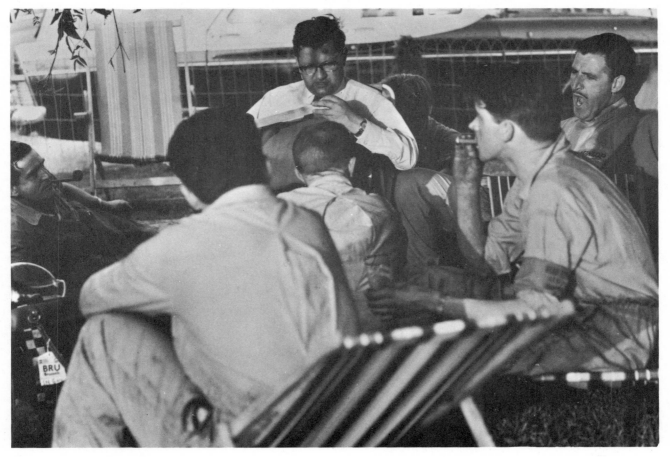

Joakim Bonnier had a narrow escape from injury whilst approaching La Source hairpin. His brakes failed, the car spun, crashed against a stone wall causing extensive damage to the Cooper, but the Swede emerged out of the cloud of smoke and dust shaken but unhurt. A few minutes later Trevor Taylor's brakes also failed at the same place. The car screeched sideways down the track, missed the wall, and came to rest in a cloud of rubber smoke.

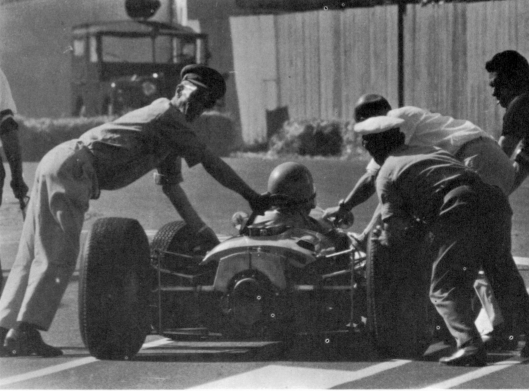

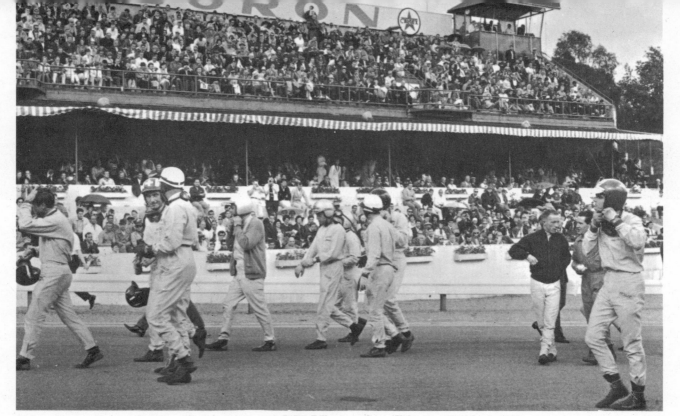

Drivers returning to the cars after briefing. It is possible to pick out Revson, Ginther, Siffert, Baghetti and Phil Hill.

15
D. Gurney
(Brabham–Climax)
3 min. 50·9 sec.

1
G. Hill
(B.R.M.)
3 min. 52·7 sec.

14
J. Brabham
(Brabham–Climax)
3 min. 52·8 sec.

24
P. Arundell
(Lotus–Climax)
3 min. 52·8 sec.

10
J. Surtees
(Ferrari)
3 min. 55·2 sec.

23
J. Clark
(Lotus–Climax)
3 min. 56·2 sec.

20
B. McLaren
(Cooper–Climax)
3 min. 56·2 sec.

2
R. Ginther
(B.R.M.)
3 min. 57·2 sec.

11
L. Bandini
(Ferrari)
3 min. 58·8 sec.

29
P. Revson
(Lotus–B.R.M.)
3 min. 59·9 sec.

27
C. Amon
(Lotus–B.R.M.)
4 min. 00·1 sec.

4
T. Taylor
(B.R.P.–B.R.M.)
4 min. 00·2 sec.

17
J. Siffert
(Brabham–B.R.M.)
4 min. 02·7 sec.

16
J. Bonnier
(Brabham–B.R.M.)
4 min. 02·7 sec.

21
P. Hill
(Cooper–Climax)
4 min. 02·8 sec.

3
I. Ireland
(B.R.P.–B.R.M.)
4 min. 04·0 sec.

6
G. Baghetti
(B.R.M.)
4 min. 07·6 sec.

28
A. Pilette
(Scirocco–Climax)
4 min. 22·9 sec.

Non-starters: A. Maggs (B.R.M.) 4 min. 07·8 sec.
R. Anderson (Brabham–Climax) 4 min. 08·5 sec.

Once again there was an interminable wait on the dummy-grid before the field moved up to the start. The Belgian flag dropped and the pack was released. Up the hill towards the Burneville woods with Arundell surprisingly in the lead. He had out-accelerated the front row and parted Gurney and Graham Hill. The advantage was short-lived. Gurney, Surtees and Clark went past. At the end of the first lap these four cars were followed by Brabham, Graham Hill, McLaren, Ginther, Bandini, Phil Hill, Baghetti, Taylor, Ireland, Siffert, Bonnier and Pilette. The margin between Gurney and Surtees was 2 seconds, but the next time round the Ferrari had closed the gap. To do so, Surtees had clocked 3 min. 52·4 sec. Clark came 3rd, ten seconds behind, whilst Graham Hill, Arundell, Brabham and McLaren were bunched together. The next time round Surtees had taken the lead, but the advantage only lasted to Stavelot. The Brabham was back in front, whilst the Ferrari was obviously in trouble. It crept back to the pits, the only consolation being that Surtees had established a new Formula One record for the circuit. The satisfaction was short-lived for almost immediately Gurney bettered it by lapping 3 min. 52·3 sec. By lap 6 Gurney held a 12 seconds lead over Clark and Graham Hill who were racing wheel to wheel, with McLaren in close attendance. By lap 10 the gap had widened to 21 seconds, with Hill ahead of McLaren and Clark.

Nobody could match Gurney on this form. By lap 15 he was 27 seconds ahead. His handling of the Brabham was a joy to watch. Everything was made to look effortless. By comparison the rest of the field was having to work hard. La Source provided contrasting studies. Gurney came round with almost mechanical perfection. No suggestion of strain or tension, he took the right line in flawless fashion. It was so natural as to be almost uninteresting. It lacked the dynamic excitement of the struggle for 2nd place between Hill, Clark and McLaren. Of the three, Clark was working the hardest, but even then he could not prevent McLaren taking his B.R.M. tow. The New Zealander held the advantage for three laps when the Lotus again closed up on Hill. The routine was the same every lap. At La Source the Lotus, braking late, almost rammed the B.R.M., came alongside down the hill, crossed the line in front, and then relinquished the advantage up the hill and out of sight. It was a tense situation and posed a hypothetical situation. Assuming

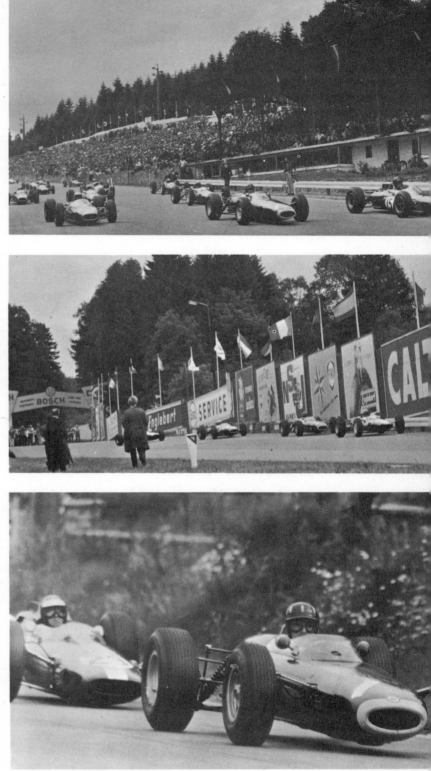

Gurney (15) had pole position on the grid, with Graham Hill and Brabham alongside. Clark was on the 3rd row. The race developed on the usual Spa pattern, the premium being on horsepower and driving skill.

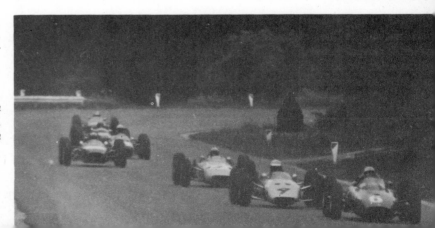

that Gurney fell by the wayside and the race lay between these two, how was Hill going to shake off Clark, for quite clearly at this vital section just before the finishing-line the Lotus had greater acceleration.

The pace had already taken its toll among the field. Surtees was now watching the race from the pits; Amon's engine had blown up; Phil Hill had dropped out near Stavelot for the same reason; Bandini stopped with mechanical trouble; Bonnier retired; Pilette disappeared off the lap chart; Siffert broke a piston. Whilst all this was going on, Gurney created a new lap record—3 min. 49·8 sec. or 137·25 m.p.h., a remarkable effort that increased his lead over Clark to 32 seconds. Fifth place changed on lap 19 when Arundell's Lotus came into the pits almost boiling. Brabham took over, being comfortably ahead of Ginther. Two laps later the position up front changed its pattern. Whilst overtaking backmarkers Taylor and Baghetti, the B.R.M. managed to give Clark and McLaren the slip. Their tow was lost. Hill was clear, about 40 seconds behind Gurney, whilst McLaren overtook the Lotus. The pace was still terrific. Gurney had a lap of 3 min. 49·2 sec. whilst Hill clocked 3 min. 50 sec.

At this juncture things began to happen in a big way. As Clark was finishing his 28th lap seemingly trouble-free, he brought the Lotus sharply into the pits. The need was water. 1½ minutes later he rejoined the race. McLaren had taken his place, but Brabham was still 5th. Lap 29 saw a significant move. When the cars came round Ginther had passed Gurney, which could only mean that the Brabham was slowing. The writing was on the wall. Lap 30 and no sign of Gurney. Instead it was Graham Hill who streaked past in the lead. Very slowly Gurney came in for fuel, only to find that there was none in the pit and he was sent back into the race. The order was now Hill, McLaren, Gurney and Clark. The last lap started with Gurney within striking distance of the Cooper, but Clark had dropped some way back. Going up the hill the B.R.M. note was not right, but still with only one lap and 4 minutes to victory, perhaps all might be well. The seconds ticked away. He ought to be coming, but nothing came. Then at La Source a car appeared, it was McLaren's Cooper spluttering and protesting. All he could do was coast down the hill and hope for the

Close-ups of drivers showing facial expressions during the race over the fastest circuit in Europe. Chris Amon (top) looks remarkably relaxed. Jack Brabham's mouth is set tight. Tony Maggs (lower) is unperturbed. Eyes show intense concentration in both Maggs and Amon.

best. In the meantime Ginther's B.R.M., a lap in arrears, passed and received the chequered flag in mistake for Graham Hill. Just as it looked as if the New Zealander had won, Clark came hurtling down the hill. The unbelievable had happened. Gurney had run out of fuel. Hill's Bendix pump had gone on strike. McLaren's Cooper had run dry at La Source. Finally Clark stopped for the same reason on his slowing-down lap, and Arundell went off to bring the winner in. It was unquestionably the luckiest win of the year. When the last lap began Clark was booked for 4th place. He must have thought he was dreaming when he saw first Hill, then Gurney stationary by the track, and finally the confusion at the line. Not until Arundell collected him did Clark realise he had won.

Post-mortems were revealing. Hill's car had just over four gallons in the tank. The trouble was the Bendix fuel pump that transfers fuel from the extra tank to the main tanks. It packed-up on that final lap. McLaren's battery went flat and ignition plus fuel pump began to falter before finally quitting. Even Gurney's car was found to have three gallons. The reason lay with the pace of the race that had the Brabham travelling at more than 150 m.p.h. for lengthy periods. As the fuel system relies on acceleration of the car to feed the fuel to a catch tank, the scorching pace of the Brabham cut fuel flow to the emptying tank. So ended a race of disasters. The unluckiest man was Dan Gurney who from the first training period was faster than anyone else. The American was the moral victor. Unfortunately such satisfaction carries no cheque or full championship points.

Results

1. Jim Clark (Lotus–Climax) 2 hr. 06 min. 40·5 sec. 132·79 m.p.h.
2. Bruce McLaren (Cooper–Climax) 2 hr. 06 min. 43·9 sec.
3. Jack Brabham (Brabham–Climax) 2 hr. 07 min. 28·6 sec.
4. Richie Ginther (B.R.M.) 2 hr. 08 min. 39·1 sec.
5. Graham Hill (B.R.M.) 31 laps.
6. Dan Gurney (Brabham–Climax) 31 laps.
7. Trevor Taylor (B.R.P.–B.R.M.) 31 laps.
8. Giancarlo Baghetti (B.R.M.) 31 laps.

Graham Hill looks the personification of grim determination. At moments such as these he has the habit of thrusting his jaw forward. Expression completely poker-faced. Giancarlo Baghetti (centre) puffs out his cheeks. The bearded Joakim Bonnier is always calm and self-possessed.

From start to the 30th lap of the 32-lap race, Dan Gurney dominated the picture. Only the cruellest luck robbed him of victory, and nine invaluable points.

After Gurney dropped out, the lead went to Graham Hill. With only one lap left, victory looked certain for the B.R.M., but once again luck deserted the apparent victor. The car stopped on the circuit.

9. Peter Arundell (Lotus–Climax) 28 laps.
10. Innes Ireland (B.R.P.–B.R.M.) 28 laps.

Peter Revson (Lotus–B.R.M.) 28 laps, but disqualified for receiving assistance.

Fastest lap: Gurney 3 min. 49·2 sec. 137·60 m.p.h. (circuit record).

The only man to benefit was Jim Clark, who was thankful to claim 4th place when he began the last lap. Not only did he see Gurney and Graham Hill stationary, but McLaren faltered just before the chequered flag.

Below: *Ferrari and the tedious business of loading-up.*

World Championship

1. Jim Clark	21 points	
2. Graham Hill	15 points	
3. Richie Ginther	9 points	
4. Peter Arundell	8 points	
5. John Surtees	6 points	
Bruce McLaren	6 points	
7. Jack Brabham	4 points	
8. Joakim Bonnier	2 points	
Chris Amon	2 points	
10. Mike Hailwood	1 point	
Bob Anderson	1 point	
Dan Gurney	1 point	

Constructors' Championship

1. Lotus–Climax	22 points	
2. B.R.M.	14 points	
3. Cooper–Climax	8 points	
4. Ferrari	6 points	
5. Brabham–Climax	5 points	
6. Lotus–B.R.M.	3 points	

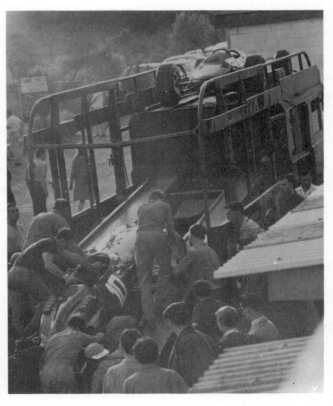

Grand Prix of France

57 LAPS **DRY AND OVERCAST** **235·8 MILES**

French logic can be confusing. According to the records 43 French Grands Prix have been held since the inaugural event in 1906, yet somehow the Automobile Club de France decided that this was the 50th in the series. Still, any excuse to celebrate. So to mark the mythical landmark an elaborate Festival of Speed was held at Rouen. We were offered film festivals in the city that straddles the Seine; a Formula 3 race in two heats; a race for racing cars of "the Golden Age"; a repetition of the 1894

Veteran car rally from Versailles to Rouen, and, of course, the 1964 French Grand Prix.

Two years had elapsed since last the race was staged here. In the interval a great deal of work has meant considerable improvements. The circuit, known as Rouen-les-Essarts, is about five miles south of the city, and consists of normal main roads. Much of it had been resurfaced so that lap times were expected to be faster, but the hairpins at la Scierie and Nouveau Monde were still

Opposite: If facial expressions are an indication of mood, the B.R.M. pair, Richie Ginther and Graham Hill, look more than discontented.

Right: John Surtees has a word with Keith Greene. On the left is Jackie Stewart, whom some experts regard the successor to Clark. Potentially the young Scot has what it takes to make the grade and he is promoted to the B.R.M. works team for 1965.

Carroll Shelby, one of the most colourful Americans on the circuit.

They could have done much worse!

"Toto" Roche and Herr Schmitz check control details.

Tom Wisdom and David Yorke swap yarns.

Innes Ireland with a hang-over.

Comte H. de Liedekerke Beaufort, President of the Automobile Club of France.

An addition to the Brabham hoarding.

It is always speculative how Tim Parnell keeps his pants up.

Martin Pfundner (right) puts the Austrian case to Dean Delamont.

cobblestones, whilst the section from the last hairpin to the pits straight was pretty rough. Overall the circuit makes a good test. Just over 4 miles long, the blending of fast and slow bends produces a lap speed of about 110 m.p.h. The pit area, scene of the dangerous 1962 crash, is too narrow, but the road then descends through three extremely fast bends, banked on the left with an abrupt drop on the right into the valley, followed by a trouble-some left-hander to the Nouveau Monde hairpin. The cobblestone surface cuts speed down to 20 m.p.h. The road then climbs through the forest, taking in several fast and slow bends, before coming to the uneven right-hander and back to the pit area. 1962 lap targets were 2 min. 16·9 sec. clocked by Graham Hill's B.R.M. in the race, and Clark's practice 2 min. 14·3 sec. in a Lotus.

We had not long to wait. A few minutes after starting Clark had beaten Hill's time, then his own, and consis-tently reduced it until it stood at 2 min. 09·6 sec. Gurney was not dawdling and finished with 2 min. 10·1 sec. Arundell managed 2 min. 11·6 sec. B.R.M. were having a messy day. So much time was spent experimenting with exhaust systems and what-not that actual practice went overboard. The culmination of an unimpressive exhibi-tion came when the mechanics changing over the orthodox 4-pipe layout for a new one consisting of 4 pipes becom-ing a single megaphone, found one side had stuck. As there was only time for a single lap, Hill went off with four pipes on the left bank and one on the other! His best time was 2 min. 12·1 sec. Ginther added to the general joy of the B.R.M. camp by forgetting he had new brake pads, came too fast into the hairpin, hit the kerb and finished in some bushes. The B.R.M. nose looked decidedly bent when he came in. Ferraris did not turn up at all. Every-one else was present, except for the rumoured Honda. For a change no entry had been received. Siffert had wretched luck. After only four laps the B.R.M. crankshaft broke following a bearing failure, and this after his engine had broken in the Belgian Grand Prix.

The last practice session was not made easier through the oil shed by Formula 3 and Historic racing machines. Times were slower, but Surtees was driving with great determination, eventually returning 2 min. 11·1 sec. which gave him a place on the front row. Hill was still not happy with the B.R.M. handling. Experiments con-tinued apace, the variables were altered without marked improvement. In the end he had to be content with a third-row berth. Brabham with 2 min. 11·8 sec. joined Arundell on the second row.

Race day was overcast but warm as the field of 17 cars did a couple of warming-up laps with the exception of Clark's Lotus which had an oil leak from a cambox cover point. After hectic work in the Lotus pit, he joined the front row of this grid:

Barry Gill (Sun) *in a persuasive mood.*

Press-box in action. Gill (Sun) *and Brinton* (Observer) *need stop-watches: Holmes* (Daily Mail) *needs sun-glasses. The* Times *correspondent needs a handkerchief.*

Alfred Moss with newly married Stirling and pretty, vivacious wife.

Before and after! . . . Richie Ginther has a marked effect on Lili Morrow of Elle.

Fore and aft! two attractive racing girls take the strain.

2	22	24
J. Clark	D. Gurney	J. Surtees
(Lotus–Climax)	(Brabham–Climax)	(Ferrari)
2 min. 09·6 sec.	2 min. 10·1 sec.	2 min. 11·1 sec.

4	20
P. Arundell	J. Brabham
(Lotus–Climax)	(Brabham–Climax)
2 min. 11·6 sec.	2 min. 11·8 sec.

8	12	26
G. Hill	B. McLaren	L. Bandini
(B.R.M.)	(Cooper–Climax)	(Ferrari)
2 min. 12·1 sec.	2 min. 12·4 sec.	2 min. 12·8 sec.

10	14
R. Ginther	P. Hill
(B.R.M.)	(Cooper–Climax)
2 min. 13·9 sec.	2 min. 14·5 sec.

16	18	36
I. Ireland	T. Taylor	M. Hailwood
(B.R.P.–B.R.M.)	(B.R.P.–B.R.M.)	(Lotus–B.R.M.)
2 min. 14·8 sec.	2 min. 14·9 sec.	2 min. 16·2 sec.

34	32
C. Amon	R. Anderson
(Lotus–B.R.M.)	(Brabham–Climax)
2 min. 16·4 sec.	2 min. 16·9 sec.

28	30
M. Trintignant	J. Siffert
(B.R.M.)	(Lotus–B.R.M.)
2 min. 21·5 sec.	2 min. 23·6 sec.

There was a clean start. As so often happens Clark was in front at the first hairpin, closely followed by Gurney. Surtees and Phil Hill were having a rare tussle, McLaren spun at the second hairpin, both B.R.M.'s were well back. The first time round Clark and Gurney were almost together, the Lotus standing lap had been 2 min. 22 sec. Surtees lay 3rd, followed by Brabham and Phil Hill. On lap three Graham Hill spun at the same point where McLaren had found trouble and dropped back from 6th to 13th. Surtees was also far from happy and came into the pits with a broken oil line. Repairs were made, but after a few more laps he retired a disappointed man. Siffert was likewise unlucky. After hectic work to fit a new engine, the clutch packed up. Whilst all this was happening, Clark was drawing clear of Gurney, then Brabham, and Arundell. Phil Hill was looking far from happy. At the tail-end, Ginther and Bandini were joined by McLaren and Graham Hill. For a couple of laps this quartet had a strenuous session until Hill left them behind. McLaren found Ginther less accommodating and stayed back. Taylor spun off the road and retired to the pits.

Jean Stanley, B.R.M. owner, with the World Champion, Jim Clark.

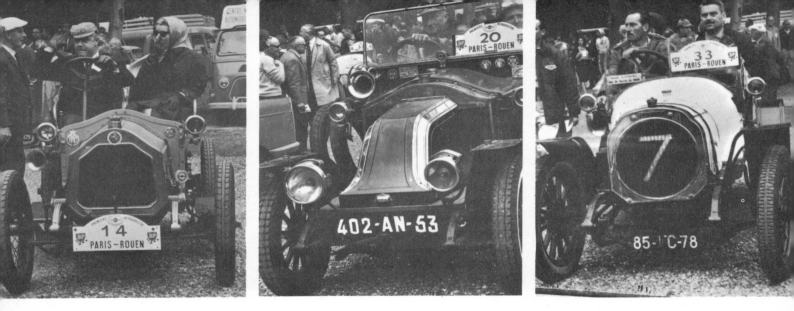

The 50th anniversary of the Grand Prix of the Automobile Club of France also coincided with the 70th anniversary of the first motor competition, the 1894 Paris to Rouen event. Appropriately a replica affair for veteran cars was staged. The entry was excellent and the cars were turned out in immaculate fashion.

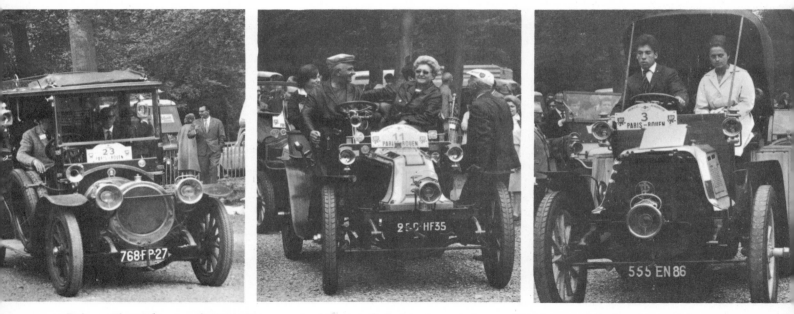

Below: *The 10-lap race for historic cars revived the sound of supercharged cars, produced some spirited racing, and victory to Patrick Lindsay (33) in his E.R.A. at over 82 m.p.h. from a Bugatti and a Frazer-Nash.*

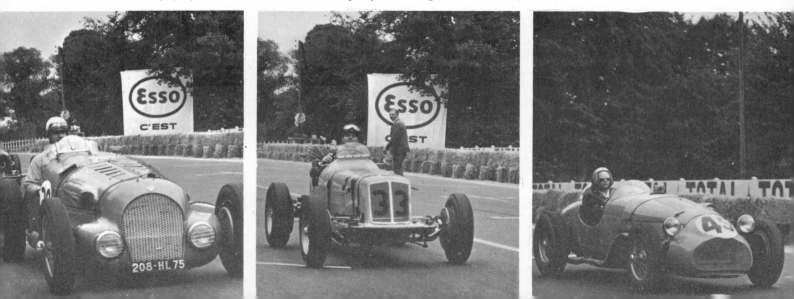

The race pattern as regards the first three places had stabilised itself and interest centred on Graham Hill's progress through the field. This was a situation in which he excels, as he once demonstrated in the British Grand Prix at Silverstone. By lap 11 he displaced Phil Hill from 5th place, then set off in pursuit of Arundell some 15 seconds away. The battle behind between Ginther, McLaren and Phil Hill was still raging. Eventually Phil Hill dropped back with locking rear brakes. By lap 22 Clark was 14 seconds in front of Gurney and had just clocked a fresh lap record of 2 min. 12·7 sec. Graham Hill's relentless pursuit of Arundell was reaching its climax and lap 23 saw him in front of the Lotus. Arundell was by no means beaten and applied intense pressure on the B.R.M. Clark almost found himself in trouble with backmarkers Ireland, Bandini and Hailwood. It took a lap to get clear of these very mobile chicanes. Lap 29 saw Gurney overtake the same trio with Bandini-tactics. Instead of picking them off piecemeal, the Californian took the lot as they entered the Nouveau Monde hairpin, using the Italian as a buffer to prevent a side-slide. It was a move that would have appealed to Bandini had he executed it himself, but reactions are sometimes different when the other fellow does it to you. Anyhow Gurney was clear without losing ground to Clark, who at this time was struggling with an ailing Lotus. A pit stop of some 15 seconds before rejoining the race in a car that sounded far from healthy. One lap and he was in again. A piston had broken. Gurney now enjoyed a lead of 1 min. 2 secs. from Brabham, who was being threatened by Graham Hill and Arundell. Ginther and McLaren were still having a rare fight with Phil Hill behind. The rest of the field had been doubled.

About this time Ireland spun at the right-hand bend after the pits, crashed badly, wrecked the car, but escaped unhurt. Trintignant came in with blistered feet. Anderson stopped with engine trouble. Lap 37 saw Graham Hill's grim determination rewarded. He went past Brabham to take 2nd place, but the Australian was by no means beaten. He nosed in front of the B.R.M. just as Arundell moved up to join the fray. For several laps spectators saw racing at its keenest and toughest. Nobody would cede an inch, but in the end it was Arundell who dropped back, whilst Hill regained 2nd place. Even so, Brabham refused to give up. Such was his mood that he set up a new lap record of 2 min. 11·4 sec. on lap 44, but he still had to be content with 3rd berth. Gurney was slowing down as there was no need to press his engine to the limit. The margin dropped from 59 seconds to 25 seconds. With about that much in hand he took the chequered flag. After the disappointment at Spa, victory was even sweeter. It was a win long overdue for the Brabham–Climax had proved itself as fast as any of its rivals. Only wretched misfortunes had denied it victory. Gurney was an immensely popular winner and he had set up a new race average of 108·77 m.p.h.

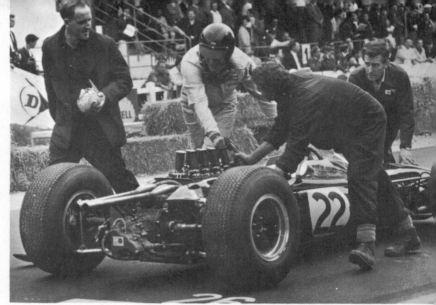

Luck deserted Clark at Rouen. After leading for 30 laps, he retired with a holed piston.

Graham Hill had a rare dice for 2nd place, eventually beating Brabham by 1½ seconds.

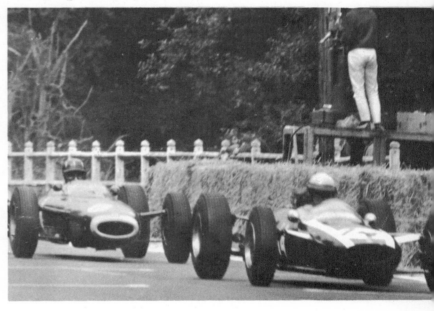

Dan Gurney's success in the Brabham–Coventry-Climax was poetic justice after his Spa disappointment.

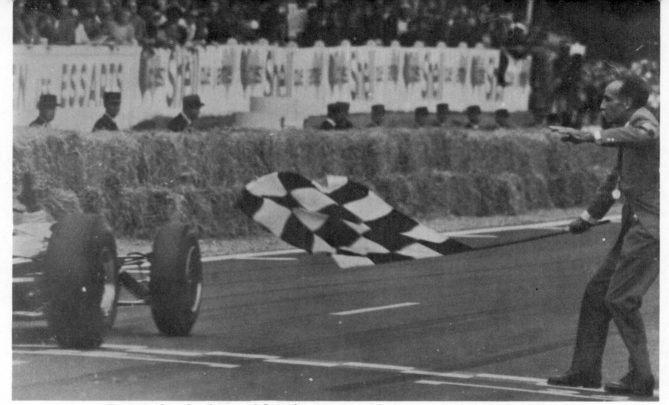

Gurney takes the chequered flag after winning with the record speed of 108·77 m.p.h.

Although Gurney had been acclaimed, intense excitement centred on the 2nd place. Brabham was working like a Trojan to beat Hill, in fact tactics became so rough that tempers became frayed. When they came into sight for the last time Hill was in front, but only just, and the verdict went to B.R.M. by eight-tenths of a second. Happily the friction between these two great drivers evaporated almost as soon as the race was over. Arundell finished a creditable 4th, with Ginther 5th. McLaren, Phil Hill and Hailwood were a lap in arrears, whilst a somewhat deflated Bandini after the Gurney episode was two laps behind.

Results

1. Dan Gurney (Brabham–Climax) 2 hr. 7 min. 49·1 sec. 108·77 m.p.h. (record).
2. Graham Hill (B.R.M.) 2 hr 8 min. 13·2 sec.
3. Jack Brabham (Brabham–Climax) 2 hr. 8 min. 14 sec.
4. Peter Arundell (Lotus–Climax) 2 hr. 8 min. 59·7 sec.
5. Richie Ginther (B.R.M.) 2 hr. 10 min. 1·2 sec.
6. Bruce McLaren (Cooper–Climax) 56 laps.
7. Phil Hill (Cooper–Climax) 56 laps.
8. Mike Hailwood (Lotus–B.R.M.) 56 laps.
9. Lorenzo Bandini (Ferrari) 55 laps.
10. Chris Amon (Lotus–B.R.M.) 53 laps.
11. Maurice Trintignant (B.R.M.) 52 laps.

12. Bob Anderson (Brabham–Climax) 50 laps.

Fastest lap: Jack Brabham (Brabham–Climax) on lap 44, in 2 min. 11·4 sec. 111·37 m.p.h. (record).

World Championship

1. Jim Clark	21 points
2. Graham Hill	20 points
3. Richie Ginther	11 points
Peter Arundell	11 points
5. Dan Gurney	10 points
6. Jack Brabham	8 points
7. Bruce McLaren	7 points
8. John Surtees	6 points
9. Joakim Bonnier	2 points
Chris Amon	2 points
11. Mike Hailwood	1 point
Bob Anderson	1 point

Constructors' Championship

1. Lotus–Climax	25 points
2. B.R.M.	21 points
3. Brabham–Climax	14 points
4. Cooper–Climax	9 points
5. Ferrari	6 points
6. Lotus–B.R.M.	3 points

Gurney (left) receives Clark's congratulations and is interviewed by Moss.

Grand Prix of Great Britain and Europe

80 LAPS **DRY AND OVERCAST** **212 MILES**

Opposite: *Hon. Gerald Lascelles and Maurice Baumgartner, President of the Commission Sportive Internationale, inspect Surtees' Ferrari.*

Below: *The improvised paddock arrangements proved reasonably effective mainly because the weather was kind.*

Last year the British Grand Prix carried the title of Grand Prix d'Europe. Seven years had passed since last it happened. The scene then was Aintree, and the winner, Stirling Moss in a Vanwall. 1964 produced several changes. For the first time since 1950 the race was

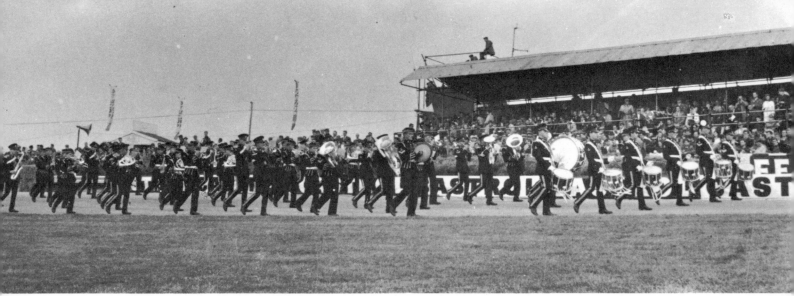

An unusual item was the impressive playing by bands of the Royal Dragoons and the 1st Battalion Royal Scots.

Joakim Bonnier finds Rob Walker's transport effective but not particularly dignified.

Betty Walker looks prepared for any kind of weather.

John Coombs and Ken Tyrrell with all the worries of the world.

A typical study of Colin Chapman listening to Jim Clark.

A recumbent view of officialdom whilst the race is in progress.

Honda driver Ronnie Bucknum making a tour of inspection with Ginther.

organised by the Royal Automobile Club, instead of delegating the task to the British Racing Drivers' Club or the British Automobile Racing Club. Sponsorship came from the *Daily Mail*. Imaginative planning was sparked-off by the circuit proprietors, Grovewood Securities. Co-operation by trade and press built up a terrific pre-race anticipation that this was going to be a memorable occasion. The publicity worked. The atmosphere throughout the meeting was like an hilarious Bank Holiday Festival, so much so that at times it was difficult to realise that this was not Butlin's Holiday Camp but a genuine Grand Prix that counted in the World Championship.

It was a welcome change to see this race held on a road-type circuit. Brands Hatch is a gruelling examination of driving ability, 212 miles containing difficult corners, blind approaches and wooded sections. Speeds vary from 35 m.p.h. at Druids to more than 100 m.p.h. at Hawthorn's Bend. Clearways is a 90 m.p.h. corner. The driver who completes the race will have changed gear more than 1,300 times. Moreover, spectator facilities are first-class, in fact hardly anywhere around the entire track do you find a poor vantage-point. A lot of hard work was put into the preliminary preparations. The marshalling was vastly improved. For those who wanted diversion there were kiosks, side-shows, restaurants and bars, a march-past of military vehicles, ancient and modern, Earl Mountbatten of Burma taking the salute, an airborne landing from helicopters including two 105-mm. howitzers, the wiping-out of a rebel outpost at Paddock Bend, a smoke-screen that blanketed the paddock enclosure, and contest for "Miss Motor Racing" organised by the *Daily Sketch*, and a demonstration of a topless-dress outfit in a racing car for the benefit of the *Daily Mirror* and appreciation of the paying public. With all these things going on, it was difficult at times to realise why we were there.

Practice sessions soon emphasised the more serious side. Not only was pole-position at stake, but the fastest lap for the first session was to get 100 bottles of champagne donated by the *Evening News*. It seemed that we could not get away from Fleet Street gimmicks. Graham Hill was the first to have a go. He lowered the existing lap record of 1 min. 40·2 sec., set up by McLaren in 1961, by taking the B.R.M. round in an exhilarating 1 min. 40 sec. Brabham was the next to improve the target. He returned 1 min. 39·8 sec. Clark went one better with

After challenging Clark for the lead, Gurney comes into the pits. The cause of the trouble an overheating transistor box.

Bette Hill and Cyril Aitkin double-check the lap times.

1 min. 39·2 sec. Gurney retaliated with 1 min. 39 sec. Then followed a pause due to Trevor Taylor going over the bank at Hawthorn's Bend through his foot slipping off the brake and wedging under the brake pedal and accelerator. The car virtually took off, severed the telephone wires, and finished up a horrible mess. Taylor miraculously escaped with bruises. Practice resumed and Brabham got down to 1 min. 38·8 sec., but his team-mate, Dan Gurney, must have been thirsty for he managed 1 min. 38·4 sec. and collected the prize.

Ferrari turned up with only one V–6 machine. Surtees took it round in 1 min. 39 sec. McLaren had 1 min. 39·6 sec. Neither Phil Hill nor Richie Ginther looked particularly happy with their cars. Their respective times reflected the fact. Anderson did surprisingly well. His 1 min. 39·8 sec. in a dated carburetter model was better than some of the works machines. Graham Hill worked really hard for his 1 min. 38·3 sec. and appeared to have booked pole position when Clark slid out about three minutes before the end of practice and returned a storming 1 min. 38·1 sec. Race day was overcast but dry. Crowd attendance was good, but thankfully well below the predicted 135,000 mark. After a preliminary warming-up lap, 23 cars formed this grid:

6	3	1
D. Gurney	G. Hill	J. Clark
(Brabham–Climax)	(B.R.M.)	(Lotus–Climax)
1 min. 38·4 sec.	1 min. 38·3 sec.	1 min. 38·1 sec.

7	5
J. Surtees	J. Brabham
(Ferrari)	(Brabham–Climax)
1 min. 38·7 sec.	1 min. 38·5 sec.

8	19	9
L. Bandini	R. Anderson	B. McLaren
(Ferrari)	(Brabham–Climax)	(Cooper–Climax)
1 min. 40·2 sec.	1 min. 39·8 sec.	1 min. 39·6 sec.

11	16
I. Ireland	J. Bonnier
(B.R.P.–B.R.M.)	(Brabham–B.R.M.)
1 min. 40·8 sec.	1 min. 40·2 sec.

2	14	15
M. Spence	H. Hailwood	C. Amon
(Lotus–Climax)	(Lotus–B.R.M.)	(Lotus–B.R.M.)
1 min. 41·4 sec.	1 min. 41·4 sec.	1 min. 41·2 sec.

10	4
P. Hill	R. Ginther
(Cooper–Climax)	(B.R.M.)
1 min. 42·6 sec.	1 min. 41·6 sec.

12	23	20
T. Taylor	I. Raby	J. Siffert
(Lotus–B.R.M.)	(Brabham–B.R.M.)	(Brabham–B.R.M.)
1 min. 42·8 sec.	1 min. 42·8 sec.	1 min. 42·8 sec.

22	26
J. Taylor	F. Gardner
(Cooper–Ford)	(Brabham–Ford)
1 min. 43·2 sec.	1 min. 43·0 sec.

17	24	18
A. Maggs	P. Revson	G. Baghetti
(B.R.M.)	(Lotus–B.R.M.)	(B.R.M.)
1 min. 45·0 sec.	1 min. 43·4 sec.	1 min. 43·4 sec.

Non-starters: 21. R. Attwood (B.R.M. 4–w–d) 1 min. 45·2 sec.
25. M. Trintignant (B.R.M.) 1 min. 54·4 sec.

The Union Jack dropped. Clark shot into the lead followed by Gurney and Bandini, but at the rear of the grid there was pandemonium. Ginther had a hesitant start, Gardner braked and was shunted by Siffert. His Brabham–Ford was out of the race with smashed suspension. Amon was left stranded with clutch trouble. In the meantime Graham Hill got a move on and went past Bandini, McLaren, Brabham and Surtees to take 3rd place. On

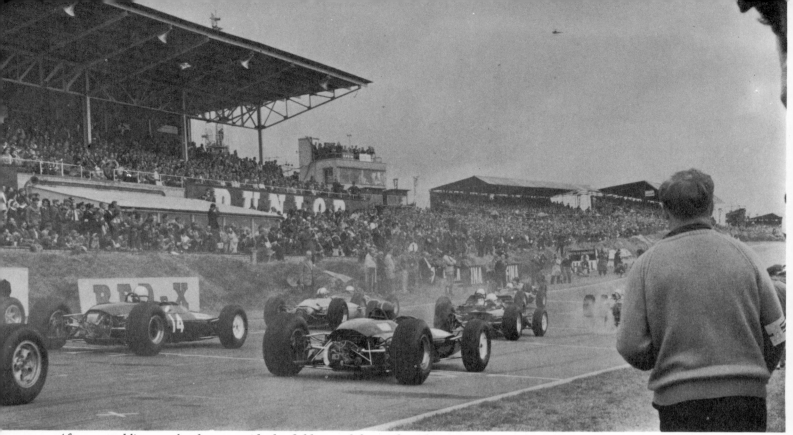

After assembling on the dummy grid, the field moved forward, and was away to a clean start, except for the tail-end where Amon had trouble with his clutch, Siffert swerved and clouted Gardner's F.2 Brabham, which had to retire.

There was no shortage of excitement or incident. From the spectator's point of view Brand's Hatch is an ideal circuit.

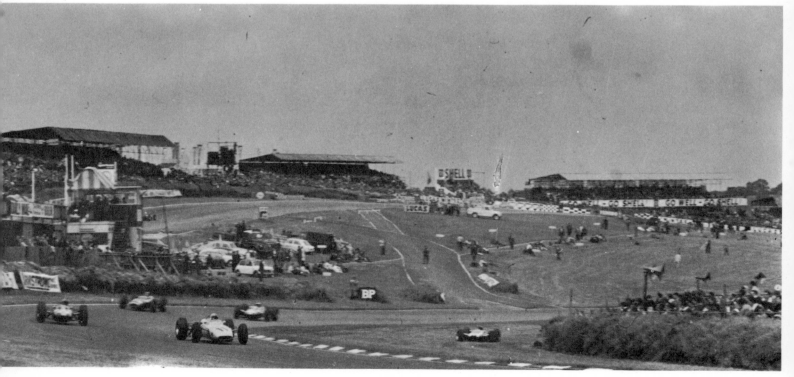

lap 2 Gurney drove like his Spa epic, lowered the lap record to 1 min. 40 sec., and was in a position to challenge Clark's lead, but the glory was short-lived. Approaching Druids, the Brabham faltered and Graham Hill became 2nd. Brabham and Surtees went by the slowing car. In the pits the transistor box was the trouble. A trigger-happy fireman drenched it in foam which only added to the headache. By the time the mess was cleared and fresh electrical components fitted, the leaders had a 4-lap start.

Graham Hill was now pressing Clark. The pace had slightly eased off as some car was shedding oil on the track. Hailwood added his quota after a trip on the grass by Druids Corner broke an oil pipe. McLaren dropped out on lap 7 with a broken gearbox. Several private fights were going on. Surtees and Brabham were disputing 3rd place. Bonnier, Phil Hill and Anderson were bunched together, until Bonnier stopped at the pits and Ireland took up the challenge. Baghetti, Siffert and Maggs were having an argument as to which one would be last. But at the front Graham Hill was on Clark's tail. The pressure was terrific. Time and again it looked as if the B.R.M. would take the lead. Hill preferred to bide his time. Psychologically it might be argued that deliberate shadowing can be strategic provided the right moment to overtake is not missed. It says a great deal for Clark's composure that he refused to be rattled. Lap after lap they circulated with seldom more than a second dividing them. The pace was so fierce that on lap 35 Bandini in 4th place was doubled. There was no doubt that the B.R.M. was less worried by oil on the track than the Lotus.

Further back Brabham had been in and out of the pits trying to discover why his car was behaving oddly. Eventually it was found that a small fuel leak was spraying petrol on the rear tyres and he was off in pursuit of Bandini. The car began to handle better. Taylor had dropped out with gearbox failure. Maggs retired with the same trouble. Raby spun at South Bank Bend to be out of the race. Revson visited the pits and stayed there. Bonnier had a broken brake pipe. On lap 43 Anderson's persistence was rewarded. He overtook Phil Hill for 6th place and gradually drew clear. The two leaders had periodically to lap back-markers. On these occasions Clark really put his foot down and gained a fraction on the B.R.M. The oil was disappearing, times were improving, and on lap 61 Clark clocked a new lap record of 1 min. 39·4 sec. with an 8 seconds lead over Hill. Lap 73 saw Clark going even faster with a fresh lap record of

Giancarlo Baghetti momentarily loses control of the Centro Sud B.R.M. Ian Raby retired his Brabham, after spinning at South Bank Bend. McLaren had gearbox trouble and was obliged to abandon his Cooper.

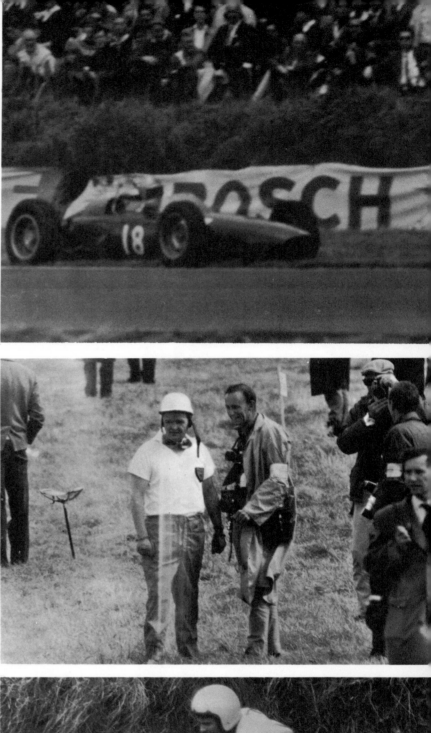

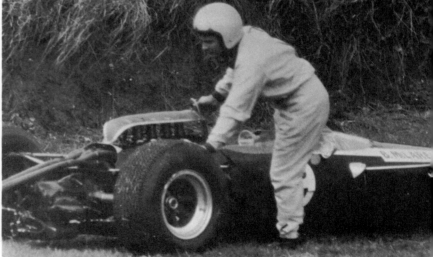

73

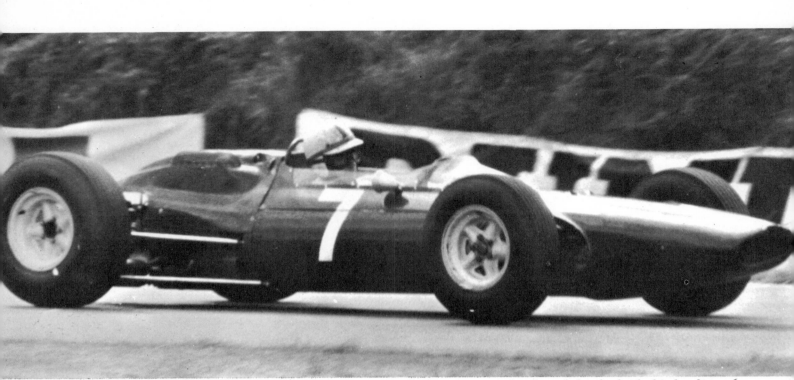

John Surtees had an uneventful race. His Ferrari seemed to be down on power, but nevertheless he finished 3rd and netted four useful points.

Jack Brabham did extremely well to finish 4th for in the early stages of the race the Australian had a pit stop for rear suspension trouble. It proved to be due to petrol on the rear tyres.

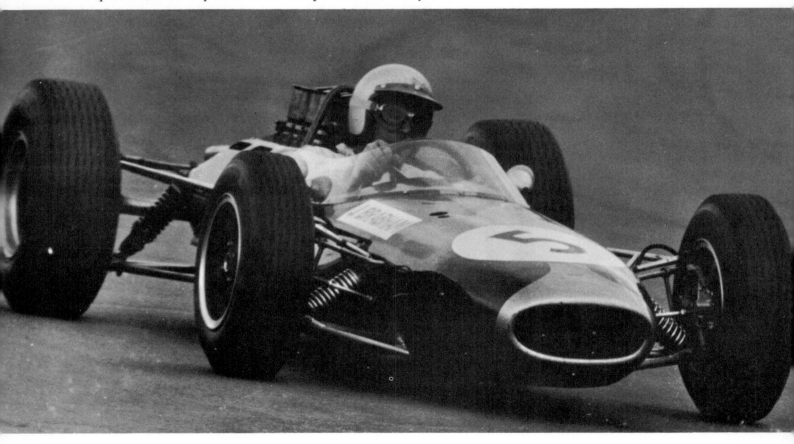

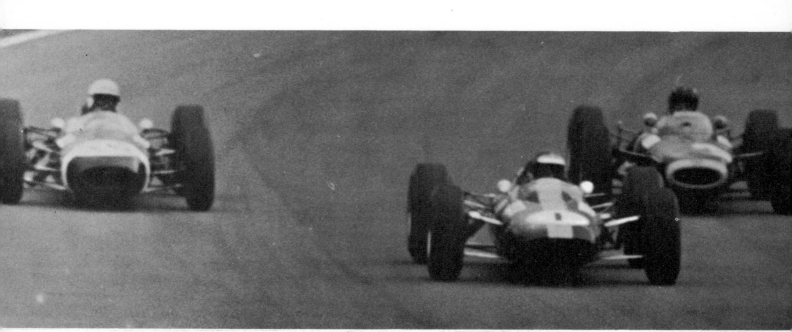

Graham Hill and Jim Clark had a rare fight. The pressure was on throughout the race.

1 min. 38·8 sec., even so the gap had been reduced to 7 seconds. For some time Hill had been troubled with a fluctuating oil pressure gauge, but at this stage of the race there was no point in holding back. He began to pull back the seconds. Meanwhile Brabham had taken 4th place from Bandini, and Phil Hill overtook Anderson for 6th. Surtees remained safely in 3rd place. The pressure up front was relentless. Hill was chopping down the lead, but time was running out. With two laps left, the gap was 4 seconds. One lap and 3 seconds. The last lap saw Hill make a superhuman effort. The margin went to 2·2 seconds, but exhausted though he was, Clark matched

This close-up of Clark gives some indication of the terrific strain with the B.R.M. on his tail.

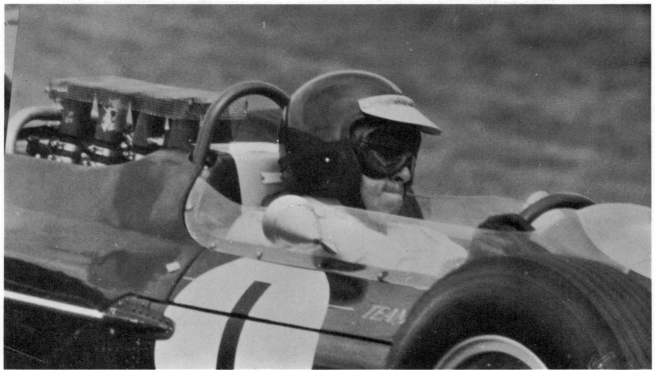

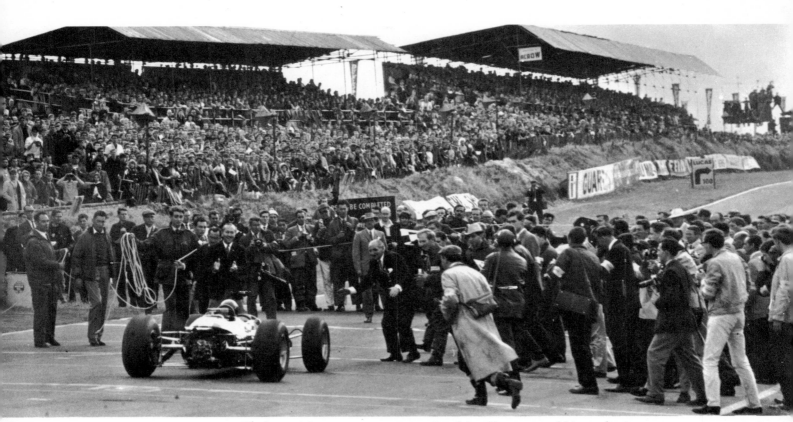

Clark receiving an open-arm reception from Chapman and his mechanics.

this last thrust. When the chequered flag dropped it was the green and yellow Lotus that claimed the titled by 2·8 seconds. Rarely have two such fine drivers been matched so closely and under such tremendous pressure. In every sense it was a truly magnificent race.

Results

1. Jim Clark (Lotus–Climax) 2 hr. 15 min. 7 sec. 94·14 m.p.h.
2. Graham Hill (B.R.M.) 2 hr. 15 min. 9·8 sec.
3. John Surtees (Ferrari) 2 hr. 16 min. 27·6 sec.
4. Jack Brabham (Brabham–Climax) 79 laps.
5. Lorenzo Bandini (Ferrari) 78 laps.
6. Phil Hill (Cooper–Climax) 78 laps.
7. Bob Anderson (Brabham–Climax) 78 laps.
8. Richie Ginther (B.R.M.) 77 laps.
9. Mike Spence (Lotus–Climax) 77 laps.
10. Innes Ireland (B.R.P.–B.R.M.) 76 laps.
11. Joseph Siffert (Brabham–B.R.M.) 76 laps.
12. Giancarlo Baghetti (B.R.M.) 76 laps.
13. Dan Gurney (Brabham–Climax) 75 laps.
14. John Taylor (Cooper–Ford) 56 laps.

Fastest lap: Jim Clark 1 min. 38·8 sec. 96·56 m.p.h. (record).

World Championship

1. Jim Clark . 30 points
2. Graham Hill . 26 points
3. Richie Ginther . 11 points
 Peter Arundell . 11 points
 Jack Brabham . 11 points
6. Dan Gurney . 10 points
 John Surtees . 10 points
8. Bruce McLaren . 7 points
9. Joakim Bonnier 2 points
 Chris Amon . 2 points
 Lorenzo Bandini . 2 points
12. Mike Hailwood 1 point
 Bob Anderson . 1 point
 Phil Hill . 1 point

Constructors' Championship

1. Lotus–Climax . 34 points
2. B.R.M. 27 points
3. Brabham–Climax 17 points
4. Cooper–Climax . 10 points
 Ferrari . 10 points
6. Lotus–B.R.M. 3 points

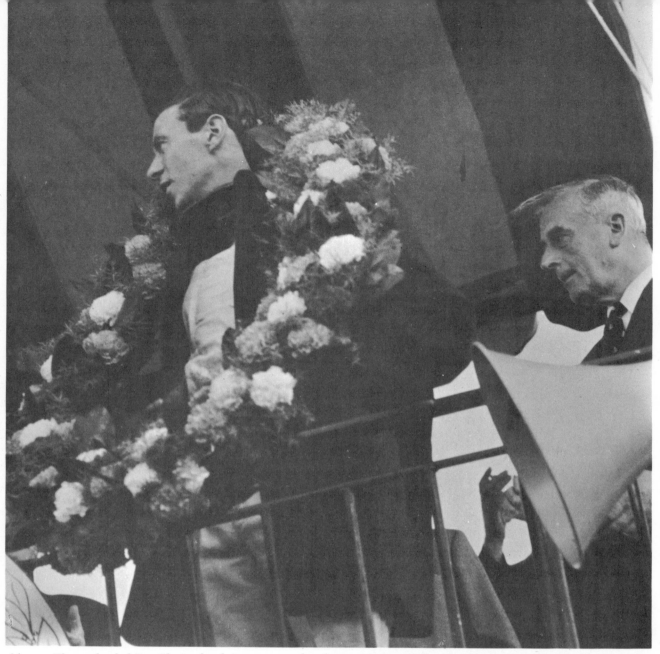

Above: *The garlanded Jim Clark after being congratulated by Earl Mountbatten* (right).

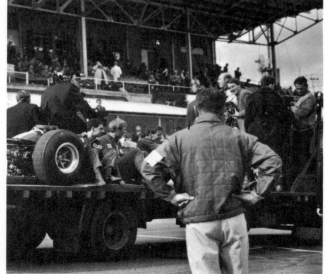

A lap of honour for the new Champion, the Lotus, Chapman, mechanics, and all.

Grand Prix of Germany

15 LAPS **COOL AND OVERCAST** **212·6 MILES**

The sixth round of the World Championship took place on the 14·2 miles Nürburgring in the dense forests of the Eifel Mountains. The circuit winds, almost writhes through more than 170 corners, climbing then abruptly dropping, and requires physical fitness, unbroken concentration and rare ability from the driver. The cars are subjected to rigorous testing of roadholding and suspension strength. Not for nothing has the Ring earned the reputation of the toughest circuit in the world. The setting is majestic. Crowd attendance is remarkable. Last year it was estimated that close on 350,000 people made the trek, probably many hoping to get a glimpse of the elusive Honda. They were not disappointed. The white car, with its transverse, rear-mounted V–12 engine made its debut, with Bucknum at the wheel. It was also a first-ever occasion for this 27-year-old American, for though he had plenty of sports car experience, this was his first Formula One drive. For untested material, both human and mechanical, Nürburgring seemed too severe an examination. The team certainly had their quota of teething troubles. On the first day's practice, overheating problems limited the morning session to two laps; the afternoon was even less successful. Overheating was still the headache and general performance well below what many had expected. Their best time in the morning was 10 min. 4·1 sec.; in the afternoon one flying lap clocked

Opposite: *The Dunlop Tower, familiar Nürburgring landmark with its map recording race progress.*

This Coca-Cola tin improvised as an oil-trap did little to enhance the Honda legend for efficiency.

Huschke von Hanstein directed his ciné at all and sundry.

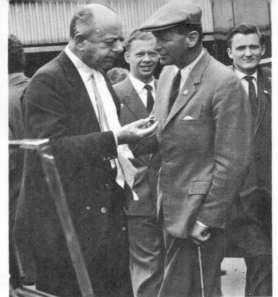
Raymond Mays, tie protected against splash, with Jacques de Wurstemberger.

Peas in a pod, but not related! Tim Parnell and A. N. Other.

Chris Amon checks his lap times.

Rob Walker lays down the law.

Gerhard Mitter, the German driver, with Colin Chapman.

Ferrari get-together . . . mechanics with Chief Engineer Foghieri (left) and Team Manager Dragoni (right).

Phil Hill invokes the Almighty!

An alternative form of racing.

9 min. 34·3 sec. The next day's training was even more unfortunate. The Honda dropped a valve. Instead of practice, the mechanics had to fit a replacement engine. Regulations next proved bothersome. Every car had to complete a minimum of five laps to qualify for the race. That eliminated the Japanese entry, as well as the popular German driver, Gerhard Mitter, who had only done three laps in the spare works Lotus, but when needs must, officialdom can bend backwards. An extra practice session was organised to allow the requisite laps to be completed, only no times would be taken.

Meanwhile the real business of preparation was in full swing. The existing lap record stood to the credit of Surtees—8 min. 47 sec. (96·87 m.p.h.) when he won the 1963 German Grand Prix in a V–6 Ferrari at a record average speed of 95·81 m.p.h. It was not long before it went. Graham Hill returned 8 min. 44·4 sec., which was even better than Clark's 1963 practice figure of 8 min. 45·8 sec. Surtees was not standing still. In a V–8 Ferrari he went round in 8 min. 45·2 sec. Gurney had 8 min. 47·8 sec. Clark was doing plenty of motoring but failed to get below 9 minutes. Brabham blew an engine. Revson clouted a tree. Amon was plagued with ignition troubles. Pilette, Mitter and de Beaufort did not appear. During the afternoon session Bandini set the pace with 8 min. 42·6 sec. Surtees almost equalled it with 8 min. 43·0 sec. Graham Hill was unable to improve on his morning time. The next day Surtees really got to grips and clocked 8 min. 39·2 sec. Clark improved to 8 min. 42·2 sec. Ginther had a gear selection argument and blew up his engine. After lunch Surtees went even quicker and returned 8 min. 38·4 sec. Gurney clocked 8 min. 39·3 sec. Clark improved to 8 min. 38·8 sec. McLaren did 8 min. 47·1 sec. Graham Hill over-revved, which meant a double engine change for B.R.M. Amon was fastest of the independents with 8 min. 54 sec. Anderson and Phil Hill looked distinctly unhappy. There was an unfortunate crash in which Godin de Beaufort, trying desperately to make his old Porsche go fast enough to qualify, overdid it at the Bergwerk corner and hit a tree. He was taken to hospital with head and spine injuries, but they proved so serious that he died on the Monday. At the time few people realised the gravity of his condition and the news came as a shock for the genial, massive Dutchman was one of the most popular of Grand Prix drivers.

Morning of race day was lightened for spectators by the spectacle of a 5-lap bicycle race in which the sweating foot-pedallers attacked the Ring in reverse direction. Although not appreciative of the finer points of the sport,

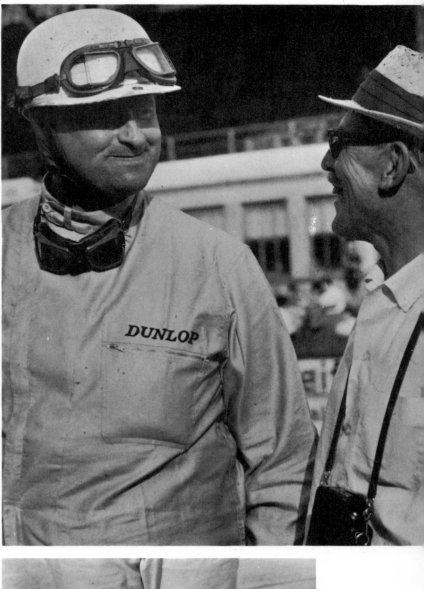

Typically happy càrefree studies of Carel de Beaufort with von Hanstein, a few minutes before the crash that proved fatal.

it was quite a sight to see the moving mass of motorcycle police leading the two-wheel assault followed by their motorised trainers, managers and supporters . . . a track replica of the cavalcade that follows in the wake of the Boat Race. For the Grand Prix there was no dummy grid, the cars taking the following 4–3–4 order:

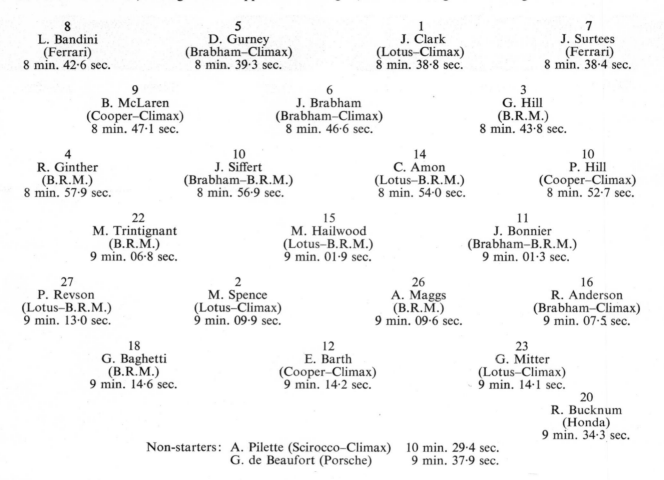

8	5	1	7
L. Bandini	D. Gurney	J. Clark	J. Surtees
(Ferrari)	(Brabham–Climax)	(Lotus–Climax)	(Ferrari)
8 min. 42·6 sec.	8 min. 39·3 sec.	8 min. 38·8 sec.	8 min. 38·4 sec.

9	6	3
B. McLaren	J. Brabham	G. Hill
(Cooper–Climax)	(Brabham–Climax)	(B.R.M.)
8 min. 47·1 sec.	8 min. 46·6 sec.	8 min. 43·8 sec.

4	10	14	10
R. Ginther	J. Siffert	C. Amon	P. Hill
(B.R.M.)	(Brabham–B.R.M.)	(Lotus–B.R.M.)	(Cooper–Climax)
8 min. 57·9 sec.	8 min. 56·9 sec.	8 min. 54·0 sec.	8 min. 52·7 sec.

22	15	11
M. Trintignant	M. Hailwood	J. Bonnier
(B.R.M.)	(Lotus–B.R.M.)	(Brabham–B.R.M.)
9 min. 06·8 sec.	9 min. 01·9 sec.	9 min. 01·3 sec.

27	2	26	16
P. Revson	M. Spence	A. Maggs	R. Anderson
(Lotus–B.R.M.)	(Lotus–Climax)	(B.R.M.)	(Brabham–Climax)
9 min. 13·0 sec.	9 min. 09·9 sec.	9 min. 09·6 sec.	9 min. 07·5 sec.

18	12	23
G. Baghetti	E. Barth	G. Mitter
(B.R.M.)	(Cooper–Climax)	(Lotus–Climax)
9 min. 14·6 sec.	9 min. 14·2 sec.	9 min. 14·1 sec.

			20
			R. Bucknum
			(Honda)
			9 min. 34·3 sec.

Non-starters: A. Pilette (Scirocco–Climax) 10 min. 29·4 sec.
G. de Beaufort (Porsche) 9 min. 37·9 sec.

The West German flag was dropped by von Diergart, President of A.v.D., and the field was away to a trouble-free start. Bandini had his nose in front at the South Curve, but by the North Curve the Italian had fallen back. Clark just led Gurney, with Surtees and Brabham almost wheel to wheel. A slight gap then another bunch with Graham Hill, Bandini and Phil Hill. Nürburgring is not a good circuit for the spectator, but in the pits there is the electronic scoreboard, which gives the progress of the leaders over the entire course. It was thus no surprise as the cars streamed towards the Tiergarten and past the pits with Clark just ahead of Surtees, Gurney a close third, and Graham Hill immediately behind. A gap before Brabham appeared in front of Phil Hill, Bandini, McLaren, Ginther, Bonnier and Amon. A Nürburgring lap is so long that differences in machine-power and driver-technique are quickly emphasised. The interval before the next group arrived made it seem like a separate race. It consisted of Siffert, Maggs, Baghetti, Trintignant, Spence and Barth. Pit stops were made by Revson, Mitter and Anderson. Hailwood blew up his engine and retired.

The leaders had set quite a pace, the standing lap time for all three was under the 8 min. 50 sec. mark. At the South Curve Surtees took the lead from Clark, whilst Graham Hill was measuring up Gurney. These four had drawn well clear of Brabham, McLaren and Bandini. The Honda was circulating nicely. The engine sounded right, and Bucknum had passed Barth, Spence, Trintignant and Baghetti. Lap 2 saw the leading four in line-formation. Evenly matched and each ready to assume the lead if Surtees made a mistake. The oil from Hailwoods' ailing car had slowed down lap times. It was now just over 9·0 min. Baghetti came into the pits with a broken throttle connection and retired. Phil Hill and Bonnier also called it a day. Clark had relinquished 2nd place to Gurney and the Lotus was now being harried by Graham Hill. McLaren was having trouble with a misfiring engine. Ginther had the same complaint and stopped at the pits for a plug check.

Lap 4 saw a dramatic turn at the North Curve. Surtees and Gurney went in together almost wheel to wheel. The Ferrari left a slight opening on one corner and the American was through, but unable to shake off the

Pat Surtees flanked by the Daily Mail *and* The Times.

Lorenzo Bandini protects his nose.

The ever-youthful Edgar Barth drove Rob Walker's Cooper.

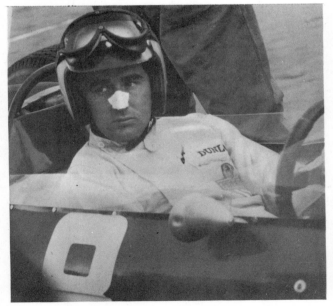

Barth found himself on the back row of the grid.

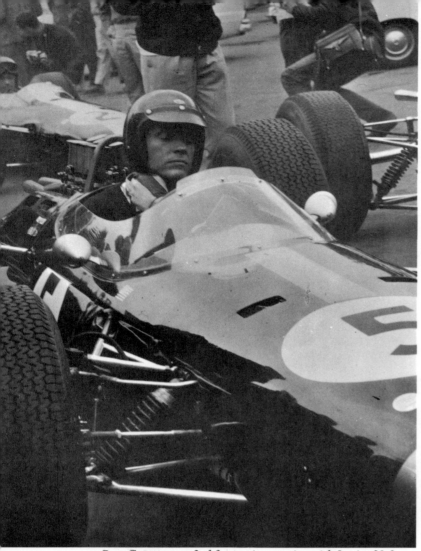

Dan Gurney was 3rd fastest in practice with 8 min. 39·3 sec.

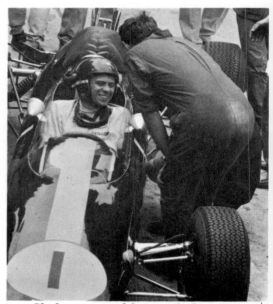

Clark was second fastest, clocking 8 min. 38·8 sec.

Spence did not get to grips with the circuit and was on 5th row.

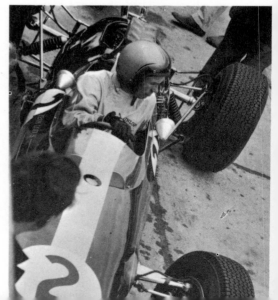

Italian car. When that lap ended both cars were still at close quarters. Graham Hill had overtaken Clark, but they were too far back to threaten the leaders. Brabham was 5th, ahead of Bandini. Amon took over 7th place when McLaren retired at the pits. Siffert was 8th. Barth broke down on the circuit with clutch trouble. Surtees resumed the lead on lap 5, Gurney got it back on lap 6, only to lose it again. Neither would give way and the vast crowd was quick to appreciate this razor-edge manoeuvring at maximum speed, in fact both cars were given an equal fastest lap of 8 min. 47·5 sec. Hill and Clark had dropped even farther back. The second B.R.M. had been overtaken by the Honda. Gurney was having heating complications. Surtees increased his speed, set up a fresh lap record of 8 min. 45 sec. and drew 3 seconds ahead of the Californian. Clark was overdue on lap 7. Hill went past in 3rd place, and shortly afterwards the Lotus crept into the pits and retired with a broken valve.

Half-way stage produced an interesting state of affairs. Surtees was out in front. His Ferrari sounded trouble-free,

84

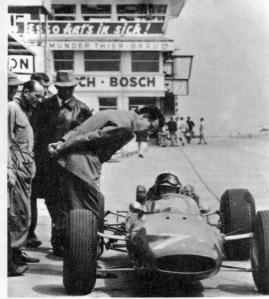

John Surtees blazed the trail. His 8 min. 38·4 sec. gave him pole position.

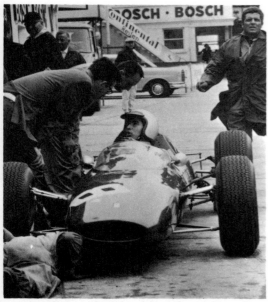

Bandini worked hard and found himself on the front row.

A special evening practice session enabled the Honda to complete the 5 qualifying laps.

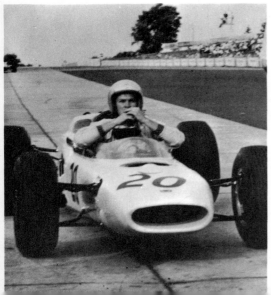

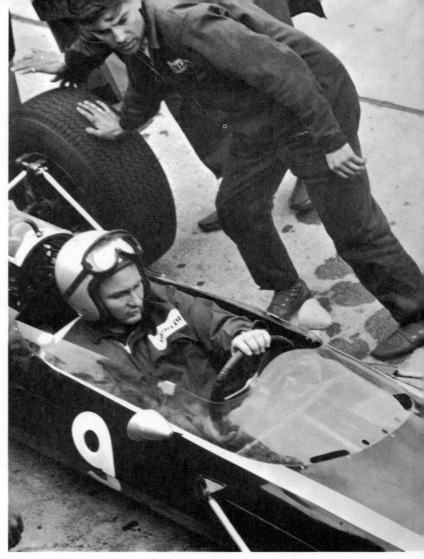

Bruce McLaren drove well to be on the 2nd row of the grid.

in fact on lap 8 he set up another lap record of 8 min. 43·0 sec. Gurney was 2nd, but not happy with the overheating. The margin was now 16 seconds. Graham Hill was about the same distance behind the Brabham. His B.R.M. was misfiring. Brabham had lost 4th place to Bandini, but managed to win it back at the North Curve. Lap 10 saw Gurney slow down and Hill went through to 2nd place, some 40 seconds behind Surtees. Gurney came into the pits and Surtees celebrated on lap 11 by clocking a remarkable 8 min. 39·0 sec. That burst put the Ferrari 46 seconds ahead of the B.R.M. The next time round the interval had grown by 9 seconds. Bandini was 3rd, Brabham having retired with a broken crown wheel and pinion. Amon had to give up 5th position because of a broken rear suspension radius rod. Bucknum spun the Honda before the Karussel, wrecked the car, but escaped injury. Trintignant succeeded in overtaking Maggs for 5th place. Siffert looked secure in 4th place. Graham Hill was having a rough drive in the B.R.M. that was misfiring so badly that it looked doubtful

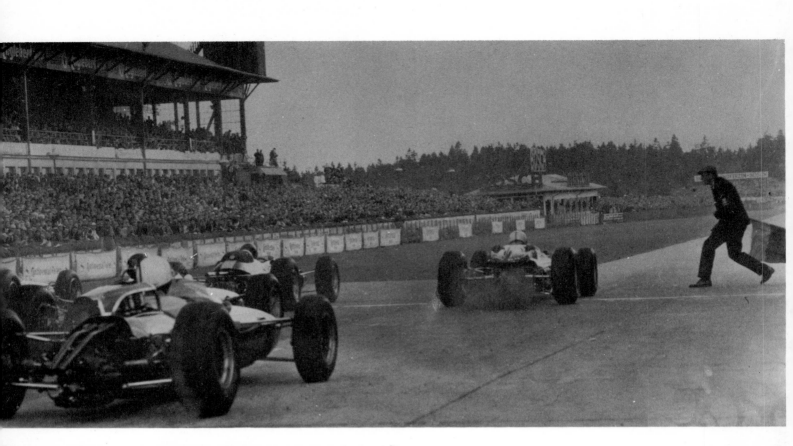

Above: *Dr. von Diergart, President of the A.v.D., drops the West German flag, and the field was away to a clean start.*

whether it would finish. Surtees set off on the last lap in command of the situation. The B.R.M. was 68 seconds behind. His car sounded fine. What more could a driver want? Certainly it was all that Surtees needed, and he came home to win at the record average speed of 96·56 m.p.h. The misfiring B.R.M. brought Hill home to 6 points. Bandini came 3rd to the joy of the Ferrari camp, but another lap and Siffert could have taken his place. As it was the young Swiss driver did extremely well to take 4th berth. Trintignant was the only other driver on the same lap, and he had to push his B.R.M. over the line. Maggs was 6th, a lap behind Surtees. The victory was as impressive as it was clear-cut. For the second year in succession Surtees had won one of the toughest races in the calendar, and in so doing had lopped off 8 seconds from his previous lap record as well as achieving a record race average. With four races to go, he had climbed the Championship table to 3rd place with 19 points. The "Prancing Horse" was back in a big way.

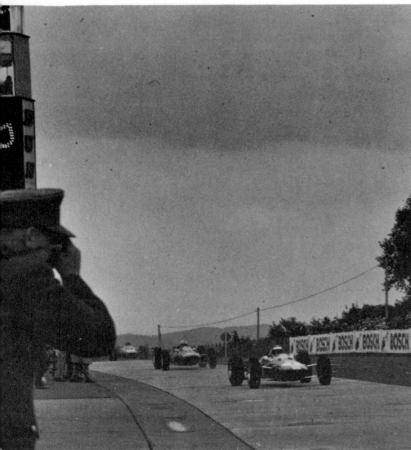

At the outset Clark led Surtees by a few yards.

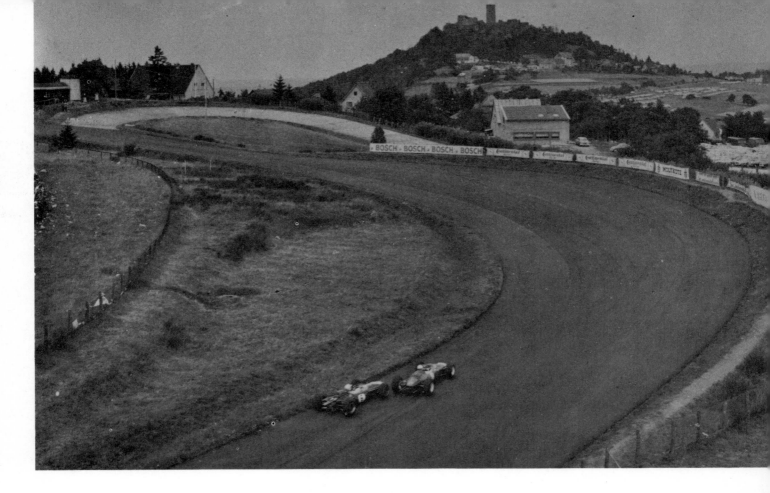

Results

1. John Surtees (Ferrari) 2 hr. 12 min. 04·8 sec. 96·57 m.p.h. (record).
2. Graham Hill (B.R.M.) 2 hr. 13 min. 20·4 sec.
3. Lorenzo Bandini (Ferrari) 2 hr. 16 min. 56·6 sec.
4. Joseph Siffert (Brabham–B.R.M.) 2 hr. 17 min. 27·9 sec.
5. Maurice Trintignant (B.R.M.) 14 laps.
6. Tony Maggs (B.R.M.) 14 laps.
7. Richie Ginther (B.R.M.) 14 laps.
8. Mike Spence (Lotus–Climax) 14 laps.
9. Gerhard Mitter (Lotus–Climax) 14 laps.
10. Dan Gurney (Brabham–Climax) 14 laps.
11. Chris Amon (Lotus–B.R.M.) 12 laps.
12. Jack Brabham (Brabham–Climax) 11 laps.
13. Ronnie Bucknum (Honda) 11 laps.
14. Peter Revson (Lotus–B.R.M.) 10 laps.

Fastest lap: John Surtees 8 min. 39·0 sec. 98·3 m.p.h. (record).

World Championship

1. Graham Hill 32 points
2. Jim Clark.......................... 30 points
3. John Surtees 19 points
4. Richie Ginther 11 points
 Peter Arundell 11 points
 Jack Brabham 11 points

The track looks wide enough, but Bandini appears to want just that little bit occupied by Brabham! The Australian had no option but to let the Italian get in front, but a fierce struggle followed, ending when the Brabham retired with a broken crown wheel and pinion.

Graham Hill finished strongly to take 2nd place, the 6 points giving him World Championship lead over Clark by 2 points.

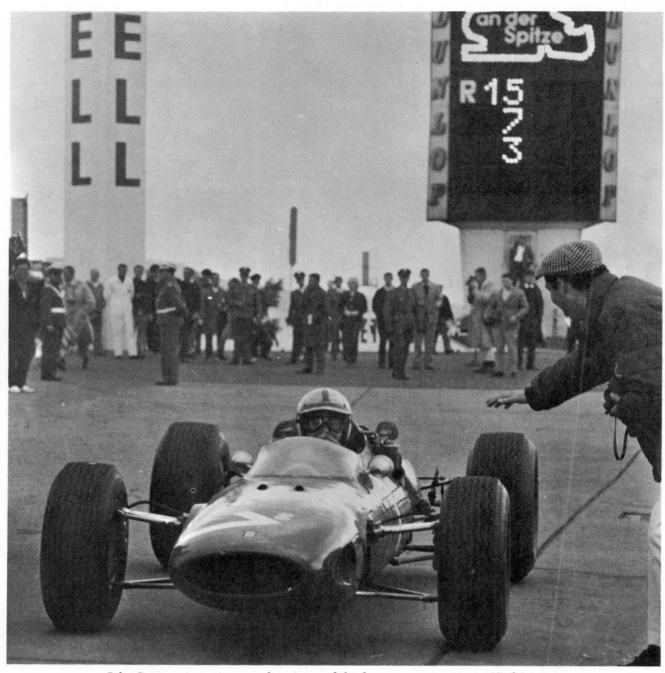

John Surtees comes in a worthy winner of the fastest race ever run at Nürburgring.

7. Dan Gurney	10 points
8. Bruce McLaren	7 points
9. Lorenzo Bandini	6 points
10. Joseph Siffert	3 points
11. Joakim Bonnier	2 points
Chris Amon	2 points
Maurice Trintignant	2 points
14. Mike Hailwood	1 point
Bob Anderson	1 point
Phil Hill	1 point
Tony Maggs	1 point

Constructors' Championship

1. Lotus–Climax	34 points
2. B.R.M.	33 points
3. Ferrari	19 points
4. Brabham–Climax	17 points
5. Cooper–Climax	10 points
6. Lotus–B.R.M.	3 points
Brabham–B.R.M.	3 points

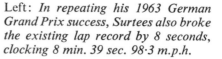

Left: *In repeating his 1963 German Grand Prix success, Surtees also broke the existing lap record by 8 seconds, clocking 8 min. 39 sec. 98·3 m.p.h.*

Below: *Ferrari jubilation was understandable, for Surtees and Ferrari were now 3rd in both Drivers' and Constructors' Championships. Further encouragement came from Bandini's well-earned 3rd place in the German Grand Prix.*

Left: *Graham Hill may not have won the trophy, but he had a man-sized swig of the champagne.*

89

View from inside the hangar-paddock of the pine-clad mountains encircling the circuit.

Grand Prix of Austria

105 LAPS **WARM AND DRY** **209 MILES**

Racing history was made when Zeltweg staged the Austrian Grand Prix. It was the first time that this country had been included in the World Championship series. The verdict is mixed. In favour must be set the warm-hearted friendliness of the officials; the enthusiasm of Martin Pfunder, the clerk of the course; the efficiency of the organisation. All these are rare qualities; unfortunately they are not sufficient in themselves to justify holding a World Championship event. In that class of racing with so much at stake certain basic requirements

The featureless circuit was laid out on the runway and perimeter track of the military airfield at Zeltweg.

Tony Maggs was handicapped with an eye complaint.

Alfred Moss has a few words with Martin Pfundner.

It could be a sneeze, it might be disdain!

Jenkinson (Motor Sport) patronises the Lotus taxi service.

. . . and it doesn't go either!

The only London bus that gives Green Shield stamps in Austria.

Dragoni decides it might be infectious.

An odd way to treat glory.

Innes Ireland inflates Graham Hill's neck tyre.

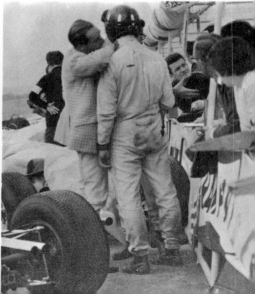

Dunlop technicians are always in attendance.

must be met. I am afraid that Zeltweg does not possess the facilities necessary for such a Grand Prix.

The difficulties cannot be overcome. The circuit is actually an Austrian military airfield. Permission to use it for motor-racing is only granted from the Friday morning until the Sunday evening. The organisers have from Wednesday evening to get facilities into existence before practice begins on the Friday afternoon. It is remarkable what can be improvised. The circuit is marked out by straw bales. Pits and grandstands are made with scaffolding bedecked with trade bunting. The timekeeper's box is an active London double-decker bus complete with Green Shield stamps. Competing cars were housed in a hangar. Spectators stood on the same level as the cars. Their protection in many places was a single wire. Admittedly they stood well back, but a car out of control at high speed or if a wheel comes off many people could be killed or injured. Memories of Le Mans and Monza are only too tragic, and safety precautions there were many. On the grounds of danger to life much remains to be done at Zeltweg.

There is another reason. The surface of the circuit is far too rough for Formula One machinery. I have never seen anything like it on any other circuit track. One of the worst features was the runway drain that cut across the circuit at the fastest of the bends. The best way to gauge the effect of this uneven surface is to list the practice casualties. Clark broke his left-hand steering arm; Ginther parted with the left front wheel; Gurney broke the left front hub carrier; Amon broke his left front steering arm; Clark repeated his steering arm break; Phil Hill clouted the straw bales and put the Cooper out of commission; Rindt had a similar experience; several cars were troubled with grounding; braking could be dicey; all told, no one could predict what effect the constant pounding would have on the cars during the race. The high vertical stresses could only result in heavy mechanical casualty rate.

Practice times produced the familiar front row grid. On the first day Graham Hill was fastest with 1 min. 10·3 sec. (101·65 m.p.h.). It was a creditable effort for he drove in acute discomfort. After a practice accident at Snetterton, his neck injury necessitated an inflated rubber

Centre: *Rob Walker might check his tyre pressures.*

Bottom Right: *The masked driver is Innes Ireland skygazing.*

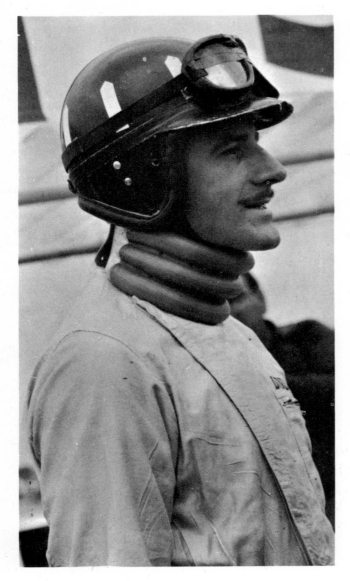

Left: *It was a pity that Hill did not meet one of the African "giraffe" women. They would have had much in common.*

collar to ease possible jarring. At Zeltweg every lap was one continuous jolt. Ginther returned a useful 1 min. 10·4 sec., later joined by Gurney and Surtees with identical times. Clark's best effort was 1 min. 11 sec. Spence clocked 1 min. 11·3 sec. Brabham had 1 min. 11·6 sec. Rindt headed the independents with 1 min. 12 sec. The final training session saw Graham Hill again fastest with a time of 1 min. 9·84 sec. Surtees came next with 1 min. 10·12 sec. Clark fractionally slower on 1 min. 10·21 sec. Gurney completed the front row with 1 min. 10·44 sec. Phil Hill made heavy weather of the spare Cooper and only managed 1 min. 13·15 sec. Bonnier found a fresh lease of life and was speediest of the independents with 1 min. 11·58 sec. Anderson managed a shaky 1 min. 12·05 sec., whilst Maggs returned 1 min. 12·4 sec.

That night was hard labour for most of the mechanics. The works Lotus patched their cars with bits from the spare car and a B.R.P. Lotus 24. The finished jobs for Clark and Spence looked of mixed parentage. Amon's

Below: *The start saw 18 cars clean away. The two in trouble were Clark (clutch) and Graham Hill (wheelspin).*

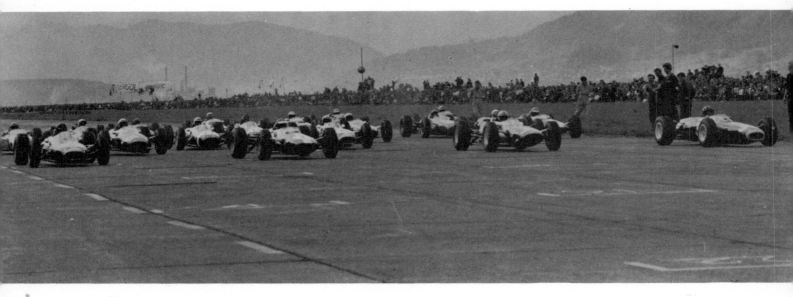

94

The complete absence of any physical feature on the runway circuit robbed the race of the distinctive atmosphere usually associated with the World Championship series. Everything was improvised, but in spite of the many problems and difficulties, the co-operative friendliness of the Austrians compensated for the innumerable irritations.

The surface of the circuit was so rough and bumpy that it took a terrible toll of machinery. The indignation aroused as car after car clouted the seams between the concrete slabs was because the OAMTC had stated the field would be resurfaced if the event was given World Championship status.

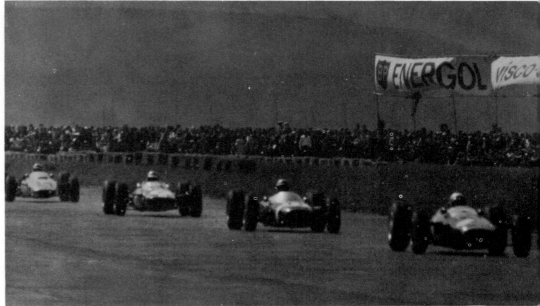

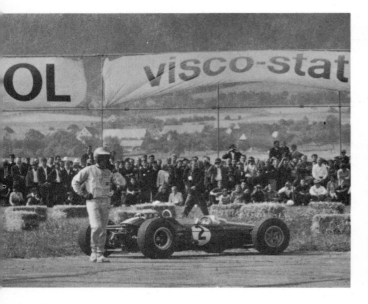

Left: *Mike Spence was one of the many casualties. He abandoned his Lotus by the roadside with a broken drive-shaft.*

car likewise had borrowed uprights and steering arms. Race day produced ideal racing weather. The puddles caused by the overnight storm had dried out. Had the downpour continued the race would probably have been postponed for there was hardly any drainage on the circuit. The Austrians put on a brave show of the flags of the competing nations, then somebody realised the Honda had not entered so the Japanese standard was hustled out of sight. Eventually the grid was formed of the following 20 cars:

95

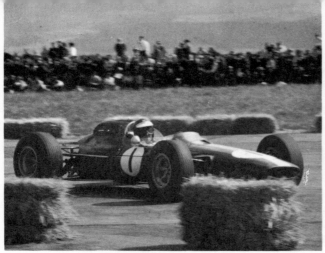

Clark's drive-shaft broke.

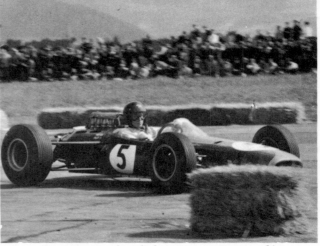

Gurney retired with front suspension trouble.

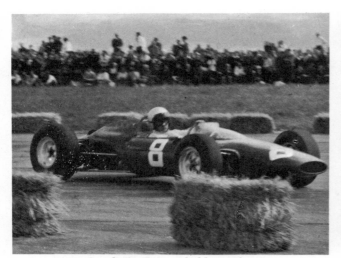

Bandini's Ferrari held together.

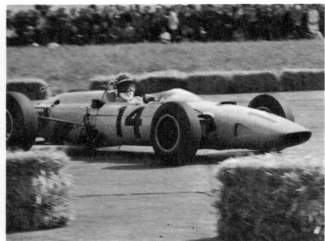

Ireland finished 5th, 3 laps behind the winner.

<div align="center">

3
G. Hill
(B.R.M.)
1 min. 09·84 sec.

7
J. Surtees
(Ferrari)
1 min. 10·12 sec.

1
J. Clark
(Lotus–Climax)
1 min. 10·21 sec.

5
D. Gurney
(Brabham–Climax)
1 min. 10·40 sec.

4
R. Ginther
(B.R.M.)
1 min. 10·40 sec.

6
J. Brabham
(Brabham–Climax)
1 min. 10·57 sec.

8
L. Bandini
(Ferrari)
1 min. 10·63 sec.

2
M. Spence
(Lotus–Climax)
1 min. 11·00 sec.

9
B. McLaren
(Cooper–Climax)
1 min. 11·25 sec.

11 ·
J. Bonnier
(Brabham–Climax)
1 min. 11·59 sec.

14
I. Ireland
(B.R.P.–B.R.M.)
1 min. 11·60 sec.

20
J. Siffert
(Brabham–B.R.M.)
1 min. 11·82 sec.

12
J. Rindt
(Brabham–B.R.M.)
1 min. 12·00 sec.

22
R. Anderson
(Brabham–Climax)
1 min. 12·04 sec.

18
G. Baghetti
(B.R.M.)
1 min. 12·10 sec.

15
T. Taylor
(B.R.P.–B.R.M.)
1 min. 12·23 sec.

16
C. Amon
(Lotus–Climax)
1 min. 12·28 sec.

17
M. Hailwood
(Lotus–B.R.M.)
1 min. 12·40 sec.

19
A. Maggs
(B.R.M.)
1 min. 12·40 sec.

10
P. Hill
(Cooper–Climax)
1 min. 13·15 sec.

</div>

As the red-and-white Austrian flag fell, Gurney was first away, followed by Surtees, Bandini, Ginther, Bonnier and Ireland. Graham Hill had a bad start through wheel-spin, whilst Clark had trouble with first gear and was left at the line. The B.R.M. set about getting clear of the backmarkers. Hill remarked afterwards that one car seemed particularly saucy. Looking across he saw, to his surprise, that it was Clark, and added that it didn't seem nearly so bad with the Lotus for company. In the meantime Gurney and Surtees had no intention of waiting and they were blazing away in the lead. Brabham dropped out for a pit stop. On lap 2 Surtees took the lead from

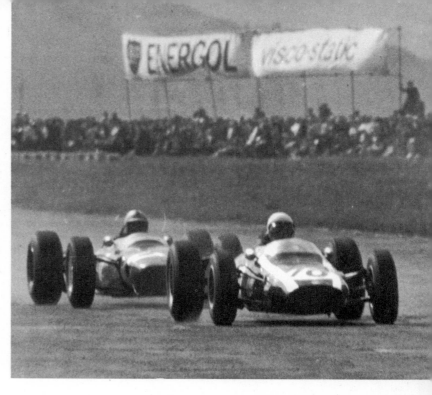

Phil Hill's Cooper (10) was far from easy to handle. At the left-hander, the car spun, struck the straw bales, and caught fire. Hill was unhurt, and attempted to release the fire-extinguisher. Officials restrained him in time for the petrol tanks exploded.

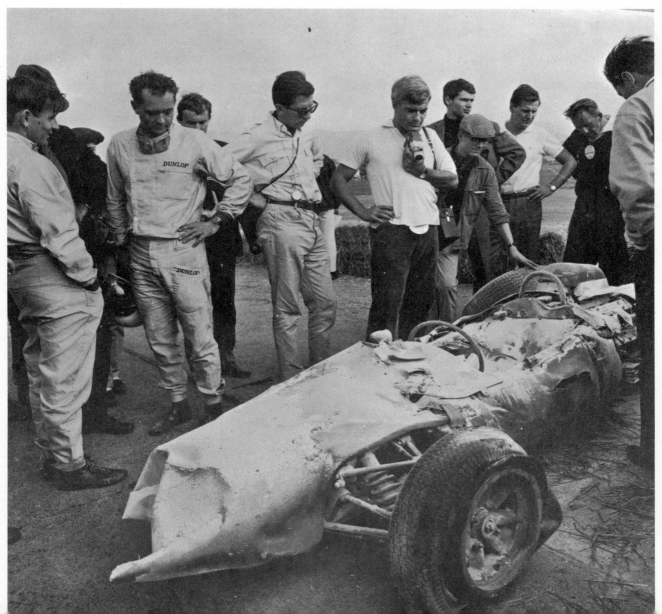

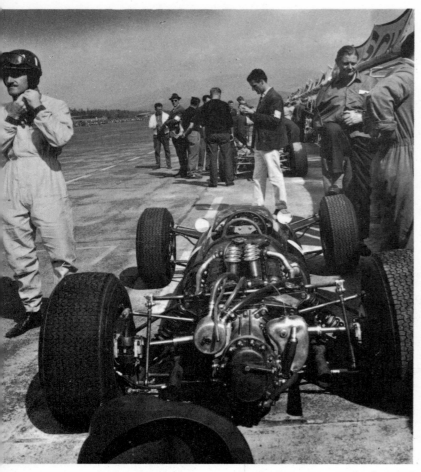

Before the race was over there were more cars broken and retired than were circulating.

Martin Pfundner gives Bandini's V–6 Ferrari the chequered flag, 6½ seconds in front of Ginther's B.R.M.

Gurney, but the worst opponent for every car was the bumpy circuit. Amon was the first to go when his engine blew up. On lap 5 Graham Hill's race ended when the B.R.M. distributor drive sheared. Three laps later Surtees retired when the Ferrari rear suspension collapsed. That left Gurney comfortably placed in the lead, though Clark was beginning to be a danger. The Lotus had gone through the field and when he overtook Bandini to take 2nd place, Gurney was 14 seconds ahead. There were several spins that altered the race pattern among the backmarkers, Anderson, Hailwood and Phil Hill losing their positions. Brabham found the cause of his trouble, a blocked fuel pipe, and rejoined the fray 17 laps behind Gurney. Trevor Taylor was the next victim with a collapsed suspension. Siffert had brake trouble, spun, clouted a straw bale and retired.

A tussle between Gurney and Clark was drawing closer. On lap 27 the Lotus was only 8·5 seconds behind. Sensing the danger the Californian widened the gap to 11 seconds. Clark quickened his pace but on lap 40 a drive-shaft broke and that was that. A couple of laps later and his team-mate, Mike Spence, packed up by the hairpin with a broken drive-shaft! Gurney was now well in front with Bandini second. McLaren added to the toll of casualties with valve spring troubles. It seemed that any driver who drove near the limit was bound to be eliminated. Gurney's spirited effort paid the penalty. On lap 47 he retired with a broken front suspension. Bandini now held the lead of 17 seconds over Ginther, with Bonnier 3rd, then a lap in arrears came Hailwood, Anderson, Ireland and Maggs. Of these Ireland's engine sounded very rough, whilst Anderson's was not much better. By now the entry was looking sadly depleted. Phil Hill was having a frightful time trying to control the unpredictable handling of his old works Cooper, but on lap 59 he slid off at the left-hander and struck the straw bales. The rear suspension collapsed, the fuel tank was punctured, a wheel careered on the track, and as Hill jumped clear, the car was enveloped in black smoke and flames. He was very fortunate to escape unhurt and had to be restrained from getting the tiny fire extinguisher out of the Cooper just as the petrol tanks exploded. The Austrian marshals were useless. Lack of experience left them helpless as the burning fuel swept across the track. To avoid it Hailwood and Bonnier used the grass.

Rindt retired with faulty steering. Bonnier lost 3rd place because of a broken valve spring. Bandini was circulating with 11 seconds lead over Ginther. With four laps to go the B.R.M. began to narrow the gap. Five seconds were pulled back, but time ran out and the smiling Lorenzo Bandini took the chequered flag with a race average of 99·20 m.p.h. Not since 1961 when Baghetti won at Rheims had an Italian won a World Championship Grand Prix. It was also the second successive Ferrari victory. Ginther was 2nd. Anderson 3rd, three laps behind the leaders in an ailing Brabham. Maggs was 4th,

Ireland 5th and Bonnier 6th. So ended the car-breaking Grand Prix. The result had little bearing on the World Championship table. The first three added nothing to their totals. Only Ginther benefited by moving to 4th with Bandini 5th.

Results

1. Lorenzo Bandini (Ferrari) 2 hr. 06 min. 18·23 sec. 99·20 m.p.h. (race record).
2. Richie Ginther (B.R.M.) 2 hr. 06 min. 24·41 sec.
3. Bob Anderson (Brabham–Climax) 102 laps.
4. Tony Maggs (B.R.M.) 102 laps.
5. Innes Ireland (B.R.P.–B.R.M.) 102 laps.
6. Joakim Bonnier (Brabham–Climax) 101 laps.
7. Giancarlo Baghetti (B.R.M.) 96 laps.
8. Mike Hailwood (Lotus–B.R.M.) 95 laps.
9. Jack Brabham (Brabham–Climax) 76 laps.

Fastest lap: Dan Gurney (Brabham–Climax) on lap 32 in 1 min. 10·56 sec. 101·57 m.p.h. (record).

World Championship

1.	Graham Hill	32 points
2.	Jim Clark	30 points
3.	John Surtees	19 points
4.	Richie Ginther	17 points
5.	Lorenzo Bandini	15 points
6.	Peter Arundell	11 points
	Jack Brabham	11 points
8.	Dan Gurney	10 points
9.	Bruce McLaren	7 points
10.	Bob Anderson	5 points
11.	Tony Maggs	4 points
12.	Joakim Bonnier	3 points
	Joseph Siffert	3 points
14.	Chris Amon	2 points
	Maurice Trintignant	2 points
	Innes Ireland	2 points
17.	Mike Hailwood	1 point
	Phil Hill	1 point

Constructors' Championship

1.	B.R.M.	36 points
2.	Lotus–Climax	34 points
3.	Ferrari	28 points
4.	Brabham–Climax	21 points
5.	Cooper–Climax	10 points
6.	Lotus–B.R.M.	3 points
	Brabham–B.R.M.	3 points
8.	B.R.P.–B.R.M.	2 points

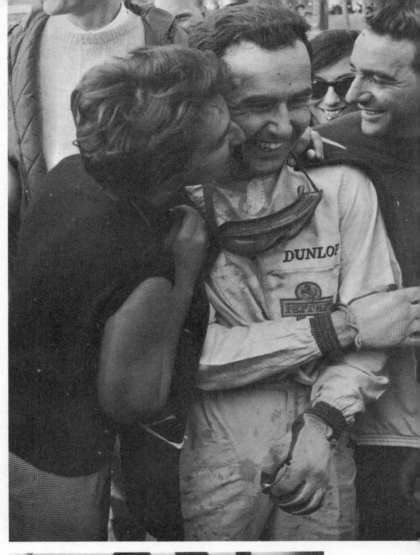

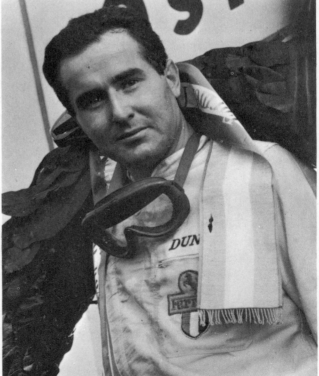

Lorenzo Bandini receiving well-earned congratulations. It was his first success in the World Championship races, and it gave Enzo Ferrari his second successive win. With Richie Ginther, these two were the only ones to complete the full race distance of 105 laps.

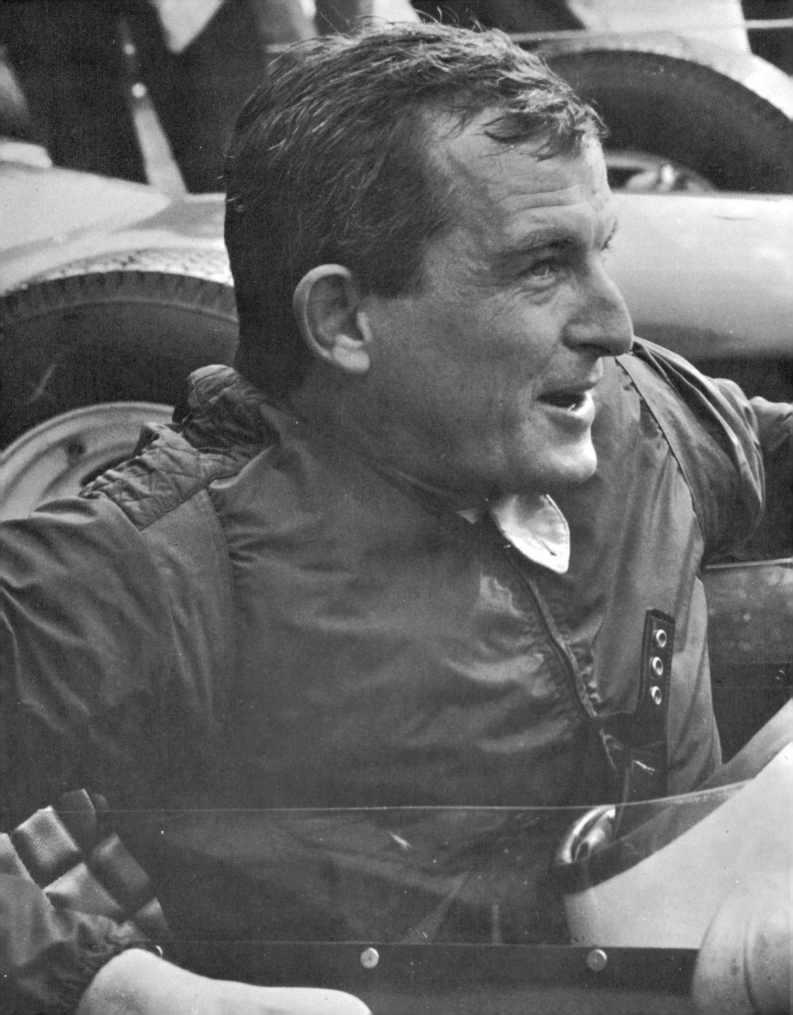

Grand Prix of Italy

| 78 LAPS | WARM AND DRY | 279 MILES |

Opposite: *Ludovico Scarfiotti was given a V–6 Ferrari, his first Formula One race since his 1963 accident at Rheims.*

Below: *Jim Clark was in the latest Type 33 Lotus–Climax.*

Below Right: *Graham Hill was in the latest B.R.M. with modified chassis, new intake and exhaust system.*

With three contenders for the World Championship and only the Grands Prix of America and Mexico ahead, a great deal turned on the result at Monza. Italian interest was further stimulated by the revival of Ferrari fortunes, whilst Bandini after winning the Austrian Grand Prix was something of a local hero. Local knowledge could be a help for the flat autodrome circuit is home ground for Maranello cars, and there were rumours of the 12-cylinder machine being at last on view. Like the Honda saga,

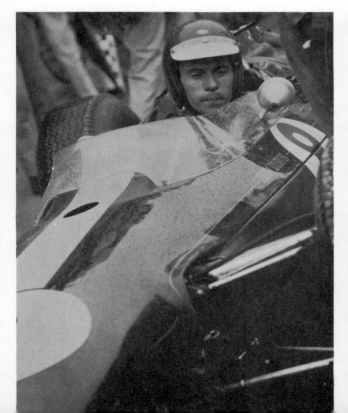

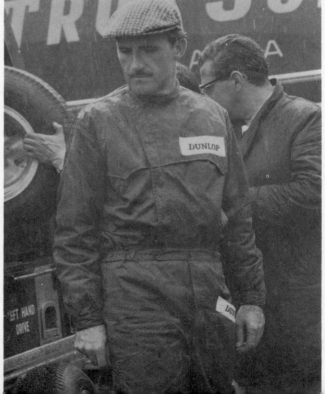

Mike Parkes in the pits, happy in spite of damaged ribs.

Giacomo Russo, the Italian Junior driver who adopts the pseudonym "Geki".

Raymond Baxter, television commentator, garnering facts before the race.

Mechanic Perkins about to launch the B.R.M.

. . . at least she hid her face!

. . . but he couldn't hide his seat.

Impressario Henry Sherek tucks into an ice.

Bette Hill licks more delicately.

Richie Ginther with son and heir.

J. H. van Haaren with his wife in the paddock.

everyone was a trifle sceptical, but this time both turned up. The Japanese car had been rebuilt after the Nürburgring crash. It was more or less the same except that the engine had fuel injection instead of the former carburetters. No one could say it was a "good-looker", but at least it was more presentable, and there were no Coca-Cola tins tied on the back. The 12-cylinder Ferrari looked impressive and was said to give a genuine 210 horsepower. The Derrington-Francis car sounded new, but proved to be the old A.T.S. in disguise, the assets of that company being bought by John Derrington, the engine tuner from Kingston, whilst Alf Francis was responsible for the development work. Claims were made that the engine had shown 210 b.h.p. at 10,000 r.p.m. The car looked good and had the Portuguese, Mario Cabral, as driver. B.R.M. brought a new car for Graham Hill, fitted with a new intake and exhaust system, the pipes coming from the top of the rear cowling like the Climax. Extra fuel tanks had been fixed along the lower sides of the engine, which were the answer to the official nominated race distance of 307 miles. Other teams had gone to the trouble and expense of anticipating additional fuel for the extra distance, when it was curtly announced that 307 had been shortened to 279 miles. The offhand announcement was in true Monza tradition.

Twenty-five cars turned up for the first practice. The target was Clark's 1963 lap time of 1 min. 38·9 sec., an average of 128 m.p.h. As there was no question of the banked track being used, sheer horsepower and a strong engine were needed to tame the 3½-mile road circuit. Gurney had both. He set up a new lap record of 1 min. 38·2 sec. Graham Hill clocked 1 min. 38·7 sec. Ginther returned 1 min. 40·4 sec. Bucknum had the same time in the Honda, an excellent effort that put him ahead of Brabham, Ireland, Bonnier, Anderson, Baghetti, to name

but five. Overheating was still a problem, but there was nothing much wrong with its 12 cylinders. Siffert, fresh from his Enna win over Clark, returned a spirited 1 min. 39·7 sec. Slipstreaming is more than useful at Monza as McLaren found during his 1 min. 39·4 sec. lap. Spence showed improved form and lapped a useful 1 min. 40·3 sec. Bandini had 1 min. 39·8 sec. John Love, who had taken Phil Hill's place in the Cooper team, had wretched luck with a broken distributor drive. It was a long way to come from Rhodesia for such a short outing. Clark's Lotus lacked the touch of speed so essential on the Monza straights, and had to be content with 1 min. 39·1 sec. Surtees had been motoring steadily without fireworks until just before the training ended. Supremely confident, he lapped 1 min. 37·4 sec., 132·06 m.p.h. On the Saturday the weather changed. Gone was the warm Italian sun, instead damp mist and rain made fast times impossible. Conditions on the circuit were treacherous, especially at Lesmo, so Friday's times served as a basis for the starting-grid, a decision that robbed the border-line drivers of a last chance to clock a qualifying time. The somewhat dispirited spectators had some consolation when the new 12-cylinder Ferrari circulated

It might appear that Chris Barber needed police protection.

The Japs have quaint habits.

Willie Mairesse (centre), *recovered after his severe injuries at Spa, with Toto Roche.*

Joseph Siffert relaxes off duty.

Young Ascari (centre) *son of former World Champion, in the pits.*

Dan Gurney with Count Giovanni Lurani.

A cheerful study of Wilfred Andrews of the R.A.C.

Bob Anderson and Ian Raby inspect the scene.

Piero Taruffi and his wife with Maurice Trintignant.

There appear to be no flies on Herr Schmitz.

After a promising performance, once holding 5th place, the Honda retired with brake trouble.

with Bandini at the wheel. Gurney chanced his luck and lapped under the 2-minute mark. The only other driver to do so was Clark with 1 min. 59·4 sec. Ireland was lucky. A radius rod bolt broke as he left the pits. Had it happened on a fast section, the result could have been nasty. The non-qualifiers were Taylor (B.R.P.–B.R.M.) 1 min. 43·8 sec.; "Geki" (Brabham–Climax) 1 min. 44·1 sec.: Love (Cooper–Climax) 1 min. 58·5 sec.: and Ian Raby (Brabham–Climax) 1 min. 52·2 sec. Trintignant had a stroke of luck. Jean-Claude Rudaz had to withdraw his Cooper–Climax because of engine trouble, so the little Frenchman was promoted to the last place on the grid.

Race day was overcast, but nothing could damp the high spirits of an enormous crowd—colourful, effervescent, vociferous. They had come to see Ferrari win. If partisanship could help in any way, they would do their bit. Their shouts, whistles and cheers might not comply with Queensberry rules, but nobody minded. An Italian car was favourite, a Milanese could well be the winner, so what price patriotism. If the other fellow's car broke down, that was the moment to cheer. The honest naïvety of such biased enthusiasm was almost refreshing. In this respect the average Englishman is a hypocrite. Time and again have I known moments of sheer delight when mechanical troubles have knocked out the opposition, but some code demands that a poker-faced expression is assumed. The main race was preceded by an event for GT cars, followed by the first exhibition on the Continent of dragster demonstrations. An American one driven by Dante Duce produced fireworks by clocking 8·5 seconds on the quarter of a mile. A spectacular and noisy prelude to twenty Formula One cars taking their places on this grid:

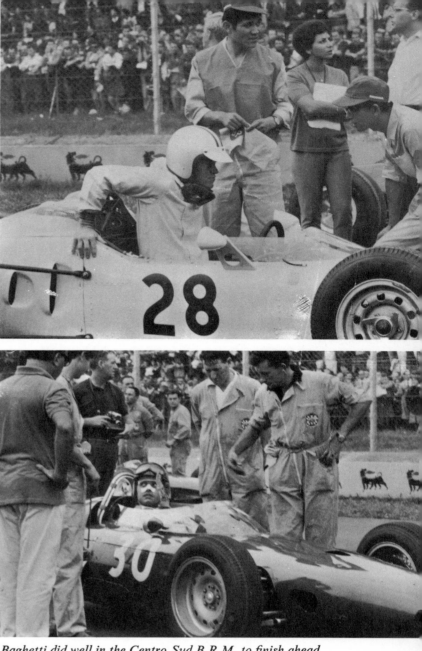

Baghetti did well in the Centro Sud B.R.M. to finish ahead of a works Ferrari.

The 3-2-3 grid was an improvement on the lengthy double row of previous years.

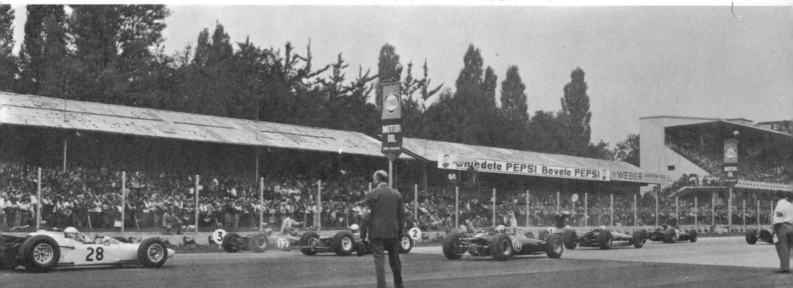

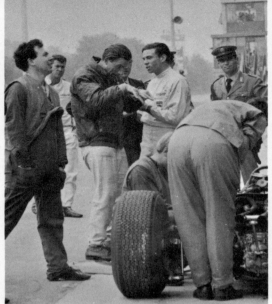

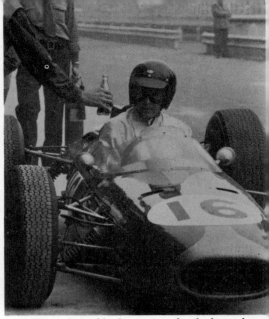

On lap 59 Brabham retired on the course with a blown engine.

Graham Hill puts the 'fluence on Jim Clark's car, which was retired on lap 28 with a broken piston.

Gurney's bad luck continued as he brought an ailing Brabham into the pits on lap 68.

2 J. Surtees (Ferrari) 1 min. 37·4 sec.	16 D. Gurney (Brabham–Climax) 1 min. 38·2 sec.	18 G. Hill (B.R.M.) 1 min. 38·7 sec.
	8 J. Clark (Lotus–Climax) 1 min. 39·1 sec.	26 B. McLaren (Cooper–Climax) 1 min. 39·4 sec.
12 J. Siffert (Brabham–B.R.M.) 1 min. 39·7 sec.	4 L. Bandini (Ferrari) 1 min. 39·8 sec.	10 M. Spence (Lotus–Climax) 1 min. 40·3 sec.
	20 R. Ginther (B.R.M.) 1 min. 40·4 sec.	28 R. Bucknum (Honda) 1 min. 40·4 sec.
14 J. Brabham (Brabham–Climax) 1 min. 40·8 sec.	34 J. Bonnier (Brabham–Climax) 1 min. 41·0 sec.	46 I. Ireland (B.R.P.–B.R.M.) 1 min. 41·0 sec.
	22 R. Anderson (Brabham–Climax) 1 min. 41·3 sec.	30 G. Baghetti (B.R.M.) 1 min. 41·4 sec.
6 L. Scarfiotti (Ferrari) 1 min. 41·6 sec.	40 M. Hailwood (Lotus–B.R.M.) 1 min. 41·6 sec.	38 P. Revson (Lotus–B.R.M.) 1 min. 42·0 sec.
	50 M. Cabral (Francis–A.T.S.) 1 min. 42·6 sec.	48 M. Trintignant (B.R.M.) 1 min. 43·3 sec.

The signal to start engines on the dummy-grid was given much too early. For five minutes the revving went on. There were anxious expressions on the faces of team-managers and mechanics before the twenty cars moved forward to the main grid. The flag fell, and McLaren was in the lead, ahead of Surtees and Gurney. One car was

left stranded on the grid. It was Graham Hill in the new B.R.M. He tried to get going. The engine began running, but stalled. He tried again, only to stall. The car was wheeled back to the pits. There were no Championship points to be collected at Monza. While this drama was taking place, Surtees took the lead almost in front of the grandstands. The cheers would have done justice to the end of the race. Immediately behind came Gurney, Clark and McLaren. A widening gap, then a clutter of cars headed by Bandini, Ireland and Bonnier. Slipstreaming made a pattern like a weaving snake. Nose to tail, then wheel to wheel, back to nose to tail. Race order changed with bewildering speed, before the whole field disappeared from sight. The pace quickly split the cars into three groups. The leading quartet were having a battle royal. Lap 3 saw Clark overtake McLaren. Lap 5 Gurney went into the lead. Lap 6 Clark went by Surtees into 2nd place. Lap 8 Surtees led once more. Lap 10 and Clark was back in 4th berth. All four were clocking about 1 min. 40 sec.

The second group consisted of twelve cars. The pushing, shoving, jostling and what-not that went on defies description. Only superb handling of machinery prevented a terrific pile-up. Less than three seconds blanketed the lot. The only casualty was Hailwood, who retired with a blown-up engine. Rarely has such a scrap taken place for the honour of 5th position. Bonnier was in front; the next time Brabham; then Ireland; to the delight of the crowd Baghetti sometimes stormed through; everybody was thrilled when Bucknum brought the Honda at the head. Scarfiotti found his return to Formula One racing a somewhat rough business for someone pushed him off the track, leaving him spinning in the South Curve. Stones and dirt were flying everywhere. This was motor-racing at its most exciting and the huge crowd was quick to show its appreciation. Even the tail threesome of Cabral, Revson and Trintignant were having fun and games until the Frenchman fell out with fuel injection troubles, and Cabral retired on the circuit.

Up front the pressure was just as fierce, but lap 27 saw a change. Clark came into the pits with an ailing Lotus. He went out again for a slow lap, only to retire with a broken piston. That left Surtees in the lead from Gurney, whilst McLaren fell away having lost his tow, but he was still about 20 seconds in front of the pack. The struggle continued with unabated ferocity. On lap 37 Gurney overtook Surtees, whilst Ginther led the second group. Shortly afterwards the leading two cars were caught up in the dicing bunch, and 5 laps passed before they were clear, leaving Ginther's B.R.M. in front of Bandini, Ireland, Brabham, Baghetti, Spence and Siffert. Lap after lap the Ferrari and Brabham swopped places, a wheel-to-wheel duel that gave no indication of the outcome. The main group had split in two. Brabham, Ginther, Ireland, Bandini and Bonnier drew away from Baghetti, Siffert and Spence. Mechanical failures were remarkably few,

There were some intensely exciting duels, not only for the lead, but wheel-to-wheel dices in the pack.

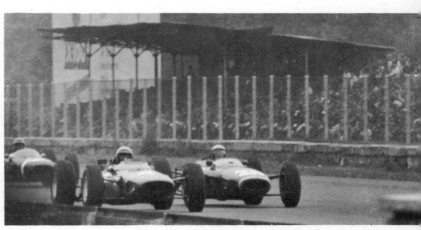

Ginther and Bandini fought a bitter battle, that ended with the weaving Italian taking 3rd place by inches.

Bruce McLaren, the only man not lapped by Surtees, drove an intelligent race to finish 2nd.

107

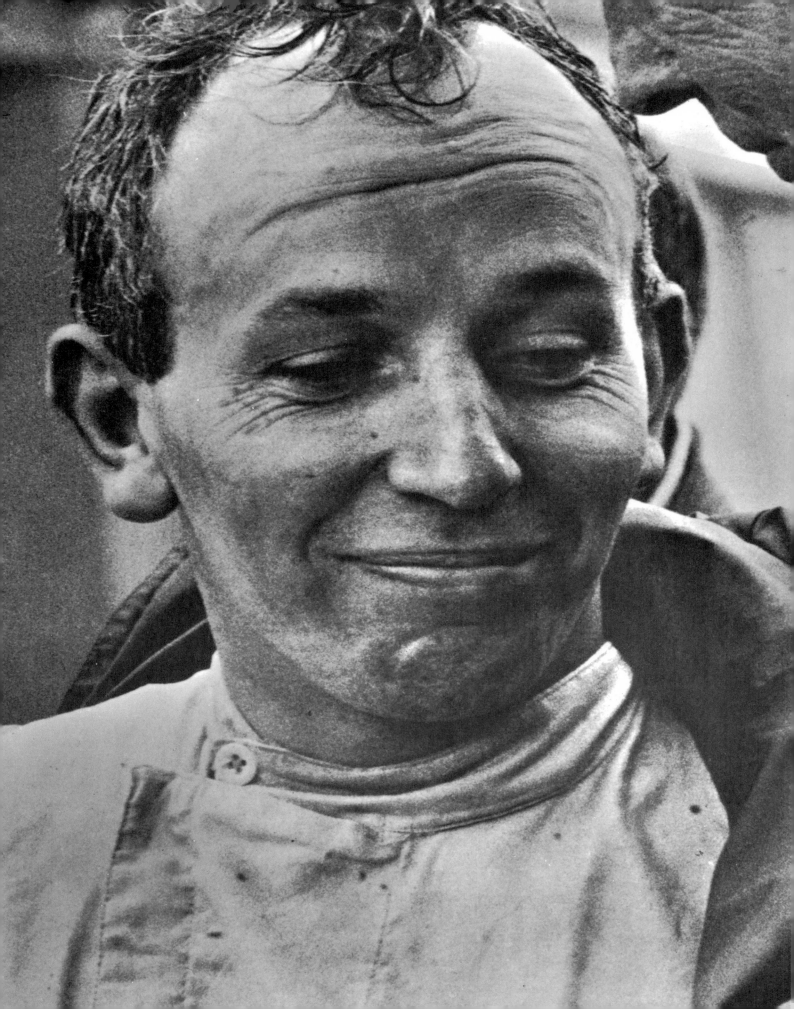

but lap 51 saw Bonnier stop at the pits with a flat battery. It was a pity because the Swede had produced one of his best drives for a long time. He rejoined the race, but was out of the chase.

A tremendous cheer came from the grandstands as Surtees once again took the lead. On lap 55 Gurney turned the tables. He was out in front, but the engine did not sound so healthy. Back in the ruck, individual dogfights had developed. Brabham and Ginther were mixing it, until the Australian stopped in the country with a blown engine. Ireland and Bandini were preoccupied in rugged fashion. Spence and Siffert were having a more polite duel. Ireland suddenly found more power, left Bandini behind and closed up to Ginther. Lap 62 showed that Gurney was in trouble. He slowed and a lap by Surtees of 1 min. 39 sec. gave the Ferrari a clear lead. The inevitable happened. Lap 68 saw Gurney in the pits. A broken battery put him back several laps. Surtees was now firmly in command. He slackened the pace and went serenely on to take the chequered flag to give Ferrari a third successive World Championship victory, more than a minute ahead of McLaren, whose 2nd place must have been some consolation to John Cooper after his Austrian mishaps. Surtees has driven many fine races, but this Monza win must have given him immense satisfaction. It was the reward for tremendous courage and cool skill, a triumph to remember. He had set up a new lap record of 1 min. 38·8 sec., 130·12 m.p.h., whilst the race average of 127·78 m.p.h. was the fastest on the road circuit. His 9 points had also lifted him high in the Championship table, only 2 behind Clark and 4 behind Graham Hill. The chequered flag had dropped, Surtees had won, but the excitement was by no means over. Everyone waited to see the outcome of the Ginther/ Bandini fight. They had been virtually wheel to wheel as both cars began the last lap. A deafening cheer told who was in front when they came in sight, but with a quarter of a mile left the B.R.M. pulled out to pass. The Italian reacted by swerving across Ginther's bows. Weaving and dodging they crossed the line together. Timekeepers could not separate the cars. The judges eventually gave Bandini the decision, later confirmed by photographs that showed the margin to be a matter of inches. Ireland was 5th. Spence and Siffert crossed the line together, Spence just having the edge. Baghetti and Scarfiotti repeated the treatment, Baghetti just getting in front. With all this excitement, the crowd was almost delirious with enthusiasm. The Italian police were swept aside— that in itself was remarkable—and Bandini was carried shoulder-high to the pits. The European season had ended with a flourish.

Opposite: Surtees' impressive victory—the third successive Ferrari Championship success—moved him into third place in the table, with 28 points against Clark's 30 and Hill's 32.

Results

1. John Surtees (Ferrari) 2 hr. 10 min. 51·8 sec. 127·78 m.p.h. (record)
2. Bruce McLaren (Cooper–Climax) 2 hr. 11 min. 57·8 sec.
3. Lorenzo Bandini (Ferrari) 2 hr. 11 min. 09·6 sec. 77 laps.
4. Richie Ginther (B.R.M.) 2 hr. 11 min. 09·7 sec. 77 laps.
5. Innes Ireland (B.R.P.–B.R.M.) 77 laps.
6. Mike Spence (Lotus–Climax) 77 laps.
7. Joseph Siffert (Brabham–B.R.M.) 77 laps.
8. Giancarlo Baghetti (B.R.M.) 77 laps.
9. Lodovico Scarfiotti (Ferrari) 77 laps.
10. Dan Gurney (Brabham–Climax) 75 laps.
11. Bob Anderson (Brabham–Climax) 75 laps.
12. Joakim Bonnier (Brabham–Climax) 74 laps.
13. Peter Revson (Lotus–B.R.M.) 72 laps.
14. Jack Brabham (Brabham–Climax) 59 laps.

Fastest lap: John Surtees (Ferrari) on laps 63 and 67 in 1 min. 38·8 sec. 130·12 m.p.h. (record).

World Championship

1.	Graham Hill	32 points
2.	Jim Clark	30 points
3.	John Surtees	28 points
4.	Richie Ginther	20 points
5.	Lorenzo Bandini	19 points
6.	Bruce McLaren	13 points
7.	Peter Arundell	11 points
	Jack Brabham	11 points
9.	Dan Gurney	10 points
10.	Bob Anderson	5 points
11.	Tony Maggs	4 points
	Innes Ireland	4 points
13.	Joakim Bonnier	3 points
	Joseph Siffert	3 points
15.	Chris Amon	2 points
	Maurice Trintignant	2 points
17.	Mike Hailwood	1 point
	Phil Hill	1 point
	Mike Spence	1 point

Constructors' Championship

1.	Ferrari	37 points
2.	B.R.M.	*36 points
3.	Lotus–Climax	35 points
4.	Brabham–Climax	21 points
5.	Cooper–Climax	16 points
6.	B.R.P.–B.R.M.	4 points
7.	Lotus–B.R.M.	3 points
	Brabham–B.R.M.	3 points

* Best six performances.

Grand Prix of the USA

110 LAPS WARM AND DRY 253 MILES

Opposite: *The press-rooms at Watkins Glen . . . light, modern and airy, with every facility required.*

Below: *Crowd scene on the grid. It is possible to pick out Surtees, Gurney, McLaren, Spence and Innes Ireland.*

The drive from New York to Watkins Glen is always enjoyable. It seems as if when summer has reduced all colour in the woods to its deepest tones, autumn influences it once again to more than the splendour of spring. Trees, so dusty and undistinguished in April and

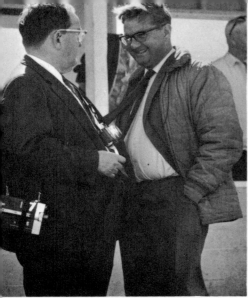

Charles Lytle and Tony Rudd have certain features in common.

Javier Velasquez (centre) who organises the Mexican Grand Prix so efficiently.

The Lotus team watch others doing the work.

Phil Hill is plainly bored with the proceedings.

Two Watkins Glen stalwarts—Race director Cameron Argetsinger and Clerk of the Course, Bill Milliken.

Mike Hailwood about to be mesmerised.

Hap Sharp managed to get out unaided.

Ireland prefers his boots up his pants.

A comfortable stranglehold for Graham Hill.

May, burn out their dross in fires of crimson and gold. Nowhere is this more strikingly shown than on the road that winds through the hills to the Finger Lake country and America's Grape Belt. It makes a colourful introduction to the pleasantest race in the World Series. It was also the best organised Grand Prix of 1964. Credit must be paid to Cameron Argetsinger and his enthusiastic colleagues, who, against long odds have built a streamlined racing set-up in a rustic setting. There are still a few blemishes. Some of the marshals are slow and amateurish when it comes to quick action about oil on the track. But these are faults that can be remedied. Basically Watkins Glen sponsors a race that is worthy of America and an appeal extending to Canada judging by the thousands who crossed the border on race day.

Several improvements had been made to the circuit during the year, in fact, the 2·3-mile track had been completely resurfaced. All sorts of optimistic forecasts were being made about lap time records. The quality of the entry was certainly good enough to set up a fresh target,

but the 120 m.p.h. lap was a little too hopeful. The field had been limited to 19 cars. Originally 20, the absentee was A. J. Foyt. There were the usual works teams, including Honda. Walt Hansgen was in the Chapman line-out. The remainder consisted of Chris Amon, Mike Hailwood, Joakim Bonnier, Joseph Siffert, Trevor Taylor, Innes Ireland, and Hap Sharp. Training began with everyone having a go at the lap record of 1 min. 14·5 sec. held by Clark; the fastest practice time in 1963 was Graham Hill with 1 min. 13·4 sec. There was plenty of effort, but for quite a time nobody bettered 1 min. 20 sec. With one hour gone Surtees was quickest with 1 min. 14·6 sec. His team-mate, Bandini, was one second slower and level with Graham Hill. McLaren appeared to have his Cooper just as he likes it and clocked 1 min. 14 sec., which was more than could be said about Phil Hill. He was down on power in a big way and nobody could pinpoint the reason. B.R.M. were circulating consistently. Various experiments were being tried, but lap times remained stubborn. B.R.P. and the Rob Walker cars were

Watkins Glen officials were prepared for all emergencies.

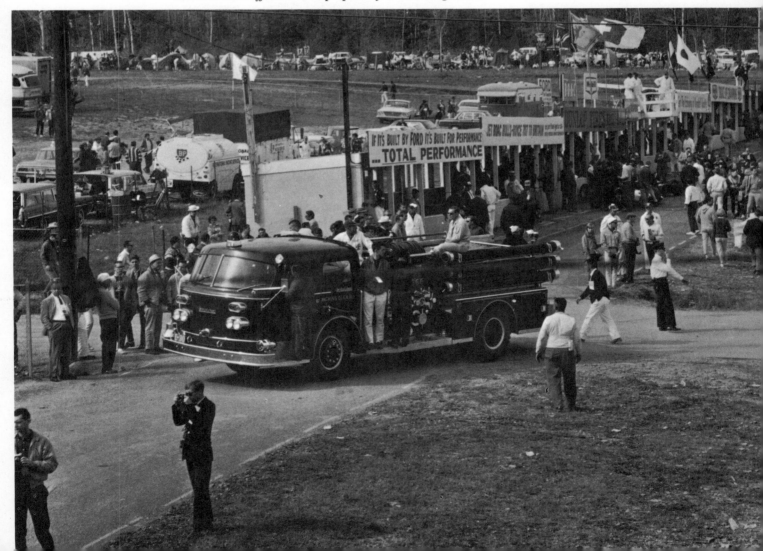

A little advertising is good for patient and doctor.

Enzo Ferrari's ostrich idea of camouflage.

A Far Eastern huddle.

If it won't work, eat it.

A film unit getting on-the-spot atmosphere for a possible Grand Prix project.

In America the women almost wear the trousers.

The veteran cop who keeps the pit area under control.

Frank Falkner, Professor of Pediatrics at Louisville University, in charge of the Cooper team.

Jean Stanley with Joseph Siffert during practice sessions.

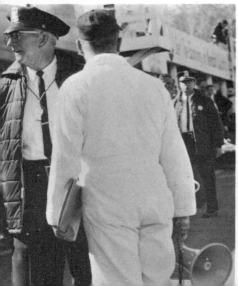

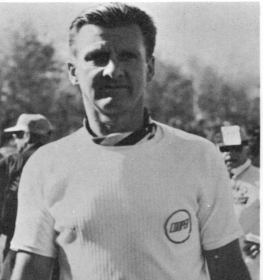

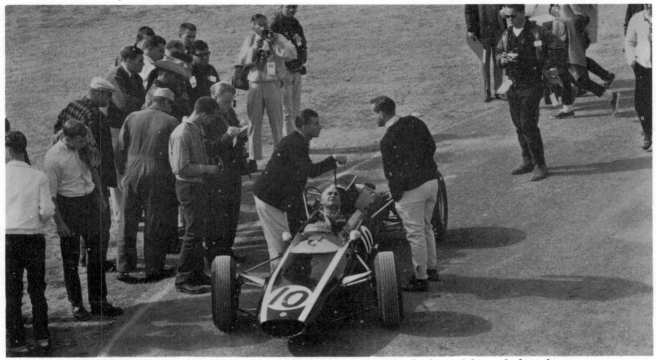

Phil Hill's Cooper was so temperamental that it was given a final test 2 hours before the race.

working hard without showing much improvement. Bucknum found the Honda handled better, the improvement reflecting in the useful time of 1 min. 14·9 sec. Gurney touched 1 min. 14·4 sec., but could not get below that mark. Instead it was Clark who had the satisfaction of clocking the fastest time of the day with a lap of 1 min. 13·23 sec.

Second day's practice produced a battle royal for pole position. Gurney, Surtees, Graham Hill and Clark were all challenging in the 12-second category. In the end Clark was fastest with 1 min. 12·65 sec. Surtees joined him on the front grid with 1 min. 12·78 sec. Second row read Gurney 1 min. 12·9 sec.; Graham Hill 1 min. 12·92 sec. The only other excitement occurring when the Honda spun at the hairpin, clouting the right front suspension and damaging the nose cowl. The throttle had stuck open. Once again the Japanese showed a surprising lack of race organisation. They had no replacement front suspension parts and they had to be collected some 3,000 miles away in Los Angeles. The unhappiest driver on the circuit was perhaps Phil Hill. Everybody with technical knowledge in the Cooper, Coventry-Climax and Lucas camps had tried to get his car in racing fettle. The engine was as

The unscheduled practice for Honda and Cooper caught traffic control people unprepared. Phil Hill narrowly missed a car, whilst Bucknum might have rammed an ambulance. Tex Hopkins took command of the situation.

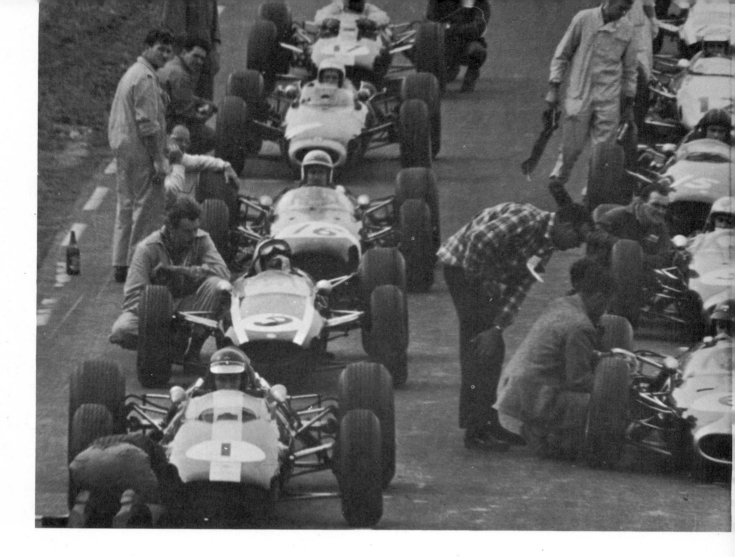

A crowded grid with Chapman peering under Clark's car, then McLaren, Bonnier, Ginther and Hansgen. The second line shows Gurney, Brabham, Amon and Taylor.

The grid complete except for Graham Hill. He was eventually located in the pit reading a paper-back thriller.

good as dead. Judging by the Californian's comments, it was one stage worse than that. It was sad to see such a first-class driver taking last place on the grid.

On race eve Cameron and Jean Argetsinger throw their lovely home open for a party that is now almost included in the Grand Prix calendar. The company is as good as the food—and both are outstanding. Commenting on this social get-together last year, I added a footnote about the differences between the English and American sense of humour. One writer (an American) took me to task. She said that her countrymen not only had a keen sense of humour, but it was more genuine than the English brand. I don't want to labour the issue; on the other hand, I have no wish to concede a point. Generally speaking, the average Englishman is not amused by the average American joke, whereas the average American considers the average English joke dull. Not the sophisticated variety. The humour of the *New Yorker* is more appreciated in Mayfair than in Painted Post: the humour of Evelyn Waugh is more likely to be appreciated in New York than in Aintree. The same sort of jokes are likely to be appreciated by appeal to the sophisticated on both sides of the Atlantic. The tendency of the best English humour is to render the rational ridiculous, whereas the tendency of the best

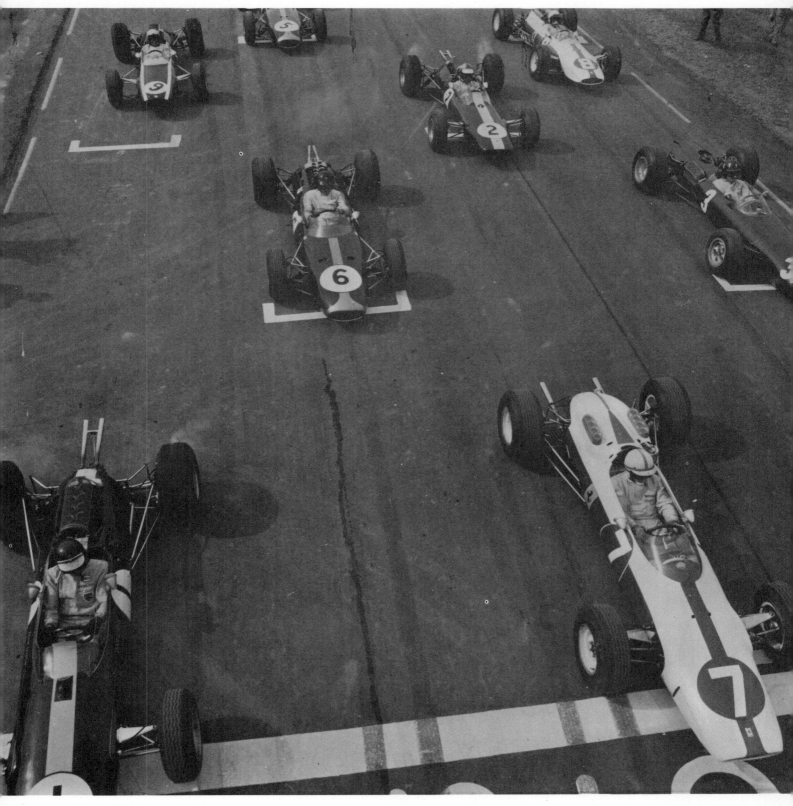

Tex Hopkins, the lavender-suited starter, dropped the Stars and Stripes, and the field of 19 cars roared away, with Clark taking the lead only to be overtaken by Surtees and Spence.

Drama on lap 45. Clark had lost the lead. The pit stop was an attempt to cure fuel injection trouble.

Jack Brabham philosophically watches the excitement in the Lotus pit. His own car had retired with a broken piston.

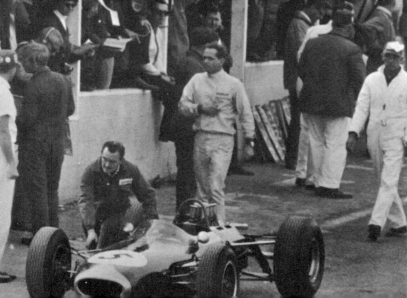

American humour is to render the ridiculous rational. Americans proceed from unreal to real; we proceed from the real to unreal. We think American humour fantastic. They find ours dull. I suppose American humour is more imaginative, but our tentative brand is safer in inexpert hands. Sometimes English officialdom can be unconsciously humorous. In the first few pages of the Classification of Occupations published by Her Majesty's Stationery Office occur the following trades: Trolloper, Whammeller, Thistle Spudder, Fang Manager, Hont Loader, Endless Rope Boy, Rider on Top, Slummer, Snibbler, and Self-acting Dickie Boy. I defy any American trade list to rival that bunch. A consoling thought which I pass on to my correspondent: we cannot all be funny, though the world would probably be a pleasanter place if we were.

Race day was sunny with a touch of mist, but the night had been fine for thousands of enthusiasts who had camped by the circuit. Both Hill and Bucknum were given permission to do a few laps in their cars. Everything had been checked on the Cooper, but it was still not right. Honda were worried about possible overheating. Nothing more could be done. The drivers paraded in open cars, a warming-up lap that caused consternation in the Lotus camp when Clark reached the dummy-grid and Chapman was fiddling about under the car. The lavender-suited Tex Hopkins waited to start this grid:

Centre: *Bandini was also in the wars. His flat-12 was eventually retired with a flat battery.*

Left: *Phil Hill only lasted 4 laps before his Cooper packed up with ignition failure.*


 7 1
 J. Surtees J. Clark
 (Ferrari) (Lotus–Climax)
 1 min. 12·78 secs. 1 min. 12·65 sec.

 3 6
 G. Hill D. Gurney
 (B.R.M.) (Brabham–Climax)
 1 min. 12·92 sec. 1 min. 12·9 sec.

 2 9
 M. Spence B. McLaren
 (Lotus–Climax) (Cooper–Climax)
 1 min. 13·33 sec. 1 min. 13·1 sec.

 8 5
 L. Bandini J. Brabham
 (Ferrari) (Brabham–Climax)
 1 min. 13·83 sec. 1 min. 13·63 sec.

 11 16
 I. Ireland J. Bonnier
 (B.R.P.–B.R.M.) (Brabham–Climax)
 1 min. 14·35 sec. 1 min. 14·07 sec.

 22 15
 J. Siffert C. Amon
 (Brabham–B.R.M.) (Lotus–B.R.M.)
 1 min. 14·65 sec. 1 min. 14·43 sec.

 25 4
 R. Bucknum R. Ginther
 (Honda) (B.R.M.)
 1 min. 14·9 sec. 1 min. 14·67 sec.

 14 12
 M. Hailwood T. Taylor
 (Lotus–B.R.M.) (B.R.P.–B.R.M.)
 1 min. 15·65 sec. 1 min. 15·3 sec.

 23 17
 H. Sharp W. Hansgen
 (Brabham–Climax) (Lotus–Climax)
 1 min. 18·23 sec. 1 min. 15·9 sec.

 10
 P. Hill
 (Cooper–Climax)
 1 min. 19·63 sec.


As the flag fell, Clark momentarily held the lead, but it was Surtees' blue-and-white Ferrari that came through, followed by Spence whose Lotus had catapulted from the third row, and Graham Hill's B.R.M. Clark was relegated to 4th. Gurney had a poor start and was 7th. Ireland's wretched luck continued. About to start the 3rd lap the gearshift lever broke below the gate and his race was over. Phil Hill was the next to drop out, the engine expiring at the end of the straight. The pattern up front remained the same. Surtees was driving with rare determination, but on lap 5 Graham Hill accelerated past Spence to take 2nd place. The advantage was short-lived. The next time round, Clark had overtaken both and began to put pressure on Surtees. Gurney displaced Spence on lap 7. For six laps the quartet manoeuvred and threatened each other, but the order remained the same until Clark pushed the nose of his Lotus in front as they came out of the right-hander before the pits. The Ferrari lost ground. Mechanical troubles eliminated Hap Sharp with selector difficulty (his pit stop lasted for 40

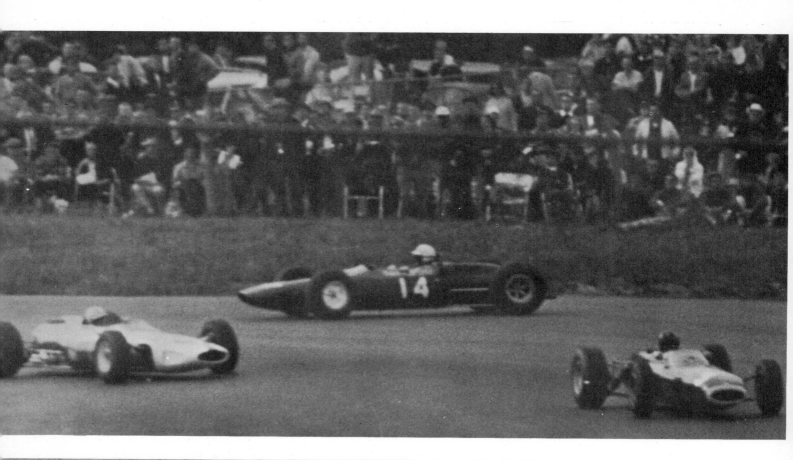

Above: *The duel between Graham Hill and Surtees was threatened at one stage when they met Mike Hailwood coming towards them.*

laps); Brabham retired with a broken piston; McLaren came in for plug changes, but the misfire persisted and Cooper's last car dropped out on lap 27.

Clark was dominating the race, apparently content with a 5-sec. lead. Graham Hill was not easily pleased. Driving the B.R.M. to the limit, he went past Surtees on lap 31. A fierce dog-fight ensued. Challenging and dicing reminiscent of Monza. Gurney had his hands full with the attentions of Spence and Siffert, the last named lapping in 1 min. 13·2 sec. Bonnier dropped out with stub axle cracked. Then slowly, almost imperceptibly the gap between Clark and the duelling cars became less. Fuel injection failure had gripped the Lotus. Lap 44 and Clark was 4th. Lap 45 in at the pits. Two laps had gone before the Lotus rejoined the race, but the car was ailing. Lap 51 back in the pits. Spence was called in. Cars were swopped, but two laps were enough for Spence's new car

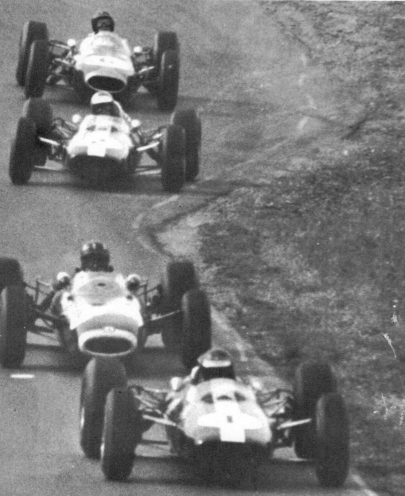

Left: *The early nose-to-tail scrap between Clark, Hill, Spence and Gurney produced exhilarating racing.*

Left: With 101 laps completed, Hailwood had the misfortune to break the oil-pressure gauge line.

before finally retiring. In the meantime Surtees had taken the lead on lap 44, but the advantage was short-lived. Graham Hill repassed the Ferrari next time round. The B.R.M. was not to be overtaken again.

Several cars were sounding sick. The Honda was troubled with overheating, hardly surprising as through the practice crash it lacked an oil cooler. On lap 50 Bucknum called it a day. He was then 12th. Two laps earlier Amon's engine seized up. Lap 54 saw Bandini in and out of the pits, but 4 laps later retired. Hill was reeling off the laps. Surtees and Gurney could make no impression on his lead. Lap 61 saw the B.R.M. overtake the second Bourne car. Somehow Ginther could not see Surtees and Gurney in his mirrors, or so it appeared, for it took them another lap to get past. By that time Hill

Below: Tex Hopkins drops the chequered flag in his usual spectacular fashion to give Graham Hill and the B.R.M. victory for the second year in succession.

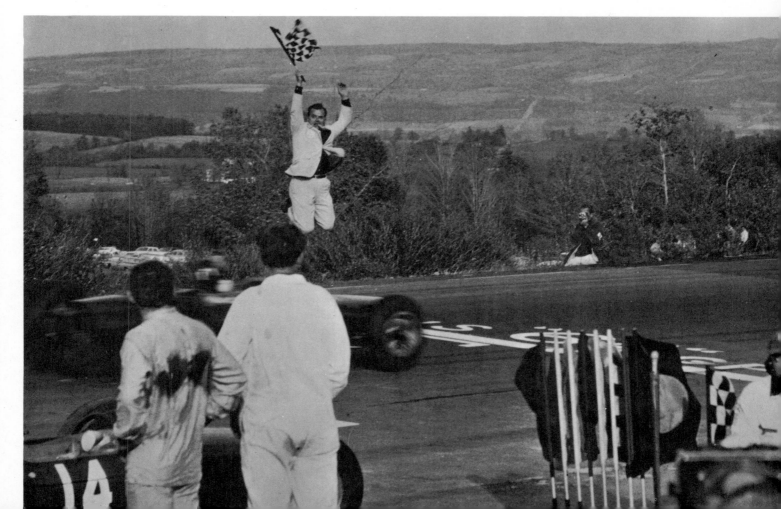

Graham Hill's victory at the record average of 111·10 m.p.h., meant that the World Championship would not be settled until the Mexican Grand Prix. The permutations were intriguing. The system ruled that Hill could only increase his total of 39 points from the 6 best results if he finished higher than 4th. Clark and Surtees, however, could add any points gained.

was 50 yards ahead. Surtees strained to pull back the lead, but spun on some oil and the margin became 17 seconds. Gurney took up the challenge, but one lap later oil pressure dropped and his race was over. With 8 laps left, Hailwood fractured an oil pipe and the corner above the pits became an ice rink. Bandini and Ireland did their best to scatter cement, only to find their efforts blocked by brawling marshals who appeared to have no idea what they should have been doing.

Only mechanical failure could rob the B.R.M. of victory. In typical unruffled fashion, Graham Hill crossed the line 30 sec. ahead of the Ferrari. It had been an impressive victory, a repetition of his 1963 success, with a record average of 110·10 m.p.h. Of the 19 starters, only 8 had finished. One lap behind Surtees, 3rd place had gone to Siffert, who drove extremely well. When he crossed the line his Brabham–B.R.M. had only one gear. Ginther was 4th. Hansgen came 5th after a race in which he incurred the wrath of the leaders through acting like an obstructive chicane. An impressive postscript to the general race organisation was the complete lap chart bearing the signature of the chief timekeeper which was distributed before the spectators had left the circuit. No other Grand Prix has seen that happen!

Results

1. Graham Hill (B.R.M.) 2 hr. 16 min. 38·0 sec. 111·10 m.p.h. (record).
2. John Surtees (Ferrari) 2 hr. 17 min. 08·5 sec.
3. Joseph Siffert (Brabham–B.R.M.) 109 laps.
4. Richie Ginther (B.R.M.) 107 laps.
5. Walt Hansgen (Lotus–Climax) 107 laps.
6. Trevor Taylor (B.R.P.–B.R.M.) 106 laps.
7. Mike Spence/Jim Clark (Lotus–Climax) 102 laps.
8. Mike Hailwood (Lotus–B.R.M.) 101 laps.

Fastest lap: Jim Clark (Lotus–Climax) 1 min. 13·2 sec. 113·11 m.p.h. (record).

Victory affects people in different ways. Graham Hill chose an obvious course.

B.R.M. Chief Engineer, Tony Rudd, took to the bottle!

World Championship

1. Graham Hill *39 points
2. John Surtees 34 points
3. Jim Clark.......................... 30 points
4. Richie Ginther 23 points
5. Lorenzo Bandini 19 points
6. Bruce McLaren..................... 13 points
7. Peter Arundell 11 points
 Jack Brabham 11 points
9. Dan Gurney 10 points
10. Joseph Siffert 7 points
11. Bob Anderson...................... 5 points
12. Tony Maggs 4 points
 Innes Ireland 4 points
14. Joakim Bonnier 3 points
15. Chris Amon 2 points
 Walt Hansgen 2 points
 Maurice Trintignant 2 points

18. Phil Hill 1 point
 Trevor Taylor 1 point
 Mike Hailwood 1 point
 Mike Spence 1 point

Constructors' Championship

1. Ferrari 43 points
2. B.R.M. *42 points
3. Lotus–Climax *36 points
4. Brabham–Climax 21 points
5. Cooper–Climax..................... 16 points
6. Brabham–B.R.M. 7 points
7. B.R.P.–B.R.M. 5 points
8. Lotus–B.R.M. 3 points

* Best six performances.

Celebration dinner at Watkins Glen with (l. to r.) Mrs. Charles Lytle, Phil Hill, Richie Ginther, Cameron Argetsinger, Louis and Jean Stanley, Graham Hill, Tony Rudd and Jean Argetsinger.

Grand Prix of Mexico

65 LAPS **WARM AND DRY** **201 MILES**

Only twice before has the World Championship depended on the result of the last race. Casablanca in 1958 produced the duel between Hawthorn and Moss. The South African Grand Prix in 1962 had the decider between Graham Hill and Clark. Mexico 1964 was much more complicated. Graham Hill had 41 points, but could only count 39 as he had scored in 7 races: Surtees had 34; Clark 30. If Hill won, he would be Champion. If Surtees won, his total of 43 points would give him the Championship, even should Hill finish 2nd, for his total could only be 42 points as he would have to discard the lowest scores of 2 and 3 points. Clark's hopes depended on Hill not finishing, and Surtees finishing no higher than 3rd. Clark would then tie with Hill on the 39-mark, but with more wins. The Constructors' Championship was equally complicated. Permutations seemed the only answer. Additional problems were created by the altitude. The circuit was 7,400 ft. above sea level with an average barometric pressure of 23·09 against the usual reading of 29·90 at sea level. The effect on man and machine was marked. The rarefied air caused pronounced fatigue among drivers and mechanics. Everything became an effort. Running upstairs became a breathless exercise, push-starting a car almost exhausting. It also meant the

Opposite: *A cheerful-looking Lotus team—Mike Spence, Colin Chapman and Jim Clark.*

Right: *Steps and stairs—Dan Gurney, Lorenzo Bandini and Richie Ginther.*

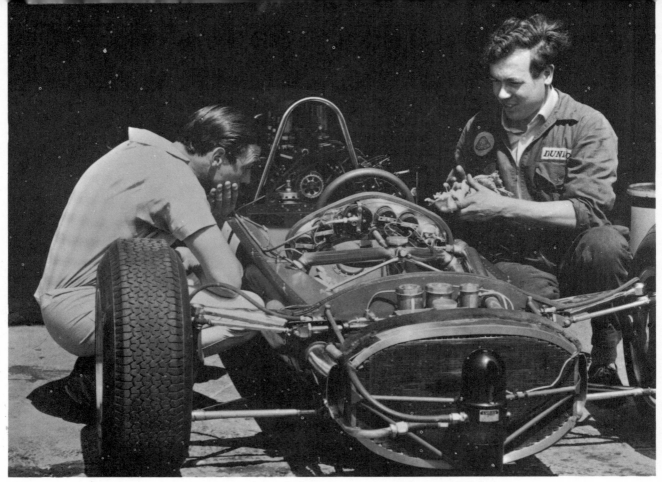

Jim Clark has a look and appears somewhat doubtful.

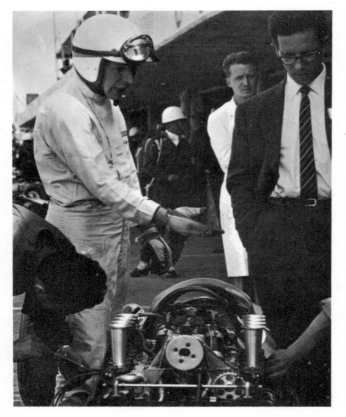

mixture being weakened by 20 per cent, representing a power-drop of some 25 b.h.p. at peak revs. Tyre pressures had to be dropped about 5 lb. As a result there were plenty of temperamental engines and lethargic racing personnel.

With the exception of the Honda team, who had returned to Tokio after Watkins Glen, the entry was fully representative. The local driver, who the previous year had driven a Centro Sud B.R.M., this time was in a works Lotus. Phil Hill was having his last drive for Coopers. It was also Ginther's farewell race for B.R.M. The first training period was largely experimental. Finding the right gear ratios and fuel injection settings produced many headaches, apart from getting to know the circuit. The 3·2-mile track was situated in a sports park on the outskirts of Mexico City. The emphasis is on roadholding with top speeds on the straight about 150 m.p.h. The track temperature read 110°F. Overheating plagued several cars. On top of all this the electrical timing equipment developed a fault through the battery going flat. Official lap times were hopelessly wrong. In the end an unsatisfactory compromise list was produced that gave

John Surtees would seem to be not quite so patient.

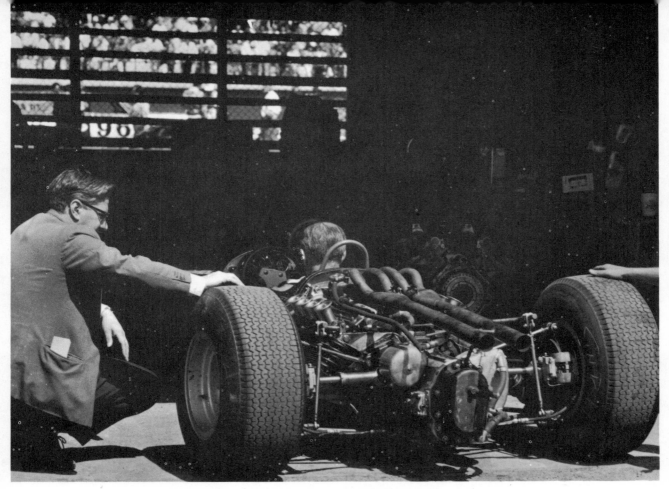

Tony Rudd takes stock of the B.R.M. situation.

a rough idea of how everybody was faring. Clark was credited with 1 min. 57·6 sec. in Spence's car, which lowered his own lap record of 1 min. 58·1 sec. sét up in the 1963 race. Gurney clocked 1 min. 58·5 sec., fractionally faster than both the Ferraris. Graham Hill was credited with 1 min. 57 sec., which was dismissed as wishful thinking, for the fastest our pit timekeeper recorded was 1 min. 59·8 sec.

Final practice produced another scorcher with road temperature over 100°F. Everyone was scratching about trying to chop off the fractions that mean grid promotion. B.R.M. were down on power, and though Hill was in and out, changing tyre pressures, and doing everything he could, lap times would not drop below 2 minutes. The new car handled well, but was handed over to the mechanics with a broken valve. Not long after the spare car was in with oil pressure problems. Ferraris also seemed short of power, and though Surtees took both cars out he could not get his times down. The Climax engines were not troubled so much by the altitude. Bonnier was fastest of the private entrants with 2 min. 0·17 sec. in a Brabham–Climax. The final grid read:

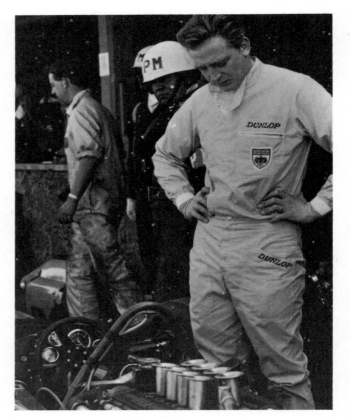

Trevor Taylor looks just as thoughtful.

Charles Lytle, whose knowledge of motor-racing is inexhaustible.

Rodriguez senior and attractive daughter-in-law, Angelina.

Warren Ohlson, who was in charge of the Scarab cars in 1960.

The photographer who came prepared.

B.R.M. runs better on Canada Dry!

Mexican police were armed with every conceivable weapon, plus tear-gas bombs.

Moises Solano, the Mexican driver who had the third team Lotus car.

Chris Amon, Mike Hailwood and Barrie Gill on safari.

Two tiny men—Moss and Ginther—chat into the microphone.

6
D. Gurney
(Brabham–Climax)
1 min. 58·10 sec.

1
J. Clark
(Lotus–Climax)
1 min. 57·24 sec.

7
J. Surtees
(Ferrari)
1 min. 58·70 sec.

8
L. Bandini
(Ferrari)
1 min. 58·60 sec.

3
G. Hill
(B.R.M.)
1 min. 59·80 sec.

2
M. Spence
(Lotus–Climax)
1 min. 59·21 sec.

16
J. Bonnier
(Brabham–Climax)
2 min. 0·17 sec.

5
J. Brabham
(Brabham–Climax)
1 min. 59·99 sec.

9
B. McLaren
(Cooper–Climax)
2 min. 1·12 sec.

18
P. Rodriguez
(Ferrari)
2 min. 0·90 sec.

15
C. Amon
(Lotus–B.R.M.)
2 min. 1·17 sec.

4
R. Ginther
(B.R.M.)
2 min. 1·15 sec.

17
M. Solana
(Lotus–Climax)
2 min. 1·43 sec.

22
J. Siffert
(Brabham–B.R.M.)
2 min. 1·37 sec.

11
I. Ireland
(B.R.P.–B.R.M.)
2 min. 2·35 sec.

10
P. Hill
(Cooper–Climax)
2 min. 2·00 sec.

12
T. Taylor
(B.R.P.–B.R.M.)
2 min. 4·90 sec.

14
M. Hailwood
(Lotus–B.R.M.)
2 min. 4·11 sec.

23
H. Sharp
(Brabham–B.R.M.)
2 min. 6·90 sec.

Race day was still hot. In the distance the snow-tipped volcano of Popocatepetl looked like a cool mirage. Preliminaries to a Grand Prix vary from country to country. Monte Carlo had majorettes and a tired-looking U.S. Naval band. Monza had a parade of national banners held by surly Italians. Brands Hatch had army manoeuvres. France had vintage cars. Holland produced a car-stunt demonstration. Austria, a flying display. Mexico had an Olympic Games touch. After the drivers had been presented to the President of Mexico, Adolfo Lopez Mateos, thousands of gas-filled balloons were released, singly and in tied bunches of several hundred. At the same moment hundreds of doves added to the swirling colours. The clusters of balloons later became the target of an aeroplane diving through the bursting rubber. The entertainment over, the cars set off on a warming-up lap, enlivened by a stray dog loose on the circuit. Spence spun, and Ginther's B.R.M. became temperamental about starting.

Ing. Javier Velasquez dropped the flag. Clark was away like lightning, followed by Gurney. Surtees almost stopped as his Ferrari began misfiring. Fortunately the plugs cleared and he joined the back-markers. Graham Hill had been equally unfortunate. Just before the flag

Jim Clark lends a hand with signals. The time was faster than Spence's grid lap!

The strain of waiting is always trying, but Hill occupied his mind with the inevitable paper-back.

fell, the elastic of his goggles failed. Effecting repairs gave him a poor start. First lap positions showed Clark well in front of Gurney, then a gap with Bandini leading Spence, Bonnier, Brabham, Rodriguez, McLaren, Graham Hill, Siffert, Phil Hill, Surtees and Amon. Tail-enders were Ireland, Solana, Taylor, Hailwood, and Sharp.

Graham Hill was intent on making-up lost ground. The B.R.M. might not be able to match the Lotus speed, but whatever happened to Clark, 3rd position would be good enough to win the title. Every lap he improved a place, sometimes two. Lap 10 and Bandini was in his sights. On Lap 11 the B.R.M. was on the Ferrari tail. Lap 12 and Hill was in 3rd berth. Gurney and Clark were

The wait on the grid was prolonged because of the presentation to the President of Mexico.

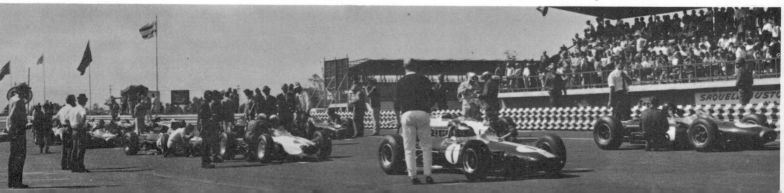

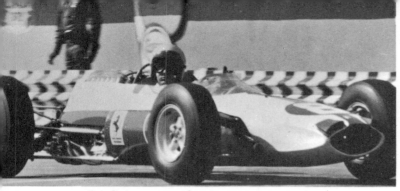

Bandini—centre of post-race controversy.

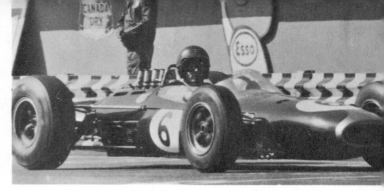

Gurney—who led only once, on the last lap.

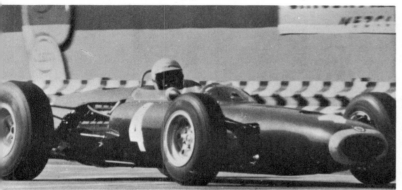

Ginther—who drove without sparkle to finish 8th.

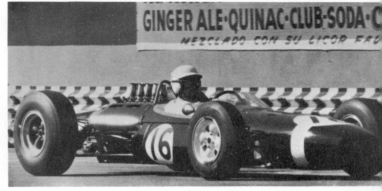

Bonnier—retired lap 10 with broken wishbone.

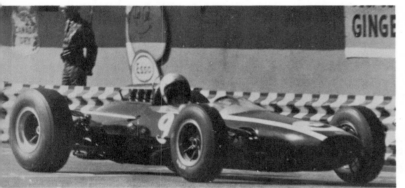

McLaren—an unspectacular race to finish 7th.

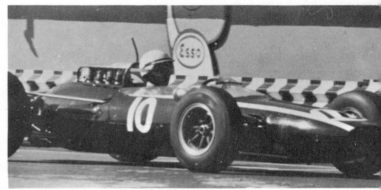

Phil Hill's last drive for the Cooper team.

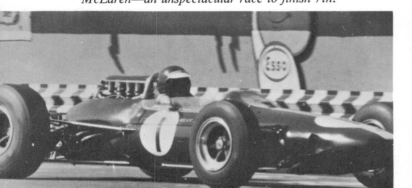

Above: *Jim Clark.* Below: *Graham Hill.*

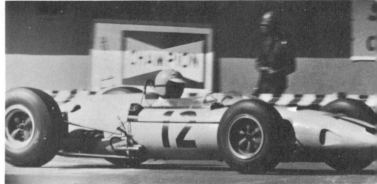

Above: *Trevor Taylor.* Below: *John Surtees.*

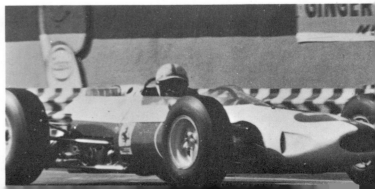

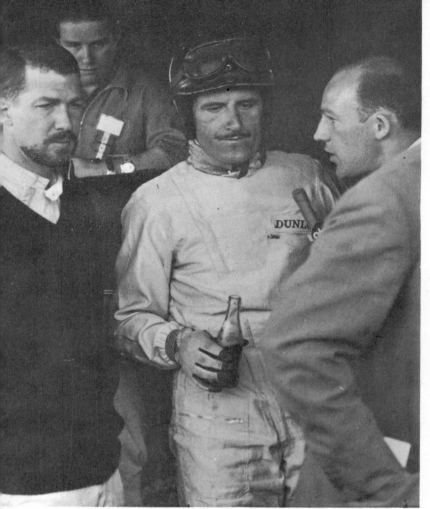

The bitterness of realisation is shown in this photograph of Graham Hill. To win the World Championship it was necessary for him to finish no lower than 3rd. Even if Clark won, the title would still be his. The danger man was Surtees, but the Ferrari was behind him. A clumsy incident when Bandini clouted the B.R.M. at the hairpin, put the Bourne car out of the running. Hill has just made the unavoidable pit stop that lost the Championship.

a long way ahead, probably too far to catch. The right tactic was to hold station. In the meantime Surtees had similar ideas. He too had been overtaking with clocklike regularity. From 13th he had progressed to 6th by lap 12.

Overheating had taken its toll of Siffert and Taylor, with Hailwood retiring on lap 12. Bonnier dropped out with a broken wishbone. Surtees managed to overtake Brabham. That put the Ferraris together, with Bandini applying maximum pressure on Graham Hill. The race-pattern remained constant without incident until Spence spun on lap 29 and Rodriguez went past into 7th place. Clark was 14 seconds ahead of Gurney, who in turn was 16 seconds in front of the B.R.M. These two seemed to be in a different race. Attention was focused on the struggle for 3rd place. Bandini was pressing very hard. I was in the pits and could not see for myself the drama at the hairpin, where lap after lap the Italian was trying to over-

This was possibly the most dramatic moment of the season. Clark was comfortably in the lead. Everything was set for a wonderful double—the Mexican title and the World Championship. The penultimate lap was nerve-racking. As Clark went past the pits, he raised his hands as if in despair. His oil pressure had gone. On the last lap his car seized solid. In this photograph Gurney has passed to win the Mexican title. Colin Chapman hurls his lap board to the ground in understandable disappointment. After an entire season the World title had been lost by a couple of minutes.

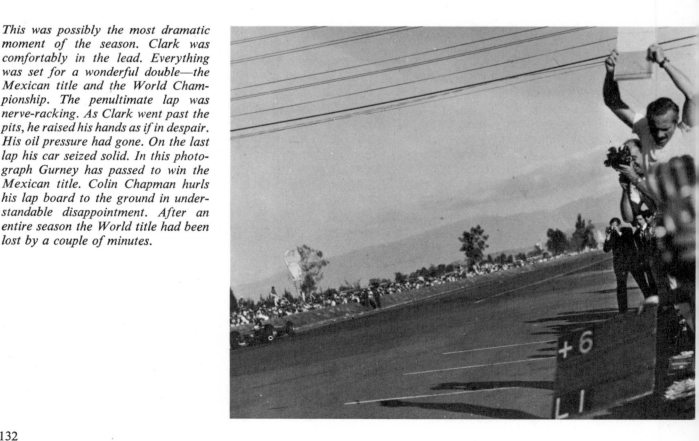

take at a point where it just wasn't possible. That at least was the opinion of Brabham who was behind; of Cahier, who was filming at that point; and the independent evidence later of the television film cameras. I have heard criticisms of Hill's reaction to the Ferrari onslaught. Some say the B.R.M. ought to have increased its speed and shaken off the Italian car. Others maintain that he should have waved Bandini on, then bided his time before overtaking at the all-important moment. Both arguments have flaws. In the first place, it was not possible to get that extra spurt out of the car. Hill was driving at the car's limit. Secondly, had he allowed Bandini to take over, the Italian would be in a position to dictate policy. By slowing down fractionally, Surtees would have been on the B.R.M. tail, would have gone past, and elementary team tactics would have given Bandini a Nelson eye every time Hill tried to get back into a challenging position.

Looking at the film afterwards, it was obvious that something was going to happen. Bandini's eagerness to take 3rd place overruled his judgment. Shaking fists could not subdue an elated Italian temperament. On lap 31 Bandini's wheel clouted the B.R.M. exhaust pipes. Hill spun into the guard rail. Bandini was able to continue, but the Bourne car's exhaust pipes had been crumpled over. It completed a faltering lap before coming into the pits where mechanics levered off the damaged ends. With them went Hill's Championship hopes. He rejoined in 13th place and one lap light. He motored hard, working his way back to 10th, only to make a pit stop on lap 53 to replace a throttle spring. That put him back to 11th. Brabham had also run into trouble. Ignition headaches meant loss of 5th place, and a pit stop that left him circulating at the back of the field. Amon retired on lap 46 with no gears.

Whilst one Championship hope had been eliminated, Clark was quietly, but impressively holding the lead that grew to 17 seconds. Gurney was doing Lotus a good turn by keeping Surtees out of the vital 2nd place, at that moment held by Bandini. Everything pointed to Clark as winner of the Championship. Unbeknown to those who watched, Clark had seen significant oil streaks appear about 7 laps from the end. He varied his line at the hairpin, did the same the next time round. Each time he saw the trail. It came from his Lotus. The pressure gauge took up the story. He eased up, but gave no sign to the pits. With one lap to go Clark had no oil pressure at all. As he passed, the Lotus had slowed down. He raised both hands in the air in utter despair. Chapman hurled his time-board to the ground in disappointment. Gurney flashed past to take the lead on the final lap. Utter confusion broke out in the pit area. Chapman showing no sign of the wretched luck that had snatched away a Lotus Championship, came across with congratulations. In spite of the shunt, the title would go to B.R.M. The thought was premature. The Ferraris were 70 seconds behind. Bandini was ahead of Surtees. To win the

Gurney was carried shoulder-high to the pits, having set a new record average for the race.

Championship it was necessary for the positions to be reversed. No one could do more to impress the fact on Bandini, for the entire Ferrari set-up—mechanics, timekeeper, engineer and team manager—climbed over the barrier-rail, invaded the tracks, and gave signs en masse to the Italian to slow down. In silence the huge crowd waited for the cars to come round. Gurney went past. The chequered flag fell. The fact that the Californian had won the Mexican Grand Prix was almost unnoticed. Clark did not appear. The engine had seized solid. A Ferrari appeared . . . a fleeting second for recognition . . . then Surtees crossed the line to claim 2nd place and the 1964 World Championship. It would be difficult to visualise a more dramatic curtain to a season. All the ingredients were there. In a way Gurney's win was the reversal of his fortune at Spa, when Clark found himself the victor after the American had the race in his pocket. Surtees had battled on after a shaky start when the Ferrari almost died on the opening lap. A regrettable incident had been the Bandini shunt, which had cost B.R.M. the title. A

postscript might be added. A number of journalists and racing personalities tried to read into the affair all sorts of insinuations. It was suggested that Bandini deliberately crashed the B.R.M. as part of Ferrari tactics. I am positive that there was not a vestige of truth in such an accusation. Bandini as an individual is one of the pleasantest drivers in racing today. He has all the natural charm of an Italian. He also has that country's temperament. He is fiery, impulsive and fearless. At times through the tension and excitement of the moment, his judgment is at fault. He takes risks that do not always come off. In the process other drivers are sometimes involved, but never, to my knowledge, have these incidents been motivated by "dirty" moves. Bandini is a natural driver in the mould of Mairesse. Both men have been criticised. At times both have been at fault. But each at heart is the personification of the genuine racing driver. I would put Surtees in the same class. The sport is hard. It is tough. It can be lethal. To win, a driver has at times to be on that razor-edge that separates success from disaster. Surtees has bridged that gap. In time Bandini may well do so, but at the moment a streak of immaturity under intense pressure may cause him to do things that could be his undoing. Mexico comes under that heading. After the race Bandini came to our pit with Dragoni, Ferrari team manager, and Forghieri, the chief engineer. All three apologised. Everyone shook hands. As far as B.R.M. was concerned, the incident was closed. Luck had not been on our side, but there is always tomorrow. Looking back three features stood out in the admirable way in which Graham Hill took his disappointment . . . Colin Chapman's sporting reaction seconds after Clark had failed . . . Surtees' modest bearing after winning the title. These may seem small things, but related to those tense moments and the prize involved, each was a refreshing commentary on Grand Prix racing.

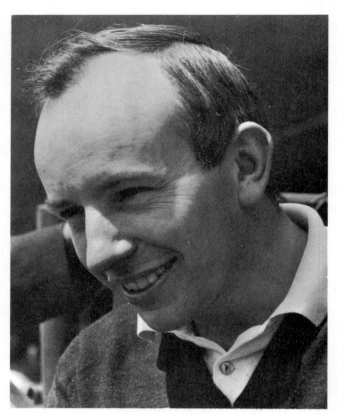

The Mexican crowd were somewhat mystified by the stir caused by the 2nd car instead of the winner. Surtees' success was an earned reward for remarkable dedicated determination.

Gurney for once lost bad luck and deservedly gained his second Championship win of the season.

Results

1. Dan Gurney (Brabham–Climax) 2 hr. 9 min. 50·32 sec. 93·33 m.p.h.
2. John Surtees (Ferrari) 2 hr. 10 min. 59·26 sec.
3. Lorenzo Bandini (Ferrari) 2 hr. 10 min. 59·95 sec.
4. Mike Spence (Lotus–Climax) 2 hr. 11 min. 12·18 sec.
5. Jim Clark (Lotus–Climax) 1 lap behind
6. Pedro Rodriguez (Ferrari) 1 lap behind.
7. Bruce McLaren (Cooper–Climax) 1 lap behind.
8. Richie Ginther (B.R.M.) 1 lap behind.
9. Phil Hill (Cooper–Climax) 2 laps behind.
10. Moises Solana (Lotus–Climax) 2 laps behind.
11. Graham Hill (B.R.M.) 2 laps behind.
12. Innes Ireland (B.R.P.–B.R.M.) 4 laps behind.
13. Hao Sharp (Brabham–B.R.M.) 5 laps behind.
14. Jack Brabham (Brabham–Climax) 21 laps behind.

Fastest lap: Jim Clark (Lotus–Climax) 1 min. 58·37 sec. 95·14 m.p.h.

1964 World Championship	PTS
1 John Surtees	40
2 Graham Hill	39
3 Jim Clark	32
4 Lorenzo Bandini	23
Richie Ginther	23
6 Dan Gurney	19
7 Bruce McLaren	13
8 Jack Brabham	11
Peter Arundell	11
10 Joseph Siffert	7
11 Bob Anderson	5
12 Tony Maggs	4
Mike Spence	4
Innes Ireland	4
15 Joakim Bonnier	3
16 Chris Amon	2
Walt Hansgen	2
Maurice Trintignant	2
19 Trevor Taylor	1
Mike Hailwood	1
Phil Hill	1
Pedro Rodriguez	1

Scoring basis: 1st, 9 points: 2nd, 6 points: 3rd, 4 points: 4th, 3 points: 5th, 2 points: 6th, 1 point.

Best six results counted in final placings, the only driver to drop points being Graham Hill, whose final tally was 41 points.

1964 World Championship

1964 Constructors' Championship

		Total	Best Six
1	Ferrari	49	45
2	B.R.M.	51	42
3	Lotus–Coventry–Climax	41	38
4	Brabham–Coventry–Climax	30	30
5	Cooper–Coventry–Climax	17	17
6	Brabham–B.R.M.	8	8
7	B.R.P.–B.R.M.	5	5
8	Lotus–B.R.M.	4	4

Ferrari and B.R.M. points were gained by works drivers only. Lotus were helped by Walt Hansgen; Cooper by Joe Bonnier: Brabham by Bob Anderson—apart from their works drivers.

Best six results: Points awarded to higher-placed car of each team.
The scoring is 9, 6, 4, 3, 2, 1, for 1st to 6th place.

1964 World Championship—Results in Detail

	First	*Second*	*Third*
Monaco Grand Prix Monte Carlo May 10 194 miles 100 laps	Graham Hill (B.R.M.) 2 hr. 41 min. 19·5 sec. 72·6 m.p.h.	Richie Ginther (B.R.M.) 99 laps	Peter Arundell (Lotus–Coventry-Climax) 97 laps
Dutch Grand Prix Zandvoort May 24 208 miles 80 laps	Jim Clark (Lotus–Coventry-Climax) 2 hr. 7 min. 35·4 sec. 98·02 m.p.h.	John Surtees (Ferrari) 2 hr. 8 min. 29 sec.	Peter Arundell (Lotus–Coventry-Climax) 79 laps
Belgian Grand Prix Spa-Francorchamps June 14 280·32 miles 32 laps	Jim Clark (Lotus–Coventry-Climax) 2 hr. 6 min. 40·5 sec. 132·79 m.p.h.	Bruce McLaren (Cooper–Coventry-Climax) 2 hr. 6 min. 43·9 sec.	Jack Brabham (Brabham–Coventry-Climax) 2 hr. 7 min. 28·6 sec.
French Grand Prix Rouen-les-Essarts June 28 235·8 miles 57 laps	Dan Gurney (Brabham–Coventry-Climax) 2 hr. 7 min. 49·1 sec. 108·77 m.p.h.	Graham Hill (B.R.M.) 2 hr. 8 min. 13·2 sec.	Jack Brabham (Brabham–Coventry-Climax) 2 hr. 8 min. 14 sec.
European Grand Prix Brands Hatch July 11 212 miles 80 laps	Jim Clark (Lotus–Coventry-Climax) 2 hr. 15 min. 7 sec. 94·14 m.p.h.	Graham Hill (B.R.M.) 2 hr. 15 min. 9·8 sec.	John Surtees (Ferrari) 2 hr. 16 min. 27·6 sec.
German Grand Prix Nürburgring August 2 212·6 miles 15 laps	John Surtees (Ferrari) 2 hr. 12 min. 4·8 sec. 96·57 m.p.h.	Graham Hill (B.R.M.) 2 hr. 13 min. 20·4 sec.	Lorenzo Bandini (Ferrari) 2 hr. 16 min. 20·4 sec.
Austrian Grand Prix Zeltweg August 23 209 miles 105 laps	Lorenzo Bandini (Ferrari) 2 hr. 6 min. 18·23 sec. 99·20 m.p.h.	Richie Ginther (B.R.M.) 2 hr. 6 min. 24·41 sec.	Bob Anderson (Brabham–Coventry-Climax) 102 laps
Italian Grand Prix Monza September 6 279 miles 78 laps	John Surtees (Ferrari) 2 hr. 10 min. 51·8 sec. 127·78 m.p.h.	Bruce McLaren (Cooper–Coventry-Climax) 2 hr. 11 min. 57·8 sec.	Lorenzo Bandini (Ferrari) 77 laps
United States Grand Prix Watkins Glen October 4 253 miles 110 laps	Graham Hill (B.R.M.) 2 hr. 16 min. 38 sec. 111·10 m.p.h.	John Surtees (Ferrari) 2 hr. 17 min. 8·5 sec.	Joseph Siffert (Brabham–B.R.M.) 109 laps
Mexican Grand Prix Mexico City October 25 201 miles 65 laps	Dan Gurney (Brabham–Coventry-Climax) 2 hr. 9 min. 50·32 sec. 93·25 m.p.h.	John Surtees (Ferrari) 2 hr. 10 min. 59·26 sec.	Lorenzo Bandini (Ferrari) 2 hr. 10 min. 59·95 sec.

Fourth	Fifth	Sixth	Fastest lap
Jim Clark (Lotus–Coventry-Climax) 96 laps	Joakim Bonnier (Cooper–Coventry-Climax) 96 laps	Mike Hailwood (Lotus–B.R.M.) 96 laps	Graham Hill (B.R.M.) 1 min 33·9 sec. 74·92 m.p.h.
Graham Hill (B.R.M.) 79 laps	Chris Amon (Lotus–B.R.M.) 79 laps	Bob Anderson (Brabham–Coventry-Climax) 78 laps	Jim Clark (Lotus–Coventry-Climax) 1 min. 32·8 sec. 101·07 m.p.h.
Richie Ginther (B.R.M.) 2 hr. 8 min. 39·1 sec.	Graham Hill (B.R.M.) 31 laps	Dan Gurney (Brabham–Coventry-Climax) 31 laps	Dan Gurney (Brabham–Coventry-Climax) 3 min. 49·2 sec. 137·60 m.p.h.
Peter Arundell (Lotus–Coventry-Climax) 2 hr. 8 min. 59·7 sec.	Richie Ginther (B.R.M.) 2 hr. 10 min. 1·2 sec.	Bruce McLaren (Cooper–Coventry-Climax) 56 laps	Jack Brabham (Brabham–Coventry-Climax) 2 min. 11·4 sec. 111·37 m.p.h.
Jack Brabham (Brabham–Coventry-Climax) 79 laps	Lorenzo Bandini (Ferrari) 78 laps	Phil Hill (Cooper–Coventry-Climax) 78 laps	Jim Clark (Lotus–Coventry-Climax) 1 min. 38·8 sec. 96·56 m.p.h.
Joseph Siffert (Brabham–B.R.M.) 2 hr. 17 min. 27·9 sec.	Maurice Trintignant (B.R.M.) 14 laps	Tony Maggs (B.R.M.) 14 laps	John Surtees (Ferrari) 8 min. 39 sec. 98·30 m.p.h.
Tony Maggs (B.R.M.) 102 laps	Innes Ireland (B.R.P.–B.R.M.) 102 laps	Joakim Bonnier (Brabham–Coventry-Climax) 101 laps	Dan Gurney (Brabham–Coventry-Climax) 1 min. 10·56 sec. 101·57 m.p.h.
Richie Ginther (B.R.M.) 77 laps	Innes Ireland (B.R.P.–B.R.M.) 77 laps	Mike Spence (Lotus–Coventry-Climax) 77 laps	John Surtees (Ferrari) 1 min. 38·8 sec. 130·19 m.p.h.
Richie Ginther (B.R.M.) 107 laps	Walt Hansgen (Lotus–Coventry-Climax) 107 laps	Trevor Taylor (B.R.P.–B.R.M.) 106 laps	Jim Clark (Lotus–Coventry-Climax) 1 min. 12·7 sec. 113·89 m.p.h.
Mike Spence (Lotus–Coventry-Climax) 2 hr. 11 min. 12·18 sec.	Jim Clark (Lotus–Coventry-Climax) 64 laps	Pedro Rodriguez (Ferrari) 64 laps	Jim Clark (Lotus–Coventry-Climax) 1 min. 58·37 sec. 95·14 m.p.h.

World Ranking of 1964

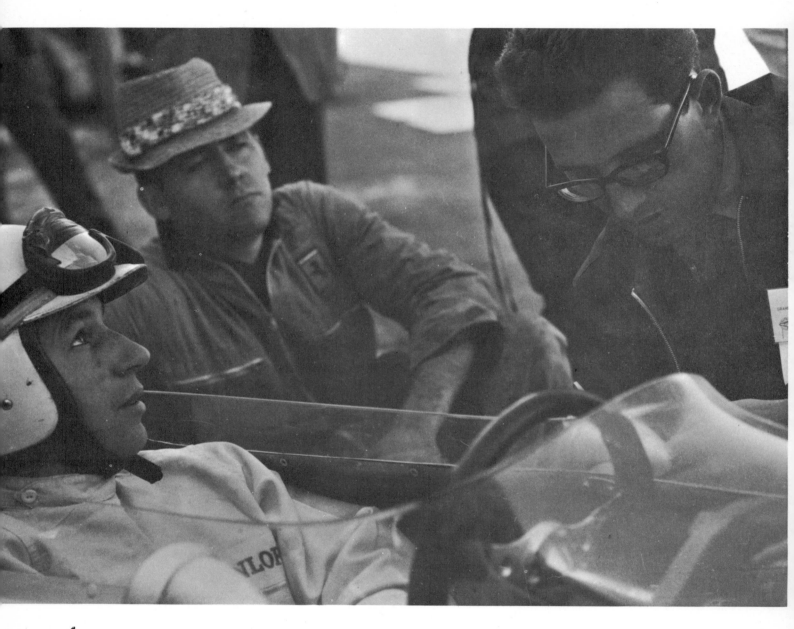

1 John Surtees

The season for John Surtees fell into two parts. Up to Rouen he was an unhappy man. Things were not going well with Ferrari. Development work was far from satisfactory. The turning-point came in Germany. The night before the race we had dinner together. It was clear from his conversation that everything hinged on the result. When Surtees races, he is the personification of determination, but when a great deal is at stake, the effort can be stupendous. The following day Surtees took the chequered flag after a magnificent struggle. He has taken part in many exacting races, but the 1964 German Grand Prix will surely figure in his tally as the landmark in his motor-racing career. Elsewhere I refer to Surtees' qualities as a man and a racing driver. Suffice it to say here that seldom has there been a more genuine or worthier World Champion.

Of the men who might have won the Championship, I rank Dan Gurney as the unluckiest, because his claims to the honour were the most convincing. He should have won the Belgian Grand Prix. His driving that day on the fastest circuit was copybook perfection. Everything was made to look effortless and easy. Add two victories in France and America, plus bad luck in the Italian and British events, and you can see how near the Californian came to an incisive win. If the Brabham can only get clear of mechanical set-backs, I question whether anybody will cope with the pace set by Gurney.

Dan Gurney 2

3 Jim Clark

Many words have been written about Jim Clark. Every additional adulatory word reinforces the strain I am sure he feels at the thought of having to face again and measure up to the legend. That he does so is but confirma-

tion of his undoubted greatness as a Grand Prix driver. There is perhaps one aspect that has yet to be decided. Clark's marked superiority in the past has often been emphasised by the fact that the Lotus was that much faster than the rest of the field, sometimes due to more powerful machinery, or more often through Clark's ability to get that extra touch of speed. In a hypothetical situation in which Surtees, Graham Hill, Gurney and Clark were in cars of equal power, in other words with the pressure on in a big way, I am not certain that Clark would emerge the winner. It would be a fight between rapier and broad-swords. The permutations are endless.

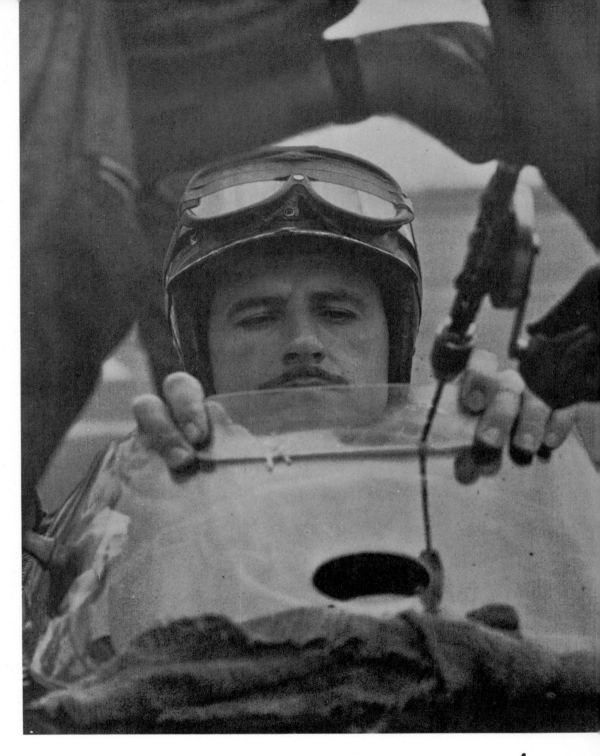

Graham Hill had a season of mixed fortunes, the Mexican incident virtually robbing him of a second World title. Hill had two good wins—Monaco and America—bad luck at Spa; tactical error cost the British race; miserable luck at Monza. He drove with immense spirit throughout the season, after a start when he was lucky to survive a crash at Snetterton. Hill is that rare phenomenon—a man who never changes. He can be so tactless that he doesn't know the difference between tongue-in-the cheek and foot-in-the-mouth. His face is immovably serene, but however grimly he purses his lips, fiercely knits his eyebrows or twitches his moustaches, he cannot

Graham Hill 4

assume the lineaments of total displeasure. He lacks the tragic mask. During a crisis—and we have our share—his face relaxes and assumes a self-conscious, almost boyish grin. In any company Graham Hill is good value. One of the finest characters in Grand Prix racing.

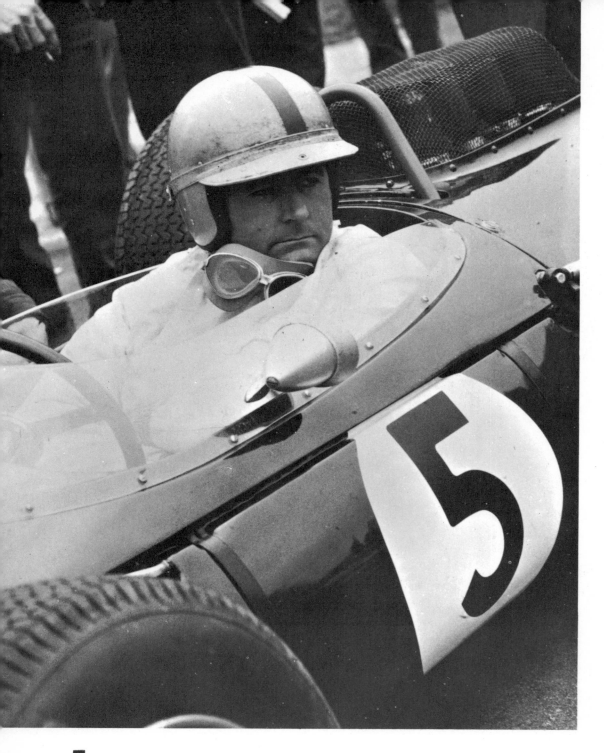

5 Jack Brabham

A couple of seasons ago it looked as if Jack Brabham had reached the point of retiring. Nothing went right. His name no longer appeared in the top six. Rather than trundle along in the ruck, I hoped the twice World Champion would have the good sense to pack-up before he became a 'has-been'. Such fears were groundless. In 1963 Brabham became the first man to gain World Championship points in a machine of his own construction. 1964 not only saw his cars win the French and Mexican events with Gurney at the wheel, but Brabham himself was driving with his former spirit. He was up with the leaders and displaying his familiar skill and guile. In such a vein the Australian is capable of repeating his former successes and not by proxy.

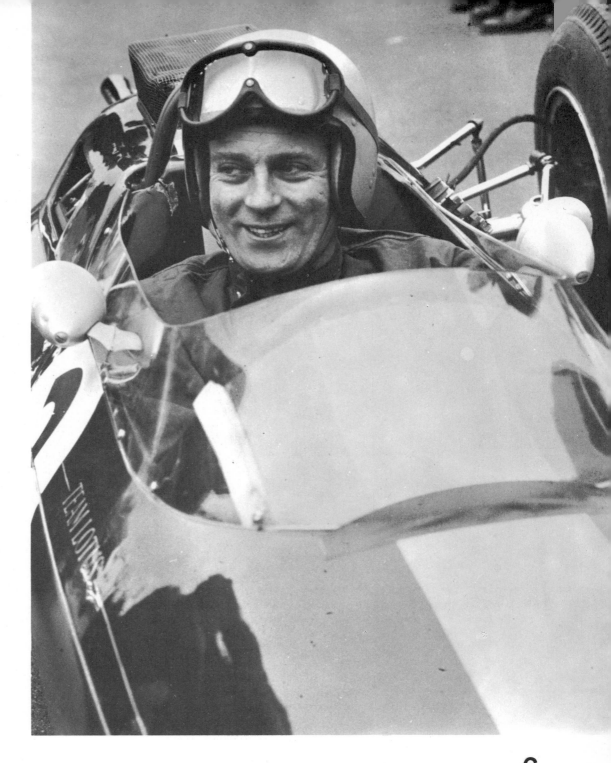

Peter Arundell **6**

Peter Arundell would be my nomination as the most improved Grand Prix driver of the year. Up to the time of his crash, which put him out of circulation for the rest of the year, his tally read 2nd Goodwood; 3rd Syracuse Grand Prix, Monaco Grand Prix and Dutch Grand Prix; 4th French Grand Prix. Arundell's fearless approach to racing was like that of Mairesse. This apparent disregard for personal safety made one apprehensive for his future. I could not see him finishing the season without an almighty shunt. There were a few murmurs about his forceful methods, but these half-cock protests were unwarranted. Some drivers are becoming far too sensitive. If things are getting too rough, it is better to quit. A nervous driver will always be in trouble. An attempt was made to blame him for Ginther's crash at Aintree. I would put it on record that in no way was Arundell involved.

143

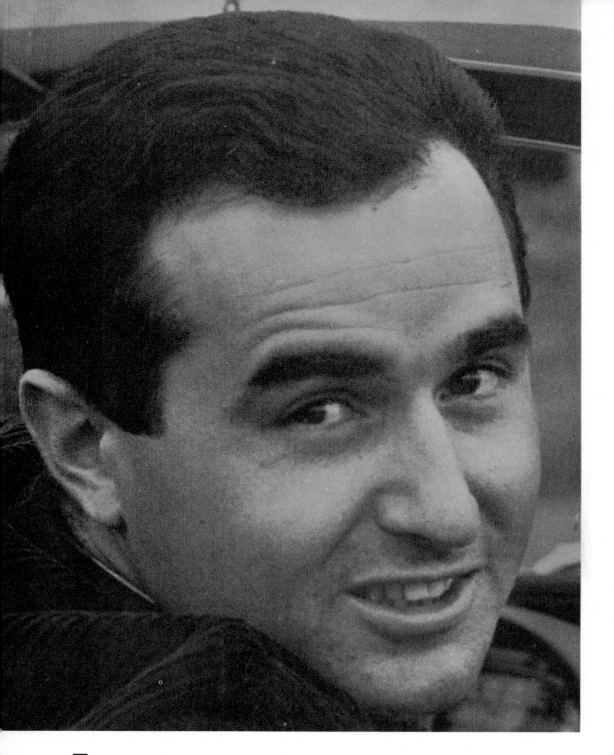

7 Lorenzo Bandini

How good is Lorenzo Bandini? I don't know the answer. He varies from race to race, sometimes from lap to lap. He is one of the most variable and on the whole unpredictable of drivers. He has intelligence, a forceful style, and, as Surtees has said, is a useful team-mate. What is the verdict from available evidence? He is good, but not as good as he imagines. The full promise is still unfulfilled. Potentially Bandini could be an outstanding driver, but as yet certain vital qualities are missing. He lacks a cool temperament that can decide in a split second under extreme pressure when a risk is justifiable and when it is suicide. It will come with experience and a certain amount of ruthless self-discipline, but what will become of him until these basic weaknesses are eliminated, God only knows, for no one can calculate what so intense a need to win, to succeed, may do to that side of talent which has its own rule of being and can never be fixed.

144

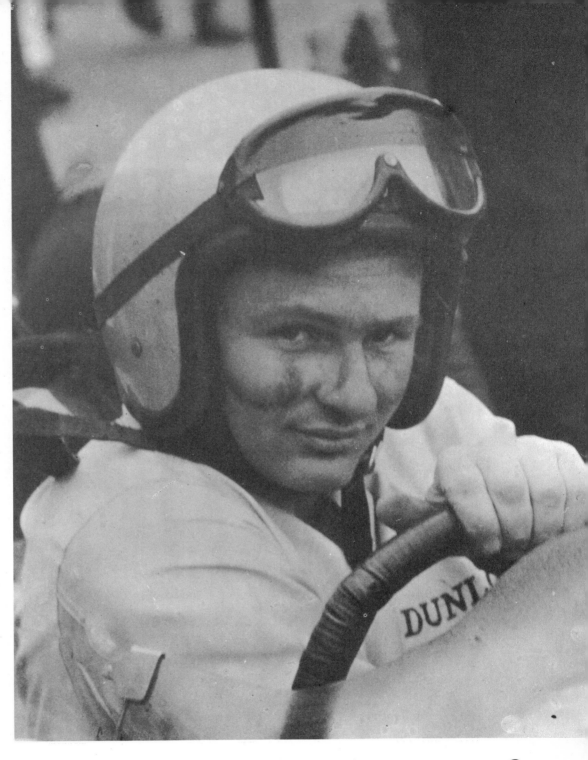

Bruce McLaren 8

Bruce McLaren had yet another season of quiet, unspectacular, consistent racing. Physically, he is unexciting to watch, rather like driving in aspic, but as a type, and using the word in its true connotation, McLaren is the *nicest* driver of the lot. I have never known him to be guilty of any doubtful tactic in any race, never obstructive, and scrupulously fair. Has considerable racing experience and a lengthening list of honours. John Cooper is a fortunate man to have his services.

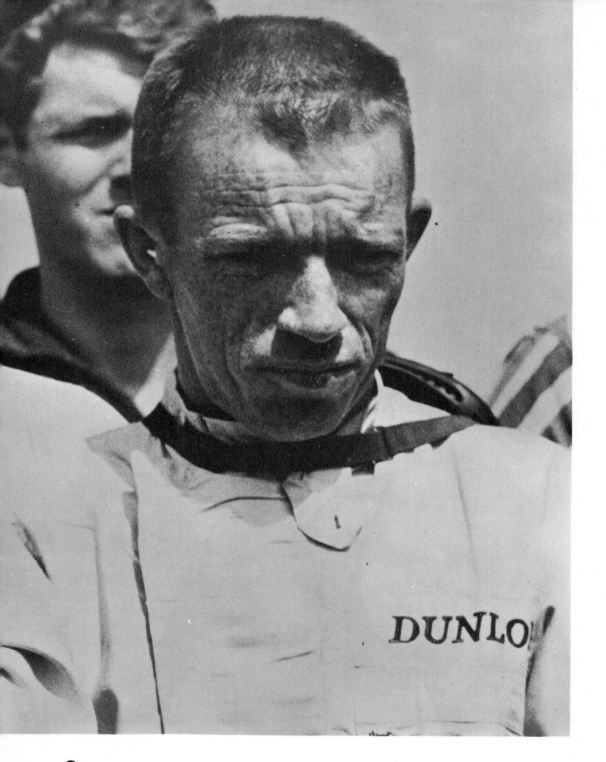

9 Richie Ginther

Richie Ginther is not a romantic figure—at his height you can't be, as another well-known racing driver has discovered; nor is he sentimental. Cheshire cats never are, but he possesses bags of natural charm. At his best Ginther is a first-class driver, but 1964 was not his year. I believe the effect of being No. 2 to Graham Hill was having a bad psychological influence. We were more than sad to part with him at B.R.M. He was a wonderful team man, co-operative, and useful in technical development, but for his own sake it was wiser to have a change. Given No. 1 berth in the Honda team and the little American will soon be challenging the Big Four.

In 1963 Joseph Siffert was named as the most improved driver of that season. Last year showed even more progress. His handling of Grand Prix machinery was convincing. Siffert has graduated in remarkably quick time to the status of a senior driver. He should now benefit from joining Rob Walker's team, where he will have Bonnier as team mate. It would be a tonic to see this young Swiss driver take the chequered flag in a Grand Prix. Given reasonable luck, such a thing is not impossible.

Joseph Siffert 10

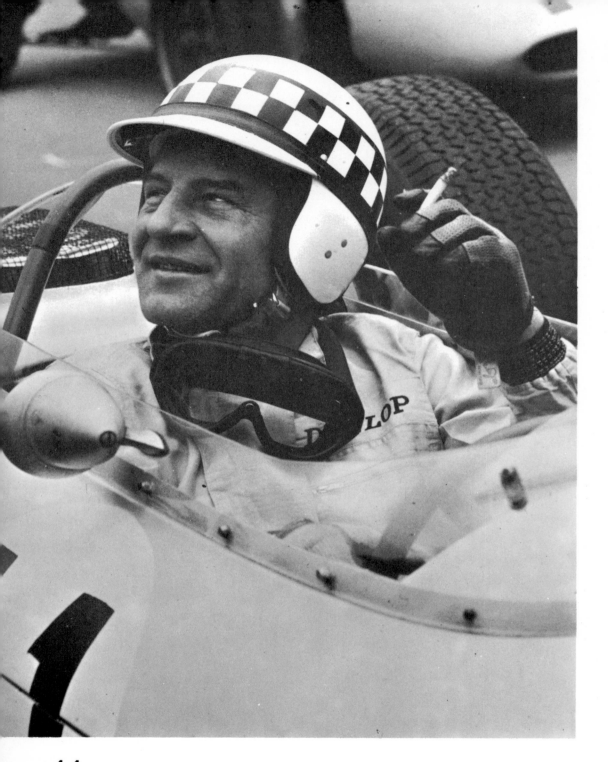

11 Innes Ireland

Innes Ireland had a tempestuous season. Nothing went right. Crash after crash dented his body, but not his spirit. It was one of those spells that every driver experiences at

some time in his career and he was fortunate to escape without serious injury. Long may it continue for Ireland is a driver of tremendous potential. He not only seems more eloquent, more joyous than any other driver, but is peculiarly available to all and everyone—utterly without pose. Always ragging his fellow-drivers, he is "Innes" to every casual pubmate or pick-me-up with the appeal, winsome and rakish, of a Frank Sinatra. It is because in an age full of supremely careful people searching for the security of personal happiness, Ireland lives without sense, without an analyst, that he provokes the most tremendous astonishment and affection from people.

Joakim Bonnier **12**

Joakim Bonnier is still a disappointment. He had quite a good season, but he ought to be so much better. It is difficult to pin-point the reason. Some of his more indifferent drives cannot be put down to faulty machinery. It is just that the urge to win, to beat the fellow in front, is not as strong as it was. Periodically he exerts himself. In that mood Bonnier is within striking distance of the leaders. With his skill, experience and ability and given a good car, it is only where he should be. Maybe 1965 will see the Swede claiming honours that could be his if the "fire" only stays long enough.

13 Phil Hill

The technical apparatus with which Phil Hill beseiges his drives has sometimes looked a little over-elaborate, recalling the old metaphor about the sledge-hammer and the nut. It would be foolish to pretend that 1964 was a

good year for the American. On paper the pairing of the ex-World Champion and John Cooper looked promising, but somehow it never worked out. Temperamentally they did not click. I hesitate to take sides as I like and admire both men, but I am certain that with a little common-sense and tact Cooper could have removed the difficulty. Onlookers could see what was causing the friction, yet nothing was done. It was a pity because Hill is fully capable of winning any Grand Prix provided he is given race-worthy machinery. When mechanical troubles are continual, it is no wonder that confidence and patience are strained to breaking-point.

Mike Spence showed several flashes of brilliance last year, particularly at Watkins Glen, but it needs to be sustained before he can reach the top ten. On the other hand, I am sure the potential is there, whether it will come to fruition as Lotus No. 2 is open to question. Jim Clark makes an excellent team-mate, but it could be deflating to an up-and-coming youngster who is trying to reach the heights. A reasonable lap can be made to look very ordinary alongside Clark's times. If this happens continually the long-term effect might easily be an inferiority complex.

Mike Spence 14

15 Bob Anderson

Unsympathetic critics like to portray Bob Anderson as the odd man out, a motor-cyclist who has found himself in the wrong sport. That is a jaundiced view. Anderson had a highly satisfactory season. At times he drove well, though occasionally his performances were erratic. Lap times fluctuated without any apparent reason, but these are defects that disappear with greater experience. This tall, restless, butcher-looking man could develop into a useful second string, though whether he will make the grade when the new formula comes remains to be seen. The same question-mark might be set beside several young drivers.

It was good to see the name Rodriguez figure in the list of starters for Watkins Glen and Mexico. Diminutive in size, at present Pedro lacks Grand Prix experience, but such is his natural determination and undoubted driving ability that he would be an asset in any works team. He has all the necessary qualities . . . youthful, fearless without being reckless and technical sympathy with his machine. It is difficult to fathom the reasoning of some constructors and team sponsors who spend considerable sums of money on their cars, then hand them over to men who cannot return winning dividends. Young Pedro Rodriguez could be a promising investment.

Pedro Rodriguez **16**

John Surtees ... World Champion

Writers who try to produce an accurate pen-portrait of John Surtees are liable to experience difficulty. At first contact he seems a straightforward enough subject, until an attempt is made to find what lies behind the impassive mask he shows to the world. Until you penetrate this reserve, his conversation· is not intimate, still less indiscreet, and reveals little of his deeper feelings. All in all, I regard Surtees as the most interesting personality in Grand Prix racing.

An individualist in every sense of the word, he is the lone wolf of the sport. A man of few words on the circuit, few drivers have ever attempted to subject themselves to such ice-cold, concentrated self-discipline. He has one ambition . . . to become the greatest Grand Prix driver. To achieve such fame, not only must luck be present all the time, but handling of machinery has to reach a pitch of automatic perfection with complete co-ordination of mind and muscle. There is no doubting the thoroughness of Surtees' approach. Technicalities are analysed in every detail. Only one thing is missing . . . the ability to eliminate error. In such a quest, every perfectionist—be he Surtees, Gurney, Hill or Clark—comes up against a ruthless opponent—his own temperament. The back-breaking, hand-blistering hours spent practising and experimenting are as naught when temperaments refuse to become akin to a feelingless automaton. By this I do not mean that Surtees has failed. For one thing, I doubt if he or anyone else ever will succeed in the search for automatic perfection. Others have tried, but the secret has not been theirs. Surtees has touched the hem of the garment. He has come within sight of his ambition—in itself an experience known only to a few.

Surtees never courts popularity. I have watched him in crowded paddocks. He moves as in lonely isolation. He retires to his own ivory tower. He walks to his car with pale, strained features, outwardly unseeing, completely impervious and oblivious to any distractions. The public loves a mystery. It takes pleasure in analysing an individual it cannot understand. Surtees is in that category. He is indifferent to criticism. He ignores public comment and inaccurate journalese. He just pursues his self-appointed course. As always happens when a man of iron determination, with ability to match, sets out to get what he wants, critics are collected on the way, but the ultimate target is eventually reached.

1964 saw Surtees gain the coveted World Championship. It was not a clear-cut victory, but it goes down in the records just the same. I am confident that next time he will claim the title before the final round. Regarding form, it has been fascinating to watch how he has mastered the change in technique between two wheels and four. The difference between "leaning" a motor-cycle through a fast curve and drifting a racing car has baffled many men. Surtees has matured into a brilliant driver with individual flashes of intuitive lightning. About a fifth of his skill is a composite of grit and determination. The rest is pure plutonium, by which I mean something that is rarer than gold. The World Championship is in worthy hands.

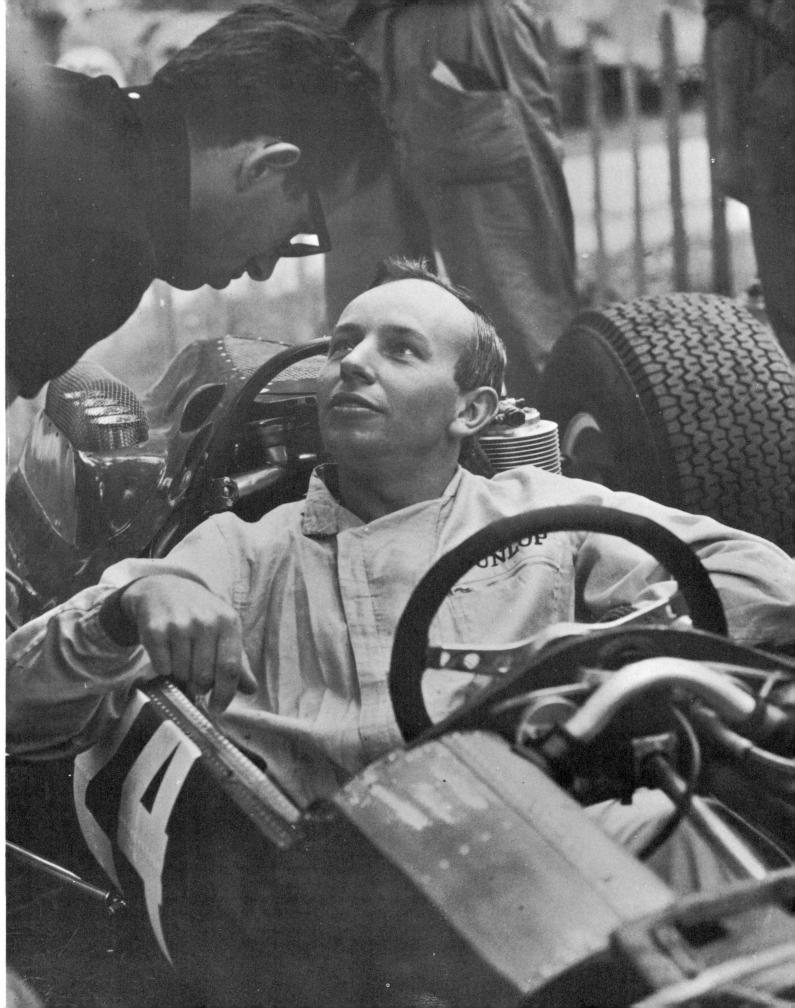

Top Ten of 1964

Louis Chiron

All French gestures are variations of the shrug. Louis Chiron, Race Director of the Monaco Grand Prix, uses the lot, plus a few of his own invention. Strained, gimlet-eyed and magnificently alarmed, he controls everything and everybody with voice and flag. His talent is irascible.

He lends a flustered dignity to the occasion like that of a goosed hen. Elegant, suave and man-of-the-world, Chiron's face is reposeful until convulsed by emotion. Then it twitches, constricts and works intensely as if a bowl of ammonia had been thrust beneath his nostrils. In spite of these Gallic eruptions, Chiron discharges his duties efficiently. All too often the start of a Grand Prix is ruined by hesitant, ill-timed flag-dropping. Chiron is never confused when the chips are down. Chiron has his idiosyncrasies. At times his manner suggests that the end of the world, when it arrives, will surely be announced in French—and why not?

The B.P. Motor-Racing Manager is easy meat, a welcome febrifuge after pompous officialdom. Has certain characteristic features. His smile is a benevolent winch. His voice has a dry mundane metropolitan quality. He pretends to be pop-eyed, but is as far removed from this type as a butterfly from a guided missile. Dennis Druitt plays an important role in Grand Prix racing and last year handled several tricky situations in masterly fashion.

Dennis Druitt

Barrie Gill

In 1964 Barrie Gill had the distinction of being the only motoring correspondent of a British national newspaper to be present in Mexico for the last round of the World Championship. This editorial decision provided the *Sun* with the only authentic eye-witness account of the drama of that day . . . well written, graphic in description, and reasonably accurate as are most of the Gill pieces. As an individual Barrie Gill is pungent and artless, innocently sly, superbly explicit . . . what one would call low falutin'. Occasionally has bursts of splenetic indignation. As a journalist he is workmanlike, industrious, and, above all, cheerfully enthusiastic, which is more than can be said for some of his morose colleagues.

Wilhelm Schmitz

Herr Schmitz is not an easy man to get to know. He can be difficult, obstinate and tough, but once the brusque surface is penetrated, a warmer, convivial individual is revealed. To Schmitz's credit is the trouble-free organisation of the elaborate machinery involved in staging the Grand Prix of Germany at Nürburgring. That it runs so smoothly in itself hides the ruthless efficiency of his methods of co-ordination and remote control. Certain Grand Prix promoters could benefit from a Schmitz refresher course on the elementary principles of race organisation.

Jack Brabham

It is always gratifying when a small concern, built-up from scratch, takes on competitors, larger and more powerful financially, and beats them fair and square.

David and Goliath acts are popular, particularly when the small man is Jack Brabham. In 1963 he became the first man to gain World Championship points in a machine of his own construction. Twelve months later his car won the French Grand Prix and Mexican Grand Prix, morally gained the Belgian Grand Prix, had wretched luck in the British and Italian, and might have collected the World Championship. It is to be hoped that he will be able to continue when the new formula comes into force in 1966. In the meantime the Australian deserves the warmest congratulations on his 1964 achievements, which could well be repeated in 1965.

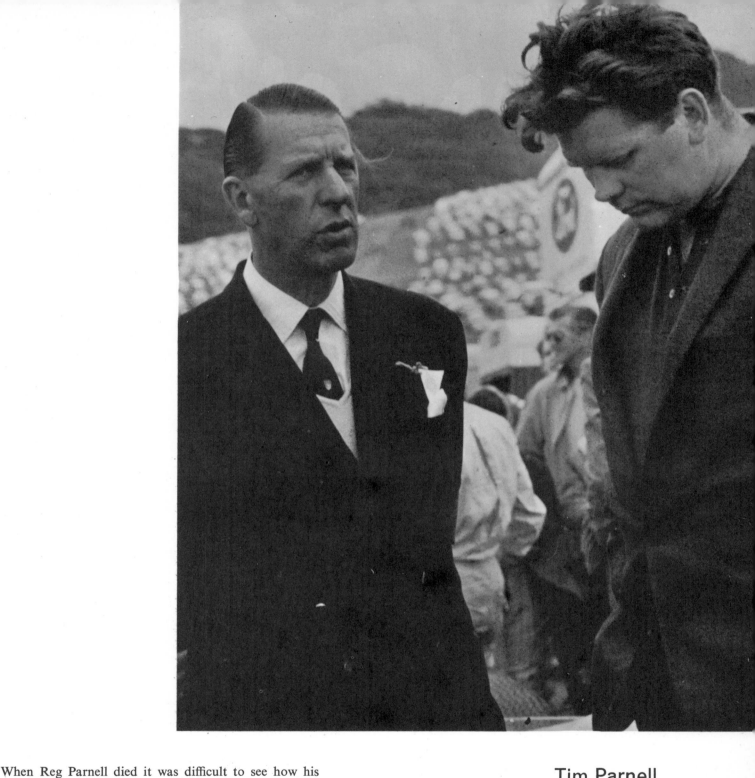

When Reg Parnell died it was difficult to see how his team could continue. To direct and control a Grand Prix outfit calls for qualities that are not readily found. Few men can cope with the multifarious chores and responsibilities apart from the technical knowledge required. His son Tim had been with the team for quite a time, but hardly looked ready to take over. Events proved otherwise. Not only did he take charge, but the cars at every race were a credit to all concerned. As an individual, Tim Parnell is a large, beefy man, a farmer's boy out for the day. On the track everything about him seems slept in, especially his hair which after a strenuous spell looks

Tim Parnell

like a nest of wet serpents. Unobtrusive in every way, Parnell is popular with everyone. Last year's efforts merit the highest praise and augur well for 1965.

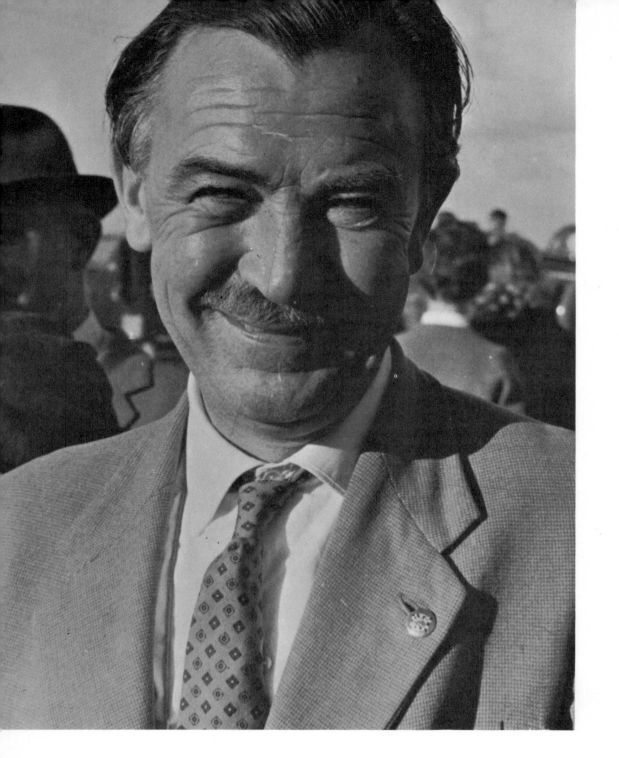

Gregor Grant

All of us know how futile it is to recommend one of our friends to another, and it is, of course, equally futile for a writer to praise another writer. Even so, I have no qualms about naming Gregor Grant. He is an odd mix-

ture. Very often conversation with him is an unpunctuated flow of irrevelances which only acute ears can render into sense, but beneath the veneer, behind the feathery yeasty voice—a sort of clipped unfocused bluffness—is an astute businessman and an accurate writer with a discerning eye for detail. Grant tackles one of the hardest jobs in journalism. He edits and produces the weekly magazine *Autosport*, which every seven days, in and out of season, maintains a high standard of production, illustration and written matter. In 1964 the journal reflected an even higher peak of lay-out and content-interest.

Convictions, as Nietsche said, are prisons. They exclude from life the fun of doubt and flexibility. The German philosopher never met Tony Rudd, B.R.M. Chief Engineer. Few men have such firm convictions on technical matters. On the other hand, they are flexible if necessity or Graham Hill is insistent, and are often larded with good humour. When things are going right Rudd takes on a protective colouring which melts him into his background like a lizard on a rock, but when action is needed, he leaves his impress in no uncertain fashion. It was not by chance that B.R.M. was the most reliable car in Grand Prix racing last year.

Tony Rudd

Dennis Holmes

The motoring correspondent of the *Daily Mail* has a face that reminds me of a French critic's description of Rejane . . . "une petite frimousse éveillée"—roughly translated—"a wide awake mug". Holmes has an eagle eye for exclusive coverage; tends to exaggerate; presumably in deference to editorial policy. Did an excellent job in publicising the British Grand Prix at Brands Hatch, though his scare-tactics about traffic jams may have affected the gate. At times looks like a draughts player lost in a universe of chess. The impression is misleading. Denis Holmes is one of the shrewdest journalists in Grand Prix racing.

Mauro Forghieri

The success of Ferrari in last year's Championship was unquestionably due to the determined driving of John Surtees. At the same time a driver can only succeed if his car is trouble free and competitive alongside the rest of the field. The reliability of the Italian cars during the latter part of the season was primarily due to the skill of Chief Engineer Forghieri, a likeable, bespectacled young Italian with hair like a tousled mop. When things are not going right, Forghieri reacts like all his countrymen. Arms windmilling, he gives the impression of being possessed by an adhesive demon that is fiercely resisting exorcism. A knowledgeable engineer, Forghieri enjoys the full confidence of Surtees, no mean critic of technical shortcomings. Together they make a formidable partnership.

These We Remember

This is a sad chapter and yet it is one that ought to be done. I once wrote that when a man of any mark dies there is not a paper up and down the land which does not carry an obituary notice. The next day he is not mentioned: henceforth silence. This abrupt cessation of comment always strikes me as a little heartless. "To live in Settle's numbers one day more." Yes, but why only one day? It would seem more respectful to suppose that it was not only the day after his death that the world wished to hear of a remarkable man. Most of these men have been dead for some time. It is unlikely that you will see their names in any paper again. This then, is the moment to remember them.

Death unfortunately casts its shadow every so often over the Grand Prix scene. I do not wish to ventilate the ethics of a sport that makes such tragedy possible. Everyone associated with motor racing knows its dangers. The drivers take part with their eyes open. Only an idiot would ignore the risks. Reaction after every race is always the same . . . thankfulness that no one has been injured or killed. When a tragedy occurs, I deplore those newspapers and magazines that dramatise with stark illustrations and text the horror of the scene, a censorship of decency that applies to books, films and television programmes. The Indianapolis crash last year and the earlier Monza disaster provided many instances of

blatant disregard of sensitive feelings. On several occasions I have photographed fatal crashes, but never have the prints been used.

The Grand Prix world is a very small one. Every time a driver dies, it means the loss of a friend. When Harry Schell died at Silverstone and Wolfgang von Trips was killed at Monza, an instinctive reaction was to quit a sport that could bring such senseless loss of life, yet such is the gentleness of Time that scars are healed. Memory aiding, it is possible to call back recollections of these men, whose skill was the quintessence of perfection. The tragic death in Germany last year of Carel de Beaufort was even more poignant for I reached the hospital as he died and felt powerless adequately to sympathise before the dignified sorrow of his mother. At moments such as these I agree with my friend, James Agate, that without wishing for personal immortality, the very futility of death demands some conscious continued existence, but not a future life which would be all Michelangelo or Sebastian Bach. There must be a paradise for the simpletons as for the picked spirits. Nectar and ambrosia are all right, but there must be common grog and laughter and good fellowship. I want a heaven in which cars shall race and the laying of odds allowed a sinless occupation. I want to see Collins and Hawthorn fight it out again, to roar at Nuvolari, and watch the skill of Caracciola till the shadows grow long. I want not only the best the celestial architects may design in the way of pits, but I want the atmosphere that means so much. I want pipes of clay and pint-pots of jasper, common briars and spittoons of jade. Out-of-doors circuits with well-matched teams, even keen-eyed officials with flags—I wouldn't even object to an etherealised Eason Gibson—enthusiastic supporters and streamlined cars, chrysoprase if you insist, but ordinary monocoque will do—and a feeling that once a week it will be Saturday afternoon. Bizarre thoughts with a serious undertone.

Each of the men I recall gave proof not only of extraordinary skill—to which quite ordinary men can attain—but of that courage which is beyond the reach of any save the few. Unfortunately cold print can never reproduce the look and the voice, but their characteristic likenesses, plus a few lines, may help to bring them back to those who knew them and for those who have only heard of their deeds.

Wolfgang von Trips—elegant, polished, disciplined. He was somewhat apart in the Grand Prix world. There was no one quite like him. Vastly more intelligent than the sport he pursued, sensitive, with a tough shell and a fine core. With his gifts, his possibility of profitable leisure, von Trips might have spent his time at his castle home in the forest near Cologne. That he should look after his family estates was one matter; that he should seek the title of World Champion was another. Yet the last ambition explained the man. We could interpret his racing career as a desire to rattle the dice once more. He proved to himself that the man of taste, the virtuoso, could face the challenge of the Grand Prix circuits. von Trips was the uncrowned World Champion of 1961.

Ricardo Rodriguez had all the fire, determination and courage to become World Champion. The only quality missing was the experience to sense when impetuosity had to be tempered by caution. That maturity was coming. Tragically on the threshold of success, the tiny Mexican was killed on his home circuit at Mexico City. We remember him for his utter fearlessness and colourful Latin charm.

Alan Stacey was another driver who was little more than a boy when he died at Spa. Without the daredevil qualities of Rodriguez, he nevertheless had plenty of guts and was a natural driver. I always wish that Stacey had declined his last drive. The night before the race he told me that the accidents to Moss and Taylor had shaken his nerve and he half-hoped that Chapman would withdraw his cars. It was not to be.

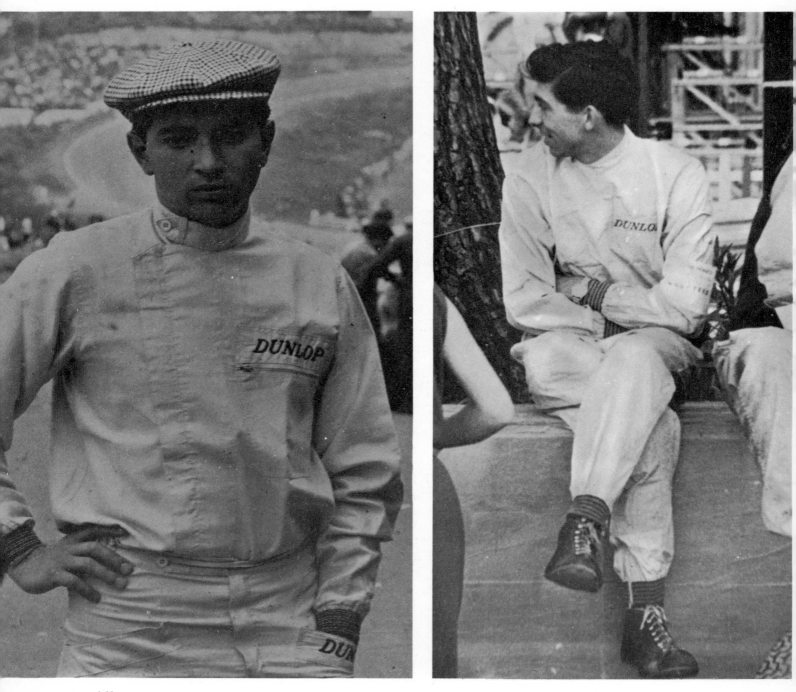

It is always difficult to convey to others the true personality of an individual. Three words are enough to recall Mike Hawthorn . . . unpredictable, irrepressible, dynamic. The only time he was subdued was when he was asleep.

When Jean Behra crashed to his death on the Berlin Avus banking, the idol of French motor-racing passed from the scene. Four times he had been motor-cycle Champion of France on a red Moto Guzzi. Following the example of Nuvolari, Varzi and Rosemeyer, he changed to four wheels and enjoyed considerable success. His stay with B.R.M. was particularly happy.

Chris Bristow could easily have matured into the Clark/Surtees class had good fortune only stayed with him at Spa. Those of us who watched that epic struggle against Mairesse will recall the feeling of apprehension caused by the wheel-to-wheel dice on this exacting circuit. The result was tragedy. We lost one of the most attractive of the younger drivers.

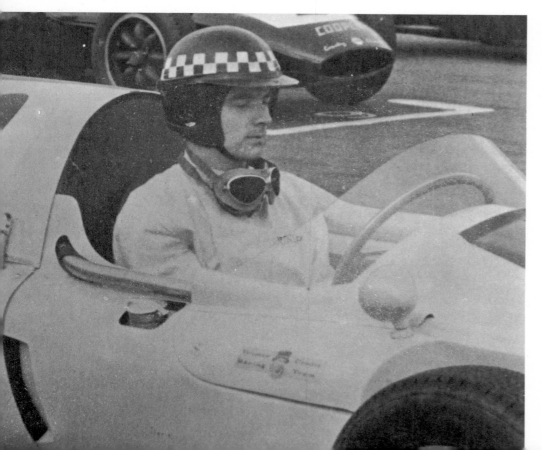

Ron Flockhart was with B.R.M. for about seven years. During that time he gave invaluable service as driver, engineer and tester. I felt that his ability was far greater than his Grand Prix record suggested, but in those days the Bourne car lacked reliability. He survived several serious crashes, but it was not on the circuit that he met death. Always keen on flying, he was preparing for an attempt to break the Sydney/London air record when his Mustang aircraft dived into wooded countryside in the Dandenong Range near Melbourne.

Harry Schell was a character larger than life. Few men have possessed such fluent charm. He might have been modelled by Ian Fleming. Everything about life intrigued him and was there to be sampled so why waste time. This devil-may-care attitude was reflected in his driving at the wheel of such cars as Cooper, H.W.M., Maserati, Gordini, Ferrari, Vanwall and B.R.M. Certainly his period at B.R.M. was never dull, and though at times the car's performance was enough to invoke despair, he was always cheerful—there would always be another day. Unhappily on a certain Friday the 13th his philosophy failed in a crash during practice at Silverstone. A rare spirit had passed.

171

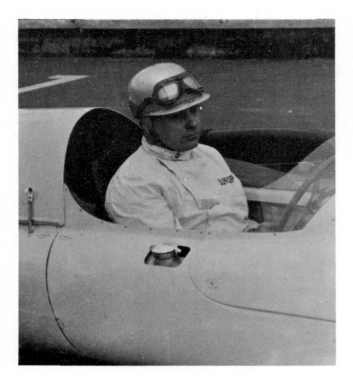

Ivor Bueb had been partner with Bristow in the 1959 B.R.P. team, but died as a result of injuries sustained in a race at Clermont-Ferrand. Bueb never aspired to be a potential champion, but his exuberant, hands-in-the-pocket style endeared him to everybody. His attitude to the sport was epitomised in an incident during the 1959 Monte Carlo Rally. On his Sunbeam Rapier these words were written upside down—"If you can read this, please turn us the right way up."

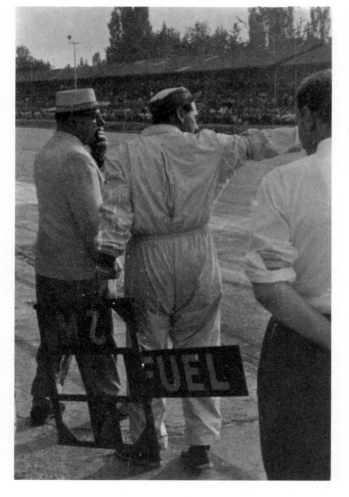

Last year saw the death at the age of 71 of Charles Cooper, the man who exerted such a revolutionary influence on racing-car design. He was a rugged character, blunt, outspoken, with a dry sense of humour. At times he was stubborn about the necessity to change the design, and his son, John, had to be the progressive influence in later years, but nothing could damp the old man's enthusiasm. He was reared in the atmosphere of motor-car racing. No one was prouder than he of the achievements of Brabham in a Cooper, which produced double wins in the Manufacturer's World Championship and the Driver's World Championship.

The death of Earl Howe at the age of 80 meant the loss of one of the prominent figures of the pre-war sport. He began serious motor-racing at Brooklands about thirty years ago and had a somewhat tempestuous career that included several serious crashes. Howe ranked as leader of the sport in Britain being President of the B.R.D.C., Chairman of the R.A.C. Competitions Committee and Vice-President of the C.S.I. His approach to official matters was keen and incisive as might be expected from the descendant of the celebrated Admiral Lord Howe who gained a naval victory over the French in 1794. His epitaph should read that here was the last of the genuine amateur drivers.

The sudden death of burly Ralph Martin of Shell International meant the loss of a knowledgeable, warm-hearted figure who was known on all the European circuits, with perhaps pride of place going to Italy, a country he had adopted as almost his second home. It is sad to think that we shall not again see this gruff, eminently likeable personality . . . Monza without him did not seem the same.

By the time these words are read it will be nearly a year since Count Carel Godin de Beaufort died from injuries received during practice for the German Grand Prix at Nürburgring. It is difficult to realise he has gone. Tall, massively built, de Beaufort did battle in an out-dated orange four-cylinder Porsche. Against him were cars of far greater power, yet such was his dogged persistence that time and again the aged machine would finish, whilst his rivals dropped out or blew up. In 1962 he outpaced and outdrove the Porsche works flat-eight machines. Had it not been for a mishap at Watkins Glen, he would have been classified as a finisher in every race counting for the World Championship.

Carel de Beaufort was full of mannerisms. Invariably he drove in his stockinged feet. Even at moments of intense pressure during a Grand Prix, he would suddenly wave to a friend alongside the track. He hated half-measures. Every-

thing had to be all or nothing. At one time he became seriously overweight. Dieting was prescribed. In a surprisingly short time 70 lb. had been lost. He stayed with me in Cambridge for a few days. At the end of his visit, I knew everything there was to know about calories.

Motor-racing was de Beaufort's life and he enriched the sport with his exuberant presence. His home, Maarsbergen Castle in Holland, bore evidence of his enthusiasm. His study held shelves of trophies, one of the most precious being the trophy given to him by the G.P.D.A., a recognition by his fellow drivers of his vastly improved driving. Talking to him was refreshing. It made one realise that to some, motor-racing is still a sport to be enjoyed. He is missed on the circuits. My thoughts go especially to his mother. After the German Grand Prix I went to the hospital, only to find he had been taken by helicopter to Düsseldorf. When I arrived it was to learn there was no hope. His high noon kept all the freshness of the morning—and he died there, never knowing disillusionment. In the words of John Masefield—". . . he has gone . . . Among the radiant, ever venturing on, Somewhere, with morning, as such spirits will". Those who knew Carel de Beaufort most know that "the death you have dealt is more than the death that has swallowed you".

Grand Prix Garden Party

Jack Brabham gives vintage car rides watched by Innes Ireland and Dennis Druitt.

It is always interesting to see public performers in every-day garb. Sometimes it is a mistake. You never can tell. An annual opportunity to see Grand Prix personalities, occurs in the wooded grounds of Fort Belvedere. Every summer a garden fête is organised by the Doghouse Club, more officially designated the Women's Motor Racing Association. Maybe I am biased, but generally speaking I find motor-racing personalities thoroughly normal and relaxed off the circuits. Maybe not much dress-sense, but at least they are unobtrusively masculine

Left: *Graham Hill checks the amount of overlap.*

Below: *Bette Hill auctions a signed Beatles record, whilst Graham's son, Damon, eyes the ice-cream.*

Masten Gregory and Innes Ireland attempt a pas de deux *with Keith Greene as soloist.*

Tony Marsh, the race-commentator, made a fluent and persuasive auctioneer.

and agreeable, though there are exceptions. I could name half a dozen types who act as if life is one long pit stop. It is always a good day at Fort Belvedere, with sideshows, coconut shy, vintage car rides, even Windmill girls

enjoying an afternoon off in their clothes, whilst at an hilarious auction I became the possessor of an autographed Beatles L.P. record and an unwilling purchaser of a hamper of food . . . could anyone ask for more?

The Brabham sideshow inverted many a customer.

At last we know what Windmill girls do in their spare time.

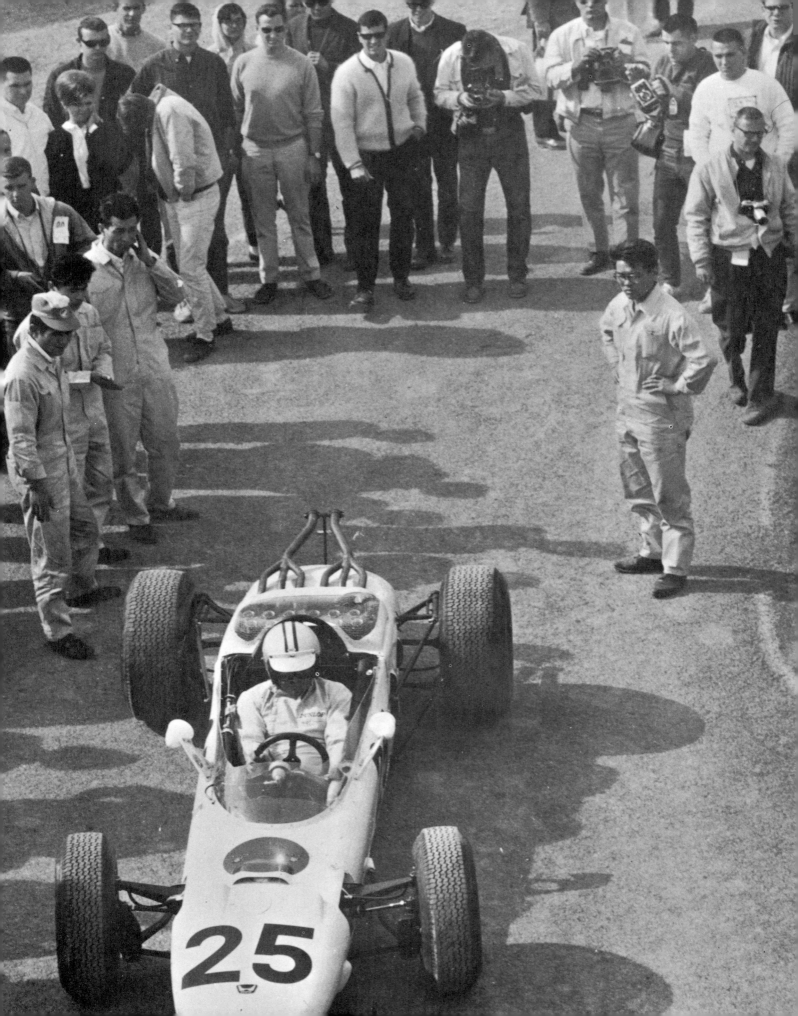

The Honda Threat

There were so many rumours, denials and contradictions about the Honda Grand Prix car that when it finally appeared at Nürburgring, a feeling of anti-climax obscured the fact that this was a milestone in the history of the sport. The spasmodic appearances of the ivory car make an assessment difficult, but a few general observations are possible. Its debut was not impressive. Team organisation was surprisingly poor. There was no excuse for arriving without the compulsory catch-tank for the engine and the gearbox breather pipes, and even less for the ridiculous spectacle of a Coco-Cola tin being wired to the back of the car. Loss of face in Far Eastern circles must be out of date.

Honda's motor-cycling experience suggested a streamlined set-up. Instead Yoshio Nakamura, chief designer and development engineer, presided over a clutter of Japanese mechanics, who spent considerable time getting in each other's way and scowling at anyone who tried to examine the car. There were several irritating, childish incidents in their attempts to ensure privacy. No one wishes to encourage rubber-necking, but legitimate interest was justified, particularly when a headline machine makes its first appearance. There is no excuse for boorish rudeness.

Another curious example of Oriental unpredictability has been their policy regarding Grand Prix drivers. Here is a large, wealthy concern about to enter a highly competitive field. No one expects a new car to avoid teething troubles. There are bound to be difficulties and many of the answers will be found in carefully analysed test reports, yet the man they chose to do the job had never driven a single seater in a race. As it turned out Bucknum did extremely well, but even his best had limitations due to inexperience. At the time of writing Bucknum is said to be paired with Redman, likewise lacking in Grand Prix experience. I refuse to believe the report, particularly when such a talented engineer-driver as Ginther is without a contract.

So far little has been seen of the man behind the project, Soichiro Honda. His record is most impressive. He founded the Honda Motor Company in 1948 with a capital of about $2,770. 1965 sees the Company's capital assets near the $30,000,000. The head office is in Tokyo. The three main plants of Hamamatsu, Saitama and Suzuka employ about 7,000. In Yamato there is a technical school for automobile and motor-cycle design as well as a training centre for mechanics. The key unit is the Honda Technical Research and Development Company in Yamato, Saitama (Tokyo) that employs 700 people. Here it is that designs originate and the Grand Prix programme takes shape.

Against such an impressive background, the rough and unfinished appearance of the Honda in Germany was even more surprising. On the other hand, the finished product is bound to reflect a high standard of automobile engineering. Regarding the car's performance in 1964, there was cause to be quietly pleased. During its few appearances, it was obviously very fast in a straight line and once the road-holding problems are solved it will be highly competitive. Reliability may be the missing link, whilst it needs an experienced Grand Prix driver at the wheel if races are to be won.

In every way Honda are welcome newcomers. It adds interest to see fresh faces, hear new engine sounds and add international flavour to starting-grids that were becoming too parochial.

Tremendous interest greeted the Honda outfit. There were teething troubles but, once cured, this machine will be highly competitive.

The swarm of Japanese mechanics and technicians added colour to what sometimes are drab paddocks. To the onlooker there seemed too many for efficient working, though in Nakamura, Honda has a brilliant designer and development engineer.

As their driver, the Japs preferred Bucknum to more experienced Grand Prix pilots. Allowing for his obvious limitations, the American did remarkably well, but commonsense suggests that in the future Honda will obtain the services of a recognised No. 1 driver like Ginther or Gurney.

The Elusive Art

Raymond Mays believes in leaving nothing to chance before taking a photograph. Pre-click routine is now more or less standard:

First—refresh memory as to which is the business end of the contraption.

Second—see if there is a film in.

Third—look round for confirmation of the fact: in this case Maxwell Boyd of the *Sunday Times* obliged.

Four—propitiate the spirits of exposure by genuflection.

Five—press the trigger before light fades or the subject gets cramp.

Generally the results are excellent, though last year the wretched instrument kept jamming after every click. Anyone with camera knowledge tended to give the B.R.M. pit a wide berth.

The Wives
Who Wait

Pat Surtees.—*Extremely pretty; features have a chiselled quality; very expressive eyes; has a special brand of dry wistful humour; impression summed-up by four words . . . pith, pertness and wit.*

Marianne Bonnier.—*Her build is pencil-slim and capable; long-limbed; wears tight-tapering slacks and moves like a mountain goat; blonde; rain-fresh skin; the most striking girl in Grand Prix circles.*

A correspondent has suggested that I am biased in my views about women in sport . . . that I adopt a patronising attitude indicative of an imagined masculine superiority . . . and more of a similar vein. I hasten to set her mind at rest. I am an admirer of these gentle Amazons. Their feats are a source of constant amazement, but there are occasions when it is difficult to determine the real function of women in sport. They charm, irritate, cajole, enfury and comfort with such facile ease that it is hard to pinpoint an abiding quality. I have seen women go through convulsions that had some slight resemblance to soccer. I have watched females vainly trying to get a respectable hold in all-in wrestling. I was intrigued by the prowess in Tokyo of Russian women after they had satisfied Olympic medicos of their gender. I have even seen the weaker sex trading blows in a boxing ring that would convince any bachelor of the wisdom of his sacrifice. Against these, we have graceful golfers, ice-skaters and lawn-tennis players, whilst Grand Prix racing has some of the most attractive females in sporting circles, in particular the wives of the drivers.

Here is a group of young women, all of whom are concerned with pit activities during a race, several being

Jackie Ginther.—*Delightful personality; half-pint sized like her husband; infectiously happy; when she laughs, which is often, she drops the corners of her eyelids and twinkles.*

Bette Hill.—*A mixture of feminine appeal and masculine assurance; strong personality; self-possessed; has disciplined herself to the shocks and alarums of Grand Prix racing.*

Betty Brabham.—*Can look deceptively serious until a sudden smile transforms her features; beneath a façade of pure mouse is a surprising toughness; warm-hearted, efficient and popular.*

Pat McLaren.—*Always competent with a melting moon-like candour of speech; grave eyes; blonde.*

Elaine Moss.—*Chubby-faced youngster; moon pale; nibbled hair style; too new to the circuits to have made any impression, but looks a very suitable wife for Stirling Moss.*

Arleo Gurney.—*Quiet and gentle in manner, but possesses a driving singleness of purpose; she is a womanly woman, not far removed from a girlish girl; devoted supporter of her husband's career.*

expert timekeepers. All are subject to the strain and stresses of the moment, the anxiety when a car does not come round and no one can tell whether mechanical failure or a crash has been the cause. It surprises me that these young women are not prematurely aged by worry, yet, whatever their feelings, no sign of concern is ever shown. Altogether a remarkable company of women, intelligent, stoical, pretty and resourceful.

During recent years the feminine side has been reinforced by another platoon loosely knit together under the generic heading of secretaries. Everybody seems to have one. Drivers sport dainty pieces under that title; loquacious P.R.O.'s strut about with wenches in attendance; journalistic types talk airily of their stenographers; that nebulous body of men sheltering under the "trade" umbrella sport an assortment of females, presumably for secretarial duties; team managers, engineers, constructors and officials—all have their quota. I suppose most of them are hard-working girls, though some of the recruits hardly look expert at those kind of duties. Not that there is anything new about the habit. It is as old as the hills though no doubt there are variations. Techniques change, but as one grows older there is neither the time nor the inclination to keep abreast of the latest developments. By convention we are conservative in taste. In any case categories vary little, the secretary-type hardly altering at all.

Invariably shrewd, she approaches her career in scientific fashion. Knowing that such work can only result in a curved spine and ever-spreading hips, the time spent on such unfeminine activities must be as short as possible. An obvious solution is a brief private secretarial career, preferably with somebody who has to be present at all the races. An executive is probably safer than a driver, the latter are sometimes rather peremptory in their orders to take things down. In a big concern the main thing is to avoid the typing-pool, that stuffy cemetery of unmarried drones. Sympathy for these females is often wasted. Many are content with their working-heaven, provided they have never heard of the text which informs us that there shall be no marrying in heaven. A few solace themselves with the thought that if only some high executive could see them, all would be well. The odds are that the fellow has already inspected them from afar, hence the relegation to earphones and wax cylinders instead of the Hôtel de Paris in Monte Carlo.

Becoming a private secretary to a lonely Grand Prix executive calls for special qualities. Getting him to approve across a wide expanse of pit counter is only the beginning. The right facial expressions must be practised, likewise postures and hand movements. Hair, teeth and figure need constant attention. Extravagance with hosiery and alluring underwear is important. Unless slacks are favoured, pit counters are conveniently revealing. Such details and the right kind of perfume are more rewarding than mastering the rudiments of shorthand and the mys-

185

teries of the typewriter. Having completed such formalities, the female must size-up her employer. Here there can be so many pitfalls. Take the expenses-paid categories. A smarmed-up P.R.O. may be all right for a few weeks, but who wants to be hitched to a "Yes-man", the boot-licking groveller without backbone who daren't say "boo" to his employer. Journalists can be interesting, but a pit badge and a cadged cigar makes Walter Mitty out of poor material. The majority of drivers are only glamorous during practice sessions when everyone looks busy and important. It is quite another story during the race. How can any fellow strike a pose when he is so far back as to be in another race. Trade representatives have all the glib of commercial travellers and often have their habits. The best bet would appear to be at a responsible level. Another safe assumption is that however brilliant may be the reputation of the eventual choice, he is, first of all, a man, with many vulnerable, probably adolescent sides to his nature. All these will emerge once she gets him alone.

An experienced female knows all the moves. Every employer comes under heading of an occupational risk for there is no guarantee that he will react favourably to the sudden urge to sew a button on his jacket, the understanding cup of coffee, the psychiatric, almost confidante approach. An elementary move is to gaze at him when he is dictating. That gives scope for registering signs of appreciation or awe at relevant passages. It always pays to flatter by inference. If the nose is stuck in the notebook, the only things that register are the ears,

Pina Brooks.—*Animated and vivacious; lively conversationalist; her striking Italian features would appeal to Pre-Raphaelite taste; wears little powder so that her skin has a bright sheen.*

Angelina Rodriguez.—*Amusing and witty; her sophistication, supple and mature, is excitingly spiced with Mexican ginger.*

by no means the most potent part of a female. If progress goes to schedule, the dictation side of the work should soon be reduced to a minimum. A fountain-pen that works is handed to him so that the impact of hands lasts a split-second longer than is necessary. A sweet innocent look is essential. The expression often requires considerable practice to look convincing. The main thing is not to over-do it. Too much haste can land a female back in the typing-pool. If he becomes over-anxious, she would be better there in any case. Such tactics are only necessary with the Big Executive. After all, he has had the full treatment long before the latest secretary came on the scene. He is invariably flattered at the thought of conquering innocence.

It is interesting to note the importance of personal appearance. Few men expected to see the day when women would get sunburned in the places they do now. Even so, it is better to be adequately clad. That is one of the upsetting things about a fashion common on the circuits of unrestricted freedom for the figure. It is all very well if the female has as many curves as a scenic railway, but it is tidier to be old-fashioned if the outline looks like a Himalayan range. The art of smiling ranks high on the list of the short-term secretary, only many fail to make sure that their make-up matches the expression. Only experience and a few set-backs can convince that an over-daubed mouth and badly tinted hair have a peculiar effect on some employers.

Then there is the question of other women. There would have to be something radically wrong with the man

Sandra Hall.—*Gay and wide-eyed, pretty and appealing, with a circus pony's mane of rebellious hair.*

A few general tips are always kept in reserve. Should an employer's wife die suddenly, expenditure on flowers for the funeral is always a sound investment. An impressionable employer often feels safer in the early stages if he knows that the dear mother of his secretary is relieved that she is working for such an understanding employer. The list could be extended, but sufficient has been said to show that the lot of a marriage-conscious secretary is far from easy. The job of a private secretary is often like that of a nurse-maid, whilst marriage to her would-be employer would turn her into a psychiatrist.

There are alternatives. She can become a manicurist, when hands can be held from the outset. Or perhaps an authoress . . . but second thoughts suggest that after all no intelligent women ever work . . . they leave that to men. In all, a mixed grill full of potentialities. The next time you see anyone sporting a secretary in the pit area, make a note of the tactics used and see what category she fits . . . and more important, what progress is being made!

if there were no other females on the horizon. The confident secretary just looks through them as if they did not exist, and shuns female friendship like leprosy. Some secretaries gain the reputation of being brilliant conversationalists. The secret is simple. She seldom talks, but becomes a sympathetic listener. General topics are avoided. Every subject must be personal and intimate. The answers take longer and the artificial relationship of employer and employee disappears quicker if his interests, hobbies and weaknesses are discovered, and wondering questions are asked of the oracle. The main thing is to let the man talk. It is here that expression is important. Generally speaking, provocative eyes and wrinkled-up nose are usually effective, provided she remembers to keep the lips slightly parted, with the body leaning a trifle forward. The pose needs practice, otherwise the result looks somewhat silly.

Nancy Bucknum.—*Charming and charming looking; sensitive features, deceptively baby-faced.*

Grand Prix Travel Album

In the course of the usual peripatetic Grand Prix season, many countries are visited, but the opportunities for sightseeing are not always seized. It is a pity because circuits are often sited in ideal centres for exploration. The Austrian Grand Prix is particularly fortunate in this connection. Looking back on the year I think of the golden roofs of Innsbruck; the glories of the Schönbrunn Palace; the Prater and strains of the *Third Man*; the Melk Monastery on the Danube; the ice caves of Werfen; von Ribbentrop's hunting lodge at Fuschl; the salt mines at Hallein; the romantic village of Grinzens; Salzburg with its Castle like mirage of Edinburgh; St. Stephen's Cathedral in Vienna; Berchtesgaden with Hitler's Eagle's Nest almost 6,000 feet in the clouds built by Martin Bormann at a cost of 25 million RM or nearly $10,000,000; the Spanish Riding School, the oldest Riding Academy in the world, with its stately Hall where the Lipizzan horses have been trained for over 225 years, and Beethoven conducted his famous concert of over 1,000 musicians. I can think of only two dissentient notes linked with Austria and both are to be do with food—an abomination not unlike *bouillabaisse*, a revolting soup made of fish, tinctured with saffron and nauseous with garlic, and roast mutton stuffed with lumps of that most villainous of the onion's poor relations.

During the Monaco stay I found an unsuspected gem tucked away in the mountains—St. Paul-de-Vence—a miniature fortified town rising from a steep gorge, built as part of the mountain, terraced with vineyards, olive and pear trees, steeply sloping streets, slits of stone stairways, old buildings buttressing each other, no cars as the alleyways are far too narrow, and a remarkable inn, *Auberge de Colombe d'Or* with Provencal decoration and an invaluable collection of modern paintings on the walls.

The mammoth statue of the Mexican President Miguel Alemán in the grounds of the University City.

Tlaloc, the giant 23 × 13 foot lava-rock monolith near Chapultepec Castle, Mexico.

Towering library of the Federal University in Mexico City designed by Carlos Lazo.

The lay-out of the campus is unusual and distinctive.

An attractive Mexican girl takes her baby to be christened.

No nation in the Western world has more dramatic or imaginative examples of massive modern architecture.

Peasant women with braided hair plus swarms of children entering the biggest church in Mexico, the Cathedral of Mexico City.

Mexico was a unique experience. Its magic is harshness. There is little pretty about its parched hues, yet many features are unforgettable. The Basilica of Guadalupe; the beaches of Acapulco; the floating gardens of Xochimilco, once a pleasure ground for Aztec nobles; the world's largest bull-ring in Mexico City; the delicate butterfly nets used by fishermen to catch tiny, almost transparent fish in Lake Patzcuaro; the gleaming silver of Taxco; the four-sided pyramid, El Castillo, of Chichén Itzá with its 90-foot platform where the high priests of the Mayans sacrificed their victims; one of the world's most remarkable buildings, the 10-storied, windowless library of the University of Mexico, its walls glowing with 7,500,000 coloured mosaics telling the story of the country; and finally, the immaculate snow-crested peak of Popocatepetl, beckoning like a icy muezzin nearly 18,000 foot above the clouds.

The Prater in Vienna, once the Imperial hunting grounds, now the favourite amusement park of the Viennese with its famous wheel.

Maria-Theresien-Strasse in Innsbruck with the Anna Column and the towering Nordkette Mountains in the background.

Salzburg . . . the façade of the Cathedral facing the Domplatz, peerless setting for Hofmannsthal's "Everyman" during the Festival.

Austria contains some of the most attractive scenery in Europe.

Statue of Johann Strauss in Stadtpark, Vienna.

The tunnel, 400 feet deep into the 5,674-foot Kehlstein Mountain, where a lift completes the journey to Hitler's "Eagle's Nest" in Berchtesgaden.

Life in the village of St. Paul in the Maritime Alps is like turning back the clock.

Wheeled traffic is impossible in the narrow lanes and flights of steps.

Left: *Fuschl . . . the swimming pool in the former home of von Ribbentrop.*

Right: *Clères, gathering-ground for last year's Grand Prix de l' Age d'Or at Rouen, has an undisturbed nature sanctuary where scenes like this are common.*

Visitors to St. Paul during the Monaco G.P., can park their cars by the famous restaurant, La Colombe d'Or, before walking into the Middle Ages.

The lanes are paved with pink tiles like Siena.

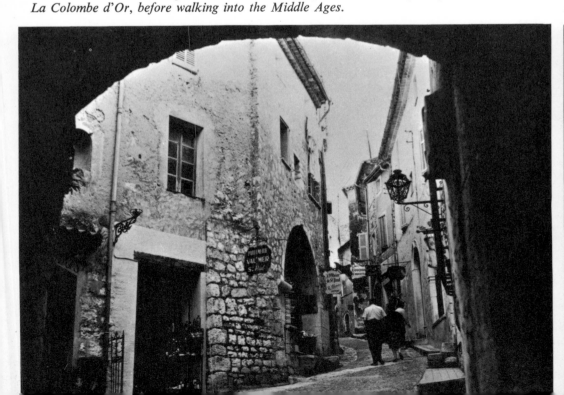

If Only . . .

"Look in my face: my name is Might-have-been"
D. G. Rossetti

In our lives "If" usually takes the form of "If only", and generally carries with it implications of regret. On the eve of a Grand Prix it is interesting to speculate how racing history might have altered had certain individuals avoided making costly mistakes, had errors of judgment been avoided, had bad luck not decided an issue in the form of mechanical failure. I can think of many instances. There was Graham Hill's magnificent drive in the 1960 British Grand Prix at Silverstone. His B.R.M. stalled on the front row of the grid and he was left at the back of the field. Determined to wipe out the memory of his start, Hill drove with rare determination. In three laps he went from 24th to 14th position. By lap 20 he was 6th Two laps later he was 5th and 17 seconds behind the leader, Jack Brabham. Ten laps later Brabham was 3 seconds ahead of Ireland and 9 seconds over the B.R.M. On lap 37 Hill overtook Ireland and went into 2nd place. On lap 50 the B.R.M. was 1·7 sec. behind the leader; on lap 51 . . . 0·5 sec.; . . . on lap 52 . . . 0·3 sec.; . . . on lap 53 both cars went past the pits wheel to wheel; on lap 54 Graham Hill had taken the lead. If only the race had ended then, an historic drive would have had its just reward and Hill would have marked up his first Grand Prix win, but the strain proved too great. Coming into Copse Corner, he overtook two cars, erred by a fraction, spun, and was out of the race with only 6 laps to go.

If only luck had lasted a few seconds longer, the same driver would have won the 1964 Belgian Grand Prix, sentiments shared by Gurney and McLaren on those confusing last laps when the first three cars dropped out leaving Clark an unexpected winner, but few drivers can murmur "If only" with more justification than Stirling Moss who time and again saw World Championship honours snatched away. Fangio's epic drive at Nürburgring was good fortune tested to breaking-point when chasing Collins and Hawthorn, after a wheel-change, he pulled back 35 seconds in 2 laps, smashed the circuit

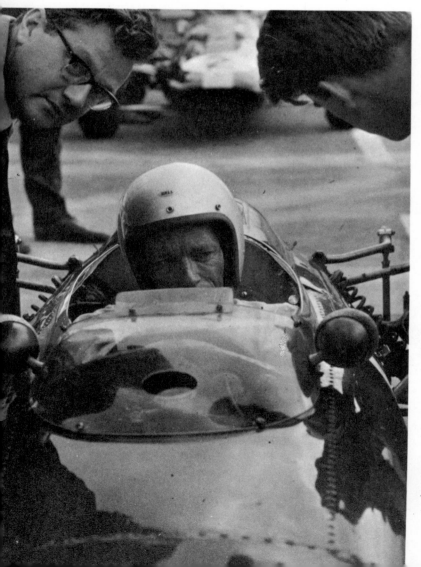

In a roll of Champions-that-might-have-been, Ginther would have to his credit three wins in the Monaco Grand Prix, three in the Italian, one Austrian and one American.

record 10 times and won by 3 seconds from Hawthorn. Every conceivable risk was taken. The "If" speculation suggests a permutation of possibilities had the Argentinian's luck not held. Then there was the occasion at Monza in 1956 when Collins voluntarily gave his car to Fangio, a gesture that enabled Fangio to win the World Championship. If the Englishman had not been so sporting, would he have won the Italian Grand Prix? I might add if only Bandini had not shunted Graham Hill in the 1964 Mexican Grand Prix!

A list of "If onlys" could be lengthy, and very often the cause was trivial. With that in mind it is interesting to see what the roll of Grand Prix champions would have been like had the honours gone to the runners-up. Here then is the revised list of Champions-that-might-have-been from 1950–1964:

1950	Fagioli	British Grand Prix
	Fagioli	Swiss Grand Prix
	Fagioli	Belgian Grand Prix
	Fagioli	French Grand Prix
	Ascari	Monaco Grand Prix
	Serafini/Ascari	Italian Grand Prix
1951	Fangio	British Grand Prix
	Fangio	German Grand Prix
	Ascari	Belgian Grand Prix
	Ascari	French Grand Prix
	Gonzalez	Italian Grand Prix
	Gonzalez	Spanish Grand Prix
	Taruffi	Swiss Grand Prix
1952	Farina	Belgium Grand Prix
	Farina	French Grand Prix
	Farina	German Grand Prix
	Farina	Dutch Grand Prix
	Taruffi	British Grand Prix
	Gonzalez	Italian Grand Prix
	Fischer	Swiss Grand Prix
1953	Fangio	German Grand Prix
	Fangio	French Grand Prix
	Fangio	British Grand Prix
	Farina	Dutch Grand Prix
	Farina	Swiss Grand Prix
	Farina	Italian Grand Prix
	Villoresi	Argentine Grand Prix
	Villoresi	Belgian Grand Prix
1954	Hawthorn	British Grand Prix
	Hawthorn	Italian Grand Prix
	Hawthorn/Gonzalez	German Grand Prix
	Gonzalez	Swiss Grand Prix
	Musso	Spanish Grand Prix
	Kling	French Grand Prix
	Trintignant	Belgian Grand Prix
	Farina	Argentine Grand Prix
1955	Moss	Belgian Grand Prix
	Moss	Dutch Grand Prix

	Castellotti	Monaco Grand Prix
	Farina	Argentine Grand Prix
	Fangio	British Grand Prix
	Taruffi	Italian Grand Prix
1956	Collins/Fangio	Monaco Grand Prix
	Collins/Fangio	Italian Grand Prix
	de Portago/Collins	British Grand Prix
	Moss	German Grand Prix
	Castellotti	French Grand Prix
	Frere	Belgium Grand Prix
	Behra	Argentine Grand Prix
1957	Musso	French Grand Prix
	Musso	British Grand Prix
	Fangio	Pescara Grand Prix
	Fangio	Italian Grand Prix
	Hawthorn	German Grand Prix
	Brooks	Monaco Grand Prix
	Behra	Argentine Grand Prix
1958	Hawthorn	Belgium Grand Prix
	Hawthorn	British Grand Prix
	Hawthorn	Portuguese Grand Prix
	Hawthorn	Italian Grand Prix
	Hawthorn	Moroccan Grand Prix
	Salvadori	German Grand Prix
	Schell	Dutch Grand Prix
	Musso	Argentine Grand Prix
	Musso	Monaco Grand Prix
	Moss	French Grand Prix
1959	Phil Hill	French Grand Prix
	Phil Hill	Italian Grand Prix
	Brooks	Argentine Grand Prix
	Brabham	Dutch Grand Prix
	Moss	British Grand Prix
	Gurney	German Grand Prix
	Masten Gregory	Portuguese Grand Prix
	Trintignant	American Grand Prix
1960	McLaren	Monaco Grand Prix
	McLaren	Belgium Grand Prix
	McLaren	Portuguese Grand Prix
	Ireland	Dutch Grand Prix
	Ireland	American Grand Prix
	Allison	Argentine Grand Prix
	Gendebien	French Grand Prix
	Surtees	British Grand Prix
	Ginther	Italian Grand Prix

Maggs would claim the French Grand Prix in 1962 and 1963.

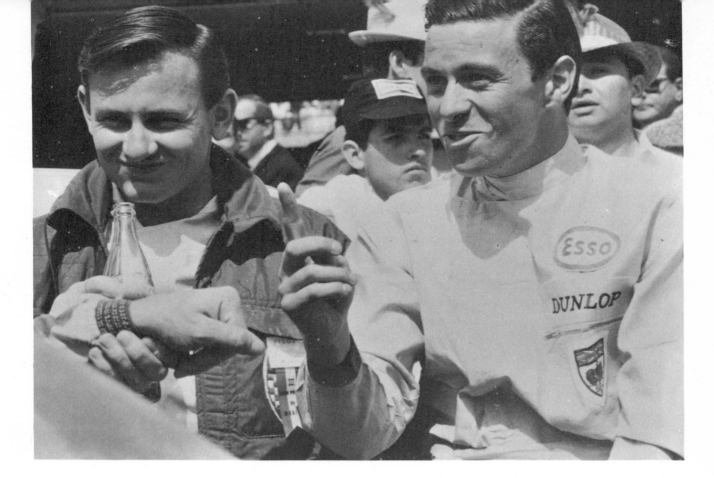

McLaren would have seven wins to his credit against Clark's one.

Trevor Taylor would have had the 1962 Dutch Grand Prix.

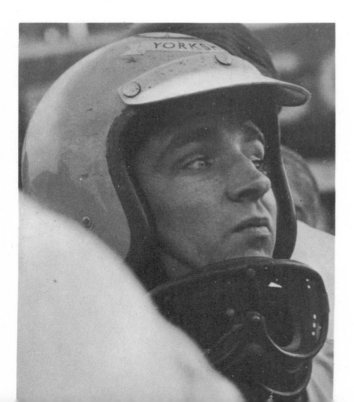

1961	Gurney	French Grand Prix
	Gurney	Italian Grand Prix
	Gurney	American Grand Prix
	von Trips	Belgium Grand Prix
	von Trips	German Grand Prix
	Phil Hill	Dutch Grand Prix
	Phil Hill	British Grand Prix
	Ginther	Monaco Grand Prix
1962	Graham Hill	Belgium Grand Prix
	Graham Hill	American Grand Prix
	Surtees	British Grand Prix
	Surtees	German Grand Prix
	Trevor Taylor	Dutch Grand Prix
	Phil Hill	Monaco Grand Prix
	Maggs	French Grand Prix
	Ginther	Italian Grand Prix
	McLaren	South African Grand Prix
1963	Ginther	Monaco Grand Prix
	Ginther	Italian Grand Prix
	Ginther	American Grand Prix
	Gurney	Dutch Grand Prix
	Gurney	South African Grand Prix
	McLaren	Belgium Grand Prix
	Maggs	French Grand Prix
	Surtees	British Grand Prix
	Clark	German Grand Prix
	Brabham	Mexican Grand Prix
1964	Ginther	Monaco Grand Prix
	Surtees	Dutch Grand Prix
	McLaren	Belgian Grand Prix
	Graham Hill	French Grand Prix
	Graham Hill	British Grand Prix
	Graham Hill	German Grand Prix
	Ginther	Austrian Grand Prix
	McLaren	Italian Grand Prix
	Surtees	American Grand Prix
	Surtees	Mexican Grand Prix

Examine the list in detail and it is obvious that honours have been scattered much wider. Injustices are righted by the addition of several names to the roster of champions. For instance, Luigi Fagioli more than merits a place. Before the World Championship was inaugurated in 1950, this massive, temperamental Italian was an outstanding driver. His innumerable successes in the mid-'thirties included the Grand Prix of Spain against opposition of the calibre of Nuvolari and Caracciola, the Grand Prix of Italy and the Coppa Acerbo at Pescara. In 1950 Fagioli came out of a twelve-year retirement at the request of Alfa-Romeo and completed the team of Farina and Fangio with marked success. His association with Mercedes-Benz was more tempestuous. As happens in many teams, internal friction led to accusations that Caracciola was getting more powerful engines and preferential treatment. Matters came to a head when Fagioli was called into the pits and kept there until his team-mate flashed past. That incident closed the Mercedes chapter. Nearly 20 years later Fagioli had personal revenge in the 1952 Mille Miglia. His Grand Turismo Lancia beat Caracciola's Mercedes for 3rd place. Not long afterwards the Italian crashed in the Tunnel at Monte Carlo and died from his injuries. His name is little known to the present generation, yet under his method of according honours to the runners-up, Luigi Fagioli would have been the 1950 World Champion.

Another worthy addition to the list of champions would have been Luigi Musso. A brilliant driver, he was the only Italian in an Italian car to beat the all-powerful combination of Fangio in a Mercedes . . . then there would be Luigi Villoresi, a member of the formidable 1951 Ferrari team of Ascari, Gonzalez and Taruffi that broke the Alfa-Romeo domination. A driver who more than qualified for such recognition was Harry Schell, whose heart was big enough to beat the world's best. I remember the 1954 Spanish Grand Prix when, at the wheel of a Maserati, he had the edge on the Mercedes–Benz of Fangio, Kling and Herrmann; the Lancias of Ascari, Villoresi and Castelloti; the Maseratis of Musso and Mieres; and the Ferraris of Hawthorn and Trintignant. It looked as if the volatile Harry would take the chequered flag, when he overdid it, hit some bales, and was out of the race. Anyhow on the strength of this ranking he would be remembered by his drive in the 1958 Dutch Grand Prix. The only possible bone of contention is that his team-mate and friendly rival, Jean Behra, qualifies for double mention. When they were both in the B.R.M. team, there was never a dull moment, particularly when things were not going right, and this recognition-advantage would have been a debating point for days.

Memories fade, but the records would help us to remember such men as Masten Gregory with his aggressive determination; Cliff Allison, who was a far better driver than his tally suggests; Roy Salvadori, suave and cool; Alfonso de Portago, colourful and impulsive. There would be comparatively new boys in Tony Maggs, fastidious and concentrated, and the rugged Trevor Taylor. Individual scores show Richie Ginther with 8; McLaren with 7; Gurney 6; Graham Hill, Phil Hill, Surtees, Moss, Musso and Gonzalez with 5 apiece; Farina and Hawthorn are on the 9-mark; Fangio tops the list with 10.

These tables prove—if proof be needed—that in championship events it is only the winner who counts. To be runner-up is gratifying, but the feat is only remembered as long as the presentation ceremony lasts. These are the men who can say with feeling: "If only . . ."!

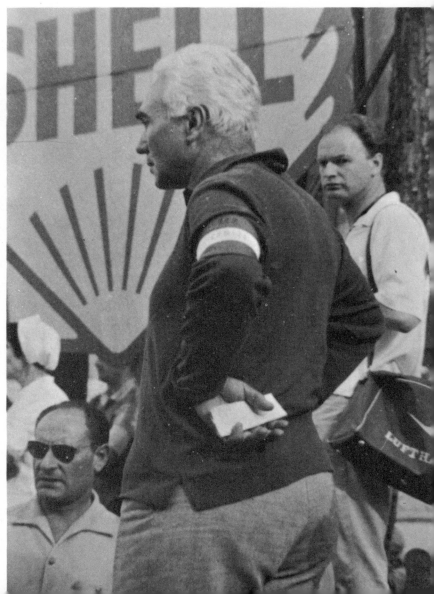

Piero Taruffi marks up a hat-trick—1951 Swiss Grand Prix, 1952 British and 1955 Italian.

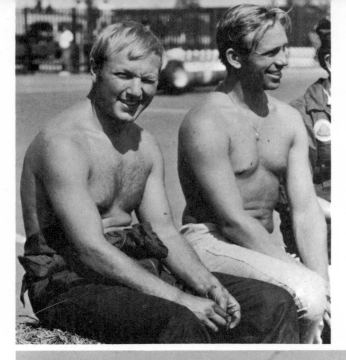

The Topless Vogue

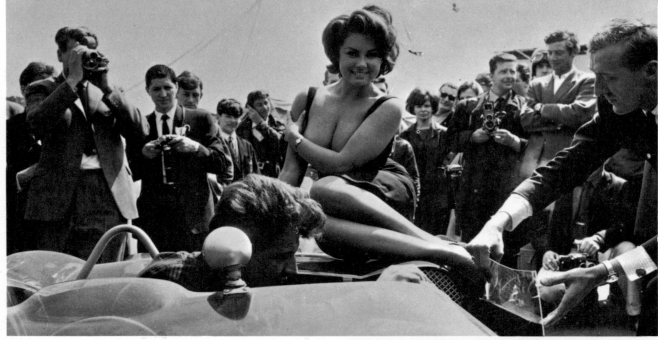

The 1964 spate of Beatlemania made it difficult at times to determine the sex of an individual, though the topless dress vogue was frequently a great help in biological detail. Mike Spence and Lotus mechanic, Derek Wild, enter into the spirit of the trend in Mexico, until Spence suddenly has an extraordinary thought! I hasten to add that all was well . . . they only *look* like a pair of nursing fathers!